PAINTING THE
HEAVENS

PAINTING THE HEAVENS

ART AND SCIENCE
IN THE AGE OF GALILEO

Eileen Reeves

PRINCETON UNIVERSITY PRESS

PRINCETON, NEW JERSEY

LIBRARY OF CONGRESS CATALOGING-IN-PUBLICATION DATA

REEVES, EILEEN ADAIR.

PAINTING THE HEAVENS : ART AND SCIENCE IN THE

AGE OF GALILEO / EILEEN REEVES.

P. CM.

INCLUDES BIBLIOGRAPHICAL REFERENCES AND INDEX.

ISBN 0-691-04398-1 (CL : ALK. PAPER)

1. ASTRONOMY IN ART. 2. PAINTING, EUROPEAN. 3. PAINTING,

MODERN—17TH–18TH CENTURIES—EUROPE. 4. ART AND SCIENCE—

EUROPE—HISTORY—17TH CENTURY. I. TITLE.

ND1460.A74R44 1997

758'.952'094—DC21 96-51631

THIS BOOK HAS BEEN COMPOSED IN GALLIARD

PRINCETON UNIVERSITY PRESS BOOKS ARE PRINTED

ON ACID-FREE PAPER AND MEET THE GUIDELINES

FOR PERMANENCE AND DURABILITY OF THE COMMITTEE

ON PRODUCTION GUIDELINES FOR BOOK LONGEVITY

OF THE COUNCIL ON LIBRARY RESOURCES

PRINTED IN THE UNITED STATES OF AMERICA

1 3 5 7 9 10 8 6 4 2

CONTENTS

LIST OF ILLUSTRATIONS vii

ACKNOWLEDGMENTS ix

INTRODUCTION
The Artist and the Astronomer 3

CHAPTER ONE
1599–1602: First Reflections on the Moon's Secondary Light 23

CHAPTER TWO
1604–1605: Neostoicism and the New Star 57

CHAPTER THREE
1605–1607: Mutual Illumination 91

CHAPTER FOUR
1610–1612: In the Shadow of the Moon 138

CHAPTER FIVE
1614–1621: The *Buen Pintor* of Seville 184

NOTES 227

BIBLIOGRAPHY 283

INDEX 305

LIST OF ILLUSTRATIONS

(Plates follow p. 150)

PLATE 1 Lodovico Cigoli, *Adoration of the Shepherds*, 1599

PLATE 2 Lodovico Cigoli, *Adoration of the Shepherds*, 1602

PLATE 3 Peter Paul Rubens, *Self-Portrait in a Circle of Friends*, ca. 1605

PLATE 4 *Self-Portrait in a Circle of Friends*, detail

PLATE 5 Lodovico Cigoli, *Deposition*, 1607

PLATE 6 Lodovico Cigoli, *Immacolata*, 1610–1612

PLATE 7 Francisco Pacheco, *Immaculada con Miguel Cid*, ca. 1619

PLATE 8 Diego Velázquez, *Immaculate Conception*, ca. 1619

FIGURE 1 Map of Mantua 71

FIGURE 2 Lodovico Cigoli, *Allegory of Virtue and Envy*, ca. 1611 173

ACKNOWLEDGMENTS

WHILE writing this book I have incurred various debts, none of which I can begin to repay, to a wide range of *viri Galilaei*. I must first thank Alban Forcione, who had the foresight and good taste to include Galileo's *Sidereus Nuncius* on the syllabus of a course in Renaissance literature well over a decade ago, for it was there that I encountered the text that still seems to me among the most astounding of the early modern period. I would also like to thank Miles Chappell: it was his study of Cigoli, Galileo, and *Invidia* that first interested me in the relationship of the painter and the Pisan scientist, and his remark that "the extent of Galileo's influence on the artists of Florence could be explored further" that inspired me to undertake this project. I have benefited enormously both from Chappell's work on all aspects of Cigoli's career, and from his close and attentive reading of an earlier version of this manuscript. I would also like to acknowledge my considerable debt to Martin Kemp, whose wide-ranging study of optical themes in Western art further encouraged me to enter this field, and whose intellectual enthusiasm and collegial generosity have proved invaluable. And I am especially grateful to Noel Swerdlow, who has always been ready to read and comment upon the various versions of this manuscript, to countenance arguments offered by a student of literature rather than of science, and to share with me his own recent work on Galileo.

I would like to acknowledge the curators of the Rare Book Library of Van Pelt Library at the University of Pennsylvania, where I began this project, and I am particularly indebted to Michael Ryan and Daniel Traister for their bibliographical expertise and enthusiasm. I would also like to thank Frank Bowman, whose field of interest might seem somewhat remote from mine, but whose dwelling place was once near and whose intellectual range, illuminating conversation, and steady friendship bridged every gap between early modern science and nineteenth-century French literature. I have also been blessed with the most inspiring and generous of mentors, John Freccero, and I thank him for the attention he has devoted to my work since I began graduate school, for his insistence that I explore the recondite field of scientific literature as much as I liked, for his interest in each new aspect of Galileiana that I encountered, and most lately, for moving heaven and earth, or at least the wheels of Italian bureaucracy, to help me obtain various documents and prints for this work. I am also grateful for the help and consideration given me by Princeton

University Press, particularly by Walter Lippincott, who encouraged me to develop the project in its earliest and most chaotic phase, and by Elizabeth Powers, who oversaw the initial version of this study, and especially by Alice Calaprice, whose editorial skill and organizational powers ensured that this publication would see the light of day. Finally, I want to thank Jim English for his boundless interest, patience, and love. It is to him that I dedicate this book.

PAINTING THE HEAVENS

THE ARTIST AND THE

ASTRONOMER

IN 1611, WHEN the telescope was a new and curious invention, those who possessed the instrument were few in number, and those who could use it with skill were even rarer. Among the more striking accounts of the incompetent observer was the one related to Galileo Galilei by his younger brother Michelangelo in an angry letter written in the springtime of that year. Lately settled in Munich, where he worked as a professional musician, Michelangelo had taken some pains to explain to his Wittelsbach patrons the telescope and what it revealed about the moon, the countless stars of the Milky Way, and the satellites of Jupiter. He may even have gone beyond the claims of the *Sidereus Nuncius* to include the most recent of his brother's observations, the phases of Venus, especially since this last discovery was considered strong evidence for the Copernican hypothesis of a heliocentric universe.[1] To his chagrin, however, his patient efforts to persuade the rulers of Bavaria of the usefulness of the tool and of the validity of Galileo's celestial observations were greatly undermined when other and less knowledgeable amateurs stepped forward to handle the telescope. Most irritating of all were the giddy blunders of an unnamed painter in whose house Michelangelo was living:

> What I wanted to tell you is this: my landlord, who is also an artist for Duke William [V Wittelsbach of Bavaria] and very friendly with him, told me recently that he was present when His Highness [Maximilian I Wittelsbach of Bavaria] received the telescope, and since this painter had seen mine more than once, and had consequently a little experience with it, he tried to assemble this new one right away. Without even checking to see if the lenses were clean, or adjusting the instrument, or mounting it on a stand, he and His Highness started observing from a window. To add to this fine spectacle, on that day it was snowing heavily, and the painter and His Highness ended up saying that they couldn't see a thing. At this point I explained to

them the circumstances which were necessary to the telescope's use; I real-
ized that Maximilian, since he hadn't been able to see anything at all, might
imagine that it wasn't a fit instrument for his eyes, and that he would never
take it up again.[2]

While this painter's ineptitude with the telescope was unusually great,
his interest in the instrument and what it might reveal about the earth and
the heavens was far more commonplace. Throughout the early seven-
teenth century, any number of painters turned with varying degrees of
competence both to astronomical pastimes and to the depiction of new
discoveries in their work, just as the central figures in the debates over
supernovae, moonspots, sunspots, comets, and the entire Copernican
world system regularly included artistic metaphors in their writings. The
subject of this book is the close and even crucial relationship between
astronomical and artistic activity in the early *seicento*. More specifically, it
is devoted to the significance of the great debates over the new star of
1604 and the lunar substance to four seventeenth-century painters, Peter
Paul Rubens, Lodovico Cigoli, Francisco Pacheco, and Diego Velázquez,
showing not only the surprising record they have left of these two dis-
putes, but also what place Galileo's own theories about the supernova
and the moon have in an artistic context.

Though the most important exchanges between painters and astrono-
mers involved

> the moon, whose orb
> Through optic glass the Tuscan artist views
> At evening from the top of Fesole,
> Or in Valdarno, to descry new lands,
> Rivers or mountains in her spotty globe,[3]

very little of the other celestial discoveries made in the early modern pe-
riod escaped the attention of the artistic community. Before returning to
the issue of the moon itself, one which had a particular appeal for the
painter, I will offer a brief overview of the widespread participation of
early modern artists in astronomical undertakings. In the same year in
which the unnamed protagonist of Michelangelo Galilei's story fumbled
with the spyglass, John Donne depicted astronomical discovery not as a
scientific controversy, but rather as a quarrel between painters:

> As when heaven looks on us with new eyes,
> Those new stars every artist exercise,
> What place they should assign to them they doubt,
> Argue, and agree not till those stars go out.

While Donne's suggestion was that the task of depicting the changing skies may have been beyond most artists, it was also in 1611 that Lodovico Cigoli and his fellow painter Domenico Cresti ("il Passignano") divided their time between decorating the Pauline Chapel of Santa Maria Maggiore and actually mastering the telescope, occasionally treating the church itself as an informal observatory from which they viewed first the clock at Saint Peter's, then the people and buildings of nearby Frascati and Tivoli, then the moon, the sun, and, finally, the Medici stars or moons of Jupiter.[4] It is possible, in fact, that Passignano observed the sunspots before Galileo himself did, and his description of them as "lakes or caverns" in the solar body was more accurate than the astronomer's insistence on dark clouds on the sun's surface.[5]

Still another Florentine artist who was then engaged in the ornamentation of the Pauline Chapel, the apprentice Sigismondo Coccapani, made observations of both moonspots and sunspots, and taught his master Cigoli how to avoid damage to his eyesight by using a technique where, because the spots were projected onto paper, the sun itself was said to be the painter.[6] Galileo relied not only upon the carefully drawn observations of Cigoli, Passignano, and Coccapani in his study of the dark patches that clouded the solar body, but also upon a fourth Florentine painter for help with his astronomical undertakings: he asked Iacopo Ligozzi to manufacture tubes for some of his earliest telescopes. Although it is not known if Ligozzi, the leading scientific illustrator in Tuscany, actually made observations himself, it would not be surprising to find that he did.[7]

Even those men connected with the art world but outside of the circle of Florentine painters with whom Galileo is traditionally associated seemed to believe in their own competence as astronomical observers. In 1611 Giovanni Battista Agucchi, today remembered as a theorist of Baroque art, discussed sunspots with Galileo, began using a telescope to study Jupiter's satellites, prepared a lecture on them for an academy of scholars outside Rome, and arranged to have an image of those planetary moons painted on a wall of his house for future inspiration. In 1612 Agucchi was exchanging letters with Galileo affirming the accuracy of the satellite positions predicted by the astronomer; by 1613 he was observing the changes in Saturn's appearance and considering, for the first time, the validity of the Copernican world system.[8]

Nor was it a matter of coincidence that the great Jesuit astronomer Christoph Scheiner first chose to publish his sunspot observations in 1612 under the pseudonym of the ancient painter Apelles. Scheiner, like Galileo, prided himself on his artistic skill: nearly a decade earlier, under "divine inspiration" and upon a challenge from an obscure, "lame, and

deformed painter of his acquaintance," he had invented the first panto-graph, a machine that could copy, enlarge, or reduce any drawing.[9] In the course of the sunspot controversy of 1612–1613, Scheiner called himself *Apelles latens post tabulam*, or "Apelles hiding behind the canvas," for two reasons: out of deference to the wishes of his Jesuit superiors, some of whom feared that the Society would be embarrassed if the astrono-mer's theories about a maculate sun later proved false; and, more impor-tantly, because he conceived of his artistic proficiency as the correlate of his observational skill.

The story of Apelles conveys a modesty and willingness to be corrected that Scheiner did not maintain. Pliny relates that Apelles hid himself be-hind his work in order to overhear and profit from the candid appraisal of passersby;[10] Scheiner, angered by the many elaborate insults offered by Galileo to "the masked Apelles," was less eager for criticism, and more inclined to conflict in his future works. But just as Galileo railed against the efforts of Scheiner and his followers years after their exchange came to an end by recalling that moment "when with poorly colored and worse designed pictures they have aspired to be artists,"[11] so the Jesuit astrono-mer persisted in presenting himself as a painter, and his observations of the sunspots as something depicted on a canvas. The metaphor would not die: in 1630, when Scheiner published his most significant solar theo-ries, the *Rosa Ursina*, he adorned it with a lengthy discussion—running to fifty folio pages—of that Apellean "paintbrush perfected in his studio," the helioscope.[12] In brief, the various analogies between the artist and the scientist remained in force because the pseudonym coincided with the actual interests of Scheiner, Galileo, and the supporters of both men.

If Galileo's first biographer, Vincenzo Viviani, is to be believed, the great astronomer wished as a young man to become a painter, but was encouraged instead by his father to devote himself to medicine, a field which he then wholly neglected for the study of mathematics.[13] Upon leav-ing the University of Pisa in 1585, Galileo began taking lessons in perspec-tive in Florence, where he, Lodovico Cigoli, and Giovanni de' Medici were tutored by the mathematician Ostilio Ricci at the home of Bernardo Buon-talenti, celebrated as an architect, engineer, and miniaturist.[14] What very little remains of his artistic production—his wash drawings of the cratered and shadowed surface of the moon, dating to 1609—testifies to his techni-cal skills, as does his election to the Florentine Academy of Design in Oc-tober 1613, in the midst of the controversy with "Apelles."[15] The astrono-mer maintained a lifelong membership in the Academy, commissioning paintings by leading artists and occasionally serving as arbiter of taste.[16] His advice was sought out by the greatest Tuscan painters of the period—Passignano, Cristofano Allori, Jacopo Chimenti, and Lodovico Cigoli—the last of whom claimed him as a very close friend and the best of his

mentors. Galileo's correspondence also reveals that he aided and encouraged two and possibly three women artists—most notably, the tragic figure of Artemisia Gentileschi—in a era in which they enjoyed rather little institutional support and individual patronage.[17]

Various references to artists and artistic practices occur in Galileo's most important astronomical works. Not all remarks are favorable; indeed, it is reasonable to conclude that he was adverse to many developments in contemporary art. In the *Letters on the Sunspots,* for instance, he had only mild enthusiasm for the *Arcimboldisti,* those "capricious painters who occasionally constrain themselves, for sport, to represent a human face or something else by throwing together now some agricultural implements, again some fruits, or perhaps the flowers of this or that season."[18] A decade later he complained in the *Assayer* of the extravagances of *trompe l'oeil,* noting the resemblance of that art to his rival's crafty arguments, these last being "disguised in such a way and fitted in piecemeal among such a variety of wordy ornaments and arabesques, or displaced and foreshortened at such angles, that perhaps those who consider them less carefully will at first think them somewhat different from what they really are."[19] In the *Dialogue Concerning the Two Chief World Systems* he went so far as to suggest great distaste for two Medici favorites, Mexican feather art, where feathers, rather than pigment, served as a medium, and *pietra dura,* or those tableaux of costly inlaid stones with which the Florentine Cappella dei Principi was then being ornamented. He exercised no great subtlety in criticizing either, bluntly stating that "a painter, from the various simple colors placed on his palette, by gathering a little of this with a bit of that and a trifle of the other, depicts men, plants, buildings, birds, fishes, and in a word represents every visible object, *without any eyes or feathers or scales or leaves or stones being on his palette.* Indeed, it is necessary that none of the things imitated nor parts of them should actually be among the colors, if you want to be able to represent everything; *if there were feathers, for instance, these would not do to depict anything but birds or feather dusters.*"[20] The latter art, that of inlaid stones, he associated repeatedly, as I will show in my first chapter, with an unscientific spirit and an excessive piety, an impression shared, perhaps, by his close friend Lodovico Cigoli as well. The works that Galileo most preferred are, as one might expect, Italian, and they range from the era that was said to have ended the very day of his birth, the High Renaissance of Michelangelo, to the late Mannerist period in which he and his fellow Tuscan artists lived and died.[21]

My purpose in this book is to show the relationship between seven seventeenth-century paintings—Cigoli's *Adoration of the Shepherds* of 1599 and 1602, his *Deposition* of 1607 and *Immacolata* of 1612, Peter Paul Rubens's *Self-Portrait in a Circle of Friends* of 1605, and the *Inma-*

culadas of 1618 of Francisco Pacheco and Diego Velázquez—and a rather limited aspect of Galileo's celestial observations, his conjectures concerning the new star of 1604, and above all, his discussion of the nature and substance of the lunar globe. What is most interesting about the relationship between Galileo and seventeenth-century painting is a certain, albeit limited, reciprocity between the astronomer and the artist. In other words, while most of my discussion treats these paintings as more or less faithful records of a scientific debate, the genesis of the entire issue of the lunar substance and its relevance to the Copernican world system derive from a term and a technique that Galileo deliberately took over from painters themselves. This was an effect called the "secondary light," long used by artists and students of optics to describe the faint illumination that occurs when a bright light, falling on a certain kind of surface, is reflected to and scattered over a second surface. Galileo used the term to argue that the dark and opaque earth, when struck by the sun's rays, was capable of sending that light back out into space and, at certain times in the lunar cycle, onto the dim face of the moon itself. While we might view his thesis as no more than a special case of the more general and widely accepted issue of the secondary light as it was presented both in perspective manuals and in countless paintings themselves, Galileo and his peers tended to see the argument in much more polemical fashion. Those who accepted it would have been almost invariably showing their support for a Copernican world system, and those who attacked it, or chose to explain the phenomenon of the secondary light in some other fashion, did so out of loyalty to either the Ptolemaic or the Tychonic universes.

Such divergences arose out of both physical proofs and metaphysical tendencies: to say that the rough and dark earth was an excellent reflector of light, and indeed that the ability to send light back out into space depended upon its rugged surface was, in Galileo's words, to draw it into "the dance of the stars," that is, into the company of the other planets, and to affirm that "she [was] movable and [surpassing] the Moon in brightness, and that she [was] not the dump heap of the filth and dregs of the universe."[22] Moreover, those who agreed that the moon's dim face was brightened by this secondary light tended to discard the traditional notion of a diaphanous or semidiaphanous lunar body, for they recognized that such illumination would be most evident on an opaque rather than a near-transparent surface. As Robert Burton pointed out in a breathless string of conclusions in *The Anatomy of Melancholy,* there was a nearly axiomatic connection, at least in the popular mind, between the theory of the secondary light, the Copernican worldview, and a belief in extraterrestrial life: "But *hoc posito,* to grant this their tenent of the earths motion: if the Earth move, it is a Planet, and shines to them in the *Moone,* and to the other Planitary inhabitants, as the *Moone* and they doe to us

on Earth: but shine she doth, as *Galilie, Kepler,* and others prove, and then *per consequens,* the rest of the Planets are inhabited."[23] Likewise John Milton, among the most brilliant of Galileo's interpretors, had the angel Raphael present the question of terrestrial reflection and the inhabited planets as the inescapable conclusion drawn by all who saw the cosmos as heliocentric:

> What if the sun
> Be centre to this world, and other stars
> By his attractive virtue and their own
> Incited, dance about him various rounds? . . .
> If earth industrious of her self fetch day
> Traveling east, and with her part averse
> From the sun's beam meet night, her other part
> Still luminous by his ray. *What if that light*
> *Sent from her through the wide transpicuous air,*
> *To the terrestrial moon be as a star*
> *Enlightening her by day, as she by night*
> *This earth?* reciprocal, if land be there,
> Fields and inhabitants: her spots thou seest
> As clouds, and clouds may rain, and rain produce
> Fruits in her softened soil, for some to eat
> Allotted there.[24]

In sum, the application of the artistic term "secondary light" to astronomical discussions meant that the technique figured, for the first time, as something other than a realistic but comparatively banal treatment of reflection in interior scenes. More importantly, it allowed painters, if they so chose, to enter, rather than merely record, the greatest scientific debate of their day.

Galileo's association of the "secondary" or "ashen" light with the practice of painting also complements a classical tradition. The tendency to describe the apparent visage in the lunar body as if it were painted was already an old one when Plutarch considered it in his *On the Face in the Moon;* the metaphor arose when the speakers in this dialogue discussed the lunar body's ability to reflect images from earth.[25] Clearchus of Soli, whom Plutarch portrayed as a wayward student of Aristotle, believed that the moon was a giant mirror, and that the light and dark patches constituting its face were the reflection of the great outer ocean with which the earth was bordered.[26] Plutarch countered the argument, which was acknowledged by his interlocutors as "the work of a man of daring and culture," first by comparing the apparent face in the moon to a painting: "In truth, the dark patches submerge beneath the bright ones which they encompass, and confine them, being confined and curtailed by them in

turn; and they are thoroughly intertwined with each other so as to make the delineation of the figure resemble a painting. This, Aristotle, seemed to be a point not without cogency against your Clearchus also."[27] He then suggested that the image on the lunar surface—the visage of a young girl, rather than that of an old man—was not a very credible likeness of the outer ocean, and here again he relied on terms drawn from painting:

> Although the outer ocean is a single thing, a confluent and continuous sea, the dark spots in the moon do not appear as one but as having something like isthmuses between them, the brilliance dividing and delimiting the shadow. Hence, since each part is separated and has its own boundary, the layers of light upon shadow, assuming the semblance of height and depth, have produced a very close likeness of eyes and lips. Therefore, one must assume the existence of several outer oceans separated by isthmuses and mainlands, which is absurd and false; or, if the ocean is single, it is not plausible that its reflected image be thus discontinuous.[28]

Plutarch's initial objections to the argument presented by Clearchus lay in the suitability of the mirrored image: the shape on the lunar surface simply did not look much like Oceanus. The artistic metaphor, however, remained intact and appears especially popular in the early modern period. Thus when other terrestrial features were proposed to explain the moon's spots—the most celebrated instance being the Habsburg ruler Rudolph II's conviction that he saw the Italian peninsula, Sicily, and Sardegna mirrored high above him[29]—the language used generally involved artistic techniques. The face in the moon, no matter what its origin, was said to be "depicted," "painted," or "fashioned with light and shadow."

Some of these terms, of course, had more relevance to optics than to conscious artistic production; to choose the most obvious instance, Johannes Kepler—who described himself as "not so much a painter as a mathematician"—wrote often of "pictures" and "paintings" projected onto either a sheet of paper or the retina.[30] In his annotated translation of *On the Face in the Moon*, in fact, Kepler chose not to comment upon Plutarch's artistic simile, and when he used such terms himself—"the moonspots paint themselves with their rays onto white paper"—there is little indication that he considered them anything other than the most accurate description of optical events.[31]

Kepler is the exception, however, to a general pattern: seventeenth-century writers routinely and deliberately compared the dark and light spots on the moon to the pigment on a painted surface. Some, like Galileo's opponents Lodovico delle Colombe and Giulio Cesare Lagalla, maintained that the apparent roughness of the lunar body were illusions precisely like those created by a painter, who used combinations of bright

and dark to evoke depth on the flat expanse of a canvas, while others such as the singularly circumspect Inquisitorial notary Benito Daza de Valdés said merely that a "good painter" would know if the moon really had mountains, leaving his readers to decide whether *buen pintor* referred to the pious mediocrity of Francisco Pacheco, or to the unorthodox, even heterodox, brilliance of the young Velázquez. The fact that the semidiaphanous moon was commonly compared to sunlit clouds, and that these had long been compared to the illusionistic effects of light and dark pigments on a canvas meant that *seicento* writers could and did establish an easy equivalence between painted surfaces, nebulous bodies, and the distant lunar landscape.

In the course of the debates that began with the publication of the *Sidereus Nuncius,* Galileo himself, accused of falling prey to the optical illusion of the lunar craters, compared the true scientist to a great artist, and the poor one to a mere copyist, or worse still, to an aesthete able only to recognize the painterly styles, poses, and figures of various *cinquecento* artists, but wholly incapable of observing the interplay of light, darkness, and perspective in nature:

> There are between the practice of natural philosophy and the study of it precisely those differences that we find between drawing from life and copying the works of others. Just as one becomes accustomed to handling the pen or pencil by copying the drawings made by the best artists, so, in order to train the mind in the practice of philosophy it is useful at first to see and observe things already studied by others, and especially the most certain ones, which are generally mathematical. But there are those who never do take up drawing from Nature, but always persist in copying drawings and paintings, such that they fail not only to become perfect painters, but are also unable to distinguish great art from bad, and good representations from poor ones, *through the recognition in thousands and thousands of natural examples the true effects of foreshortening, contours, lights, shadows, reflections, and the infinite variety of different viewpoints.*
>
> Thus the habit of poring over the writings of others without ever raising one's eyes to examine the works of Nature itself, and the attempt to recognize in them truths already discovered by others and to investigate a few of the infinite number of those left undisclosed, are practices which will never make a man into a natural philosopher, but merely into a student of the philosophy of others. I do not believe that you would call someone who was familiar with the drawings and canvases of every artist "a great painter," even if he were easily able to distinguish the style of this one from that one, and to say that this pose came from Michelangelo and that one from Raphael, and this group from Rosso [Fiorentino] and that one from [Francesco] Salviati, and was even able to copy them.[32]

As is evident in Galileo's description of what the aesthete can neither judge nor represent—the changing play of light, shadow and reflection on an obliquely viewed and apparently colorless surface—this ideal painting is none other than that of the moon. Nor was this particular comparison an idle metaphor—though those, too, flourished during the debates over the lunar substance—for the practice of painting or engraving the telescopic moon was for a brief period a common artistic practice in Tuscany. In his *Notizie,* for instance, the seventeenth-century historian of art Filippo Baldinucci recalled that as a young man in Florence he had observed Baccio del Bianco painting the moon, for the latter was one of several "clever painters" engaged by Grand Duke Ferdinando de' Medici to produce images of the lunar body. These artists had been enjoined by the grand duke to carry out their projects without consulting each other, Baldinucci wrote, adding: "I do not know what the high-minded Grand Duke intended, unless it was in part to see how each of them perceived those mysterious spots under magnification, as a greater illustration and confirmation of the evidence already revealed by that noble instrument."[33]

Despite undertakings of this sort, Galileo seems to have been for the most part unimpressed with even the best lunar representations. When his friends Nicolas Fabri de Peiresc and Pierre Gassendi arranged for the moon's surface to be depicted by Claude Salvatus, the painter on whose work Claude Mellan based his much-admired engravings, for example, the astronomer had only mild praise for his efforts, noting that even if some of the images were of "reasonable" quality, a crucial feature of the lunar body, "those extremely long ranges of steep mountains and other clusters of jagged shoals" had been omitted and could not be distinguished in the drawings even by observers who were able to see it on the moon.[34]

Yet these lapis and chalk representations compared favorably, in Galileo's view, to a set of engravings lately sent to the grand duke of Tuscany, ones that would eventually be published by Francesco Fontana, a Neapolitan instrument maker whose telescopes were the most powerful in the world.[35] These lunar views were "extraordinarily awkward," he felt, and had evidently been "drawn by someone who had never looked at the moon's face, but who had depended upon the written description of a very coarse person."[36] Who the unfortunate artist and engraver might have been is not clear, but it is certain that the "very coarse person" was Fontana himself, who was described by admirers and enemies alike as a talented but unschooled technician, and whose homely comparison of his enlarged image of the moon with the central marketplace in Naples was derided by Galileo as "a crude expression and evidence of the dimwittedness of that Neapolitan artisan."[37]

What is startling about Galileo's remarks is not his tone—tactful criticism was not a genre he mastered—but rather the moment in which they were made, October 1637, when the astronomer was completely blind in one eye, and nearly sightless in the other. For already in July 1637 a despairing Galileo had confided to his friend Elia Diodati, "Add to this—*proh dolor!*—the total loss of my right eye, which is the one that accomplished what I may rightly call those many and glorious tasks. Now it is, my Lord, entirely without sight, and the other, which was and is imperfect, is deprived of what little use I might make of it, since its constant tearing allows me to do nothing, nothing, nothing that requires sight."[38] Yet he was somehow able, in these days of faltering vision, to make his own observations as well, using, in all likelihood, one of Fontana's telescopes, and describing the moon's daily, monthly, and annual libration. In what would be among the last of his contributions to early modern astronomy, Galileo described the changing angles from which the moon's surface is seen from a mobile earth in terms that were explicitly artistic, treating libration as if it were a question of a variously illuminated portrait of a woman's face. He noted, therefore, that over the course of an evening the moon appeared to look up and then down, such that an observer would see now more of her chin, now more of her forehead, and that from one month to the next he would see one ear and then the other, and through the year he would find her head inclined to one shoulder or the other.[39] Galileo's eyes would deteriorate still more over the course of the next year, but it is clear that when the young John Milton visited him at Arcetri, what struck the poet about the man he later recalled as the "Tuscan artist" was less his blindness than that penumbral vision that allowed him both to correct the lunar paintings of others and to offer an imaginative astronomical portrait of his own.[40]

While Galileo had criticized the artist associated with Mellan, Gassendi, and Peiresc for the features omitted in his lapis and chalk drawings, arguing elsewhere that it was precisely the familiarity of "the wide fields scattered in the plains, and the long ranges of mountains and clusters of shoals" that allowed us to compare the lunar and terrestrial bodies, there was always the risk that depictions of the moon might too closely resemble the earth.[41] Consider, in this connection, a curious observation offered by Pierre Gassendi in his discussion of Mellan's engravings of the moon. Just as Galileo had argued in his *Dialogue Concerning the Two Chief World Systems* that the similarities between the earth and its satellite did not mean that the moon was home to anything remotely like men, or animals, or plants, but rather that it was the habitat of living organisms "far beyond all our imaginings," so Gassendi reminded his readers that whatever forms of life existed on the lunar body, they would surely sur-

pass both the most extravagant of conjectures and the reach of the latest telescopes.[42] He concluded these sober remarks, however, with a story that appears at first glance designed expressly to increase such speculations, and to associate them with the efforts of painters:

> There is no hope or reason that all this might be observed by any telescope, even if we hear that lately there one was made in Naples that was able to enlarge the moon and to show everything much more distinctly than before, and even if Rubens could write a few years ago to Peiresc that there was an excellent and scrupulous painter named Heymus near him who had told him that he had seen an optical tube in the possession of [Cornelis] Drebbel that was a palm's breadth in diameter and which allowed one to make out plains, forests, buildings, and fortifications on the moon, none of them any different from those on the earth.[43]

Gassendi's anecdote is in every way surprising: the letter to which he refers is not extant in the correspondance of Rubens and Peiresc, and the Flemish artist was in any case extraordinarily skeptical of Drebbel, dryly asserting that he looked more impressive from a distance than at close range, and showing little of his contemporaries' enthusiasm for the many claims of this magus-like figure.[44] If Rubens reported any such statement on the part of the anonymous Heymus—one of the many painters named "van Heem" or "van Hem"—it was surely in derision, though it is not clear whether he was mocking the apparent gullibility of the artist or the hucksterism of Drebbel, who often bragged about his ability to produce optical illusions and who was then residing in England, where the question of an inhabited moon was of peculiar interest.[45] It cannot be a coincidence that the manner in which Heymus was described reflects this very ambiguity, the expression *egregius probusque pictor* referring either to a particularly honest and upright painter and suggesting that he, like Rubens and Gassendi himself, had denounced Drebbel's sham, or to a painstaking and meticulous artist, precisely the type of man who might be tempted to paint the wholly illusory minutiae of the moon. As in the case of Daza de Valdés's cryptic allusion to the *buen pintor*, Gassendi's reference suggests that some sort of responsibility, either for recognizing genuine lunar features or for perpetuating myths about the earth's satellite, rested with the painter.

I turn from these general issues to the precise subject matter of the seven paintings discussed in this book. Though there is no shortage of seventeenth-century mythological scenes or landscapes in which lunar phenomena are presented, I have chosen, apart from the obvious exception of Rubens's *Self-Portrait*, to concentrate on sacred painting, limiting my argument to two *Adorations,* one *Deposition,* and three *Immaculate Conceptions,* and I have done so for several reasons. Canons for sacred

painting were more rigorous than those involving secular subjects, and the former rather than the latter category appears to me the more valuable source of information about both the astronomical debate and the manner in which solilunar configurations should be rendered for the edification of the faithful. Scriptural commentaries, moreover, exerted some influence over the artist, and they often serve as a complementary record of the ongoing discussions between proponents of the Ptolemaic, Tychonic, and Copernican world systems. And since both Galileo himself and Galilean scholars of the late twentieth century have found themselves increasingly involved, or perhaps embroiled, in questions relating the doctrinal to the scientific, paintings in which the sacred subject matter is nuanced by an astronomical argument seem to me of the greatest interest and significance.

I have begun with two pretelescopic works, Lodovico Cigoli's 1599 and 1602 *Adorations,* because they help us establish a more accurate chronology in the development of the issue of the secondary light, an effect that Galileo began to associate with Copernicanism only around the summer of 1605. I argue that the lunar phenomenon, while clearly depicted in the latter painting, is just as clearly understood as an idle bit of astronomy rather than as strong evidence for a heliocentric world system. Indeed, the point of the two lunar vignettes in these *Adorations* is their absolute irrelevance to the Nativity in the foreground: the lunar globe hovering over two oblivious shepherds is only something to be left behind as the faithful make their way toward Bethlehem on the day of Christ's birth. But while Cigoli's early *Adorations* are characterized by this strident absence of connection between astronomical knowledge and the ostensible subject of the paintings, the focus of my second chapter, Peter Paul Rubens's *Self-Portrait in a Circle of Friends,* would seem to bear witness to the opposite tendency, for the celestial phenomena presented in this work of 1605, the aurora borealis, cannot be understood independently of the Neostoicism which Rubens, Galileo, and the other sitters in the portrait practiced. The association of Galileo's conjectures about both the aurora and the new star of 1604 with Neostoic and Copernican cosmology proved, if anything, a bit too close, for by the spring of 1605 the astronomer realized that the supernova would not provide him with evidence for a mobile earth, and he discarded the greater part of the arguments to which Rubens's painting alludes, making the portrait a rare document of this phase of his development.

Within several months, however, Galileo reached a fuller understanding of the moon's secondary light, and this discovery appears to have convinced Cigoli of the relevance of the phenomenon of incidental reflection in painting, of the merits of Copernicanism, and most importantly, of the relationship of scientific and religious knowledge. Thus in my third chap-

ter I try to reconstruct the artistic context from which Galileo's explanation of the secondary light may have emerged, and I show how the *Deposition* of 1607, completed about eighteen months before the invention of the telescope, serves as a focal point for the painter's knowledge of light and shadow, his understanding of the lunar effect as evidence for Copernicanism, and his presentation of spiritual *and* scientific progress as inseparable. This is to say—and Cigoli does, I think, say it, with a particular reading of the Johannine gospel—that Scripture now could and should be accommodated to the latest advances in astronomy.

My fourth and fifth chapters concern an other and not unrelated lunar issue, the great debate over the moon's nature and substance in the first decade after the publication of the *Sidereus Nuncius*. It comes as something of a surprise to see that the most heated arguments for a spotless, smooth, and transparent lunar globe emerged after the invention of the telescope, such that by 1614 the crescent moon was described by one astronomer as "wholly luminous . . . like a cloud or crystal," and was declared to be "completely pellucid like crystal or some other glass" during a solar eclipse. But aside from Galileo, who was disconcerted to find his depiction of the rough and opaque moon so vigorously contested, perhaps rather few early seventeenth-century scientists, and fewer still of their readers, found a flawless and glassy lunar globe less reasonable than the earthlike body lately discussed and engraved in the *Sidereus Nuncius*. The traditional association of the pure, immaculate, and translucent moon with the Virgin Mary made Galileo's comparison of the lunar globe with an opaque, spotted, and cracked wineglass embarrassingly inappropriate, and those who contested the claims made by the Pisan relied on terms unmistakably drawn from Marian conventions. They also depended, as I noted earlier, on an updated version of Plutarch's topos of the painted moon in order to maintain that the apparent peaks and craters were nothing but illusions created by the uneven distribution of dark and light material in an otherwise featureless globe. Just as contrasting pigments on a canvas created the appearance of depth, Galileo's detractors wrote, so the admixture of a two-toned but homogeneous substance counterfeited the mountains and depressions the Pisan astronomer claimed to have seen through his telescope.

Both the association of the crystalline moon with Marian iconography and the artistic conventions that did away with its spots and contours meant that some sacred paintings involving the lunar body served as a natural focus for the debate between Galileo and his adversaries. More precisely, the most significant works were those representing Revelation 12 and the Immaculate Conception, where a woman clothed in the sun and crowned by twelve stars stood on the moon and was menaced by a

dragon. After examining the earliest arguments against the *Sidereus Nuncius,* therefore, I show in my fourth chapter how Lodovico Cigoli defended the Galilean hypothesis in his greatest and most beautiful work, the *Immacolata* of the Pauline Chapel at Santa Maria Maggiore in Rome, painted from 1610 to 1612. Whereas Cigoli suggested in his *Deposition* of 1607 that faith could be accommodated to scientific advancement, here he went further, implying that those who failed to make such an accommodation—and that meant in this case those who insisted upon an immaculate crystalline moon—were not merely ignorant in astronomy but lacking in piety as well. As careful analysis of the *Immacolata* makes plain, the observer who failed to see the moon as Galileo described it and Cigoli painted it—massive, solid, opaque, and everywhere covered with mountains and craters—occupied the shadowy region beneath the lunar body with the Satanic dragon of Revelation 12. There is strong evidence to suggest, moreover, that their blindness to a truth at once scientific and scriptural was occasioned, in Cigoli's view, by envy as much as by ignorance, and even that he imagined a particular group of Galileo's adversaries, the so-called *Colombi* of Florence, as the invidious souls clustered in the shadows with the serpent.

But while Cigoli's *Immacolata* was one last attempt to combine the astronomer's latest discoveries with Scripture, or to accommodate, as some would have it, Galileo's theories to the pronouncements of the Man from Galilee, it scarcely managed to solve the puzzle of the lunar substance. My fifth and final chapter is devoted to the increasing insistence on a pure, immaculate, and wholly featureless moon, one from which all trace of opacity, obscurity, shadows, and even phases had been erased, in part by a group of Jesuit scientists. Here I discuss the crystalline moon in the *Inmaculadas* of Francisco Pacheco and Diego Velázquez, both completed around 1621, but taking opposite sides of a debate at once doctrinal, astronomical, and artistic. After showing how Pacheco's work conforms to conclusions about the crystalline moon drawn in 1613–1614 by several Jesuit writers, I contrast it with the *Inmaculada* of Velázquez, where all that Galileo had said about the rough, dark, and mountainous moon finds confirmation in the odd icon beneath the Virgin's feet.

I conclude the chapter and the book with an examination of two documents that contest, albeit in different ways, the pervasive association of the pure and Immaculate Virgin with the pure and immaculate moon in which so many posttelescopic thinkers believed. The first of these texts is by Galileo himself. Written in July 1611 and ostensibly a repudiation of the theory of the crystalline lunar globe, the *Letter to Gallanzone Gallanzoni* can also be read as an implicit criticism of the emerging doctrine of the Immaculate Conception, the basis of many of the Marian

associations with the moon. This is not to say that Galileo necessarily doubted or upheld the Immaculate Conception itself, but rather that he recognized it as the underpinning of the theory of the crystalline moon, and attacked both notions at once by pointing to what was illogical, arbitrary, and above all dangerously novel in them. His remarks would have been of particular significance for the Jesuits, who were at once advocates of the Immaculate Conception and sometime proponents of the glassy lunar globe on which the *Immacolata* stood, but who had also been enjoined by the statutes of their Society and by letters from the general of their order to eschew innovation in philosophical and doctrinal matters.

Given the implied conflict in the Jesuit position, it is especially appropriate that my last document, the *Sphaera Mundi,* was written by a member of that order. Father Giuseppe Biancani argued in support of Galileo's lunar theories; more to the point, however, he made a number of oblique references to the Marian obsession of his adversaries, presenting, in brief, what the Pisan astronomer had lately discovered in the heavens as a new Revelation 12, a scene to rival and eventually to replace those older paintings where the Immaculate Virgin stood on her immaculate globe. It is significant that Biancani defined the conflict over the lunar substance, now a decade old, in pictorial terms, for it implies a recognition of the artist's role in this most interesting of astronomical debates.

Some attention should be paid, finally, to previous studies of Galileo and the arts. The classic work in this field is of course Erwin Panofsky's *Galileo as a Critic of the Arts,* which first appeared as a short monograph directed to art historians in 1954 and was subsequently published, slightly modified in form, in *Isis* two years later. Panofsky argued that Galileo's distaste for Mannerist tendencies in art—his contempt for anamorphosis, for *intarsia* or pictures made of inlaid wood, for the *wunderkammer,* for the *Arcimboldisti,* for all manner of distortion—had its echo in his "classicizing" scientific attitudes, where regularity, harmony, and symmetry prevailed. And in fact Panofsky was able to show that Galileo's otherwise unaccountable avoidance of the ellipse in his discussion of planetary revolutions might best be considered in light of his aesthetic attitudes, the ellipse being a variation on the circle and just one more instance of the Mannerist distortion of the perfect forms favored by the High Renaissance.[46] We might add, for the sake of completeness, three more items to the list of Mannerist favorites criticized by Galileo—*trompe l'oeil, pietra dura,* and Mexican feather art—seeing in them the same deviation from the "norm of nature" of Renaissance painting. In substance, Panofsky's contribution to the field lay in this establishment of rather strict analogues between aesthetics and scientific thought, some of

which had been made by Galileo himself, others that might simply be inferred, and all of which turned upon the opposition of High Renaissance aesthetics to the late aberrations known as Mannerism.

Subsequent studies have shown Galileo's influence on particular artists, especially on Adam Elsheimer, whose 1609 *Flight into Egypt* revealed a starry sky like that described months before in the *Sidereus Nuncius,* and above all on Lodovico Cigoli, whose *Immacolata* stood on the cratered moon first glimpsed by the astronomer.[47] Attention has for the most part been limited to iconographic details—the numberless stars of the Milky Way, or the opacity and plasticity of the rough lunar globe—and the way in which they confirm claims made in the *Sidereus Nuncius.* Some analysis has also been devoted to Galileo's own artistic ability (as opposed to his aesthetic sensibilities), for it is certain that his skill as a draftsman aided him both in understanding, for example, the rugged surface of the moon or the slow movement of the sunspots across the solar body, and in depicting these phenomena for an audience that never had or never would use a telescope.[48] Of late the limits of Galileo's use of naturalistic representations of the heavens have been shown; his reliance on scientific engraving, confined to his work on the sunspots and the moonspots in the years 1610 through 1613, has been discussed in terms of both the changing status of pictorial information in astronomy and Galileo's own preference for the "incorruptible monuments of letters."[49]

What is now necessary, I believe, is some attempt to draw together Galileo's aesthetic sensibilities and artistic abilities, his influence on *seicento* painters, and his sense of the strengths and limits of the genre in the presentation of astronomical information. Galileo's well-known comparison of Lodovico Ariosto's *Orlando Furioso* to Torquato Tasso's *Gerusalemme Liberata,* refigured as the difference between a tasteful Renaissance gallery and a cluttered Mannerist *wunderkammer,* does indeed signal a host of artistic preferences and intellectual tendencies. What is crucial is the way in which these preferences, or better, prejudices, correspond to actual pronouncements made by Galileo in the course of his astronomical arguments.

> It has always seemed to me that [Tasso] is extraordinarily meager, impoverished, and stingy in the matter of poetic invention, and that Ariosto, by contrast, is magnificent, rich and wondrous; and when I reflect upon the knights and all their adventures and undertakings, or any other of the tales told in [Tasso's *Gerusalemme Liberata*], it is as if I have entered the workshop of a curious little fellow, someone who takes great pleasure in surrounding himself with objects that are perhaps unusual for their great age, or for their scarcity, or for some other reason, but which are in fact mere

trinkets, as for example, a petrified shrimp, or a shriveled up chameleon, a fly
and a spider trapped in a piece of amber, and some of those earthen dolls
that they say come from ancient Egyptian tombs, and—as for painting—a
couple of sketches by Baccio Bandinelli or il Parmigianino, and other odds
and ends of this sort.

On the other hand, when I enter the *Furioso,* I see before me a treasury,
a tribune, a royal gallery adorned with a hundred antique statues carved
by the greatest masters, and paintings of the most famous subjects by the
best artists, and a vast collection of vases and crystal and agate and lapis lazuli
and other jewels, and finally an abundance of rare, priceless, marvelous and
superb things.[50]

Extant correspondence reveals what common sense would suggest, that
some members of Galileo's circle neither saw Torquato Tasso as the "cu-
rious little fellow" of the *wunderkammer,* nor condemned the kind of art
with which he was associated. Though Lorenzo Pignoria and Paolo
Gualdo, friendly with Galileo since his Paduan days, both urged him to
publish his commentary on Tasso, they had known and greatly appreci-
ated the author of the *Gerusalemme Liberata,*[51] and appear to have
mocked the junkshop analogy in private letters. Pignoria and Gualdo
alike were avid collectors—the inventory of the former's library and stu-
dio sounds not unlike the abode of the "curious little fellow"[52]—and fre-
quently described to each other thrifty acquisitions made in Padua and
Rome. Galileo would probably have been unimpressed, for instance, by a
purchase Pignoria recounted to Gualdo in August 1614:

> I've bagged an old painting, more than two *braccia* across and one in
> height, and without other ornamentation, where you see the Most Blessed
> Virgin adoring the Christ Child before her. And it's got two figures on each
> side, Saint Jerome and John the Baptist on the right, and on the left Saint
> Mary Magdalene and Saint Joseph. The figures are well placed, and the
> manner is very charming, something like Giovanni Bellini's, but softer. In
> sum I've done well for myself, and when Your Lordship returns he will see
> a nice canvas. It was in the hands of a Jew, lest it be thought that I'd stripped
> some altar.[53]

And it seems that Galileo would have liked still less Gualdo's acquisi-
tion and the tone of Pignoria's next letter, for both suggest that his
friends were amused rather than enlightened by his professed distaste
for the painter Parmigianino and his opposition of the *wunderkammer*
to the royal gallery: "The way I see it," Pignoria wrote to Gualdo in
November 1614, "Your Lordship is fast becoming an antiquarian. . . .
And in truth it's especially nice when you can find someone giving some-
thing away. That's the best way to go about it. I believe that the medal-

lion that once belonged Monsignor Gatimberto is signed by the painter Parmigianino."[54]

But while Pignoria and Gualdo may have been correct, or certainly within their rights, to take exception to Galileo's implicit condemnation of Tasso and of the Mannerist mania for curiosities, it is also true that the astronomer's criticism of what he saw as the random, haphazard, and unreal aspects of the *Gerusalemme Liberata* corresponds well to a certain insistence on realism in his scientific works. I intend by this not just a reiteration of Panofsky's elaboration of the "classicizing" tendencies of Galileo's thought, but rather a stricter and more limited association of remarks made in the *Considerazioni al Tasso* with those offered in the course of his astronomical arguments. As one might imagine, the common denominator of an issue at once aesthetic and scientific is painting, and more specifically, the treatment of light and color. Consider, then, a final comparison of Tasso and Ariosto, one in which the common term is artistic technique:

> One defect in particular is very common in Tasso, and is born of a great narrowness of wit and poverty of poetic conceits. Because he often lacks subject matter, he is forced to go around cobbling together various and piecemeal conceits, ones that have no dependence on or connection to each other, and so his story turns out looking more like a picture made of inlaid wood than one painted in oil. This is because the bits of inlaid wood, being a hodge-podge of different colors and thus unable to blend together in such a way that their edges lose their jarring contrasts in hue, necessarily make figures appear dry, crude, and devoid of contour and relief. In oil painting, on the other hand, since the outlines are softly blended together, there is no harsh progression from one shade to another, and so the painting that emerges is soft, contoured, with volume and relief. Ariosto softly shades and rounds his work, being most abundant in vocabulary, expressions, and poetic conceits, while Tasso, lacking in all that is necessary to the task, labors away in a rough, graceless, and crude fashion.[55]

It is significant that Galileo's version of true poetry depended on an effect like that rendered by the proper handling of light: Ariosto's work appeared so nuanced and subtle to him—in brief, tridimensional and real—that he could compare it to paintings in which the diffused secondary illumination guaranteed a soft overall harmony in the color scheme and avoided any "harsh progression from one shade to another." His distaste for the jarring tones of inlaid wood, quite apart from the Mannerist art in which they are most manifest, would emerge elsewhere, for in one of his anonymous treatises on the new star of 1604, Galileo compared the flaws in either a Ptolemaic or Tychonic world system to the "too bright colors and excessive darkness of the shadows" of a portrait painted without

adequate attention to the question of secondary light, implying that such light was both the hallmark of a good painting, and at that point the single most important argument for the Copernican universe. The muted effect provided by the secondary light, in other words, answered at once to both an aesthetic preference and an intellectual demand, ensuring that the nuanced and harmonious palette associated with it had its prototype in the world picture so convincingly presented by the great Tuscan artist.

1599–1602

FIRST REFLECTIONS ON
THE MOON'S
SECONDARY LIGHT

I N THE FALL of 1610, Michael Maestlin, professor of astronomy at the University of Tübingen, wrote a short letter to Johannes Kepler, astronomer to the Holy Roman emperor, Rudolph II, in which he congratulated his former pupil on a recent publication. The *Dissertatio cum Sidereo Nuncio* was in fact a comparatively modest work, a thoughtful response to the first important treatise on telescopic observations, Galileo Galilei's *Sidereus Nuncius*, rather than a description of Kepler's own extraordinary progress in astronomy, or, to make a familiar distinction, something closer to a book review than to an original piece of research. Maestlin was nonetheless especially pleased by one aspect of the *Dissertatio*, the scrupulous attention that Kepler had paid to questions of priority and chronology, and for this he thanked his greatest student: *Egregie sane tu in tuo scripto . . . Galilaeum deplumasti. . . .* "In your essay you did an exceedingly good job of plucking that Galileo of his feathers. He is not the first inventor of the telescope, nor is he the first person to notice the rough surface of the moon, nor the first to tell the world of the many stars in the sky."[1]

Galileo's various claims to priority were frequently contested, and it is not my intention here to restore or divest him of more feathers, but rather to examine a phenomenon that neither he, nor Kepler, nor even Maestlin was the first to notice, and to show what was novel and important in the account offered in the *Sidereus Nuncius*. At issue was the moon's secondary light, an effect which Galileo maintained he "had observed not recently, but many years ago, [and] shown to some close friends and pupils, explained, and given a causal demonstration."[2] As I will argue in this and the third chapter, Galileo's adoption of the term

"secondary light" was of particular interest to certain artists in his circle, for painters traditionally used the same term to describe incidental reflection in their paintings. Early documents will show, in fact, that whether or not he originally conceived of the effect in artistic terms, he presented the lunar issue as if it were part of painters' discussions of reflected light and muted color. It is very likely, moreover, that among the "close friends and pupils" with whom the astronomer first discussed the phenomenon was the greatest Tuscan artist of the period, Lodovico Cigoli, who managed to take the secondary light from its typical setting—the interior scene—and show its relevance to both astronomical and doctrinal issues.

It may well be that Galileo's claim to have demonstrated the cause of the secondary light "many years ago" is overstated. There is certainly no mention of the phenomenon, much less of its origin, in his earliest astronomical writing, the somewhat lackluster *Trattato della sfera* of 1586–1587, though this treatise does involve an extended discussion of the appearance of the crescent moon, when that light was most readily visible. While it is possible that he noticed the secondary light in the 1590s, it is likely that he really understood its importance as an argument for Copernicanism only after 1604, when the appearance of a new star late in that year encouraged him to take up the study of astronomy—and the defense of a heliocentric system—with an unprecedented vigor. It can be shown, in any case, that Galileo did arrive at his explanation at least four years before he ever lifted a telescope to the heavens, that he saw it even then as evidence of the Copernican world system, and that he relied on the conventions of painters to convince those around him. As I will demonstrate in this chapter, Galileo was probably aware of the secondary light as early as 1602, though it is unlikely that he fully understood the effect or explained it in artistic terms at that point. If Lodovico Cigoli's 1602 *Adoration of the Shepherds* can be used as a guide, the ashen light with which the moon in that painting is adorned was no more than an astronomical curiosity, a remote corner in a canvas devoted to the more central event of Christ's birth. The relative unimportance of this lunar phenomenon changed around the summer of 1605, when Galileo began to see it as strong evidence for the Copernican world system, and to associate it with artistic conventions about reflected light.

In this first chapter and in the third one, therefore, I will discuss the relationship between Galileo's astronomical progress and the evolving lunar iconography in three of Lodovico Cigoli's paintings, the *Adoration of the Shepherds* of 1599 and 1602, and the *Deposition* of 1607, arguing for an ultimate convergence in sacred, scientific, and artistic concerns in the single issue of the secondary light. It is true that there are significant obstacles to establishing a detailed chronology of those years: neither

Galileo's early commentaries on the *Almagest* nor his Copernican *De sistemate mundi* survive, and except for a proemium and fragmentary notes associated with the supernova of 1604—documents to which my second chapter is devoted—his three public lectures on the new star have also perished. No trace remains of what would be a very valuable document for historians of art and of science, his treatise on sight and colors, composed sometime prior to 1610 and mentioned by Galileo when he sought permanent employment at the Medici Court. The relationship of that work to Cigoli's "learned book" on the nature and qualities of color in painting is also a matter of mere conjecture, for the artist's manuscript has likewise vanished. Cigoli's treatise on perspective, extant and awaiting publication, would tell us much about reflected light were it not for the fact that the very section where the phenomenon would be discussed was excised, probably around 1628-1629. Nor are there many letters to or from Galileo for the years 1585 to 1610, and those that we possess often have little to do with Galileo's development as an astronomer, much less with his particular interest in lunar phenomena. Finally, despite the fact that Galileo and Cigoli had maintained a close friendship since at least 1585, when they both studied perspective in Florence with Ostilio Ricci, there are no letters at all between them for the period in question, and it is largely from those exchanged in 1610 to 1613 that we may surmise the warmth of their relationship, and more particularly, the ability and desire of each man to understand the work of the other.

These lacunae notwithstanding, there are several Galilean documents that allude to the issue of the secondary light, such that we may surmise roughly when he first observed the effect, when he showed it to others, and when he adduced it as evidence of the earth's planetary nature. These three moments, presented as synchronous in the *Sidereus Nuncius*, were undoubtedly separated by several years: it is unlikely that even a thinker of Galileo's range and imagination recognized in his first observation of the ashen light on the moon's surface that it might have anything at all to do with the second motion that Copernicus had attributed to the earth. We can, however, infer the stages in his gradual appreciation of the lunar issue first by reexamining his extant writings on the subject, and then by comparing them to the various treatment of lunar phenomena in two of Lodovico Cigoli's *Adoration of the Shepherds* and his *Deposition* of 1607.

Nor is this process an unusual one, for Cigoli's *Immacolata* of 1612 is routinely discussed—albeit in no great detail—in terms of its explicit dependence on the telescopic view of the moon in the *Sidereus Nuncius*. I am suggesting, therefore, that the exchange between the two men did not suddenly emerge in the penultimate year of Cigoli's life when the unaccountably brave, or brash, artist depicted a maculate moon beneath

the feet of the Immaculate Virgin in the cupola of a chapel dedicated to that most intellectually unadventurous and incurious of patrons, Pope Paul V. Rather, the painter, like Galileo himself, had very gradually come to view a particular lunar effect as evidence of larger and more significant claims about the Copernican world system, that he had some experience in making astronomical arguments part of his sacred paintings, and that he also knew that such issues might well be overlooked or misunderstood by some of those who saw his works.

This view, I realize, makes Cigoli something of an intellectual, but apart from his poor spelling and his professed (and unlikely) ignorance of Latin, there is nothing in the background, tastes, and friendships of this well-read and active member of literary and artistic academies to suggest that he was otherwise. It does not make him the painter of secret or hermetic subjects: as I will show, his presentation of lunar issues is, like that of Galileo, quite straightforward, and his interpretations of the relevant texts, again like those of Galileo are literal rather than figurative, dependent as much on the letter as on the spirit. Cigoli would have recognized, however, that what observers of his sacred paintings failed to grasp in the way of scientific information—then and now—derived not from any deliberate obscurity in his manner, but rather from their unwillingness to accept that an artist could and would combine the astronomical and the celestial in a single canvas.

Development of a Theory

Toward the beginning and end of the lunar cycle, Galileo noted in the *Sidereus Nuncius*, the unlit portion of the moon's surface—all that was outside its horns—was covered with a faint glow. Visible to the unaided eye, this light was grayish blue in color, prompting later seventeenth-century writers to describe it as "duskish leaden" and "ashen," the latter term being in use even today.[3] Galileo stated that the effect was not due to direct illumination from the sun, nor to that provided by Venus or by the stars, but rather to sunlight reflected by the earth. It is for this reason that the secondary light is strongest at the beginning and the end of the lunar cycle, when the moon faces a "full earth." As the moon sees less and less of the illuminated portion of the terrestrial hemisphere, the amount of light reflected to its surface diminishes, becoming imperceptible at quadrature, when it is 90 degrees distant from the sun.

Another term for the ashen light, "earthshine," makes clear the relevance of the lunar phases to the issue. As the name implies, the light reflected off the earth to the moon is similar to that reflected off the moon to the earth, which means, of course, that the illumination provided us by

the crescent, full, or gibbous moon is also a kind of secondary light. In several cases the problem of the ashen light was solved when observers recognized precisely this sort of reciprocity, arguing that the earth, if seen from the moon, would appear full at the beginning of the lunar cycle, then waning as the moon was waxing, then invisible at the full moon, and then waxing as the moon waned.

The terrestrial origin of the secondary light appeared inconceivable to many early modern thinkers, even to men as original as the anti-Aristotelian philosopher Francisco Patrizi. In his greatest work, the *Nova de universis philosophia* of 1591, Patrizi offered a brief description of the ashen color that the moon sometimes had, but he did not consider the earth as the cause of the phenomenon: "When indeed [the moon] begins to make her appearance at the beginning of her cycle, in that part in which she does not shine, she is seen nonetheless to be spherical in form, but dyed with a certain dark color. From that day forward, this color grows ever darker, right up to the full moon. At this point, there is no trace of the dark color, but her face is almost completely luminous, except for those parts that are called spots, and which occupy not a small portion of her surface."[4] Patrizi's observation is not entirely accurate: the secondary light is not normally visible after quadrature, when she faces less than half of the lighted hemisphere of the earth. His account is interesting, however, in that it occurs in the midst of a protracted comparison of the earth to the moon, this section being devoted to the opacity of both bodies. Yet neither this similarity nor those that follow led Patrizi to conclude, as Galileo would do less than two decades later, that some of the light rebounding off the opaque body of the earth would reach the moon, just as some of the sunlight that strikes its surface will brighten our nights here below.

A letter written immediately after the publication of the *Sidereus Nuncius* suggests that among all the revelations in that treatise, it was that involving the ashen light, rather than those concerned with the moons of Jupiter, or the numberless new stars now visible in the Milky Way, or even the rough surface of the moon itself, that Galileo's first audiences found hardest to believe. In March 1610 the English ambassador, Sir Henry Wotton, sent a breathless dispatch from Venice back home to the earl of Salisbury. Kidnappings, plottings, poisonings, and negotiations between countries on the verge of war—the usual subject of his missives—pale, at least in Wotton's view, beside his account of Galileo's findings:

> I send herewith unto his Majesty the strangest piece of news (as I may justly call it) that he hath ever received from any part of the world . . . [Galileo] by the help of an optical instrument . . . hath discovered four new planets

rolling about the sphere of Jupiter, besides many other unknown fixed stars; likewise, the true cause of the *Via Lactea*, so long searched; and lastly, that the moon is not spherical, but endued with many prominences, and, *which is of all the strangest, illuminated with the solar light by reflection from the body of the earth, as he seemeth to say. . . .* And the author runneth a fortune to be either exceeding famous or exceeding ridiculous.[5]

It is some measure of Galileo's ability to convince an incredulous audience that less than fifteen years later Wotton himself included a passing reference to the secondary light in one of his own works: in his *Elements of Architecture* the former ambassador alluded casually and knowingly to "that lustre, which by reflection, doth spread about us from the face of the Earth."[6] His initial surprise notwithstanding, however, the phenomenon had previously been discussed by other writers: for as Kepler *deplumans* gently reminded Galileo, he had already mentioned it in 1604 in the *Astronomia pars optica*, where he cited an explanation published by Michael Maestlin in 1596 in which solar rays reflected from the earth served to light up the lunar surface.[7] Nor was Maestlin the first to analyze the effect in this way; he had been preceded by at least two men who had not seen their observations into print, Leonardo da Vinci and Fra Paolo Sarpi. Before turning to the accounts provided by Leonardo and Sarpi, however, I will offer a brief history of the term "secondary light" as it appeared in nonastronomical contexts, namely, in treatises devoted to optics and painting.

Medieval writers generally commented upon the secondary light when distinguishing it from primary and direct illumination. Thus in the thirteenth century John Pecham associated it both with that faint radiance that fills a house even when the sun is already over the horizon, and with those rays that illuminate a house whose windows face north, the solar body tracing an arc to the south of the edifice. The secondary light, in other words, entered a building only as reflected rays, the primary rays having struck parts of the earth unseen by anyone in that dim dwelling.[8] Pecham's contemporary Witelo described the phenomenon in a slightly different fashion in his *Perspectiva*: when primary light entered the single window of a house, secondary light would be diffused throughout the various rooms of that building, such that no corner of it would remain completely dark. And though these grim little houses would have no place in the limitless splendor of the *Paradiso*, Dante offered an abstract reference to secondary light at the beginning of that canticle, noting that the "second ray usually emerges from the first, and rebounds towards the heavens."[9]

In treatises destined for the painter, the secondary light was occasionally, though not often, liberated from its darkroom. In the 1430s, for

instance, Leon Battista Alberti turned to a pleasantly bucolic setting to prove that reflected light could take on the color of the surface from which it sprang: the faces of people walking across fields in bloom, he noted, had a pale green cast because of the grass beneath their feet.[10] While familiar with the term used by Pecham and Witelo, Alberti referred to the phenomenon as "reflected" rather than "secondary" light. At no point did he examine its astronomical application.

The earliest recorded instance of such an argument was that made between 1506 and 1509 by Leonardo da Vinci. In this artist's view, water rather than land was the better reflector of sunlight, and thus the ocean "receives the solar rays and reflects them on the lower waters of the moon, and indeed affords the part of the moon that is in shadow as much radiance as the moon gives the earth at midnight. . . . And the brightness [of the secondary light] is derived from our ocean and other inland seas. These are at [the time of the new moon] illuminated by the sun which is already setting in such a way as that the sea then fulfills the same function to the dark side of the moon as the moon does to us on the fifteenth day when the sun is set."[11]

Elsewhere in the vast collection of Leonardo's manuscripts, there are similar discussions of the way sun rays behave on the surfaces of both the earth and the moon, and from these his steps toward the theory of the secondary light can be reconstructed. In a notebook from about 1487–1490, Leonardo concluded an examination of the sun's reflection on terrestrial seas with the observation that the moon, too, "must have seas which reflect the sun, and the parts which do not shine [i.e., its spots] are land."[12] In a manuscript dating to 1490–1492, he wrote that "if you could stand where the moon is, the sun would look to you as if it were reflected from all the sea that it illuminates by day, and the land amid the water would appear just like the dark spots that are on the moon, which, when looked at from our earth, appear to men the same as our earth would appear to any men who might dwell in the moon."[13] And in 1508 Leonardo once again described the earth's appearance from the moon or a star, noting that "it would reflect the sun as the moon does."[14]

But it is the British Museum manuscript, also known as Codex Arundel 263, that provides the most interesting instances of Leonardo's lunar theory. In this collection of notes, compiled from 1480 until 1518, Leonardo described the watery surface of the moon as a spherical mirror, but one whose numberless waves cast a great many reflections of the sun. These single reflections blended together to form the image of "one continuous sun" on the face of the lunar body, a series of lustrous points that appeared more or less the same to any observer. To distinguish between the reflection that would form on a perfectly polished globe and that of the ruffled surface of the moon, Leonardo offered the following analogy:

[I]f the aqueous sphere which covers a great part of the moon were perfectly spherical, then the images of the sun would be one to each spectator, and its reflections would be separate and independent and its radiance would always appear circular; as is plainly to be seen in the gilt balls placed on the tops of high buildings. But if those gilt balls were rugged and composed of several little balls, like mulberries, which are a black fruit composed of minute round globules, then each portion of these little balls, when seen in the sun, would display to the eye the lustre resulting from the reflection of the sun, and thus, in one and the same body many tiny suns would be seen, and these often combine at a long distance and appear as one.[15]

Leonardo also made a passing reference to the secondary light in this section of the manuscript, observing that the moon's surface was illuminated by our oceans as they mirrored the image of the sun. It was the manner in which the sun was reflected on the rough seas of the moon to the earth that most interested him, however, and he returned to this sort of secondary light yet again, explaining that "the moon, with its reflected light [*lume riflesso*], does not shine like the sun, because the light of the moon is not a continuous reflection of that of the sun on its whole surface, but only on the crests and hollows of the waves of its waters; and thus the sun being confusedly reflected, from the admixture of the shadows that lie between the lustrous waves, its light is not pure and clear as the sun is."[16]

A significant impediment to Leonardo's understanding of the ashen light was his altogether puzzling ignorance of the exact manner in which the phases of the moon came about. Manuscript F, for instance, contains a serious error in both text and diagrams concerning the respective positions of the sun, the earth, and the lunar body at the time of the full moon, and the Codex Leicester breaks off in the middle of a formula describing the proportion of the light on the horns to that on the rest of the globe precisely because such a formula would have involved a more accurate notion of the cycle of the phases.[17] Leonardo's several allusions to the appearance of the earth from the moon emphasized merely the brilliance of the light reflected off that body, moreover, rather than the earth's progression from "full" to "gibbous" to "crescent" over the course of one month's observation. In the British Museum manuscript, however, he noted in the middle of his discussion of the moon's secondary light, "Here you must prove that the earth produces all the same effects with regard to the moon as the moon with regard to the earth," which suggests some awareness of the reciprocity of this exchange of light and the similarity of the phases which each body would exhibit if viewed from the other.[18]

The notebooks from which most of these observations come—Ashburnham I, or Bibliothèque Nationale 2037, and the A, F, and British

Museum manuscripts—were held from Leonardo's death in 1519 until 1570 by his student and heir, Francesco Melzi, and as best we know the dispersion of the collection did not begin until 1585–1590, when Melzi's descendants allowed the notebooks and drawings to be stolen or taken from their villa at Vaprio d'Adda and to be circulated in northern Italy and in Spain.[19] Though there are striking similarities between the British Museum manuscript and Fra Paolo Sarpi's lunar theories, it does not seem likely that these notebooks had any direct influence on the issue of the secondary light in an astronomical context. At most, some common source can be posited.

Of unquestionable significance, however, was Leonardo's examination of the characteristics of such light, which he called *lume derivativo* or *lume riflesso*, in a nonastronomical setting. His *Trattato della pittura* was compiled by Francesco Melzi from the various notebooks around 1530; by the end of the sixteenth century several manuscript versions were in circulation, and were particularly esteemed in Florence and the Veneto.[20] While made without reference to the moon, Leonardo's exhaustive studies of reflected light in the *Trattato* are consonant with the conclusions reached in his other manuscripts in that the artist recognized that such light could be very luminous, widely diffused, and strongly colored by the object from which it rebounded, but he did not believe that the earth's land masses offered a good surface for such reflections. Thus while Leonardo treated both indoor and outdoor manifestations of the secondary light—the latter interested him more after about 1505—he argued that if solar rays were to strike the ground, they would not be able to be seen because they would be "corrupted by the obscurity of the earth."[21] This conclusion, reiterated several times in the course of the *Trattato*, is not unlike those reached by Leonardo in his discussions of the surfaces of both the earth and the moon, where land masses were presumed incapable of reflecting light.

Subsequent perspective treatises of the *cinquecento* returned the secondary light to the darkened rooms first described by Pecham and Witelo and elaborated by Leonardo in the *Trattato*. Thus when Egnazio Danti distinguished in 1583 between primary light—"that which comes immediately from the luminous body"—and secondary light in his commentary on Giacomo Barozzi da Vignola's *Regole della prospettiva prattica*, he did so in a manner that suggested the latter would have little importance for those not engaged in painting interior scenes:

The light that enters a room through a window, not being able to strike every corner of that room, illuminates it completely through reflection with a second light [*luce seconda*] that is caused by the first, and *artists call this illumination "reflected light" [lume riflesso]*. . . . Thus in a dark room only

those light rays that can pass straight through the window will enter, and
they will then strike the walls, or the floor, and then [break] and light up the
corners, and the brighter these primary rays, the brighter the secondary light
will be. From which we see that every single solar ray that enters a chamber
illuminates the entire room with its reflection.[22]

It is likely that Danti's allusion to the artists' "reflected light" was made
with particular reference to the studies of the phenomenon in the *Trattato
della pittura*; his preface to Vignola's treatise mentioned Leonardo's work,
and he had seen one version of the *Trattato* sometime in the 1570s.[23]

In 1584, just one year after after Danti's posthumous publication of
Vignola's *Regole*, a very different treatise on perspective appeared, Gio-
vanni Paolo Lomazzo's *Trattato dell'arte de la pittura*. Exuberant and
occasionally mystical in tone, bristling with tripartite distinctions, and
laden with examples from contemporary painting, this work provided a
somewhat fuller discussion of the secondary light, but it gave no hint of
the term's usefulness to astronomers. Lomazzo began by distinguishing
between primary and secondary light, the first of which was further di-
vided into three subcategories. Primary light could come from the sun—
and here the author alluded both to open air scenes and to those in which
light streamed in through windows—or from divine presence, as in paint-
ings of the Nativity, Baptism, or Resurrection of Christ, or finally, from
artificial means such as lamps, flames, furnaces, or torches.[24] Despite the
variety that characterized his description of the different kinds of primary
lights, Lomazzo relied on the inevitable interior scene in his discussion of
the secondary light:

> The secondary light . . . is caused not by direct rays, but by reflected ones,
> and is diffused everywhere around the primary light when the latter enters,
> for example, a chamber, or a covered arcade, or a portico. Because we see
> that when the primary light enters such a place, and strikes all around one
> area, a second light is diffused everywhere, and it is this that we call "secon-
> dary," and it always follows the primary one. It can never be as bright as the
> primary light from which it is derived, and yet it always illuminates the most
> distant corners, and especially at night.[25]

Like Egnazio Danti, Lomazzo knew Leonardo's *Trattato* well, and he
occasionally cited it in his treatise. Neither Danti nor Lomazzo, however,
considered what the secondary light might do if freed from its indoor
setting; aside from Leonardo, the first writer to do so was Fra Paolo Sarpi,
who also recorded his observations in an unpublished bundle of notes. A
Servite friar and state theologian of the republic of Venice, Sarpi is known
within the ambit of Galilean studies as the first man in Italy to have news
of the invention of the telescope, and the individual to have interested

Galileo in the new device.[26] The friendship between the two men began in the 1590s, when they met at the home of the learned Giovanni Vincenzio Pinelli, but Sarpi's investigation of the moon's secondary light antedates his acquaintance with Galileo by at least a decade; the notes or *Pensieri* in which he considered the cause of the phenomenon and drew his conclusions are from the years 1578 to 1583.[27]

The first relevant reference in the *Pensieri* is to the issue of reflection in general, where Sarpi wrote that "secondary light [*la luce seconda*] is nothing other than an imperfect reflection, that is, one taking place on an unpolished surface."[28] In a slightly later notation Sarpi modified the term somewhat, referring not to *luce seconda* but rather to *lume secondo,* the difference involving the scholastic distinction between the luminous source and its diffusion. It is clear that at this point—somewhere between 1578 and 1583—Sarpi associated the celestial version of the secondary light with solar rays reflected off the *moon* to the *earth*, not vice versa: "The fact that the moon receives light from the sun is evident in lunar eclipses, and the fact that she is not a spherical mirror is obvious because we do not see the sun reflected on her surface, as indeed we do on other such mirrors. Therefore the moon is opaque, but not polished. Thus the behavior of [sun]light [falling directly on the moon] is similar to that of our secondary light, that is, the reflection that takes place on unpolished surfaces. Because it is very distant, it looks a lot weaker than our secondary light, or rather, weaker even than twilight."[29]

In the next note Sarpi went on to consider the appearance of our planet from the moon, writing, "If one were on the moon and observing the earth, over the course of one lunar month he would see in this globe all of the moon's appearances, all of her phases, and both sorts of eclipses."[30] In the following note he began with the faulty assumption that the moon's spots were actually great lunar seas and bays, and then contended (correctly) that their glassy appearance would provide a weaker reflection than would the rougher contours of dry land. "Since the moon is an opaque and unpolished body, it must be rougher in those places where there are spots, or rather, in these places the moon must be transparent to some depth, and thus her seas cause her spots. Because of the [lunar] seas, which have a polished surface, the earth gives more light to the moon than does the moon to the earth, and that light that we see on the darkened part of the moon's face when she is crescent comes, perhaps, from the earth, since it cannot be the moon's own."[31]

It seems that Paolo Sarpi reached his conclusions in a manner not unlike that of Leonardo da Vinci. As I noted above, Leonardo's work includes, first, a discussion of the moon as a rough and wave-covered mirror of the sun; next, an allusion to the possible relevance of the apparent phases of both the terrestrial and lunar bodies to the issue of reflected

light; and finally, several meditations upon the transmission of light from the seas of the moon to those of the earth and vice versa. Sarpi made similar, though not identical, inferences about the lunar body: like Leonardo, he first studied the sunlight reflected off the moon to the earth, rather than the other way around, and he then subscribed to the notion of lunar seas. Both men saw this version of secondary light as that caused by an uneven surface; Leonardo wrote that the sun's image on the wave-covered moon was "confused"; Sarpi, speaking more generally, called such phenomena "imperfect reflections."

Their most substantial difference—and it is here that Sarpi surpasses Leonardo—involves the relative abilities of land and water to reflect sunlight. It is not evident to me how the Venetian reached the correct conclusion, if not through experimentation. It is true, of course, that one might decide that land was the better reflector by studying the contrast between the ashen light at dawn at the end of the month and that visible about a week later, in the evening at the beginning of the lunar cycle. In the former case, the matutinal observer in Italy will see a brighter secondary light because of the greater expanse of land struck by solar rays; as Galileo would explain at least fifty years later in the *Dialogue Concerning the Two Chief World Systems*, when it is dawn in Italy the moon faces a terrestrial hemisphere with "fewer seas and more land, containing all Asia."[32] When, by contrast, it is evening in Italy at the beginning of the month, the ashen light is much weaker, for the new moon faces only the westernmost portions of Europe and Africa and then the immense stretch of the Atlantic Ocean.

Nothing in Sarpi's *Pensieri* or in his extant correspondence indicates that he was aware of this aspect of the secondary light, but there is an important discussion of the differences in the reflective surfaces of water, earth, round stones, and spherical mirrors in letters he wrote to a friend in France in March 1610, directly after the publication of the *Sidereus Nuncius*. As those documents will suggest, it is almost certain that Galileo and Sarpi worked together in 1606–1607 to determine whether land or water was the better reflector of light, a point to which I will return in my third chapter in my treatment of Galileo's study of the ashen light in those years.

What Sarpi expressed with such hesitation in his *Pensieri* was much more vigorously defended by Michael Maestlin when he lectured on the subject of the moon's secondary light at the University of Tübingen around 1592, and published an account of it in 1596. Maestlin argued that the light could not be the moon's own, since it was not always visible, but rather that it was "borrowed from another source," just like that on the horns themselves. For those skeptical of the earth's ability to reflect solar rays, Maestlin wrote,

Indeed the position of the moon with respect to the earth shows us the source from which such a light might be derived. For when the moon is new, she is placed between the sun and the earth, and she looks directly at the face of the earth, which is entirely illuminated by the sun. And we have noticed that in various places, the earth's surface is bright and resplendent with reflected solar rays. For instance, this bright surface blunts the sharpest sight in open places, and even within the innermost reaches of buildings, wherever it is allowed to enter through a pinhole, it completely floods that place with light. Who will deny that this [reflected] light is the same as that which is collected and reflected off of all the world's land and water?[33]

Maestlin's account differs in several ways from the explanations characteristic of perspective manuals. He did not use the term "secondary light," but rather "reflected rays" to describe the effect; more importantly, he compared the ashen light on the moon's face to a dark room brightened by reflected rays entering through a pinhole, rather than by primary light pouring in through a window and then illuminating even the most remote corners through secondary reflection. And while his description of the manner in which reflected rays lit up shadowy places in the "innermost reaches of buildings" does not contradict anything in artistic treatises, it was specifically contraindicated for most types of painting, and would have been less useful to painters than the more conventional discussions of rooms with windows opened to the light of day. Finally, because the astronomer prided himself on the thorough artistic education that he had given his son and namesake Michael Maestlin—an undertaking that turned to bitterness in 1600 when the young painter ran off and hid in what his Protestant father regarded as the most obscure of dark rooms, a Jesuit house—we can be fairly certain that he was familiar with arguments of the sort presented by Danti and Lomazzo, and would have referred to such discussions had they seemed to him particularly relevant.[34]

Galileo as Sometime Copernican

Galileo's knowledge of the secondary light probably dates to the early 1600s, but it is unlikely that he immediately recognized the effect as an argument for Copernicanism. His acceptance of Copernicanism itself, quite apart from the question of the ashen light, was a gradual process, and I believe it took place as follows.[35] In 1585 Galileo left the University of Pisa without a degree, settling in Florence where he and Lodovico Cigoli began studying perspective with Ostilio Ricci, court mathemati-

cian to the grand duke of Tuscany.[36] Galileo supported himself by tutoring private students, and it was for their instruction that he composed the rather traditional *Trattato della sfera* in 1586–1587. In November 1589 he found what may have appeared more secure employment, for he returned to the University of Pisa as a professor of mathematics, a position that obliged him to read both Ptolemy's *Almagest* and Copernicus's *De Revolutionibus Orbium Coelestium*, perhaps for the first time.[37]

Late in 1592 Galileo left Pisa for the more prestigious University of Padua, where he had been appointed professor of mathematics. Around 1595 he decided, in an attempt to explain the daily ebb and flow of the tides, that the earth might indeed undergo an annual revolution about the sun, and that the combination of this motion with the daily rotation was what caused periodic oscillations in bodies of water throughout the globe. This conclusion meant that Galileo could now call himself a "Copernican," and so he did, composing the pro-Copernican *Letter to Jacopo Mazzoni* in May 1597, and writing to Johannes Kepler three months later that he had accepted the new world system "for many years." He also told his fellow astronomer that he had no intention of making his beliefs known in his public lectures, as Copernicanism then had few adherents and a great many opponents. From mid-1600 to mid-1601, therefore, he worked on the Copernican *De sistemate mundi*—a treatise that he destroyed just prior to his trial of 1632—but continued to use his *Trattato della sfera*, now very much out of date, in order to introduce both private and university students to the study of astronomy. Apart from the addition of a new preface to the latter work around 1602, he does not seem to have altered the *Trattato* at all, finding that it served his pedagogical purposes well enough. We do not know to what extent he made his Copernicanism known in lectures to the rank and file of his students, though it is very likely that he taught some of his best pupils about the mobile earth and the heliocentric system.

In October 1604, while Galileo was intent upon his studies of motion, a bright new star appeared in the heavens, and in response to the great interest in the supernova, he gave three public lectures on the subject in November or December of that year. As I will show in chapter 2, while it is improbable that they included any overt support of the Copernican world system, it is clear that the Neostoic tenets on which they were based were largely consistent with a heliocentric cosmos featuring a mobile earth. It is also evident that Galileo concluded privately that there was a way to use the phenomenon of the supernova to prove or disprove Copernicus's second motion, that of the earth's annual revolution about the sun, and he waited for such evidence to become available in the earliest part of 1605. The new star, alas, did not behave as he had expected:

its virtual disappearance by the spring of that year conformed neither to Neostoic arguments about its origin nor to Copernican predictions about the earth's path around the sun. Despite this disappointing turn of events, at least two members of Galileo's circle, Paolo Gualdo and Peter Paul Rubens, represented him as a Copernican: the former did so in his biography of the late Gian Vincenzo Pinelli, in an explicit reference to Galileo's privately circulated *Letter to Jacopo Mazzoni*, which he called a *Commentarius pro Copernico*, and the latter in his *Self-Portrait in a Circle of Friends* of 1605.[38]

The debates over the new star of 1604 have both general and quite specific relevance to the issue of the moon's secondary light: as has long been recognized, it was the supernova's appearance that induced Galileo, then far more interested by studies of motion, to devote himself more fully to astronomical matters. In the second place, because he originally believed that the new star was a stray bit of terrestrial vapor that had undergone rarefaction and traveled to the farthest reaches of the firmament, Galileo was required to discuss the nature of reflection, a question of that was also of considerable relevance to the problem of secondary light.

But third, and most important, the philosophical polemic over the new star was of great significance for those who understood the secondary light in artistic terms. It was Galileo's position, and he maintained it throughout both this debate—where he took the unusual step of positing an earthly origin for the new star—and his entire career, that rigorously developed conclusions about terrestrial phenomena would have direct application to more remote objects as well.[39] In other words, the traditional Aristotelian distinction between terrestrial and celestial had to be discarded: experiments performed on objects near at hand could indeed tell humans something about the heavens, and in many cases they would tell all that could ever likely be known. As regards the lunar issue, this meant that the way reflected light behaved on earth, and the manner in which such light was depicted in paintings, were among the best guides for describing what might sometimes be observed on the face of the moon. Distance was, of course, a factor in the question of reflection, but the arbitrary distinction of terrestrial and celestial was not.

Except for an important metaphor involving painters and astronomers in the *Considerations of Alimberto Mauri*—one which I will examine in some detail in my second chapter—there is very little material showing Galileo's allegiance to Copernicanism or to any other cosmological theory for the period between the summer of 1606 and the publication of the *Sidereus Nuncius* in March 1610, where the best evidence for the earth's annual revolution about the sun derives from the metaphysical argument about the secondary light. Because the importance of this issue

cannot be overemphasized, in what follows I will examine Galileo's various discussions of lunar phenomena from 1585 to 1607 in some detail, comparing the gradual changes in his viewpoint in those decades to astronomical elements in two paintings of Lodovico Cigoli, the *Adoration of the Shepherds* of 1599 and 1602.

Matters of No Small Marvel

The *Adoration of the Shepherds* of 1599 (see plate 1) is but one of several versions of this subject painted by Cigoli around the turn of the seventeenth century. Recently acquired by the Metropolitan Museum of Art in New York, this particular painting was probably commissioned by a member of either the Ricci or Ricciardi family, as an emblem of a hedgehog (*riccio*) in the left-hand foreground seems to suggest.[40] In this work Cigoli depicted the lunar body in the right-hand background, just beyond the doorway of the stable where the Holy Family is gathered. The direction of the horns indicates that it is dawn at the end of the lunar month, and the two men with the torch are those shepherds of Luke 2:15 who said after their encounter with the celestial messenger, "Come, let us go straight to Bethlehem and see this thing that has happened, which the Lord has made known to us." It is reasonable to assume that the old moon, more luminous than the fire beneath it, and yet much less radiant than the star above the Christ child, is an intermediate form of light in a well-articulated sequence. Giorgio Vasari, for instance, had praised such hierarchies of light in a Nativity scene—his own, as it turned out—adding to the overall radiance the splendor emanating from the Christ child himself:

> [I]n the other wall painting I depicted the Birth of Christ, portraying a nocturnal scene lit up by the splendor of the Child, Who was surrounded by several adoring shepherds. In doing this, I managed to imitate sun rays with various colors, and I drew the figures and everything else in the scene from life, and with the light, so that they were as life-like as possible. Then, because that light did not extend beyond the roof of the stable, from that point upwards and all around I substituted a second light that came from the radiance of those Angels that sing *Gloria in excelsis Deo* in mid-air. Apart from this, in certain places the shepherds themselves were bearing light, since they go about with burning sheaves of straw, and elsewhere there was the moon, the star, and that Angel who appeared to the shepherds.[41]

In his *Trattato dell'arte de la pittura*, moreover, Giovanni Paolo Lomazzo had noted that light sources in a a painting might be "natural," by which he meant either the sun or the moon, or "artificial," as in the

case of flares, lamps, or furnaces, or "supernatural," this last form of illumination being particularly appropriate to the Nativity of Christ. But if there is a certain logic to the presence of moonlight in the painting, there would appear to be none at all in the manner in which Cigoli has rendered the crescent, for no matter what we believe he knew of astronomy, we cannot argue that this best student of perspective ever thought that the lunar body took on the hollowed-out contours depicted in this work. This complicates the original issue somewhat, for we need to explain first what the artist himself understood about lunar phenomena, and then what he thought others saw when they observed the moon. Both sorts of questions can be tentatively answered through comparison with Galileo's discussion of the moon in the work he composed while studying perspective with Cigoli in the 1580s, the *Trattato della sfera*.

Compare, first, Cigoli's naive presentation of the lunar body in this canvas with the simplistic and almost primitive mannner in which the astronomer had described the moon's nightly changes in figure and size: "The moon's many different shapes are a matter of no small marvel to men, for she appears to us now in the form of a very slender crescent, and then swelling little by little in the middle, she seems to be a half circle, and then puffing up even more, she becomes a perfect circle, and then beginning to shrink, she is reduced to a half circle, and then to a crescent, and finally, she vanishes entirely."[42] Galileo followed this naive impression of the lunar phases with a more rational explanation: the moon was a dark, solid, and opaque body orbiting about the earth and variously illuminated by the sun. An observer will see at most half of any sphere, he added, "as men skilled in perspective have demonstrated."[43] This was a standard remark in most early modern discussions of the lunar body and of eclipses, but it acquires a new relevance in the context of the 1599 *Adoration*, where the artist's knowledge of the phases is specifically opposed to the shepherds' impression of a moon that somehow manages to swell, shrink, and vanish over the course of a month. The men in the fields, in other words, would imagine the moon to be a hollowed-out body like that in this painting; those "skilled in perspective" would know both the true explanation of the phases and how the crescent would appear to the unschooled.

Consider, too, what the informed observer of the painting would understand in the curious proximity of the moon and the flare. In his *Trattato* Galileo had stated that "the moon is by her nature a dense, opaque, and dark body, just as the earth is, and it only shines when it is struck by solar rays and illuminated by them."[44] Any student of astronomy would have recognized in this observation a commonplace of the Aristotelian-Averroistic tradition, and it would have been especially familiar to early

modern Italian scholars, all of whom felt the influence of the sixteenth-century Paduan scholar, Agostino Nifo. Averroes, drawing upon a passing remark supposedly made by Aristotle in his *On the Generation of Animals* in which the moon and the earth were briefly compared, had written "the Philosopher meant by this statement that the moon is not luminous, except in the way that the earth is when it is lit by fire."[45] Nifo, in his turn, further developed the comparison by suggesting that there were other similarities between the two bodies: "Just as the earth is nonuniform in some parts, being rarer here and denser there, so the moon is in some places rare and transparent, and opaque in others; what men call her "face" results from these differences in her parts. . . . Averroes proved by the authority of Aristotle that the earth can be compared to the moon, *since just as the earth is illuminated by fire, so the moon is by the sun,* and just as the nonuniform parts of the earth are illuminated in various ways, so the brighter and darker parts of the moon appear to be."[46] Galileo, too, believed that the moon was, like our planet, at once wholly opaque and covered with patches of rarer material. As late as 1640, blind and bedridden, he dictated his last work and returned to the question of lunar seas, certain that many observations about the resemblance of the moon to the earth had been made in the "physiological books" of Aristotle, and regretful that he no longer had the strength or ability to find these half-forgotten passages.[47] At the same time, the very off-handedness of the reference to Aristotle in this context is an even clearer allusion to Copernicus, who had just as casually mentioned that the ancient philosopher had said "in his *de Animalibus,* that the moon has the closest relationship with the earth."[48]

More relevant, however, to Cigoli's painting are the traditional comparisons of the obscure earth to the moon, and of the light provided by fire to that of the sun, a symmetry evoked by the identical illumination of the doorway to the stable and the inner surface of the crescent moon itself. But if the learned observer of the 1599 *Adoration* understands that the earth is to the moon as fire is to the unseen sun, the shepherds surely do not, as the rindlike shape of the lunar body suggests. Nor does anything in the painting's composition imply that such knowledge is even relevant: the shepherds are, after all, leaving behind the monthly marvel of a swelling and shrinking moon to witness a singular event in human history, and exchanging the comparatively banal mystery of its "many different shapes" for the new miracle of "this thing that has happened" in Bethlehem. While their journey away from the dim light of the lunar crescent toward the supernal radiance of the new star from the East is no more than we might expect, the 1599 *Adoration* is troubling in its implied contrast between the pious ignorance of the

shepherds, who understand nothing of the lunar phases but at least recognize that a much greater marvel awaits them in the City of David, and the spiritually irrelevant knowledge of the learned observer, who may see the relationship of the fire to the earth and the sun to the moon, but no more than that.

Pietre Dure and Hard Science

In the brief interval between the 1599 and 1602 *Adorations*, Cigoli devoted himself to a great number of projects, two of which may tell us something about his growing interest in the issue of the moon's secondary light. Apart from commissioned paintings, stage sets, and various ornamentations for the marriage of Maria de' Medici to Henry IV of France, the artist was also engaged in writing a lengthy treatise on perspective and in the decoration of the Cappella dei Principi. These last two undertakings could not have been more different. The *Prospettiva pratica* was a sophisticated technical study of perspective and shadows, and as I will show in my third chapter, it almost certainly contained a brief but important reference to Galileo's theory of the moon's secondary light. The Cappella dei Principi was a vast octagonal funeral chapel located in the Florentine church of San Lorenzo and reserved for the grand dukes of Tuscany. Destined to be entirely adorned with various scenes composed of inlaid precious stones, the Cappella constituted an artistic and fiscal challenge, and the project did not end, in fact, until 1961.[49] Cigoli's works in precious stones or *pietre dure* were intended for the altar of this edifice, but the biography written in 1628 by his nephew Giovanni Battista Cardi suggests that it was more the artist's respect for the wishes of his Medici patrons than any particular enthusiasm for the chapel's ornamentation that led to his involvement in the project:

> Beginning work on a chapel behind the choir of San Lorenzo, and desiring, like the magnanimous soul that he was, to make it most sumptuous, Grand Duke Ferdinando de' Medici was bent upon having something extraordinary: he wished it to be painted, though not with pigments and brushes, but rather with compositions made of inlaid stones. Having unveiled this admirable idea, and finding that it met with a certain resistance, he asked Cigoli his opinion, and was told that it could be done. Finding himself therefore committed to the project, Cigoli undertook this burden with care, and after having drawn up his own designs [for scenes in *pietre dure*] and finished various narrative cycles, for five or even six years he wasted a lot of time on it, since the artisans did not have much experience with this kind of work.

Because of his diligence, however, they finished a few things, and he showed them that such a project was possible.

And the Grand Duke, recognizing with what devotion he was served, offered him food and lodging above the Uffizi Gallery [near the *Opificio delle pietre dure*, the workshop for precious stones], kindnesses for which Cigoli was always thankful, but never willing to accept. And this was perhaps because Cigoli, intent upon preserving his freedom, and without wanting to neglect his duties towards his Prince, preferred to devote himself to certain of his studies, and in particular that involving perspective.[50]

Cardi's opposition of the burdensome task at San Lorenzo to the more appealing study of perspective is an important one. It suggests first of all that the inordinate amount of time Cigoli spent on the Cappella dei Principi prevented him from bringing his *Prospettiva pratica* to completion. More significantly, however, Cardi implied that the difference in tenor between the work in precious stones and the study of perspective was greater, for instance, than that between either project and Cigoli's principle activity as a painter. Now this is a reasonable view, for painting would occupy a middle ground between "compositions made of inlaid stone" and the abstract science of perspective, but there is also a certain amount of external evidence that suggests that the Medici passion for inlaid stones, traditionally associated with alchemy,[51] was regarded as the emblem of the pseudo-scientific, and thus as a natural foil to more rigorous undertakings like that of Cigoli's study of perspective and cast shadows. Because such an opposition is important to Cigoli's 1602 *Adoration of the Shepherds*, and because it may involve the manner in which the moon in that painting is depicted, I will briefly discuss its presence in the work of Galileo.

Let me begin with the most famous instance, Galileo's celebrated reference to the Medusa in the third of his *Letters on the Sunspots*, thus far not examined in light of its relevance to work then being carried out in the Cappella dei Principi. When the astronomer criticized the Aristotelian resistance to the idea of a spotted and thus mutable sun in 1612, he implied that there was some connection between his rivals' philosophical tendencies and the fetishes of those men interested in *pietre dure*:

> And since her slight alterations do not threaten the Earth with total annihilation, nor do they constitute imperfections, but are rather her ornamentation and glory, then why do you deprive other heavenly bodies of such things? Why are you so fearful of the destruction of the universe through alterations that are no more harmful to the natural order than these here on earth?
>
> I suspect that our desire to measure everything with our limited human standards makes us take refuge in strange imaginings, and that our particular

dread of death makes mutabilty hateful to us. But I do not believe, on the other hand, that in order to become less changeable, that we would really want to encounter the head of the Medusa, so that she might turn us into marble, or diamond, depriving us of our senses and of other movements that cannot survive in us without constant alterations.[52]

Galileo's initial comparison of those thinkers who could not accept that changes occurred in heavenly bodies with those who prized precious stones, the most permanent of elements below, takes on particular importance when considered in terms of the ongoing work in the Cappella dei Principi. Not only were the walls of that mausoleum to be covered with the coats-of-arms of sixteen cities in the grand duchy of Tuscany, all made of alabaster, mother-of-pearl, lapis lazuli, coral, and various types of jasper and marble, and the altars with scenes fashioned out of these and other precious and semiprecious stones, but the defunct grand dukes themselves were to be commemorated in life-sized statues, composed of a variety of *pietre dure*. The flesh, for instance, was to be of porphyry, the eyes of an appropriately colored gemstone, and so forth. Significantly, the decaying bodies of the grand dukes themselves would not be buried in the funeral chapel, despite the presence of enormous sarcophages made of red granite and decorated with jasper and lapis lazuli, but rather beneath the floor of a vault one story below.[53] Custom and hygiene dictated this arrangement, but what is most relevant to Galileo's observation is how willing the Medici appeared to be to "encounter the head of the Medusa," and how certain the patrons of the Cappella dei Principi seemed that their stony polychrome effigies might allow them to "become less changeable," even, or rather especially, in death.

Galileo's pronouncement even took on a prophetic aura later in that decade when the sickly Grand Duke Cosimo II commissioned an ex-voto of precious stones in which he himself was portrayed praying at an altar for the good health that had always eluded him. This work, among the most famous of all the Medici projects in *pietre dure*, was begun in 1617 but not finished until 1624, three years too late to help the grand duke, who had died before his thirty-first birthday.[54] It is also unlikely that Galileo would have been pleased by the somewhat more timely execution of yet another work in *pietre dure;* according to the court diarist Cesare Tinghi, "[A]fter lunch on the first of October 1621, a head of sculpted porphyry made by Martin Ferreri of Fiesole was brought to the [widowed] Archduchess [Maria Maddalena de' Medici]. Because it is made of such hard material, it is a rare object, and it is the portrait of Grand Duke Cosimo II, though it does not resemble him too much."[55]

Galileo returned to a more forceful version of the Medusa metaphor in the first day of the *Dialogue Concerning the Two Chief World Systems,*

insisting, perhaps, on the grand dukes' particular fetish by stating that it was an overwhelming terror of death that "re*duce*d" men to prize incorruptibility over change and growth.[56] He reserved his most interesting arguments for his discussion of the earth's quality as a lodestone in the third day of that work, for throughout this section he treated the lodestone, though not a particularly attractive substance, as the most valuable of precious stones. Those readers not inclined to believe that the earth was a huge magnet—and the idea was still a novel one in 1632—appeared burdened both with Aristotelian foolishness and with the fetishes surrounding the *pietre dure*:

> The interior substance of this globe of ours, then, cannot be material which can be broken or dissipated, or is loose like this topsoil which we call "earth," but must be a very dense and solid body; in a word, very hard rock [*durissima pietra*]. And if it must be such, what reason have you for being more reluctant to believe that it is lodestone than that it is porphyry, jasper, or another precious marble? If [William Gilbert, author of the *De Magnete*] had written that the inside of this globe is made of *pietra serena*, or chalcedony, perhaps the paradox would seem less strange to you?[57]

Galileo also noted with evident satisfaction the circumstances in which the stones so prized by the Medici and their artisans in the *Opificio delle pietre dure* were inferior to the lodestone. Curious about the porosity and composition of the lodestone, he took it to the workshop in the Uffizi Gallery to have it cut and polished, and found that it was adulterated with the very substances most esteemed by others, various *pietre durissime* having no attractive power whatsoever. Here the appearance of the genuine part of the lodestone is carefully noted in a description that rivals those later made by Filippo Baldinucci of different types of jasper and marble,[58] and the "spots of color" off-handedly compared to "any very dense, hard stone," and discussed in terms of size and number, but never beauty or worth:

> I had the artisans who work in the Uffizi Gallery of my Lord the Grand Duke [in the *Opificio delle pietre dure*] smoothe for me one face of that same piece of lodestone which was formerly yours, and then polish and burnish it as much as possible. To my great satisfaction, this enabled me to experience directly just what I sought. For there I found many spots of color different from the rest, bright and shiny as any very dense, hard stone; the rest of the field was polished only to the touch, being not the least bit shiny, but rather covered as if with a mist. This was the substance of the lodestone, and the shiny parts were of other stones mixed with it, as was sensibly recognized by bringing the smooth face towards some iron filings, which leaped in great

quantities to the lodestone. But not a single grain went to the spots mentioned, of which there were many, some as large as a quarter of a fingernail, some rather smaller, and many quite small; those which were scarcely visible were almost innumerable.

Thus was I assured that my idea had been quite correct when I first judged that the substance of the lodestone must not be continuous and compact, but rather porous. Better yet, spongy; though with this difference: where the cavities and cells of a sponge contain air and water, those of the lodestone are filled with hard and heavy stone, [*pietra durissima e grave*], as shown by the high lustre that they take on.[59]

Galileo's repeated association of precious stones with an unscientific spirit was perhaps justified by certain circumstances: during the lean years of the 1620s, the costly and time-consuming project at San Lorenzo could reasonably have been perceived as an obstacle to the advancement of science in Tuscany.[60] On at least one occasion, however, Galileo's reference to the art of inlaid stones suggests that he regarded it not just as an icon of poor or pseudo-science, but also as the emblem of an obsessive religiosity. This perspective would not have been particularly suprising: from 1604 the Cappella dei Principi was widely rumored to become the shrine of the Holy Sepulchre—and thus the symbolic burial place of Christ as well as of the Medicis—and there were long and complicated negotiations with the grand emir of the Druses over this arrangement.[61] The project did not come to fruition, but the mere possibility of it excited new interest in and attention to the decoration of an already extraordinarily ornate funeral chapel. In a fragment associated with the *Dialogue Concerning the Two Chief World Systems* but not included in the final redaction of that ill-fated work, Galileo appeared therefore to relate the Medici taste for *pietre dure* to both a certain regression in scientific matters and a not unrelated religiosity: "I will concede to you in matters of theology just as much as I concede to the Grand Duke in precious stone, but I have nonetheless a single cameo, and it is more lovely than all of those possessed by the Grand Duke. And therefore in this particular, in knowing what should be decreed about the Copernican hypothesis, I believe that I surpass any of the greatest Scriptural scholar."[62]

It should be evident from the foregoing that Galileo's distaste for inlaid stone involves more than mere aesthetics. The connotations of the art range from the unscientific preference of the Peripatetics for the changeless heavens to the fetishism and perhaps the excessive piety of his Medici patrons, both attitudes posing a real or imagined threat to the advancement of Galileo's work in astronomy. Now this is a considerable amplification of Cardi's implied opposition of Cigoli's labors at the Cappella dei

Principi to his studies in perspective, and in the absence of letters written by the artist in those years, it is difficult to know the extent to which he shared Galileo's attitude toward the art of *pietre dure*. The question acquires new relevance, however, in his 1602 *Adoration of the Shepherds*, to which I now turn.

A First Glimpse of the Secondary Light

In his 1602 version of this painting (see plate 2) Cigoli made several important changes, reversing the direction of the horns to suggest a nocturnal scene at the beginning of the lunar cycle, and showing that the crescent enclosed not thin air but a solid globe, one adorned with a curious greenish gray color. In the later painting, moreover, both the lower horn and the interior part of the moon are highlighted with a brilliant white, as if their surfaces had the hard finish of polished stone, and were somehow illuminated by the torch below them.

In comparing the lunar features of Cigoli's earlier *Adoration* with passages drawn from Galileo's *Trattato*, I showed how the artist favored the naive or wondrous view of the moon over the more technical explanations offered by the scientist later in the same work, and I suggested that he portrayed this impression of its phases as "a matter of no small wonder" because it was in better keeping with the shepherds' viewpoint than would have been the more rigorous notion shared by astronomers and masters of perspective. Here the matter is somewhat more complicated, for we have no extant Galilean text with which to compare Cigoli's second painting, and no particular knowledge of what explanation of the secondary light shepherds would be most likely to adopt. Judging from Cigoli's virtual citation of Galileo's swelling and shrinking moon in his rindlike crescent in the *Adoration* of 1599, however, we may wonder whether there is some connection between the naive understanding of the secondary light and the stony luster of the lunar globe in the latter painting.

Apart from the notion of a lunar body subject to such swelling and shrinking, the oldest genuine theory of the moon was that attributed to the ancient Chaldeans and occasionally to the learned Berosus himself. According to Lucretius, the Chaldeans "imagined that the moon is like a ball, and that she stays on a course beneath the sun. . . . She may rotate about her axis, just like, perhaps, a ball one half of which is tinged with bright light, and in turning bring forth the shapes of the phases."[63] Lucretius himself was very skeptical of such a notion, as was his contemporary Vitruvius, who described both the theory and its exotic provenance

in somewhat greater detail: the Chaldean Berosus, he wrote, had taught his followers that the moon was a globe, half of which was a glowing white, and the other a deep blue color, *caeruleus*, usually associated with the sky or the sea. The brighter hemisphere was attracted to the sun, and turned toward it, so that when the moon was closest to the solar body—just before, during, and after conjunction—only the darker part would be visible to an earthly observer. As the moon in its orbit moved away from the sun, it rotated slowly about its own axis; because the blue part was of the same color as the night sky, it was almost invisible, and so the moon took on the appearance of phases. The light that it bore was its own, rather than being derived from the sun, and both halves of the moon were composed of opaque and solid material.[64]

The account was repeated in the second century A.D., again with sneering disbelief, by Apuleius.[65] In late Antiquity, however, Saint Augustine found the white and deep blue moon just as plausible as the theory of the phases, and a fitting allegory for the Church, "whose spiritual side is brilliant, and carnal side dark."[66] As if in response to the skeptics, he recommended a little exercise with a two-toned stone ball, neglecting the fact that the moon—whatever its color and substance—makes its way around the earthly observer in a month-long cycle:

> For if you fashion a ball, one half of which is bright white in color, and the other dark, and you have the dark part before you, you will see nothing of the bright hemisphere, and then as you begin to rotate that part towards you, if you do it just a little, you will see first a crescent of the bright part, and this will grow slowly until all of the bright part is before your eyes, and none of the dark part will show. And if you continue to rotate the ball slowly, the dark part will begin to appear, and the bright portion to diminish, until it is reduced to a crescent again, and then it will be completely lost to sight, with only the dark part showing.[67]

Medieval writers often dismissed the Chaldean notion by showing that it could not account for the moon's appearance when it underwent eclipse, for there it seemed to many, though not all, observers to possess no light of its own. Thus in the fourteenth century Albert of Saxony objected not to the phaselike appearance of a two-toned moon, but to the claim that it was a luminous body like the sun:

> It is true that the moon might be imagined by someone to have a luminous and a dark side, and that she moves about her own axis, completing in a month one rotation in a movement that is different from that which she has on account of her orbit, and that little by little she turns her lighted side towards us, and the other away from us. After opposition she begins again

to conceal some of her luminous side, and to turn the dark side towards us. In this way some people want to account for both the issue of the apparent phases of the moon and the question of whether she receives her light from the sun. In brief, it is possible that with this fanciful notion they can account for the moon's waxing and waning, but they cannot use it to explain what is observed in a lunar eclipse, and it is safer to say that the perceptible amount of light which the moon sheds on us comes to her from the sun.[68]

Despite its apparent flaws, the Chaldean theory remained in vogue even during the early modern period. Though presented by the antiquarian Coelius Rhodiginus as a mere instance of the outmoded astronomy of the ancients,[69] it was later vigorously contested by Tycho Brahe, who asked:

> Who among astronomers and physicists does not know that the moon is endowed with no light of her own, or very little of it, and that that which she has and reflects to us is borrowed from the sun? For what some people fancifully imagine, that half of the moon has its own light, and the other half is opaque, and that she turns about her own axis in such a way with respect to the sun and us that she might therefore reasonably be thought to draw her light from the sun, I say, that lunar eclipses, if nothing else, will surely convince us that this idea is a sheer fiction, for when shadowed by the earth, she remains deprived of this light. If the moon truly enjoyed its own light, and were in the shadow of the earth, she would not lose it, but would rather shine forth more brilliantly with it, for every light appears brighter in darkness, when it is not obscured by other and greater radiance.[70]

The theory was described and dismissed even by some of those writers who believed that the moon did indeed have its own light. The devout Danish scientist Caspar Bartholin, for instance, was assured by 1 Corinthians that the lunar globe possessed some radiance, for there he read that "There are heavenly bodies and there are earthly bodies; and the splendor of heavenly bodies is one thing, the splendor of the earthly another. The sun has a splendor of its own, the moon another, and the stars yet another."[71] But Bartholin found the Chaldean notion implausible, and while he did not mention the celebrated and favorable reception the theory had enjoyed in the work of Augustine, he characterized it with that distinctly Augustinian word *nugae,* "trifles."[72] The great Dutch thinker Willebrord Snel interrupted his treatise on the comets of 1618 to show how ridiculous he found the Chaldean theory,[73] and the notion was attacked again in 1626 by the Jesuit theologian Bartolomeo Amico, who described it as "this fantasy,"[74] and even as late as 1658 Pierre Gassendi felt obliged to point out its absurdity in his discussion of the moon's light.[75]

What is remarkable in all of this is the sheer longevity of the Chaldean theory, especially in view of the fact that the only well-known author to support it was Augustine, who had been equally persuaded by the more orthodox notion of the phases, and who was not generally regarded as an authority in astronomical matters. The language used to describe it invariably involved flights of fancy: beginning with Lucretius, critics of the theory relied on verbs such as *fingere*, nouns such as *imaginatio*, and modifiers such as *fantastice* and *fictitium* to portray both the notion and those many men who had somehow been convinced by it from Antiquity through the early modern period. At the very least, we must wonder who it was—besides the ancient Chaldeans and the unlikely confederate they found in Augustine—that believed the moon to be a two-toned globe, and why such thinkers were of any concern whatsoever to astronomers of the sixteenth and seventeenth centuries.

Comparison of the Chaldean theory to the moon in Cigoli's 1602 *Adoration of the Shepherds* and to two contemporary documents may offer a partial answer to such a question. It seems likely that Cigoli did intend to depict the moon as Berosus and his unknown followers imagined it, and as Augustine fashioned it, for in the painting the lunar globe is composed of two distinct halves, the one of a luminous white substance, and the other of a darker glassy material. Vitruvius, Rhodiginus, and Bartholin had all emphasized the hue of the darker hemisphere: it was said to be "tinged with a deep blue color," and thus of the same shade as the night sky.

The pigment which Cigoli would have used in both this part of the painting and in the aerial region where the angels hover may have been "air blue," also known as "blue ashes," and *cenere* or *bigio* in Italian, renowned for its beautiful azure tones.[76] Because it is a derivative of copper, however, when it is mixed with oil—as it would have been on this canvas—it changes quickly to a dull green color.[77] Closer inspection of both the moon's colored hemisphere and the sky directly above the Christ child reveals not a blue but rather a green cast, one that is appropriate neither to the heavens, nor to the Chaldean moon, nor to the ashen light with which the lunar globe is sometimes adorned.

A story told by Filippo Baldinucci suggests that Cigoli did indeed use pigments that were subject to this sort of discoloration, and that he took pride in his ability to handle these more difficult materials:

> It happened one day that Santi di Tito—who, we might say, had been in great measure Cigoli's teacher—found himself at the latter's house and saw him at work on a painting in the presence of the person who had commissioned it. With that freedom to correct every artistic touch when it seemed to him necessary—a license that Santi had acquired with his mastery

of design—he reproved Cigoli sharply for his use of verdigris [a copper acetate of which emerald green, among other colors, is composed]. It was a color that quickly turned black and ruined the most beautiful of paintings, he warned, as if he knew it from experience.

But Cigoli had long devoted himself to studying the way to keep colors fresh and brilliant on the canvas, such that they would remain for a very long time neither more nor less than they had been when they were first placed there, and he was at that instant seized with great anger. He was able to suppress his rage, and he replied with the following words, "My Lord Santi, please pardon me if I answer you, for perhaps I really should not. I am of the opinion that verdigris, and perhaps still other colors, can indeed have the effect that you have described when handled by those who do not know how to mix and manage it, but not by anyone who could have learned to paint from you, since, by your grace, I was able to do it." And Santi said to him, "You know perfectly well that I was not even thinking about you, whose abilities and talents are most familiar to me." And thus Cigoli, with a reverent and pleasant response, was at once able to justify himself, to placate and praise his teacher, and to impress the gentleman who was present with an even greater sense of his wit and virtue.[78]

It is not likely that the story (if it is true) has anything to do with the 1602 *Adoration*, both because Santi di Tito died in 1603, and more importantly, the episode suggests an exchange between a teacher and a pupil considerably younger than Cigoli would have been when completing this painting. Whether the details about Cigoli's tact and presence of mind are true—for it was evidently the cleverness of the reply rather than the painter's actual abilities as a colorist, much less the freshness of hues now decades old, that Baldinucci seemed most to admire—it does appear likely that Cigoli did sometimes use copper-based pigments, despite their tendency toward discoloration. Such may be the case with the *Adoration*, where neither the moon nor the heavens have the dark blue shade described by Vitruvius, Rhodiginus, and Bartholin.

We might reasonably ask whether Cigoli actually intended to depict both the Chaldean moon and the ashen light in this painting, since either representation would involve bright horns that enclose a hemisphere of darker blue. Put another way, what indication do we have that there was any real or perceived relationship between these two very different impressions of the lunar body? It would, of course, be a remarkable coincidence if Cigoli had merely happened to portray the moon in a manner that suggested the ashen light before he knew of the existence of the phenomenon, and precisely in the period just before Galileo began to regard it as evidence of the Copernican world system. But there are also several

contemporary texts that imply that there was some connection between the two-toned moon and a primitive understanding of the secondary light. This may explain, moreover, both the apparent renaissance of the Chaldean theory, at least within the popular imagination, and the otherwise unaccountable attention devoted to it by early modern astronomers.

The Moon's Color

Several contemporary writers referred to the secondary light as a dark color with which part of the lunar body was tinged. Generally speaking, such descriptions indicate that the effect was either not well understood or not accepted by the author, for those who knew it to be caused by solar rays reflected off the earth, such as Leonardo, Sarpi, Maestlin, and Kepler, emphasized instead how bright that portion of the moon appeared to be. By contrast, when Galileo's perennial rival Lodovico delle Colombe referred to the moon's ashen light, he called it *quel suo lividore,* "that bruised color of hers," and he noted that even the sun's constant light on the lunar surface did not manage to fade this bluish tone.[79] As I will show, Colombe's emphasis on the moon's color is almost certainly a rejection of theories of the secondary light then discussed in Florence, and it may be an appropriation of one aspect of the Chaldean hypothesis.[80]

Thus far, though, we can only point to a general similarity between men like those who had once subscribed to the Chaldean theory of the moon, and a writer like Colombe, who did not believe the secondary light to be caused by reflection, in that both sorts of thinkers described the moon as particolored, and the color involved was dark, typically a blue somewhere between black and purple. More crucial, however, is an allusion made by another Florentine, Raffaelo Gualterotti, who discussed the ashen light in December 1605. Gualterotti, Galileo, Cigoli, and Colombe were well acquainted: all four men frequented the Medici Court, and the latter three were members of the Florentine Academy, while Gualterotti, Galileo, and Cigoli were also members of the Accademia della Crusca.[81] Gualterotti first met Galileo in 1578, when the latter was only fourteen years old; he had a variety of professional contacts with Cigoli, and from at least 1602 to 1604 both were involved in the ornamentation of the Cappella dei Principi.[82] Gualterotti and Colombe attacked each other's work in print, but Colombe apparently counted among his close friends his rival's son, Francesco Maria Gualterotti.[83]

In September and December 1605 Gualterotti published two brief works in which he advanced astronomical arguments remarkably similar

to those made later by Galileo in the *Sidereus Nuncius*. The likeness can hardly be coincidental, given that Galileo, Gualterotti, Colombe, and Cigoli were in Florence in the summer of 1605, and that all but Cigoli would allude in writing to the ashen light in December of that year. The first work, the *Discorso di Raffael' Gualterotti Gentilhuomo Fiorentino sopra l'apparizione de la nuova stella*, is composed of twenty short chapters and two poems. In one of these verse sections Gualterotti concluded that the earth was not unlike the other planets, and he based his argument in large part on the appearance of these dark and dense bodies when they were illuminated by solar rays.

> Between [the Earth and the Moon] I see little or no difference, / and I would not be able to call the wandering moon anything / but a dark and dense body, / one that looks luminous when struck by the Sun. / And that she is really dark in substance / our senses alone will convince us / because if the Earth hides the Sun from her, / she loses all her light, and remains black. / . . . Such that she, who appears so bright and beautiful to us, / is an obscure and dense Star. / . . . So, too, is [Mercury], the great Messenger of the Gods, / who in his flight plows and cleaves the second Heaven. / . . . And so, too, is [Venus], and thus all the planets / and all the other stars in their various patterns / should seem to you like the Earth, / And if the Earth undergoes changes, so, too, must they.[84]

Gualterotti's discussion is less forceful than Galileo's for two reasons: first of all, this most infelicitious of poets chose to express himself in verse, and more significantly, he argued that the planets were like the earth in that they, too, underwent change, rather than the earth was like the planets in that it, too, must have an orbit about the sun. Both conclusions were anti-Aristotelian, of course, but only the latter was explicitly Copernican. The basis of both comparisons was the appearance of heavenly and terrestrial bodies when struck by the sun, an issue to which Gualterotti returned, a few months later, in his *Scherzi degli spiriti animali* of December 1605. In the middle of this giddy mixture of astrology and alchemy, Gualterotti offered a succint but correct explanation of the ashen light, and a brief allusion to the ways in which the lunar effect was misunderstood by others:

> Then when the Moon is new, we see [it] weak and muted, with only one narrow band illuminated by the Sun. *But that muted part is not its color, nor its own light, nor the light of the Sun piercing her as if she were transparent or diaphanous.* It is instead the light of the Sun that is in the surrounding Air, and though it does not reach the Moon, when striking the Air around her it is reflected there, just as at dawn the Sun's rays are reflected in the Air above the Earth, and they whiten it somewhat. And perhaps because the

Sun always illuminates one half of the Earth, the Earth reflects the Sun's rays onto the new Moon, because when the Moon reaches quadrature, she is no longer in that place where the Air can reflect the Sun's rays to her, nor where the Earth can send to her the light given to it by the Sun.[85]

Gualterotti referred to three other hypotheses about the moon's ashen light before stating his own explanation of the phenomenon. The second of these, that the moon itself was a source of light, had been proposed in the mid-sixteenth century by Erasmus Reinhold in his edition of Georg Peurbach's *Theoricae novae planetarum*;[86] the third theory, that solar rays penetrated and illuminated a semidiaphanous moon at certain points in its orbit, had been presented in the thirteenth century by Witelo in his *Perspectiva*.[87] The first and least explicit theory, that the leaden portion of the lunar globe was its "color," is not to be confused with the various colors that the moon takes on during eclipse, for these were usually taken as evidence of Reinhold's position, as when Giovanni Antonio Magini decided that the "dark and horrible color" with which the eclipsed moon seemed to glow meant that it had its own obscure light.[88] Gualterotti's allusion to the "color" of the lunar body may, on the other hand, have been to an updated version of the Chaldean thesis, where half the moon was understood to be of the same shade as the night sky. If the ancient hypothesis did appeal to some of those moderns who observed the ashen light and tried to find an explanation for the phenomenon, it is difficult to say how seriously they took it. It seems unlikely, for instance, that they went so far as to deny the existence of the lunar phases, as the Chaldeans and Augustine had supposedly been inclined to do; what appears more plausible is that they borrowed various elements of the ancient theory in order to account for isolated effects, the most notable of which would have been the moon's bluish color when it is newly crescent.

Lodovico delle Colombe was such a thinker, and his opinions would have been well known to Galileo, Cigoli, and Gualterotti. As I mentioned earlier, Colombe referred to the ashen light as the moon's "bruised color" in December 1605, the same month in which Gualterotti published his explanation of the phenomenon. Now Colombe did not believe that the moon was actually composed of a white and a blue hemisphere, but rather of a single substance disposed in varying degrees of density, and in 1611 he described this theory in some detail, comparing the moon to a rough globe of white enamel encased in a perfectly smooth shell of crystal.[89] As different as this notion is from the Chaldean theory, Colombe's rendition had two features that clearly recalled the latter. First of all, he echoed Augustine's experiment with the two-toned stone ball in his own discussion of the crystalline globe, neglecting, like the Church father, to examine the orbital movement that such an exercise would log-

ically entail: "If someone were to take up a large ball of very clear crystal, within which a little Earth is fashioned of white enamel, complete with woods, valleys, and mountains, and he were to expose it to the Sun and hold it rather far from the eye of the observer, the ball would not look round and smooth, but rather rough and mountainous, and shadowed where not lit by the Sun, because the transparent part of the globe is invisible."[90] Second, Colombe alluded to the portion of the lunar globe covered with the ashen light in terms of its color, writing "when the crescent alone is illuminated, since there is rather little light, and it does not surround the moon entirely, the unilluminated part that we see is of a sky-blue color [*é di color celeste*], and not dark or black, as when it is encircled by a greater radiance."[91] Colombe's impression of the new moon—that crystalline globe where a shiny white crescent embraces a glassy blue interior—corresponds well to both the manner in which Cigoli rendered the stony lunar body in the 1602 *Adoration* and to Gualterotti's subsequent reference to the moon's "color." This does not necessarily mean, however, that Cigoli fully understood what the secondary light was in 1602, but rather that he knew what it surely was *not*: an explanation of the sort elaborated by Colombe in 1611, hinted at in 1605, and perhaps circulating in Florence as early 1602, may have seemed to him the epitome of the naive understanding of the lunar effect. The bright color of the sky around the moon in the painting suggests that Cigoli believed in something like the first and more vaguely worded portion of the argument advanced by Gualterotti in his *Scherzi degli spiriti animali*, namely, that sunlight striking the air about the lunar body was then reflected onto the moon's surface, illuminating the darkened portion as well as the horns. As imprecise as the explanation is, in December 1605 it seemed to Gualterotti more probable than the notion of sunlight reflected off the earth's surface, for he qualified the latter part of the hypothesis with *forse*, "perhaps," as if it were a newer conjecture and not yet entirely confirmed.

Even as late as 1610, when he had already established that the primary cause of the moon's ashen light was terrestrial, Galileo himself apppeared reluctant to rule out the possibility that some of the effect was due to reflection occurring in the haze around the lunar body. Gualterotti had compared the phenomenon to dawn on earth, meaning that the air in the region above the moon would be brightened by solar rays well before the sun appeared above the lunar horizon, and in the *Sidereus Nuncius* Galileo described this aspect of the ashen light in much the same way, explaining that "a certain dawn light is spread over nearby areas of the Moon, just as on Earth twilight is spread in the morning and evening."[92] The comparison finds a nice emblem in the *Adoration of the Shepherds*, where the crepuscular light diffused over the earth is understood to be similar to the pale dawn on the face of the moon.

To conclude, then, with Cigoli's 1602 *Adoration*, we may state that it offers both a naive impression of the ashen light and a much more sophisticated understanding of the effect. These two very different views of the same phenomenon, so neatly fused in the lustrous two-toned moon of the painting, recall the two other activities that absorbed Cigoli in those years: his dutiful work with precious stones in the *Opificio delle pietre dure*, and his ongoing studies in perspective and shadows. The opposition of those two undertakings—suggested in Giovanni Battista Cardi's biography of his uncle, and exemplified throughout the writings of Galileo—takes on a new relevance in the context of this painting, for nothing could be more different than the explanations of the ashen light offered by thinkers like Colombe and Cigoli, the first deriving from an ancient and unscientific theory about a polished and gemlike globe, and the second involving some theory of reflection, and awaiting further study and refinement.

Scripture and Science

The implicit contrast in both versions of the *Adoration of the Shepherds* between pious belief and astronomical knowledge is not a particularly surprising one. There is much in both paintings that would signal to the learned observer that his interest in the latest lunar details was no more than *curiositas*, and entirely without relevance to the drama of his Savior's birth. While the moon is not rare in Nativity scenes, there is no reference in Scripture to its presence, and the vignette itself occupies a relatively small portion of the canvas. Unlike the bright scene of the foreground, it is largely devoid of color, certainly more so than conventions of distance and lighting would require. The shepherds themselves turn their backs on this "matter of no small marvel" to see instead "this thing that has happened" in Bethlehem, and there is every indication that they are right to do so, and that their further speculation on the moon's many shapes or its apparent color would be an idle bit of foolishness. It is not, in other words, simply that the lunar vignette forms a plausible part of the background, but rather that it stands as something to be overlooked or even actively rejected on the day of Christ's birth.

This would suggest that at the turn of the century Cigoli saw no means of combining religious faith and scientific inquiry in a single canvas, or perhaps no need to do so. There would be little reason to suppose that such an undertaking was advisable, for those few exegetes who had attempted analogous accommodations of Scripture to advances in astronomical thought had not met with success. The most celebrated instance was the effort of the Augustinian monk Diego de Zúñiga, who had pro-

posed in 1584 that a passage from the Book of Job, "It is God . . . who makes the earth start from its place so that its pillars are shaken," was not a reference to an earthquake, as was traditionally accepted, but to the mobile earth described by the "ancient Pythagoreans" and more lately by Nicholas Copernicus.[93] Zúñiga's commentary was widely contested, so much so that he acknowledged the apparent absurdity of the earth's daily rotation (though not that of its annual revolution) three years later, and in 1616 the original exegesis was placed on the Index.[94] Between 1542 and 1543, Georg Joachim Rheticus had written a more ambitious work, a brief treatise in which he showed Scripture's frequent and unequivocal references to a mobile earth, making a special attempt to appeal to both Catholic and Protestant audiences, but his *Epistola de terrae motu* was not published until 1651 in Utrecht, by which time it was hardly noticed.[95]

But while Cigoli's seeming insistence on the irrelevance of astronomical knowledge to religious faith is in perfect keeping with his times, his own attitude toward the issue would undergo a profound change over the course of the next five years: Copernicanism becomes an inseparable part of his *Deposition* of 1607, to which my third chapter is devoted. It seems probable that his new willingness to combine religious and scientific elements in a single canvas—a tendency that would come to full flower in his *Immacolata* of 1610–1612—derived, at least in part, from Galileo's influence, and more precisely from the astronomer's understanding of the ashen light as a strong argument for Copernicanism, and as an effect borrowed from artistic convention.

1604–1605

NEOSTOICISM AND THE
NEW STAR

"I
T IS IN NO way damaging to an astronomer not to have seen the
first apparition of the new star; it is not as if he were obliged to spend
all night of every night in observation, just in case something novel
shows up."[1] So wrote Galileo when, some weeks after the emergence of
the nova of 1604, popular interest in the phenomenon forced him to turn
from his studies of motion to the composition and presentation of public
lectures on the bright new star lately sighted between the constellations
of Sagittarius and Ophiuchus. This moment, traditionally associated with
the Pisan scientist's emergence as a Copernican astronomer, is notori-
ously difficult to reconstruct: only the exordium of the first of Galileo's
three lectures on the new star survives, his notes on the subject are sparse
and chaotically arranged, his correspondence from the period is practi-
cally inexistent, and his authorship of two subsequent treatises on the
phenomenon, the *Dialogue of Cecco di Ronchitti* of 1605 and the *Consid-
erations of Alimberto Mauri* of 1606, are unknown to many of his con-
temporaries and contested by the occasional modern scholar.[2] It is none-
theless the case that in the course of his initial studies of the nova Galileo
believed he was on the verge of establishing and publishing convincing
proofs of a heliocentric world system. He failed to do so—such evidence
would come slightly later, during his lunar investigations—but, as I will
show in this chapter, he did make his arguments known to several of his
associates, and most significantly, to an artist of his acquaintance, the
great Flemish painter, Peter Paul Rubens. The fact that the best corrobo-
rating record of Galileo's intellectual development in this otherwise ob-
scure period lies in Rubens's *Self-Portrait in a Circle of Friends* of 1605
suggests, moreover, an increasingly close association between the tasks of

the artist and the astronomer, a relationship which the later chapters of this book will confirm.

Thus, while the astronomical issues examined in this chapter differ from the those of the rest of this book, the former being devoted to discussions of the new star of 1604 and an explanation of the phenomenon of the aurora borealis, the latter to theories of the moon's nature and substance, all have in common the informed exchange between early modern scientists and artists. There are, moreover, several other specific connections to be drawn between these two aspects of Galileo's development as an astronomer. First of all, an argument used by Galileo's Aristotelian rivals—a comparison of the apparent depth of the aurora borealis with the illusions practiced by any painter on an ordinary canvas or wall—anticipates the same analogy, used for the same purpose by other Peripatetic philosophers, in debates concerning the rugged lunar surface in later years. It is also evident that Galileo's study of the nature of reflection, which began with his interest in both the new star and the aurora borealis, was closely related to his subsequent analysis of the moon's secondary light. As I will suggest in this chapter, a single philosophical context, the Neostoicism practiced by Rubens and his associates, may have provided the setting for both lines of inquiry.[3] Finally, the question of an artist's competence in astronomical matters—one which was posed explicitly, if somewhat rudely, by Tycho Brahe in 1602 in his posthumously published discussion of an earlier nova—would be implicitly answered by Rubens in 1605, and again by the painters to whom the third, fourth, and fifth chapters of this book are devoted.

On the Significance of the New Star

Given the great public interest in the new star of 1604, it comes as no surprise that Galileo offered three lectures in Venice on the phenomenon within six weeks of its appearance. As he would recall several years later, these were well attended, drawing an audience of more than one thousand people, but they remained unpublished, and only the author's brief description of their contents and the exordium of the first discourse survive today.[4] Writing in late 1604 to a friend who had repeatedly requested a copy of these lectures, Galileo explained his reluctance to publish them as a treatise, noting that they had been designed for the instruction of young people and the masses, and consisted of no more than the geometrical demonstration of the new star's place in the firmament.[5] Though hardly novel to Galileo and most astronomers—for Tycho Brahe had likewise explained the position of the new star of 1572—the assertion that the nova was located high above the lunar

sphere would have amazed and puzzled many among Galileo's auditors. Basing his argument on the fact that the new star appeared against the same starry backdrop even when viewed from widely separated places on earth and was therefore quite distant from the terrestrial globe, Galileo flatly contradicted the traditional Aristotelian view of the immutability of the heavens. While the star's absence of parallax, or change in apparent position, did not necessarily mean that it was in fact located between Sagittarius and Ophiuchus, it proved that it had to lie well beyond the moon, perhaps in the vicinity of the outermost planets, and thus within the region conventionally associated with permanence and incorruptibility.[6]

There is no reason to doubt Galileo's assertion that this was the subject of his lectures on the new star; one wonders, indeed, how he was able to transform this single argument, revolutionary though it was, into material sufficient for three separate addresses. But the tone of the extant exordium suggests that this discussion of parallax was not merely an isolated attack on the strictures of Aristotelian cosmology, but rather part of a more general development of Neostoic astronomy. Before we turn to the technical features of the Neostoic cosmos, consider, first of all, the tenor of Galileo's address to the audience assembled before him: "Almost as if it were a new miracle from the heavens, this light has lifted the dull and downcast eyes of the masses from the earthly to the divine, something that the crowd of numberless and brilliant stars with which the ethereal fields are adorned does not have the power to bring about. This is indeed the constitution of the human condition, such that everyday sights, though worthy of admiration, escape our notice, and, by contrast, if anything unusual and out of the ordinary appears, it calls together the entire populace."[7] Most members of the audience of these Latin lectures—few of them, surely, having the "dull and downcast eyes of the masses"— would have recognized Galileo's allusion to the opening lines of Book Seven of Seneca's *Natural Questions*, at that point where the Roman Stoic contrasted the relatively neglected quotidian marvel of the heavens with the extraordinary interest generated by a comet:

> No man is so utterly dull and sluggish, with head so bent to the earth, as never to lift himself and turn his mind to divine things, especially when something novel shines like a miracle in the heavens. As long as the ordinary course of things prevails, habit masks the true magnitude of the firmament. Such is our constitution that everyday objects, even when most worthy of our admiration, pass us by. On the other hand, the sight even of the smallest things is attractive if their appearance is unusual. Thus it is that this field of stars with which the vast heavens are adorned does not call together the populace, but when anything out of the ordinary happens, then all eyes are turned to the sky.[8]

The great attention Galileo granted the younger members of this crowd and the tutorial tone of his address to them are also worth noting. Though this part of the exordium has nothing about it that is specifically Stoic, the fact that Galileo portrayed his public lecture as an event designed above all for the instruction of noble young minds recalls the ancient educational ideal of *contubernium*, an arrangement in which an older man saw to the moral and philosophical training of younger ones, and a system particularly favored by the Stoics:[9] "You bear witness, you many young people who have flocked here to hear from me how I differ in my views of this marvelous apparition. Some of you are terrified and moved by empty superstition, believing it a portentious sign and herald of an evil omen; others are now wondering whether the star is in fact in the highest heavens, now looking for a vapor burning near the earth. And everyone is diligently inquiring through study the exact substance, motion, place, and nature of this apparition. By Hercules! this lofty desire is worthy of your genius!"[10] Let us overlook both the fact that there is no evidence that these public lectures had as their special focus *iuventus*, or those under forty years of age, and the fact that Galileo himself was then not quite forty-one, and turn instead to his remarkable, or rather remarkably stilted, use of the interjection *Mehercle, By Hercules!* It echoes the exordium of Seneca's discussion of the comets: "By Hercules, one could not raise a more magnificent question, or dedicate oneself to a more useful study, than that of the nature of the stars and planets."[11] It is also generally in keeping with the philosophical tenor of Galileo's discussion of the new star, for Hercules had a particular importance within Stoic thought, serving, along with Ulysses, as a kind of heroic ideal of virtue.[12] His status as exemplum was preserved in the early modern period by Neostoics: Hercules figured prominently, for instance, on the title page of Justus Lipsius's celebrated 1605 edition of Seneca's works.

The exordium is all that remains of Galileo's first public lecture of November 1604, but in what follows I will show how it is related to notes on the new star dating from the same period. As I mentioned above, Galileo resisted publishing the lectures, stating with truth and uncharacteristic modesty that his geometrical demonstration of the star's absence of parallax was entirely too simple a subject to merit further attention. He promised, however, that he would soon publish a more ample discussion of the phenomenon, and he suggested in a letter of late 1604 that such a treatise would have startling and far-reaching consequences.

In that letter Galileo wrote that the treatise would present not just his opinions of the new star's place and movement, but also his views of its substance and generation. Because the nova was obscured by its proximity to the sun from late November until after Christmas, he explained, he would have to wait for its reappearance to judge any changes in its

location, apparent size, and brightness, but he hoped that this additional data would eventually permit him to surpass the simple hypotheses of the lecture hall.[13] It is not clear that this letter ever reached its destination— for the autograph copy breaks off in midsentence, just before Galileo divulges the precise nature of his conjectures—and even its addressee is unknown. On the basis of Galileo's respectful tone and rare salutation, *Molto Illustre et Eccelentissimo Signore et Padrone Colendissimo,* and in light of a reference to a mutual friend, it has reasonably been conjectured to be Girolamo Mercuriale, an esteemed professor of medicine at the University of Pisa, nearly thirty-five years the astronomer's senior, and something of a patron of his at the Medici Court.[14]

Though the treatise which Galileo promised to send to Mercuriale is not extant, its contents, whether projected or actual, can be clearly established from the few notes that survive today. It is also possible to reconstruct how that information was related to what the astronomer expected to see in the weeks and months after the new star's separation from the sun, and why any of this material should have borne such important consequences. In brief, all arguments, like the exordium of the first lecture, were Neostoic in tenor, and as such formed the groundwork for a Copernican world system. Let me begin with the most intelligible documents, the astronomer's fragmentary notes on the nova's substance and origin. Though Galileo described the new star's appearance as "fiery," he did not consider it combustible, as did the Aristotelians, but rather composed of vaporous masses, or "exhalations," as he called them.

> Some fires, though they appear extremely bright from a distance, are because of their weakness nearly invisible at close range. Thus the New Star could well be an illuminated exhalation, such that anyone nearby might not see it, and it would look to them like nothing more than those vapors that rise and are illuminated by night.[15]

> It is not absurd to place such condensation in the heavens, and around the moon, since we see similar things around the earth.[16]

> In order that this New Star sparkle like all the other ones, it does not appear that it must be composed of a most solid substance, as is believed of all the rest of them. This one, in fact, might be a reflection not only of a solid body, but also of a diaphanous one, as for example of a cloud.[17]

> It is therefore deduced that there is no reason that an immense body of vapor, such as the vast mass which this New Star must be, could not be carried away from the earth. Indeed we see even that the most serene air, I mean the air here below, is completely filled with vaporous clouds. When green wood is exposed to flame, though it does not appear to diminish sensibly in size, it creates an enormous quantity of evaporation in smoke.[18]

Such conjectures would have both confirmed and overturned the most popular of early modern speculations. On the one hand, it was commonly believed that the new star, like the comets with which it was routinely compared and confused, was born of hot and dry terrrestrial vapors or exhalations. However, within an Aristotelian framework, these wayward vapors did indeed burn, and they consumed and eventually exhausted whatever fuel was available to them. Nothing of the sort occurs in Galileo's account, where the new star is routinely compared to moisture-laden clouds. More importantly, in the popular view such phenomena invariably remained below the sphere of the moon, whereas it is abundantly clear that Galileo believed that vapors originating on earth sometimes rose to the highest heavens and from there took on a fiery, starlike appearance.

These notions, while evidently a reaction against the strictures of the Aristotelian cosmos, are also consistent with the Neostoic tenor of Galileo's public lectures on the new star. In a series of papers devoted to the contribution of the Stoics to early modern science, Peter Barker and Bernard Goldstein have shown that several features of anti-Aristotelian astronomy clearly derive from Stoicism, and more particularly, from such familiar sources as Seneca's *Natural Questions* and Book Two of Cicero's *On the Nature of Gods*.[19] Barker and Goldstein have traced this line of influence and diffusion to the sixteenth-century professor of mathematics Jean Pena, to the influential cardinal Robert Bellarmine, and even, with some qualification, to the work of both Tycho Brahe and Johannes Kepler. Though their studies make no reference to the theories—early or late—of Galileo, I believe there is considerable evidence to show that the Pisan astronomer's conjectures about the New Star of 1604 are also Neostoic in origin.

Three characteristics, according to Barker and Goldstein, were typical of the Neostoic cosmos. In the first place, a single medium stretched from the earth to the most remote stars, meaning that both the Aristotelian distinction between terrestrial and celestial physics and the doctrine of planetary spheres might be discarded. Secondly, change took place through an endless universal cycle of rarefaction and condensation. Stoics and Neostoics maintained that the earth exuded moisture, the evaporating moisture became air, and the purefied air converted to a fire that burned without being consumed known as "ether," at which point the inverse process of condensation began. Sometimes the order of conversion was varied: as Seneca suggested in a celebrated description of underground caverns, all elements were formed of all, such that air trapped in such places might become water, or fire, or earth.[20] Finally, Neostoics generally believed that the planets, composed of fiery ether, were not car-

ried along by the surrounding medium, but moved rather by their own intelligence, or, as they often phrased it, "like the birds of the air and the fish of the water."[21]

The first two notions are merely implicit in Galileo's description of the nova, where a mass of watery vapor rising from the earth passed unimpeded through the air to the farthest firmament, and at length took its place as rarefied fire or ether among the other stars. But it is also the case that in his notes on the new star Galileo made explicit his Stoic source, offering that philosophical school as a context for conjectures that might otherwise be taken as a bald attack on Aristotelianism, as the following examples will show. In a search for those relatively few ancient and modern thinkers who believed that the heavens were, like the earth, subject to generation and corruption, Galileo remarked that the late-sixteenth-century astronomer Johannes Praetorius Ioachimicus, author of a treatise on comets, "approved the view of Jean Pena, namely that the air extends all the way to the fixed stars, which is also the view of Pythagoras and the Stoics, who believed that such celestial phenomena could be created."[22] The reference to Pythagoras in addition to the Stoics is particularly interesting, for the cosmological system proposed by the ancient philosopher was frequently (if erroneously) compared to the heliocentric model of Copernicus, Copernicans were often called "Neopythagoreans," and Galileo himself likened some aspect of Pythagorean thought to Copernicanism throughout his career.[23] While the allusion to Pythagoras in this context does not necessarily imply that Galileo likewise associated Stoicism with a mobile earth, a passage he copied from Seneca's *Natural Questions* and preserved in the notes on the new star of 1604 suggests that it was precisely this aspect of that philosophical movement which most interested him:

> In the seventh book, second chapter of his *Natural Questions,* Seneca says: It will also tend to clear up this question if we try to learn whether the earth stands still while the universe revolves around it, or whether the converse is true, the universe standing still while the earth revolves. There have been persons who have even said that it is us who are unknowingly carried about by the frame of things, that risings and settings are not due to a movement of the heavens, but rather to our own rise and fall. The subject is worthy of our study, if we are to learn where we stand, whether our lot is the most sluggish or the most rapid of abodes, whether God moves all things around us, or moves us around them.[24]

It seems certain, therefore, that in late 1604 Galileo regarded the new star first as confirmation of Stoic cosmological conjectures, and more precisely, as evidence for the Copernican world system. Before turning to the

question of what it is he hoped to discover upon the nova's separation from the sun, however, I would like to discuss a text routinely ignored by Galilean scholars. I believe it is both the only extant portion of the treatise he promised Girolamo Mercuriale in the letter mentioned above, and, as I will develop later, it is the ostensible source of inspiration for Peter Paul Rubens's painting of the same period.

The Aurora Borealis

Having established that the ethereal new star had originated in a mass of vapor arising from the earth, Galileo then offered a much more detailed description of the nova's generation, explicitly associating it with the puzzling phenomenon of the aurora borealis.

> It very often happens that vapors rise above the earth, and that in ascending, they reflect the light of the sun, as when sometimes in the middle of the night the sky is in fact so greatly illuminated that it sheds more light on earth than does twilight. I have often observed this myself, and always such a light appears towards the North. And the reason is obvious: it is because those vapors from the south that are trapped within the dark cone of the earth's shadow either on the east or the west can, however, be seen above us to the north, such that they permit more diligent consideration.[25]

Next Galileo described an aurora borealis witnessed by him and presumably by thousands of other observers in southern Europe.

> I saw in the Veneto, around the second hour after sunset, the air toward the north so bright, that it lit up those walls that faced in that direction more than would the full moon, while those that looked south were completely dark. And it caused still more amazement when the streets that most closely ran along a north-south axis were illuminated on both sides by the splendor, and the rooftops there cast no shadow on earth the way they would in sunlight or by moonlight. This was because in the latter cases the illumination comes from one point, so to speak, while in this former instance, the great light emanated from a full quadrant of the heavens. Very often vapors of this kind appear blood-colored or golden.[26]

This explanation, though by no means correct—for the aurora is caused by electrons and protons entering the upper reaches of the earth's atmosphere from the solar region, encountering gases of low density, typically nitrogen and oxygen, with which they interact to form displays of bright light—was strikingly different from that offered by Aristotle in his *Meteorologica* and followed by most early modern thinkers.[27] Known since Antiquity as a "chasm," the aurora was thought to originate in

vapors rising from the earth, condensing low in the terrestrial atmosphere, and then suddenly combusting.[28] Aristotle described the seeming depth of the auroral chasm as an optical illusion produced by the stark contrast between the darkened night sky and the brighter fire of the combustion. Early modern commentators on the *Meteorology* often embellished this comparison in artistic terms, noting, for example, that "when painters portray things that are hollow and deep and distant from the viewer, as for example a cave or a well, they use a black or dark blue color, placing flat white or bright yellow around the dark part. When they want to depict anything that projects forward, or seems to be somewhat closer, they represent it with flat white or similar colors, applying black or dark blue around it."[29]

The emphasis on illusion also served to explain another aspect of aurorae. From Antiquity through the seventeenth century, these spectacular nocturnal displays seemed to most observers to represent scenes of combat and carnage, and while the type of warfare waged varied with historical circumstance, ranging from the "galloping horsemen in golden armour" described in 2 Maccabees, to the phantasmagoric naval battle that appeared above the port city of Amsterdam in 1588, to the exploding projectiles described by French observers in 1621, the theme of conflict was constant.[30] Some aurorae, moreover, are also accompanied by sound; this aspect remains unexplained today, but through the early modern period such phenomena seemed a natural part of the unnatural battle waged in the lower reaches of the heavens.[31] The most rational and objective of commentaries on the *Meteorology,* therefore, tended to rely on the issue of illusion to explain, or rather to explain away, these troubling spectacles of *son et lumière.* Thus Francesco Vicomercati, writing in the mid-sixteenth century, offered the soothing conclusion that

it may indeed be that a cloud or denser air or a burning exhalation is positioned with respect to the light such that now and then mountains, or sometimes armed men, or perhaps other living beings are represented. There will be mountains, for example, if the air illuminated by light is surrounded by other dark and dense air. For the central part of the light mixes with a dark color, and is encircled all around by light, such that abysses and crevices appear. By contrast, therefore, if light or something bright is surrounded by a dark color, it will project like a mountain. . . .

Nothing, however, prevents a cloud from being illuminated such that the likeness of a man, or even of many of them in arms, or other living things appear. And when there is an exhalation in a cloud, various things may be concluded from it, as for example that it is compressed by the cold and density of the cloud, and that in seeking an outlet and shattering the cloud, it emits a noise. And it happens that because of the various densities of

clouds, and the varying force of this explosive exhalation, different sounds
are emitted, such as those of war trumpets, or whinnying horses, or a call to
arms. . . . Indeed when there is thunder and when winds lash solid objects,
we hear various sounds, almost as if wild beasts were around us. Thus it is in
no way surprising that the images of various things are seen up in the sky, or
that sounds of various thing are heard.[32]

Galileo's discussion of the aurora neglected entirely this dimension of
the phenomenon, for it involved neither painterly illusions nor the related
issue of warlike apparitions. In recompense, however, two aspects of his
argument would have served to associate the aurora more closely with the
new star of 1604. In the first place, auroras visible in Galileo's latitude
are, as he acknowedged, most often reddish or golden, and these are
precisely the colors of Mars and Jupiter, the planets at whose conjunction
the nova appeared, the exact hue of the star itself being described as any-
thing within that range.[33] Second, and perhaps less obvious, Galileo's
explanation of the aurora borealis makes it clear that he thought them
to be most frequent in the summer, when the conic shadow cast by the
earth tilted to the south and the vapors rising from the terrestrial surface
had but a short distance to emerge into the light of the sun. This is in-
correct—for at lower latitudes the auroral maximum is actually in March
and September—but nearly fifteen years later Galileo offered the same
explanation in his *Discourse on the Comets,* and it is unlikely that he ever
viewed the matter differently.[34] It therefore seems plausible that he be-
lieved that the exhalation resulting in an auroral display had emerged
sometime in the summer months and risen in a straight line away from
the earth toward the zodiacal constellation of Sagittarius, then prominent
in the nighttime sky. Several months later, at the time of the conjunction
of Mars and Jupiter in Sagittarius on October 8, the vaporous mass,
though long lost to sight, was still traveling away from the earth, but it
would now have been transformed, according to Stoic theories of rarefac-
tion, into ether.

It is possible that Galileo considered the planetary conjunction the
cause of this transformation, rather than a simultaneous and unrelated
event; at least one of his Neostoic colleagues believed this to be the
case, as I will explain below. Its changed state, in any event, made the
new star visible on October 9, 1604, and it increased in brightness until
November 1, gradually becoming fainter over the course of the next
year, and vanishing entirely by October 1605.[35] Galileo first observed the
nova just a few days before its maximum, on October 28, 1604, and he
offered his three public lectures on it within the next month, limiting his
remarks, apparently, to geometrical demonstrations of its absence of

parallax. Between late November and Christmas the nova, though still bright, was too close to the sun to be seen, and in this period Galileo was at work on the treatise involving far-ranging conclusions about the universe in which the new star had appeared, as his letter to Girolamo Mercuriale explains.

It is reasonable to assume that Galileo expected to find confirmation of the Copernican world system in his observations of the new star after its separation from the sun. Because his original observations of it nearly coincided with the star's gradual loss of brightness, he may well have concluded that any reduction in splendor and apparent size was due to the earth's annual movement about the sun and, at that point, away from the nova, and that movement toward it after the winter solstice would result in a corresponding increase of apparent magnitude and brilliance. His letter to Mercuriale also makes plain that he anticipated some change in the new star's apparent site, presumably an alteration in its elevation. One of the few extant notes from this period states that Galileo believed at least one of the changes recorded in the apparent site of the new star of 1572 could have been caused by the earth's annual orbit about the sun.[36]

Given these expectations, the astronomer must have been increasingly confused and disappointed by what he saw in the first months of that year. There are a few extant measurements of its position dating from February and the beginning of March, but these are sparse and inconclusive.[37] There is a single reference to its apparent size, and none at all to its brightness. As we know, however, since November 1 the new star had continued to diminish rather than to increase in apparent size and brightness, and such characteristics would hardly have suggested that the earth was drawing nearer to it in its annual rotation about the sun.

For several reasons, then, I believe that Galileo definitively abandoned the argument by the spring of 1605. It is likely that he was still convinced of its correctness in January and February, for a letter from the Paduan scholar Lorenzo Pignoria to Nicolas Fabri de Peiresc emphasizes the fact that Galileo was able to observe the nova as a morning star in early 1605, a proclamation which suggests that the astronomer fully expected to find something plausible in the additional data.[38] It was also in this period that he began a response to Baldessare Capra's vituperative *Consideratione astronomica circa la stella nova dell'anno 1604*, a treatise in which Galileo was ridiculed by a former student for his tardiness in observing the nova the preceding fall.[39] It is reasonable to assume that Galileo's defense—which he published only in 1607, in the course of a suit against Capra for other and more serious offenses as well—was originally destined to be part of the promised treatise on the new star, and that his response to the charge was to serve as a prelude to the Stoicizing discussion of the new

star, the phenomenon of the aurora, and the Copernican world system
they should have revealed.

From this perspective, Galileo's whole study of the new star seems a
failure: the nova did not appear to conform to Stoic theories of rarefac-
tion and condensation; there was no reason to associate it with the aurora
borealis; and it was clear by the spring of 1605, when it was greatly di-
minished in size and brightness, that it offered no evidence for the Coper-
nican world system. It is not surprising to see that so little remains of
this argument, and that Galileo avoided mention of it in future years. We
are therefore all the more fortunate that any trace of this stage of the
astronomer's development survives. As noted above, the best record is
Peter Paul Rubens's contemporaneous *Self-Portrait in a Circle of
Friends*, to which I now turn; more diffuse accounts exist in Ilario Alto-
belli's manifesto of 1605 and Rafaello Gualterotti's *Discorso*, with which
this chapter will end.

Portrait of a Stoic Circle

A letter from the springtime of 1635, written by Galileo's old friend Nic-
olas Fabri de Peiresc just two years after the condemnation of the *Dia-
logue Concerning the Two Chief World Systems* and concerning a mechani-
cal model of the earth's motion, suggests that Rubens had known the
scientist for a long period.[40] The friendship between them may date to
1602, when Peter Paul Rubens and his brother Philip went to Padua. A
letter written by Philip suggests, however, that when they visited that
city's university they were unimpressed by all disciplines except that of
medicine.[41] Within two years, however, both brothers had met the as-
tronomer, had found much to admire in his work, and even saw Stoicism
in several aspects of his argument.

Apart from an interest in Stoicism, Rubens and Galileo shared a num-
ber of intellectual concerns. Both men wrote treatises on color, though
neither essay now survives, and both would also be concerned in later
years with the relationship between painting and statuary. While Galileo's
letter of June 1612 has the form of a *paragone*—the traditional discussion
of the relative merits of the two arts—and the extant section of Rubens's
De imitatione statuarum is devoted to the manner in which statues dif-
fered from human figures depicted in painting, there is a certain common
ground in their emphasis on the issue of correct shading and relief.[42] This
may be unavoidable: given that the realistic treatment of light is prized in
both works, it is logical that both authors, whether debating the value of
the two artistic media or merely contrasting the representation of men in
marble and on a canvas, would comment upon the harsher shadows and

contours of statues. The artist's discussion is the more detailed: it is as if Galileo's rhetorical question, "Who would believe that a man, when touching a statue, would think that it is a living human being?" finds a serious answer in Rubens's observation that among the differences between men and marble are

> above all the contrasts in shading, since the diaphanous quality of flesh, skin, and cartilage do much to soften the shadows that are twice as somber in most stone, and to diminish what would be the abrupt descent into darkness in statues. Remember, too, that there are areas of the body that change with movement and that may be either relaxed or contracted, because of the suppleness of the skin. These places are generally neglected by the common sculptor, but they should certainly be included, with moderation, in paintings. And as regards light, statues will appear entirely different from human flesh, for the glow of stone and its dramatic sheen will at least dazzle the eyes of the viewer, and may make the surface seem to stand in higher relief.[43]

Though a note on the nature of reflection and a reference to painted shadows in Galileo's later work on the new star of 1604, the *Considerations of Alimberto Mauri,* suggest that he did consider the astronomical problem in artistic terms—in a manner consistent with the painter's precepts—there is no particular evidence that he and Rubens exchanged their views on either color or statues in the course of their meeting in Mantua. Yet it is perhaps of some significance that in his discussion of musculature Rubens referred specifically to the work of Girolamo Mercuriale, the professor of medicine to whom Galileo's fragmentary letter on the new star was presumably addressed.[44]

Rather little is known about Rubens's *Self-Portrait in a Circle of Friends* (see plate 3). The painting dates to 1605 or 1606, but neither the circumstances under which it was created nor the patron for whom it was destined is now understood.[45] Rediscovered and attributed to Rubens in 1932, the sitters in the portrait were convincingly identified by Frances Huemer only in 1983.[46] The two younger men on the far left are Juan Batiste Perez de Baron, the son of a prominent Portuguese merchant residing in Antwerp, and Willem Richardot, the son of Jean Richardot, president of the Privy Council of the Netherlands.[47] Both were former students of the man on the far right, the great Neostoic scholar Justus Lipsius.[48] At the center of the painting in the blue-gray cloak is the figure of Peter Paul Rubens, and behind him is his brother, Philip Rubens, who was Richardot's tutor during his travels in Italy and, like him, among Lipsius's favorite pupils. The canvas has generally been viewed as a representation of a Stoic *contubernium* of sorts, and it is easy to see in it a forerunner of Rubens's much better known *Four Philosophers* of 1611, where the artist, his brother, Lipsius, and another *contubernalis*, Jan Woverius,

cluster beneath a bust of Seneca.[49] But in the case of the earlier painting, identification of the bearded figure facing Rubens long posed a great dilemma. Clearly central to the work's Neostoic tenor, and something of a counterpart to Rubens himself, whose forearm he clasps, this man was convincingly identified over a decade ago by Huemer as Galileo Galilei. Comparison with contemporary portraits of the scientist, as for example Domenico Tintoretto's painting of 1605, render this identification still more plausible.

As Huemer pointed out, Philip Rubens and his fellow students Perez de Baron and Richardot visited Mantua in March 1604, and Galileo made his way to the court of the Gonzagas in the same month, seeking, gaining, and eventually declining an offer of employment from Rubens's patron. Justus Lipsius, by far the oldest member of this group and only a year or so from death, was not actually present at the meeting in Mantua, though his absence suggests to me that the representation commemorates less an actual event than an abiding interest, on the part of all sitters, in the study of Stoicism, and, as I will argue, particularly in the scientific aspects of that school.

Two aspects of this painting have not been satisfactorily analyzed. The first is the real reason for Galileo's presence in this close circle of northern Neostoics; it is not sufficient, I believe, simply to say that he, like Rubens, was interested in both the sciences and the arts—for so were many of those individuals we commonly identify as *Renaissance men*—or that they had several mutual friends, or even that the two had then found favor in the eyes of Duke Vincenzo Gonzaga. Galileo's place in the painting surely turns on his importance as a Neostoic thinker, and more precisely, on his brief and now obscure role as a Neostoic astronomer. I will return to this argument by way of elaborating the second, and more glaring, difficulty in previous readings of the portrait, the time of day it is normally understood to take place, and the atmospheric phenomenon it is thought to represent.

The background of the *Self-Portrait of the Artist with Friends* has long been identified as an accurate depiction of a detail of the Mantuan landscape (see plate 4). The bridge slanting away from Galileo's left shoulder is the Ponte San Giorgio; the tiny thatched roof near its end is that of a hut on a small island in the Lago di Mezzo; and the church and steeple in the background were then actually present on the opposite shore. The same vista, in fact, had formed the background of Andrea Mantegna's *Dormition of the Virgin*, present in that period in the grand duke's collection at Mantua. In contrast to the bright scene of Mantegna's work, Rubens's dark view of the Mantuan landscape has been described as a dramatic sunset at the end of a stormy day.[50] I will argue, however, that the artist has depicted something considerably more dramatic, namely,

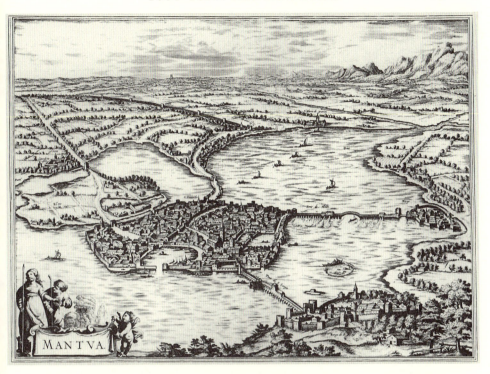

FIGURE 1. Map of Mantua. Rare Book Room, Princeton University Library. (Photo: John Blazejewski)

the aurora borealis and the man who first associated this phenomenon with Neostoicism in general and with the new star of 1604 in particular.

Consider first the same area in an early modern map (fig. 1).[51] Here it is the Ponte San Giorgio that runs diagonally across the lower right-hand portion of the map, pointing roughly like the hour hand at five o'clock. Above it, at just about three o'clock, is the more imposing Ponte dei Mulini, characterized by a series of water mills. Renaissance cityscapes of this scale were not generally oriented with north at the top, but comparison with a modern map shows that the Ponte dei Mulini runs almost due north, and the bridge in Rubens's portrait, truncated here, veers off toward the northeast.[52] Were the older map rotated by ninety degrees in order to crudely approximate the "north at the top" convention and to reconstruct the line of sight in the painting, therefore, the sitters in the upper window at the Palazzo Ducale would have looked north-northeast over the Ponte San Giorgio, to the small island, and finally to the church on the opposite shore.

This detail alone makes it unlikely that Rubens intended to depict a sunset here, for surely such a scene would have been oriented to the

West. Moreover, the unusual treatment of light is far more consistent with an aurora borealis than with a sunset on even the most stormy of days. The broad sweep of reddish light on earth—an arc that would include the upper portion and a segment of the Ponte San Giorgio, the side but not the front of the island hut, the facade of the church but not that of its tower, and the streaks of light low on the northern horizon—is in fact an extension of the chasm, the area beyond that circle of reddish light being cloaked in the darkness of night. Given that the line of sight from the Palazzo Ducale is north-northeast, the chasm itself appears to represent the north point of the zenith, as one might expect in a depiction of the aurora borealis.

It thus seems to me likely that Rubens's painting was begun, though perhaps not completed, in early 1605, in the wake of Galileo's earliest conjectures about the new star, and at that moment when the sublunary phenomenon of the aurora borealis appeared—to certain Neostoics, at least—to have some connection to the formation of novae. For several reasons, however, I do not think it very probable that Galileo, Rubens, and the other sitters in the portrait actually observed the aurora borealis together. In the first place, we know Lipsius to have been absent from any meeting that took place in Italy. Second, Galileo's visit to Mantua was in March 1604, and though he almost certainly met the younger Neostoic scholars at that point, it is clear that they cannot have spoken of a star that was yet to appear; it also seems unlikely that they witnessed the aurora, given that the astronomer associated the phenomenon only with the summer months. Third, while it is possible, or even probable, that Galileo saw the aurora borealis more than once before finding an explanation for it, his allusion to an observation made somewhere "in the Veneto" cannot refer to Mantua, for that city proudly maintained its independence from the larger territory, and anyone even remotely interested in the patronage of the Gonzagas would have refrained from suggestions of this sort.

On the other hand, it is entirely reasonable to suppose that the members of this group, with the exception of the aged and ailing Lipsius, devoted themselves to a general discussion of Neostoicism and its astronomical applications, and that the older scholar and mentor, whose influential *Physiologia Stoicorum* would be published in that same year, was with them in spirit. This particular detail both explains and complicates the intensity of Rubens's representation of Lipsius. While it is true that Lipsius had written in his study of the natural philosophy of the Stoics that the discipline began with the sage's awed contemplation of atmospheric and celestial phenomena and ended with the loss of such wonder and with the greater satisfaction of certainty, when he addressed the question of the earth's motion he reviewed the affirmative position of

the usual suspects, Pythagoras and certain Stoics, only entirely to condemn their hypotheses: "You are looking at madness here! By what other name should I call it? Or what in all this might I investigate? And yet—such is the love of paradoxes—even in our fathers' day a noble mathematician revived this heresy, but it was buried with him. By common consent we believe that we on earth stand still, and we leave to the heavens their motions."[53]

Several scholars have associated the painting with the death of Lipsius, though they have reached rather different conclusions. One historian has asserted that the portrait was conceived first and foremost as a funeral monument to the philosopher, and that the somber atmospheric conditions contribute to the mood of grief and quiet reflection; another has argued that Lipsius's awkwardly placed figure was only added after his death in March 1606 and therefore rather late in the composition of a work not originally designed as a memorial.[54] It seems to me possible that Lipsius's presence, its disquieting intensity, and its somewhat clumsy placement might have less to do with his death than with his own complicated role as a Neostoic opponent to Copernicanism: Rubens may have added the figure of the great scholar after Galileo realized that his Stoicizing conjectures concerning the new star and the aurora, however valuable in themselves, would not provide proof of a mobile earth and heliocentric world system.

But Lipsius's hostility to Copernicanism is no particular guide to Rubens's views, or, for that matter, to those of his visiting compatriots. While it is difficult to establish the extent to which the artist shared the beliefs of the astronomer, the mere fact that he depicted Galileo, a circle of Neostoics, and the aurora borealis precisely at the moment when the Pisan had associated the phenomenon of the new star with Stoic hypotheses and a Copernican world system suggests a certain sympathy for such doctrines. At the very least, we can infer considerable interest, if not outright conviction, on the part of Rubens.

It may also be relevant that the portrait coincides with Baldessare Capra's attack on Galileo in his *Consideratione astronomica.* Nearly a year earlier, in the course of his visit to Mantua, Galileo had been asked by Vincenzo Gonzaga for his opinion of Capra. He had responded with a certain contempt, noting that while his former student was said to be competent in both astronomy and judicial astrology, he was also the son of a meddlesome old man and the confederate of a peculiar German individual, both of whom dabbled in medicinal secrets, as, for example "a certain pill . . . the size of a tiny seed, that when swallowed would keep one healthy and strong for more than forty days, without the need for food or drink."[55] Given that Gonzaga and the rest of his court may already have been disposed, on the basis of this early report, to dislike and

distrust Capra, it is possible that Rubens's portrait serves also as an endorsement of Galileo, whose professional abilities were now under attack by his one-time student.

Galileo's temporary glorification of the aurora borealis would have appealed to the Flemish painter on other grounds as well. Now in his fifth year as a foreigner resident in Italy, and conscious of the supposed superiority of the artistic tradition of his adopted country, he would have been pleased to see that it was splendor from the *North* that best illuminated the Mediterranean landscape where he worked. He would also certainly have been aware that the adjective most commonly used to describe the sight was "reddish," or *rubens*.

It is also clear that the portrait serves as a clever corrective to the Aristotelian view of the aurora, for there the phenomenon was explained in painterly terms, the chasm and accompanying vaporous displays of dark and light being considered an optical illusion of the sort practiced by artists. Here, by contrast, Rubens used the materials traditionally associated with the aurora—black and dark-blue pigments and brighter highlights—at once to depict it illusionistically and to suggest that it was for the Neostoic *contubernium* gathered here much more than a mere painter's trick.

At the same time, the philosophical knowledge and technical expertise which the painting involved would have served as an indirect response to certain objections raised in 1602 by Tycho Brahe's posthumously published discussion of various studies of the new star of 1572. Though not necessarily known to Rubens, the *Astronomiae instauratae progymnasmata* was quite familiar to Galileo, whose notes from this period suggest that he consulted it to learn, among other things, which modern thinkers adhered to the Stoic conception of the universe, which ones had seen in the earlier apparition some evidence of the earth's movement, and how slow some of these astronomers had been to make their first observations of the new star.[56] Among the many authors criticized by Brahe, the most miserable was certainly Georg Busch, a German painter and astronomer who wrote several works on both the new star of 1572 and the comet of 1577.[57] Brahe made clear the abundant foolishness of Busch's conjectures, for the painter believed that the nova, though it lacked a tail, was a special type of comet, and his measurements of its place and movement were so faulty that he considered it to be sublunar. Busch also devoted considerable discussion to the astrological significance of the new star, and he appended to his works various and apparently unconvincing drawings of the phenomenon. What is most striking in Brahe's discussion, however, is the fact that he presented many of the *Buschiani errores* as the correlative of the author's sometime artistic profession. Thus the Danish astronomer concluded, for instance, his criticism of Busch's estimation of stellar size, distance, and magnitude with a triumphal *intole-*

rabiliter deviat hic Pictor Buschius, and he delighted in ridiculing the man's "figments and pigments," and deriding "that fictive, depictive sketch of his."[58] While Galileo and Rubens would have found little or nothing at all in Busch's works to admire, Brahe's automatic association of astronomical error with artistic practice would surely have irritated both thinkers. Given that Galileo increasingly related astronomical expertise to certain aspects of painting, and that Rubens's canvas commemorates such collaboration, the *Self-Portrait in a Circle of Friends* stands as an implicit corrective to Brahe's biased presentation of the unfortunate Georg Busch.

The question of the diffusion of Galileo's conjectures remains unanswered. Though it is possible that Galileo's short-lived theories about the new star and the aurora were relayed to Rubens through one of their several mutual friends—and here Girolamo Mercuriale would be the most obvious candidate for such communication—it seems to me much more likely, in view of their roles as counterparts in the painting, that the scientist conveyed his hypothesis directly to the artist, either in a visit of which we have lost all trace, or, more plausibly, in one of the many inextant letters of that period. Put differently, Rubens's insistence on a collaborative enterprise, one in which he and Galileo appear to have resolved the issue of the new star in a Neostoic context, may well evoke the earlier Mantuan encounter in the spring of 1604, but it also suggests more recent and sustained contact between the two principal figures of the *Self-Portrait in a Circle of Friends*. The fact that the particulars of Galileo's earliest argument about the nova were even then generally unknown also implies that he divulged them to relatively few individuals, and then, it would seem, only to those whose own philosophical tendencies would guarantee his theory the most favorable reception.

Though satisfied enough with his analysis of the aurora borealis to publish that explanation years later during the controversy of the comets of 1618, it also appears that Galileo sought to suppress all vestiges of a theory associating that phenomenon with novae. In this he was evidently rather successful, but some garbled version of the argument survived in his lifetime, for during the cometary episode he was repeatedly accused by his rival, the astronomer Orazio Grassi, S.J., of suggesting that the aurora borealis and comets, rather than novae, were composed of the same materials and had the same origin. Galileo was so irritated by the charge that he denied it four times in the space of a single treatise, and despite his usual concern for priority, he did not once refer to his earlier conjectures concerning the aurora and the new star.[59] The Neostoic context of his work, while not entirely absent in his cometary theories, is greatly muted. Rather than alluding directly to Seneca's suggestion that we must determine whether it is the earth or the sun that moves before we can under-

stand the nature of comets, for instance, in 1619 Galileo stated simply and much more blandly that the ancient philosopher "recognized and wrote how important it was for the sure determination of these matters to have a firm and unquestionable knowledge of the order, arrangement, locations, and movements of the parts of the universe."[60]

While the *Self-Portrait in a Circle of Friends* thus stands as the best record of this earlier phase of the astronomer's activity, it is not the sole account of a Neostoic approach to the problem posed by the new star of 1604. Significantly, those who offered similar hypotheses were among Galileo's friends. In what follows I will discuss the theories of two such thinkers, the spare and sober manifesto of the Franciscan theologian and amateur scientist Ilario Altobelli, and the chaotic treatises of the artist Rafaello Gualterotti, whose work on the moon's secondary light I mentioned in the previous chapter. Galileo's discussion, however obscured by time and especially by his own unwillingness to develop it, is nonetheless much clearer than those of his colleagues. To borrow the expression used (rather unjustly) some years later by the mathematician Bonaventura Cavalieri to distinguish between Galileo's cometary theory and the piecemeal conjectures of his rivals, it is as if the Pisan's work on the new star of 1604, enhanced by the contribution of Rubens, were "a most natural portrait of Nature," and the arguments of Altobelli and Gualterotti more "like those images which, reflected in agitated water and taking on various and disjointed aspects, offer to the eye of the beholder a most confused appearance."[61]

Neostoicism and New Stars

Despite its sometime association with Copernicanism, by the beginning of the seventeenth century the Neostoic cosmos had acquired a certain respectability. Not the least of its early proponents was the Jesuit Roberto Cardinal Bellarmine, who was in 1604 a very strong, if unwilling, candidate for the papacy. In the 1570s, as a lecturer in Louvain, Bellarmine had upheld the anti-Aristotelian notions of the mutability and fluidity of the heavens, and he had referred specifically to the Stoic views aired in Book II of Cicero's *On the Nature of the Gods* in order to justify such hypotheses.[62] Using a phrase that had grown out of Cicero's conjectures and had been current among philosophers since the Middle Ages, he stated that because the heavens were composed of a single and yielding substance, the planets were not pulled along by them but were able rather to "move of themselves, like the birds of the air or the fish of the waters."[63] Ironically, this particular comparison was later contested by members of Bellarmine's own order, namely Benedict Pereira and

Christoph Clavius of the Collegio Romano, and it is likely that these men realized that the cardinal was prominent among the Stoicizing thinkers they criticized.[64]

Another theologian whose cosmological views bore some influence of Stoicism was Galileo's close friend Ilario Altobelli, a Franciscan Conventual then living in Verona.[65] Unlike Galileo, Altobelli was among the earliest observers of the new star; he first saw it on the evening of October 9, 1604, and soon thereafter wrote to Galileo proclaiming that the nova would "make the Aristotelians go mad."[66] In late November, around the time Galileo offered his three public lectures on the phenomenon, Altobelli was also preparing a brief treatise on the new star.[67] Divided into eight chapters, this work does not seem to have survived, but an astronomical manifesto authored by Altobelli in this period is extant.[68] It consists of six points of contention with Aristotelian scholars, and while based largely on opinions established by Tycho Brahe in the wake of the new star of 1572, it is also consistent with some, but not all, of the Neostoic notions with which Galileo was then engaged. Thus while Altobelli and Galileo both believed that the heavens were subject to change, and that the nova was located well beyond the moon, the former maintained that new stars, like comets, were generated among the upper planets. Likewise, both astronomers discarded the Aristotelian conception of spheres of air and fire for a single and continuous atmosphere between the earth and the most distant stars, but Altobelli adhered to the Tychonic configuration of the universe, and Galileo to the Copernican model. And while Altobelli used the phrase "like fish in water" to describe the movement of planets through the fluid substance of the heavens, he did so without particular reference to the Stoic thinkers with whom the comparison was often associated.[69]

Thus, while there are Stoic elements in Altobelli's manifesto, it cannot be said that he, like Galileo, developed such tenets within the context of that philosophical tradition. Some of this is due to Altobelli's dependence on Tycho Brahe, who sought to distinguish his work from the markedly Neostoic efforts of Jean Pena.[70] It is worth noting that several decades later Robert Burton, a shrewd observer of developments within early modern astronomy, would explicitly deny that there was much difference between the opinions of Tycho Brahe and those who more readily identified themselves as Neostoics; in his view, a thinker like Altobelli would have been associated with the latter group despite the absence of Stoicizing gestures and postures evident in Galileo's work:

It is much controverted betwixt *Tycho Brahe,* and *Christopher Rotman,* the *Lantsgrave* of *Hassia's* Mathematitian, in their Astronomicall Epistles, whether it be the same *Diaphanum,* cleernesse, matter of aire and heavens,

or two distinct substances? *Christopher Rotman, John Pena, Jordanus Brunus,* with many other late Mathematitians, contend it is the same, and one matter throughout, saving that the higher, still the purer it is, and more subtile. . . . *Tycho* will have two distinct matters of Heaven and Ayre; but to say truth, with some small qualification, they have one and the same opinion, about the Essence and matter of Heavens, that it is not hard and impenetrable as *Peripateticks* hold, transparent, of a *quinta essentia, but that it is penetrable and soft as the ayre it selfe is, and that the Planets move in it, as Birds in the ayre, Fishes in the sea.*[71]

But it is also true that the cultured and well-read Altobelli, whose letters contain urbane references to Cicero and Galen, two important transmitters of Stoic thought, would have readily recognized Stoic aspects of his astronomical arguments, and could have easily elaborated them, had such rhetorical amplification seemed appropriate to him. Galileo's tactic of developing nonastronomical Stoic tropes—the paraphrase of Seneca's meditation on the neglected quotidian spectacle of the heavens, the insistence on *iuventus* and *contubernium,* the heavy-handed use of the archaic interjection *Mehercle!*—alongside a technical argument consistent with Stoic natural philosophy has no counterpart in Altobelli's work.

The presence of Stoic elements is much more pronounced in Raffaello Gualterotti's *Discorso sopra l'apparizione de la nuova stella,* a treatise which I mentioned earlier in connection with the development of the theory of the ashen light. Written during and revised just after Galileo's visit to Florence in the summer of 1605, the *Discorso* bears a certain similarity to the Pisan's work of the same epoch, especially in its treatment of the issues of the secondary light and the new star.[72] Without making specific reference to Stoicism, it builds upon a variety of doctrines associated with that school, most of which appear drawn from common sources such as Book III of Seneca's *Natural Questions,* Book II of Cicero's *On the Nature of Gods,* and certain sections of Plutarch's *On the Face in the Moon.*

In the previous chapter I described Gualterotti's lengthy comparison of the earth and the moon, for it was in the similarities of the terrestrial and lunar globes that the author saw evidence for the ashen light and perhaps for the former body's status as a planet. Gualterotti's insistence on such likeness is also typical of Stoic arguments for a unified cosmos, and against the traditional model in which the sphere of the moon served as the border between terrestrial impermanence and celestial perfection. Thus in *On the Nature of Gods,* Cicero discussed the moon's influence on the earth's seas by way of presenting a universe governed by cosmic sympathy; in his *Discorso,* Gualterotti used the fact that both bodies, while low, rough, and dark, were good reflectors of light to preface a similar meditation on the unified cosmos.[73]

Gualterotti also stated that the heavens were both penetrable and mutable, and the manner in which he developed these notions was distinctly Stoic. He insisted, for example, on the planets' ability to move through space, explaining that "with a determined course they swim (like fish in water) and penetrate and cut through the heavens," and noting elsewhere that when those bodies "flip and wind their way" through the surrounding medium, it must give way to them, "as water does to fish."[74] Such movements allowed him to discard the epicycles and deferents as well as the rigid celestial matter of the Aristotelian cosmos, and persuaded him rather that the heavenly bodies were guided by their own intelligence. Both concepts—the familiar fish simile and the concomitant belief in planetary intelligence—recall the second book of *On the Nature of Gods,* where Cicero stated that the planets moved through the ether, as did animals on earth, in the water, and through the air, and that they did so through their own intelligence.[75]

Gualterotti thought that the new star might have produced by various means, and these hypotheses are recognizably Stoic in origin. He believed, for instance, that the fluid heavens might have become so compressed as to have formed the nova, a possibility associated with Stoicism in Plutarch's *On the Face of the Moon,* and briefly described there as pertaining to the creation of the fixed stars.[76] In conformity with the Stoic model of condensation and rarefaction, Gualterotti also maintained that earth contained, or as he put it, "participated with," water, water with air, and air with the heavens, this last being composed of a pure fire identical with ether, and he insisted, as did Seneca in his discussion of underground rivers and caverns in Book Three of the *Natural Questions,* that each element contained all the other ones.[77]

It was therefore possible, in his view, that soil or stones on the earth's surface emitted water, that the water formed vapor, and that the vapor traveled unimpeded to the farthest reaches of the firmament, taking on the appearance of a new star.[78] Such events were rare, Gualterotti conceded, and he believed that certain planetary conjunctions were required to attract and sustain these exhalations. Recalling the unusual atmospheric and celestial conditions that had prevailed in the weeks before the emergence of the nova, Gualterotti noted that around sunset on September 25, 1604, there had been a conjunction of Saturn and Mars in the sign of Sagittarius, in precisely the location of a conjunction of Saturn and Jupiter in the preceding year.[79] In a typical blend of careful observation and fanciful speculation, Gualterotti recalled that

we saw a vast quantity of exhalations, and very tenuous and fine vapors rise and fill all the sky, and when the sun struck them, the air towards the West was the color of fresh blood. Because in that period I spent every evening in the [Uffizi] Gallery of [Ferdinando I,] the Most Serene Grand Duke of

Tuscany, I saw in the setting sun a black spot somewhat bigger in size than Venus. I saw this spot in the same place for several evenings: it was between the center and edge of the sun, which at that time was setting between the North and the West, and as I have said, the sky was always illuminated with ruby-red light. . . .

From these things you can understand that the first conjunction of Mars and Saturn, together with the conjunction of Mercury, Venus, and the moon in the sign of Scorpio, attracted the greatest part of these chaotic swirling exhalations and vapors. The sun attracted a more united and rarefied mass of vapor, and kept his eye on it for a few days until it departed, for that exhalation felt first drawn still closer to the sun, and then the solar body shot it like an arrow sixty degrees away to the conjunction of Mars and Jupiter.[80]

There is much to be learned from Gualterotti's bizarre account of the new star's genesis. Though it is reasonable to find in a treatise so influenced by Stoic theories of natural philosophy that Gualterotti, like Galileo, associated the stellar phenomenon with vapors of terrestrial origin, it is somewhat surprising to find that both men also described the nova in terms of the aurora borealis. Gualterotti's argument is the less coherent, for there is no real attempt to explain the "ruby-red light" along the northwest horizon. He was also incorrect to maintain that on the evening of September 25 and for several succeeding days—just after the autumnal equinox, in other words—the sun was setting between the North and the West. It is quite likely, however, that Gualterotti did observe the aurora borealis in that period, for three separate accounts of its occurrence and the warlike spectacle it offered on the evenings of September 28 and 29 are preserved in Transylvanian and Hungarian chronicles.[81] Gualterotti's allusion to the sunspot is also noteworthy; in addition to being the earliest such observation in the seventeenth century, the reference tallies nicely with his mention of the aurora borealis, both effects being associated with the increased solar activity of that period.[82]

This is not to say that Gualterotti had any real understanding of what he had observed, but rather to suggest that the curious resemblance that his treatise bears to Galileo's recent theories on the new star is undoubtedly a consequence of the contact between the two men in Florence in the summer of 1605. It may be that Galileo actually discussed his conjectures with Gualterotti, but given the relative incoherence of the account in the *Discorso*, we would be obliged to see in the former an extraordinarily ineffective teacher, or in the latter a most miserable student. Taking into consideration, too, the fact that the new star had ultimately failed to provide Galileo with conclusive evidence for the Copernican world system, it does not seem likely that the astronomer divulged much of the

hypothesis that had seemed so promising to him earlier that year. It is more plausible, therefore, that an intermediary such as Girolamo Mercuriale—who was a frequent visitor to the Medici Court and probably familiar with the Neostoic doctrines Galileo had lately discarded, if not with his reasons for doing so—provided Gualterotti with some version of the arguments that appear in the *Discorso*. This individual or series of individuals would have offered to Gualterotti the most basic components of Galileo's earliest conjectures about the new star—that despite its superlunary position, the celestial phenomenon originated in a mass of terrestrial vapor; that such an argument was consistent with Stoic cosmology and perhaps with Copernicanism as well; and that those same vapors could be used to explain the aurora borealis—without developing the technical aspects of any one of these hypotheses.

Gualterotti's explanations of the new star of 1604 in the *Discorso*, complemented by various Stoic elements such as an insistence on the relationship of free will to fate, and a reference to *krasis,* an important physical theory of homogeneous mixture, would undergo further change in the coming months.[83] Some measure of Galileo's disenchantment with the Neostoic tenor of his theories about the new star can be gained by comparison with Gualterotti's second work on the nova, the *Scherzi degli spiriti animali,* which was published in December 1605. As I mentioned in the previous chapter, this treatise provided a tentative and substantially correct explanation of the ashen light, one that surpassed the vague conjectures of the *Discorso*. At the same time, however, the Neostoic elements of the *Scherzi* are considerably muted. Thus while Gualterotti was still certain that the cosmos underwent a constant transformation through rarefaction and condensation and that the heavens were penetrable, he did not rely upon the piscine simile in his description of planetary movement but merely stated that the wandering stars "plowed and cut their way" through the surrounding medium.[84] And rather than opposing Aristotle at every juncture, as he had done from the opening pages of the *Discorso,* he described the ancient thinker as "the greatest philosopher that there ever was," and, in a gesture recalling that of Ilario Altobelli, limited his criticism of him to his analysis of the Milky Way.[85]

Significantly, however, Gualterotti's somewhat slavish dependence on Galileo appears even more pronounced in the *Scherzi*. Apart from the issue of the ashen light—which might possibly have involved collaboration between the men[86]—two passages are noteworthy in their resemblance to the astronomer's work. As I noted earlier, a good many of the extant notes on the nova concerned the issue of cloudy exhalations, and in one in particular, Galileo stated that "when green wood is exposed to flame, though it does not appear to diminish sensibly in size, it creates an enormous quantity of evaporation in smoke."[87] It is likely that such an

assertion antedated his conjectures about the aurora borealis, for while it recognizes that a vast amount of vapor would be required to generate any celestial object the size of the new star, its insistence on the unaltered appearance of green wood after its exposure to flame suggests that no extraordinary, or even perceptible, event was necessary to create large quantities of vapor. Gualterotti, in his turn, abandoned the obscure references to the aurora borealis and vapor-laden autumnal skies that had characterized the *Discorso* and noted instead in the *Scherzi* that "as small as the earth is, an infinite quantity of vapor and exhalation can arise from it, just as a great quantity of smoke will come from a few green branches that have been brought to a boil and allowed to hiss [*cigolare*] on a gentle flame, such that if the smoke were to condense in the upper reaches of the atmosphere just as it undergoes rarefaction here below, it would soon fill almost the whole entire hemisphere."[88] It is possible that Gualterotti's reliance on the verb *cigolare*, "to hiss" or "to sputter," refers to his sometime colleague and rival Lodovico Cigoli, who was also present in Florence during the summer of 1605, and whose well-informed involvement in Galileo's astronomical undertakings is undeniable. For one thing, in the spring of 1606 Cigoli himself would adapt a line from *Inferno* XIII—"as a green branch that is being burnt at one end will murmur and sputter [*cigola*] with the wind that escapes through the other"— to describe his despair over envious detractors who maligned a painting completed in those years.[89] For another, Gualterotti's work bears witness both to a particular preoccupation with Galilean discoveries, an obsession that might well have included those individuals like Cigoli who *were* privy to such research,[90] and to a fondness for word-play, a penchant indulged with remarkable freedom in the *Scherzi*.[91]

Gualterotti's second reference to Galileo's work is more problematic. In the course of describing the *spiriti animali* with which his treatise is largely, if sporadically, concerned, Gualterotti noted that the source that produced such spirits in humans was virtually inexhaustible, and he justified the statement by arguing that "we see that a piece of amber, if carried about an entire province, never stops emitting its perfumed Spirits, such that if it were carried around the whole world, the whole world would be filled with them, and yet the amber would never lose any of its scent."[92] The remark anticipates one made to rather different effect by Galileo nearly twenty years later in the *Assayer* when he bade his readers to "take a ball of amber or musk, or some other odoriferous material; carry it with you for a fortnight, and it will fill with odor a thousand streets, and in fact every place that you visit. This will not happen without some diminution of material, for without that there would doubtless be no odor; yet if you weigh it after this time, no sensible diminution will be found."[93] The two examples make precisely contrary points: on the basis of the imperceptible

change in the ball of amber, Gualterotti asserted its unchanged mass, while Galileo used this and another instance of slow but steady alteration—the gradual wearing away of gold leaf—to show merely that neither our senses nor our instruments are sufficiently refined to measure such erosion.[94] While it is possible that Galileo and Gualterotti happened to come up with their examples independently, or that the paradox of the amber ball was something of a commonplace and a ready point of reference in many philosophical arguments of this sort, it seems to me not unlikely that the latter author derived the argument from the former and followed it with conclusions better suited to the purposes of the *Scherzi degli spiriti animali.* Moreover, the inference made by Galileo, that while we are incapable of appreciating certain changes in mass we know that these must surely take place, complements his observation of the unaltered bulk of green wood, where a living branch exposed to flame will manifest no sensible diminution in size and yet manage to generate a vast quantity of vapor. This similarity may mean that the two instances originally appeared in the same context, as part of Galileo's general conjectures about the nature of change occurring through rarefaction and condensation; the fact that both examples figure as paradoxes, or at least as puzzles, may reflect the uncertainty that he, not to mention the confused follower he found in Gualterotti, felt about this aspect of Stoic physics.

Such ambivalence notwithstanding, within a decade of the nova's appearance the Neostoic arguments of the *Discorso* and the *Scherzi* may have seemed familiar, or even tiresome and irrelevant, to a certain audience. So suggested the Baroque poet Giambattista Marino, a friend of Gualterotti's, in his weary assessment of the entire issue in his *Dicerie Sacre* of 1614, where he managed nonchalantly to confuse the debate over the movement of the planets with that of the fixed stars of the firmament:

> I do not want to join those most subtle investigators of nature, who, armed with their dialectical arrows and sharpening the points of their arguments, are forever debating whether the stars were drawn from that mass of light created in the beginning by the Eternal Artist, or whether they were formed by condensation of the same substance of the heavens, just as fish were formed from water and terrestrial creatures from earth. Nor do I care to discuss the lengthy and protracted issue of whether the stars that are placed in the heaven that takes its name from its firmness are fixed there like knots in wood or darting about like fish in the sea.[95]

Marino's casual reference to the Neostoic argument offers only a very confused image of the problem that Galileo and especially Rubens sought to make clear in 1605. Were it not for the *Self-Portrait in a Circle of Friends,* the fragmentary nature of Galileo's work in that period would have virtually guaranteed his early conjectures the obscurity he later de-

sired, and have left them as muddled in appearance as those of Marino. There is, finally, a certain irony in the complementarity of the roles of the artist and the astronomer: it is as if Rubens, in preserving the scientist's theory of the new star, took on the task of presenting it as well. Consider, then, in this light the words with which Galileo prefaced his description of the aurora borealis, and how much more appropriate they seem to Rubens:

> It remains only that I affirm in the midst of everyone at last what it is that I believe about this most marvelous apparition [of the New Star]. I am by no means unaware that I, too, will undergo judgment, and also that there will be no shortage of those who will contest and reject my views. To them, however, I would like to say this one thing: I am not of such audacity that I would believe that it is impossible for the phenomenon to be composed of something entirely different, and I will even say it. Indeed the notion that I might be worried by that fear and the outcome is so far from reality that I would not blush now to admit openly that I am ignorant of the true nature of not only this new star, but in fact, even of that of the thousands of old and familiar ones.[96]

This attitude, certainly, is much more characteristic of Rubens, who painted the vaporous substance of which the New Star was supposedly composed, rather than of Galileo, who never saw the argument into print, and who, even in a portrait devoted to his conjectures, stares distractedly off into the distance. It is Rubens, too, with his direct gaze at the spectators who seems to affirm something, as Galileo said, *in medium,* "in the midst of everyone," and to expect that there would be those who, like Lipsius himself, might contest or even reject his views. And it is Rubens, finally, who, in contrast to the other sitters in this remarkable portrait, seems excluded from that great circle of reddish light, and—his surname notwithstanding—untouched by its ruddy cast. Such would be the demeanor of a man who could say, *non erubescam,* "*I would not blush* now to admit openly that I am ignorant of the true nature of not only this new star, but in fact, even of that of the thousands of old and familiar ones," and who would nonetheless find his notion worth recording.

Postscriptum: A Stoic Version of the Secondary Light

In this chapter I have concentrated on the astronomical issues of the new star of 1604 and the aurora borealis, showing how these phenomena, like those of the moon's phases and secondary light, might also be considered a legitimate concern of the artist. While this period of Galileo's develop-

ment was admittedly a brief one, and while we have but one instance of
the collaboration of the artist and the astronomer in this matter, this does
not mean that the episode was without resonance for the scientist when
he abandoned a stance that was so recognizably Neostoic. As the follow-
ing chapters will show, his subsequent work on the new star as well as his
ongoing investigation of the nature of reflection both rely on painterly
metaphors and techniques, suggesting that for Galileo collaboration with
artists was a constant feature of his progress of an astronomer, regardless
of the success or failure of a particular theory.

At the same time, it also seems possible that the issues of the secondary
light and the new star, which I have thus far treated as discrete scientific
problems, were in fact connected in the minds of at least some early mod-
ern thinkers and formed part of a general Neostoic cosmology. I mention
by way of conclusion two specific instances of such associations, both in-
volving men of Galileo's acquaintance. The first and more complicated
argument concerns Nicolas Fabri de Peiresc, who as a young man spent
the years 1600–1602 in Padua and who was, like Galileo, a close compan-
ion of Paolo Sarpi and a member of the learned circle of Govanni Vin-
cenzo Pinelli, as well as a friend of Willem Richardot, one of the sitters in
Rubens's portrait.[97] In his detailed biography of the French scholar,
Pierre Gassendi noted that immediately after his return from Italy Peiresc
began a study of light, and that he was most interested in investigating
the problematic correlation of light and heat in various luminescent,
phosphorescent, and iridescent material.[98] Such queries were not infre-
quent: the sensational "Bolognese stone," a lump of barium sulfate that
acquired phosphorescent properties when calcined, had been discovered
in 1602 in the hills outside Bologna and may have already been known
in Padua.[99] But long before this stone was found, more commonplace
luminescent phenomena were being analyzed in Paduan circles, and it is
certain that Peiresc's optical investigations were influenced by his recent
stay in that city.

To begin with a typical—if uncommonly poignant—allusion to such
issues, and an example familiar to Paolo Gualdo and Lorenzo Pignoria,
the Paduans most closely connected to Peiresc,[100] when the poet
Torquato Tasso addressed the stray cats of the hospital where he was in-
carcerated for madness from 1579 to 1586 he described the nocturnal
glow of their eyes as if it were actually a form of light. In verses at once
amusing and pathetic, he prayed to these "lamps of my studio, oh cher-
ished cats, / If God saves you from beatings, / If Heaven sends you milk
and meat, / Grant me then the light to write these lines." As the poet
told it, both the cats and the light they supposedly generated soon multi-
plied—black, white, tabby, and tailless creatures crowding him as he
wrote—and he ended his work with the request that they provide him

with a final bit of illumination, in order that his sonnet not lack, like some of them, a *coda*.[101]

What Tasso expressed with such troubling wit was part of an ongoing debate concerning the nature of luminescence. In 1600, Girolamo Fabricio d'Acquapendente, the most celebrated professor of medicine at the University of Padua, turned to the same question in his treatise on vision; arguing that those creatures endowed with extraordinary nocturnal sight—cats, wolves, owls, and the occasional human[102] serving as the most frequent examples—did indeed have some sort of light in their eyes, he compared this glimmering to that generated by luminescent fish and putrefying flesh.[103] Because the glow of cats' eyes was, like that of fish and rotten meat, virtually invisible by day, Acquapendente concluded that all such phenomena emitted an "inferior" or "impure" sort of light. In support of the traditional association of light with diaphanous objects (such as cats' eyes, in this case) and darkness with dense and opaque ones,[104] he offered the most peculiar of anecdotes, recalling that

> in the year 1592 at the time in which we celebrate the feast of the risen Christ, three Roman youths, students of noble background, acquired a lamb, and they ate part of it on Easter Day. What remained they hung up, as it happens, because they kept it in that place, and that night when they went near it, they saw various parts of the lamb shining as if lit by candles. Thus they sent the lamb to me, and when we examined it in a dark room, we noticed both the flesh and the fat shone with a great silvery splendor, and at the same time we noticed that parts of a kid goat, which had touched the lamb, were bathed in the same glow. If anyone touched this flesh—of either the lamb or the kid goat, I mean—the splendor immediately stuck to his fingers, and not just his fingers, but even the faces and the bodies of those who came into contact with it.[105]

Acquapendente went on to note that while the lamb's flesh did not look diaphanous by daylight, at nighttime it glowed so brightly that it took on such an appearance, losing such light little by little as dawn approached. Just as those parts that were the most nearly translucent—soft tissues like the bladder and the fattest portions—gave off the greatest light in the dark, so those that were leaner and closer to the bone, being by comparison considerably more dense and opaque, emitted no glow at all either by day or by night.[106]

After the publication of Acquapendente's *De visione* in 1600, the luminous lamb of Padua acquired a notoriety surpassed only by the phosphorescent stone of Bologna.[107] It is extremely probable that Peiresc's experiments of 1603 represent an elaboration, and perhaps a correction, of the conclusions reached by the physician. Though it may be that he did not discuss luminescence with the professor of medicine during the private

audiences granted him during his stay in Padua in 1601,[108] the following documents suggest that he did analyze such phenomena with their mutual friend Paolo Sarpi, and that both he and the Servite friar, unconvinced by the solutions offered by Acquapendente, understood the problem in terms compatible with Stoicism. Thus it was that while in Montpellier in 1603 the young Peiresc, entering *in contubernium*[109] with the jurist Giulio Paci, brought luminous fish and mollusks into the legal scholar's *cabinet de curiosité* one night and began examining their glowing scales and shells in the darkness of that setting.[110] The rigid and rather traditional Paci—devotedly Peripatetic and routinely amazed by his companion's demonstrations[111]—attributed the curious light to heat arising from putrefaction, but Peiresc objected that he felt no warmth arising from either the fish or the shellfish—which were not, in any case, rotten[112]—and he also noted that not even decaying wood, though it glowed in the dark, gave off any heat. Why was it, he asked Paci, "that granaries grown warm with rotting material, and moistened quick lime and other equally hot things did not emit light? And if glow-worms shine because of heat, why was it that other and warmer animals did not shine even more brightly?"[113] Paci suggested in his turn that the scant heat given off by such animals and plants was "virtual" rather than "actual," but this conjecture, borrowed from the Scholastics, was evidently judged entirely inadequate by both the young Frenchman and his biographer.

Peiresc then went on to explain the imperfect correlation of heat and light in phenomena that shone without warmth, or in objects that became hot without generating light, as weakened or rarefied manifestations of sunlight. Thus, according to Gassendi, he believed that "sunlight, even when it is enfeebled or veiled, always provides warmth, *just as a vapor is nothing other than a rarefied form of water, which, when it is contracted and dense, becomes liquid.* When sunlight is direct or primary, it is sufficiently dense to make its heat felt; when it is reflected or secondary, it is so tenuous as to provide no warmth for the senses."[114] Though there is nothing in Gassendi's account that directly pertains to astronomy, it is clear that the Stoic mechanism of rarefaction and condensation could be used to explain the problem of the secondary light as well as that of the new star. While it is possible that such arguments were advanced in Pinelli's circle, which was described years later by an admirer as a *contubernio*,[115] they may also have been conjectures aired more privately and based more narrowly on the earlier work of Paolo Sarpi, for several of the *Pensieri* strongly resemble the theories advanced by Peiresc. Sarpi, well known for his interest in Stoicism,[116] had investigated the nature of vision and light with Acquapendente. He was described by Acquapendente as "a distinguished philosopher, and above all a scholar of the mathematical disciplines, especially of optics," and was credited by him in his *De visione*

of 1600—the same work in which the memorable meal of luminous mutton was discussed—with discovering the manner in which the pupils of cats' eyes dilate and contract.[117] According to Sarpi's first biographer, Fulgenzio Micanzio, Acquapendente's recognition of the theologian's contributions to his work on vision, however flattering in tone, fell somewhat short of the truth; in Micanzio's view, Sarpi was also "the first to observe that the tunic of the eyeball is dense and opaque, like the other membranes, but becomes diaphanous and transparent because it is continually fed by a clear liquid, *just as the nature of mountain caverns renders the earth, though it is most opaque, diaphanous, because of the constant flow of water.*"[118]

Now, the suggestion that Sarpi was actually responsible for progress that was attributed to other men in fields as diverse as optics, anatomy, and astronomy was, as I will show in my next chapter, something of a leitmotif in his early biographies. What I would like to emphasize here, however, is its dependence upon the Stoic mechanism of rarefaction and condensation. Specifically, the analogy evoked by Sarpi is derived from Seneca's discussion of subterranean rivers and caves in the context of his theory of the constant cycle of elemental change,[119] and it represents, in the context of theories of vision, an attempt to account for physiological processes as well as geological and astronomical ones by one and the same means. It is possible, in fact, that the great interest shown by members of Sarpi's circle in the underground caves of nearby Costozza—where subterranean waters, a continual damp wind, and, regrettably, the occasional infusion of noxious gases cooled a splendid villa—is related to such conjectures, for the site was visited without incident by Peiresc in the spring of 1602, and, rather disastrously, by Galileo in the summer of the following year.[120]

The same reliance upon the single mechanism of rarefaction and condensation also characterizes Sarpi's analysis of the relationship of light and heat in luminescent and phosphorescent phenomena:

That heat and light are one and the same thing or perhaps inseparable companions is proven to us by the sun, by lanterns, and by heated wood and metals, which, being warmed by great movement, take on a reddish glow. The light of glow-worms and of rotten wood can be said to be heat generated by putrefaction. Nor does it help to object that some things of scant warmth give off light, as for example rotten wood and cats' eyes, and that other very hot things do not glow, such as iron that is being heated, because light is not born of great heat, but rather of *pure* heat. This is clearly observed in a piece of iron, that, being pounded on an anvil, heats up so much that it glows, and even before it glows, it gets so hot that sulphur catches on fire.

To this observation we may add a logical conjecture: if great warmth generates light, then so should lesser and even very small amounts of heat. Nor should it be objected that the light of the moon, if reflected in a concave mirror, generates no heat whatsoever, since we have noted that the moon's secondary light [i.e., light reflected off the lunar surface] is weaker than the earth's secondary light [i.e., that reflected off the earth], and weaker even than twilight. Therefore it is clear that since our secondary light, if reflected in a concave mirror, is even at noontime too diffuse to heat anything up, the same rule will hold true for the moon.[121]

It should be clear that the theories advanced by Peiresc and Sarpi represent a departure from the arguments of Acquapendente, for while all three scholars associated luminescence with a brilliance that was described as "weak," "impure," or "inferior" and which they recognized as a form of secondary light, there is nothing in the physician's discussion that would recall the contemporary interest in Stoic physical doctrines. Peiresc's suggestions, by contrast, are vaguely reminiscent of such hypotheses, the analogy used by him after his visit to Padua to distinguish between primary and secondary light being stated in terms of rarefaction and condensation. This association, finally, would not in itself be indicative of a particular interest in Stoicism except through comparison with the bolder statements made by both Sarpi and his biographer, for there the phenomena of primary and secondary light are explicitly linked both to astronomical arguments involving the moon and the very processes of condensation and rarefaction by which the new star and the aurora were thought to have been generated.

A second and slightly later instance of a common philosophical approach to two different problems involves a statement made by Galileo's rival Lodovico delle Colombe. Like Galileo and Gualterotti, Colombe was in Florence and at the Medici Court in the summer of 1605, and, as I mentioned in the previous chapter, all three men made reference to the moon's secondary light later that year. In alluding to *quel suo lividore,* or "that bruised color of hers," Colombe appears to have adopted a version of the Chaldean moon, a stony two-toned globe rotating on its own axis and so offering the illusion of phases. While such a theory would be elaborated by him several years later in the wake of the invention of the telescope and the publication of the *Sidereus Nuncius,* it is possible that the original context of the phrase *quel suo lividore* was not Chaldean but rather Stoic, and that Colombe's misinterpretation of it derives from a rejection, conscious or otherwise, of notions he associated with his long-standing rival Galileo.

I raise this possibility because one chapter of the seventh book of Seneca's *Natural Questions,* the work that seems to have influenced Galileo

so much in this period, begins with an oblique reference to the moon's ashen light, a radiance described by the Roman author as the *lividus color* that sometimes covers the lunar globe in the sun's absence.[122] Seneca does nothing to resolve the problem—for the puzzle of the moon's appearance is offered as one of a host of examples intended to show the great variety of natural phenomena—but it may be inferred that by the early modern period at least some of his audience understood the description as a reference to the secondary light. In his translation of the *Natural Questions* in 1620, Thomas Lodge rendered the Latin expression "a leaden colour," and while there is no particular reason to assume that he was familiar with the ashen light and the controversy surrounding the issue, the fact that John Wilkins referred to and explained the phenomenon as a "duskish *leaden* light" in his *Discovery of a World in the Moone* suggests that he was aware of its presence in the Stoic text.[123]

It is in any case reasonable to suppose that Galileo understood Seneca's reference to the moon's *lividus color* as an allusion to the very problem that had interested him for several years, and one which, unlike the new star of 1604, would at last provide him with proof of the Copernican world system. Such evidence was not long in coming: less than six months after he had abandoned his conjectures about the nova, Galileo would find in the moon's ashen light an argument for the earth's status as a planet. And while he may have regarded Rubens's portrait as a monument to the failure of one theory, it is clear that he relied on the specialized knowledge provided by painters to prove that the moon was rough, rocky, and opaque, and that the earth revolved about the sun. Thus while the *Self-Portrait in a Circle of Friends* has languished in a kind of historical vacuum, its subject obscured by the passage of time, its triumphal repudiation of the Aristotelian theory of illusionary aurorae unappreciated, and its punning reference to Rubens's own name unknown, both the subsequent depictions of the moon and the painterly metaphors on which astronomical arguments relied would become increasingly explicit and comprehensible to an interested audience.

1605–1607

MUTUAL ILLUMINATION

B Y 1607, LODOVICO CIGOLI would insist upon the accommo-
dation of Copernicanism to Scripture, presenting the *Deposition*
as a monument to the inseparable nature of scientific knowledge
and religious faith. How he arrived at this particular admixture of doc-
trinal and scientific matters, and how the lunar iconography of his paint-
ings evolved under Galileo's influence between 1602 and 1607, will be
one focus of this chapter. The other and related concern will be the man-
ner in which the astronomer was guided by artistic conventions in his
understanding of the secondary light, for as several documents of this
period suggest, his final resolution of the lunar issue involved terms bor-
rowed from painters and most familiar to men like Cigoli. In what fol-
lows, therefore, I will try to reconstruct the exchange between Galileo
and the artistic community in those years, showing not just how Cigoli
made the lunar phenomenon central to his *Deposition* of 1607, but also
what part painting itself played in Galileo's study of astronomy in that
same period.

Guided by a Secondary Light

I suggested in my first chapter that the tenuous note in Raffaello Gual-
terotti's explanation of the secondary light may mean that in December
1605 he regarded the terrestrial origin of the effect as a new and still
questionable hypothesis. Lodovico delle Colombe's reference to the
lunar issue, "that bruised color of hers," was also made in December
1605, the casual tone of the remark implying that both the author and his
audience were familiar with the argument. Galileo's earliest extant allu-
sion to secondary light occurs in a letter written to Cosimo II de' Medici

in December 1605, and concerns reflected light in general, but not nec-
essarily the light scattered about on the face of the moon. The circum-
stances surrounding his correspondance with the future grand duke of
Tuscany, and the contemporaneous references to the ashen light made by
Gualterotti and Colombe all imply, however, that the issue was astro-
nomical, and that the discussion was of recent date, almost certainly from
the summer of 1605.

In fragmentary notes written in November or December 1604 and
concerned primarily with the issue of the new star, Galileo argued that
reflection was of two sorts, that which took place in a diffuse way on
rough surfaces, and that limited to a minute portion of a polished body.
He then determined, as had his friend Paolo Sarpi some twenty years ear-
lier, that the moon could not be a mirror, but he did not, at least in this
note, go on to compare the manner in which light behaved on the rough
surface of the earth with what it presumably did on the face of the moon.[1]
Though in later years Galileo would often suggest that the ashen portion
of the lunar globe provided more illumination than did the horns—so
much, he said, that one might read by this twice-reflected light[2]—at this
point the astronomer did not even consider that the brilliance of the new
moon derived from anything other than sunlight reflected off of its cres-
cent and onto earth: "It is proved by experiment that the moon is
brighter than the [fixed and wandering stars], first because all of them
together cannot illuminate the earth as the moon does alone, and sec-
ondly, because even the smallest part of her horns [i.e., the moon at first
visibility] greatly surpasses in light all the fixed stars."[3]

It was in this same period—one largely devoted, as I argued in my sec-
ond chapter, to the development of astronomical notions within a Neo-
stoic context—that Galileo observed that the ability to receive and reflect
light was not limited to heavenly bodies such as the moon and fixed and
wandering stars, but was shared by a variety of terrestrial objects. In one
particularly interesting passage criticizing the customary association of ce-
lestial objects with weightlessness, transparency, and radiance, and terres-
trial ones with heaviness, opacity, and darkness, Galileo wrote that

> it is first of all a great error, when various things are shining in the sky, to
> consider them all as if they were of the same essence and nature, since
> they might in other respects be different from the rest of the heavens,
> and nonetheless be capable of receiving and reflecting the light of the
> sun, as for example are wood, and stone, and clouds. It would be no differ-
> ent than if someone were to say that gold, lead, wood, stone, ice, fruit,
> flesh, bones, and wax were one and the same, simply because they were
> all inclined to fall towards the center of the globe and were all illuminated
> by the sun.[4]

Though Galileo's marginal note indicates that he intended to return to this point, it was never elaborated.[5] The premise, however—that a body's terrestrial nature is not a necessary index of its ability to reflect light—is clearly the first step in a discussion of the earth's role in projecting solar rays onto the face of the moon.

Though these notes fall short of any satisfactory resolution of the problem of the secondary light, it appears that within a year Galileo had discovered the origin of the phenomenon. He spent July, August, and September 1605 in Florence and Pratolino with the Medici Court, where, as I have suggested, the lunar issue was evidently a subject of discussion. Galileo's principle task at the Court was to teach Cosimo II de' Medici, then fifteen years old, to use a calculating instrument, the "geometric and military compass," a tool with various applications to astronomy as well as to surveying and gunnery. It is likely that either their lessons or the conversation at the Court also included some discussion of the secondary light, as this exchange of letters following that summer's instruction will suggest.

In November and December 1605, Galileo set about seeking permanent employment at the Medici Court. He was at that point intent upon conveying both the benefits of what Cosimo had learned during their summer together and the value that continued study would have for the future grand duke. He may, however, have had his doubts about the effectiveness of his instruction, for in early December 1605 Galileo received word from an official at the Medici Court that "As regards what you wish to know about the studies of the Most Serene Prince [Cosimo], and whether he understands his mathematics, I can tell you with absolute certainty that from the time Your Lordship left Florence, His Most Serene Highness has not even seen, much less used, the [Geometric and Military Compass], not because he doesn't like mathematics, but in part because he cannot recall all of its uses, and in part because the Court is constantly going back and forth [between Florence, Pisa and Livorno]."[6] Cosimo himself appeared worried about what he had learned, confessing with embarrassing candor in a letter to his tutor that "even if the hardy seed which your Lordship labored to plant in my mind has for various reasons failed to bear fruit in the way that it might have and should have, I have faith nonetheless that were you to return here, you would not find it so smothered that you could not with a little effort bring it to flower."[7] Given these preoccupations, it may be that Galileo sought in a letter of December 1605 to recall to Cosimo's mind not a subject as complicated as the compass, but rather a simpler issue, one that the boy had discussed with him and was sure to remember, such as that of the moon's secondary or reflected light. The allusion itself—part of an extended metaphor devoted to the ruler's brilliance and his subjects' relative obscurity—clearly

presupposes Cosimo's understanding of the phenomenon, and it implies that he had spoken of it with Galileo during the previous summer: "I have waited until now to write to Your Most Serene Highness because, constrained by a timid respect and unwilling to strike a note of temerity or arrogance, I preferred to send my regards to you through trusted friends and associates rather than to appear before you. *For it seemed to me that upon leaving the darkness of night, rather than staring immediately and directly into the most serene rays of the rising sun, that I should instead approach this sun by using secondary and reflected lights [lumi secondarii et riflessi] as a guide.*"[8] The rising sun metaphor is a familiar one: Cosimo liked it so well that Galileo used it again in the dedication of his treatise on the geometric and military compass once he had been awarded permanent employment at the Medici Court.[9] The conceit of the "secondary and reflected lights" is, however, hardly a commonplace, and if Galileo relied upon it in his effort to be named Cosimo's preceptor, he must have been certain of the significance it had for his pupil. Because Galileo's allusion to the secondary light was made in December 1605, as were those of Raffaele Gualterotti and Lodovico delle Colombe, and because all three men were associated with the Medici Court in the summer of 1605, it is reasonable to assume that Galileo's recognition of the terrestrial origin of the light dates to this period.

There is an evident similarity between the arguments raised by Gualterotti in the *Discorso sopra l'apparizione de la nuova stella* and in the *Scherzi degli spiriti animali* about the earth's ability to reflect light and those more explicitly Copernican statements made by Galileo in the *Sidereus Nuncius* some five years later, but it is impossible to say which individual influenced the other, or whether they were both influenced by a third person, or arrived at their conclusions while working together at the Medici Court. What does seem likely is that Galileo, and perhaps Gualterotti as well, conceived of the secondary light in artistic terms, as an allusion made in his next work on the nova of 1604, the *Considerations of Alimberto Mauri*, will show.

Bright Colors and Dark Shadows

When Gualterotti discussed the part of the moon enclosed by the horns, he called it *abbagliata*, meaning that it was somewhat muted in color. Colombe used the same term in December 1605 to describe how morning stars were obscured by the radiance of the rising sun,[10] and Galileo would rely on the word in 1632 in his most detailed explanation of the secondary light.[11] While the context of these arguments is astronomical, not artistic, their understanding of the term *abbagliata* is consistent with the way it was used to describe a certain aspect of color modeling in

painting, most notably by Giorgio Vasari in his *Vite*. The favorable and specific connotations of the word *abbagliata* in Vasari's work stand in contrast, moreover, to the way it was more commonly used, as for example by Giovanni Paolo Lomazzo, who intended by it no more than a generic confusion or bedazzlement through excessive light, the standard production of the poor painter.[12] It differs even more sharply with the way in which Galileo himself used the term before adopting its artistic sense, for as recently as May 1604, in the course of declining employment at the Gonzaga Court in Mantua, he relied on the word to portray the blindness and awe he evidently felt in the presence of even those rulers whose blandishments he could resist:

> Since I have never had any goal other than honoring and doing everything possible to please, obey, and serve your Highness, if the integrity of my motives were to come under scrutiny, I believe that no one would find anything there but the utmost sincerity. And yet, if perchance through my blindness I have failed to perceive those faults that might be evident to others with clearer vision, may your Highness excuse and pardon my weakness, in the event that dazzled [*abbagliata*] by the unaccustomed splendor, it has stumbled somewhere, and please be assured that in absence no less than in presence [at the Mantuan Court] I will always be your most humble and most devoted servant.[13]

Because it appears that by the summer of 1605 Gualterotti and Galileo, if not Colombe, understood the word in the narrow and technical fashion that Vasari used it, some examination of its appearance in the *Vite* is in order. In his definition of painting, Vasari relied on a familiar kind of color modeling, sometimes known as "Alberti-style modeling" or "down-modeling," where for any field of color, as for example a garment, a pure pigment would be used for the midtone, to which white would be added for the lighted portions of that same material, and black for its shadowed area.[14] The range of light, midtone, and dark could be further subdivided, if necessary, Vasari noted, and he called the hybrid shades that would result *abbagliati*, meaning that they were muted or attenuated versions of the pure color. Vasari referred several times to such shades, admiring the tonal unity that these gradations bestowed on a composition. In distinguishing between three different styles of Italian *quattrocento* painters, for instance, he made clear his preference for the third mode, where the subdued colors and half-shadows of *abbagliamento* were most evident:

> When among the arts those that derive from design come into competition, and artists rival each other in their work, it is certain that the best of them, through great effort, will almost daily discover something new to satisfy the various tastes of men. As regards painting, some, depicting obscure and un-

usual things, and thus showing the difficulty of their undertaking, make their brilliance known with [cast] shadows; others, portraying colorful and pretty things, and believing that these, since they stand out most, will best please the eye of the observer, easily win over the greatest number of men; and still others, painting with chromatic unity and by muting [*abbagliare*] the colors, softening in the appropriate places the lights and the shadows of the figures, merit the highest praise and show their intelligence with true grace.[15]

Vasari did not devote himself to the optical nature of these muted colors and penumbral lights, but other writers known to Galileo and Gualterotti, and among them Leonardo da Vinci and perhaps Lodovico Cigoli, discussed them more fully, showing how the gradations in a uniformly colored surface were due to the manner in which some areas reflected light and others were illuminated by such reflections. In the range between the brilliant white highlight and the pure midtone, therefore, the color of the surface would be somewhat attenuated where it was strongly illuminated by direct light, while in the range from the midtone to the darkest and most heavily shadowed portion, some of the surface would be brightened by reflected light. As regards the exchange of light between the earth and the moon, both bodies could properly be called *abbagliati*, for direct illumination from the sun muted somewhat the true color of their surfaces, while the reflected light that each provided the other meant that dark and shadowed regions were suffused with an ashen radiance.

Thus far, then, I have argued for the commensurability of the artistic and astronomical use of the word *abbagliata*, and have shown the manner in which Vasari's reliance on it applies to the question of the secondary light. That Galileo saw the lunar issue in artistic terms, or tended to present it to his "close friends and pupils" in this fashion, may be inferred from one of his two pseudonymous works on the nova of 1604, the *Considerations of Alimberto Mauri*, probably composed in March and April of 1606, and published in June of that year. This treatise was in great part concerned with the ridicule of Galileo's rival Lodovico delle Colombe, who had put forth a remarkably poor explanation of the nova in December 1605, but it also included an important reference to the problem of the secondary light.

When the new star emerged in the heavens, some authors, denying the validity of parallactic measurements, insisted that it had to be sublunary, like all mutable things. Other and more daring writers attempted to explain the paradox of an apparent alteration in the eternal and incorruptible region beyond the moon by alleging that in the slow rotation of the remote crystalline sphere of the heavens, variations in density created,

from time to time, a lens effect that allowed the earthly viewer to perceive stars otherwise lost to sight. A description of these crystalline or heavenly spectacles was published in Florence in December 1605 by Lodovico delle Colombe, and refuted in June 1606 by a certain Alimberto Mauri, a name then and now considered to be a pseudonym of Galileo.[16] The *Considerations of Alimberto Mauri* have that peculiarly Galilean combination of elaborate courtesy and boundless enthusiasm for the weakest details in an opponent's work: the arguments introduced by Colombe to explain the heavenly spectacles and their miraculous magnification of these distant stars were meticulously examined, variously interpreted, and shown to lead in every case to "manifest absurdities." Thus "Mauri" pointed out that "though spectacles were invented in 1280, yet in all that time their use, rendered uncertain only in lowly objects, has never until now, and by you, been employed in favor of Astrology and added to higher and celestial things."[17] He proved, moreover, that if the nova were in the Prime Mobile, as Colombe suggested, and were seen through a "lens" the size of those of the heavenly spectacles, the slow movement of this crystalline sky, completing a west to east circuit once every 49,000 years, would have kept the star behind it visible for decades, rather than only for a few months: "If your spectacles had caused for us the sight of such a star, we should not have lost it, and therefore having such a nuisance on our nose, we should in recompense enjoy the sight of such a shining star at present and for many years still."[18] The unhappy inventor of the heavenly spectacles was addressed throughout as *nostro Colombo*, "our Pigeon."

The major focus of the *Considerations* is the irresistible target provided by Colombe; the rest of the work contains several contradictions, particularly in its various discussions of the lunar body. At one point, for instance, "Mauri" stated that the moon received its light from the sun, and he cited the medieval scholar Witelo as the appropriate authority in this connection.[19] It is true, of course, that Witelo believed that the moon was illuminated by the sun, but he also considered its secondary light to be caused by solar rays that penetrated the lunar globe. It is difficult to know if "Mauri" shared this opinion, for elsewhere he affirmed the opinion of Erasmus Reinhold, that the moon had its own light. As if in answer to his rival Colombe, or to any reader who would tax him with inconsistency, "Mauri" wrote: "And do not contradict me because I said [earlier] that stars receive light from the sun. For though luminous in themselves, the complement and completion of their splendor is nevertheless given to them by the sun. This is clearly seen to happen in the moon, which as Reinhold says has a certain light of its own, special to it, since if it had none, it is manifest that in total eclipse, when the sun is completely out of sight, there would not be seen in her disk

[that black] and frightening color."[20] But "Mauri" also affirmed that the moon was a "dark and shadowy" body, and a mountainous one, not unlike the earth itself.[21] This particular opinion is one that Galileo would express in the *Sidereus Nuncius*, but the consequences drawn from it are not: "Mauri" attributed the moon's "stained darkness" to the "curvature of its mountains," noting that these slopes were less capable of receiving and reflecting light than were the "smooth and polished" regions that lay beneath such heights.[22] This is precisely the contrary of the argument developed in the *Sidereus Nuncius*, for there the dark spots on the crescent were more reasonably said to be its low-lying regions, while the mountains that rose so dramatically above its surface would be the first surfaces to reflect light.

No coherent lunar theory can be developed out of these various hypotheses—some of which are flat contradictions of Galileo's earlier work—for it is difficult to imagine what "Mauri" intended by a body that was simultaneously illuminated by the sun, self-luminous, and dark, and at once mountainous and a smooth, mirrorlike reflector of light. It is, however, perhaps more to the point to question what *Galileo* intended by such uncharacteristic contradictions. I can only conclude that he avoided entirely his earlier and more coherent hypotheses about the moon's secondary light because he believed that the Copernican implications of such a theory would neither win him any followers in his effort to ridicule Colombe and the notion of the heavenly spectacles, nor secure him employment at any Italian court, a possibility of increasing concern to him as his prospects at Padua diminished.[23] That Galileo still believed that the ashen light had a terrestrial origin, that he associated it with painterly practices, and that he regarded it as evidence of Copernicanism and grounds for conversion to that world system seem to me suggested by one of the few similes present in the *Considerations*, as I will now show.

Toward the beginning of the *Considerations*, "Mauri" mentioned in passing a recent book on the heavens, the *De numero, ordine, et motu coelorum adversus recentiores* of Antonio Lorenzini, published in Paris in 1606. Lorenzini's work was already familiar to Galileo: in 1605 this scholar had produced a treatise on the new star, one in which he attacked the Pisan's three public lectures on the subject and suggested instead that the nova was a wayward bit of vapor from the Milky Way that had somehow wandered to the lunar orb and was illuminated by starlight. Lorenzini was distressed by the emphasis Galileo and other "mathematicians" placed on parallax—for they argued that the fact that the new star showed no parallax meant that it was relatively remote and certainly far beyond the moon—and he insisted throughout on the immutability of the heavens. His modest abilities as an astronomer were nicely conveyed by his

confused references to something he believed was called "parallapse," and the book was described by Galileo's friend Ilario Altobelli as one that did more damage to its author than to the mathematicians whose theories it attacked.[24]

Lorenzini's next work, a broad condemnation of "the moderns," was no more effective than the first, and when "Mauri" chose to comment on its criticism of Nicholas Copernicus, Christoph Clavius, S.J., and Giovanni Antonio Magini, he could not have done so because he sincerely believed them harmed by the kind of objections raised in the unfortunate *De numero, ordine, et motu coelorum*.[25] Clavius and Magini, the two most prominent astronomers in Italy—and the former, the most influential, perhaps, in all of western Europe—accepted the Ptolemaic, not the Copernican, world system.[26] Significantly, both men were regarded as likely candidates for conversion to Tycho Brahe's geoheliocentric theory, though only Magini was particularly interested in the scheme, and he was by no means convinced by it.[27] They had little in common with the long-dead Copernicus, apart from the fact that all three were "moderns" and mathematical astronomers, but this apparently had been sufficient to provoke the hapless Lorenzini to attack them. Lorenzini, "Mauri" wrote,

> dabbling in natural philosophy—the whole point of which is the examination of the heavens—permits himself to speak out against Magini, Clavius, and Copernicus, and a great many other scholars of the last century. With extraordinary modesty he has set about merely reproving them, he says, rather than refuting them, and it is true that he offers no valid reasons for criticizing their work, that is, the number, order, and motion of the heavens, which is precisely the object of Astronomy. It is as if one were to consider men who had spent their lives cutting and sewing clothes, for example, too low and even audacious if they were to dare criticize in an otherwise perfect painting, something besides the draping of the garments, *either the brightness of the colors, or the excessive darkness of the shadows*, those things which a good painter would use in another portrait to bestow all the life and beauty that was missing in this one.[28]

The simile by which "Mauri" defends Magini, Clavius, and Copernicus is an extremely interesting one, for it implies that there is some analogy between their suggested modifications of the Ptolemaic world picture and the tailors' bold criticism of the painting they see before them. Such a figure recalls, of course, Copernicus's celebrated description of the odd portrait created by Ptolemy and his followers, one in which no harmony prevailed between individual features and the whole: "They have not been able to discover or deduce from [planetary motions allegedly involving homocentric circles, eccentric circles, and epicycles] the chief thing, that is the form of the universe, and the clear symmetry of its

parts. *They are just like someone including in a picture hands, feet, head, and other limbs from different places, well painted indeed, but not in the least matching each other, so that a monster would be produced from them rather than a man.*"[29] The metaphor of the universe as a painting—though not necessarily as a portrait—was also frequent in Italian literature: Baldessare Castiglione used it in the *Cortegiano*, Benedetto Varchi in his *Lezioni sulla pittura e scultura*, and, much later and to much greater effect, Marco Boschini in his *Carta del navegar pitoresco*.[30] But the suggested connection between astronomical and artistic activity in the simile used by "Mauri" is more than a poetic commonplace: it recalls the precise circumstances in which Galileo may have first explained the secondary light to "some close friends and pupils." The focus of the tailors' attention, what they would correct in an otherwise perfect painting, is the very flaw that Galileo would have others see in a world system that did not involve the play of the secondary light: without the *abbagliamento* provided by reflection, the colors would be too bright, and the shadows excessively dark. Only when a portrait was embellished with the kind of muting favored by Vasari would it be lifelike and beautiful, and this would apply equally well to likenesses of a particular individual and of the entire cosmos.

We would do well to ask what in this figure is indubitably Copernican, given that the earth's ability to reflect light onto the face of the moon was merely a metaphysical argument rather than physical evidence for its other planetary characteristics, most notably its annual orbit about the sun. Put another way, could the muted colors and half-shadows caused by the exchange of light between the terrestrial and lunar globes be a feature of a "portrait" of any world system besides one involving a mobile earth?

Here again comparison with Copernicus's simile is instructive. The monster concocted by the various followers of Ptolemy—that busy mixture of epicycles and eccentric circles—has neither life-likeness, meaning verisimilitude, nor beauty, since there is no symmetry between the farrago of motions used to describe one planet's motion and those pertaining to any other wandering star. Copernicus's implication is that these considerations alone, though they are no more than aesthetic judgments drawn from Horace's *Ars Poetica*,[31] should persuade the most casual observer of the Ptolemaic system of its utter unlikelihood. The figure adopted by Galileo involves a similar reliance upon considerations of a purely aesthetic sort: while it is physically possible that an immobile earth might reflect light onto the moon—that the terrestrial globe might, in other words, somehow counterfeit the nature of the planets while possessing none of their other characteristics—such an arrangement would be entirely lacking in plausibility and harmony. Just as muted colors and

half-shadows bestow "life and beauty" on the portrait of an individual, so do they confer verisimilitude and a pleasing symmetry on a world system, but only on one where the earth is indeed a planet.

This strict association of the secondary light with a mobile earth suggests that Galileo regarded Magini and Clavius as potential Copernicans, as if once they saw that the moon's ashen color was caused by reflection, aesthetic considerations of verisimilitude and symmetry would compel them to number our globe among the planets. Such expectations, while perhaps unrealistic in themselves, are indeed typical of Galileo's behavior toward these two astronomers directly after the publication of the *Sidereus Nuncius*. In April 1610 he journeyed to Bologna, for instance, to show Jupiter's four moons to Magini, and there he relied on metaphysical arguments to convince his colleague of a mobile earth. He stated that the presence of these satellites around a known planet not only deprived the earth of the unique—and therefore central and motionless—position it enjoyed in the Ptolemaic scheme, but also made it all the more likely that the terrestrial globe, encircled by its own moon, also made its way over the course of a year about the sun. Regrettably, Magini was unable to see the Jovian satellites through Galileo's telescope, and he maintained that they were no more than an optical illusion caused by defective lenses, thus liberating himself of the burden of the metaphysical argument.[32]

Galileo had somewhat more success with Father Clavius, who acknowledged after reading the *Sidereus Nuncius* that astronomers might, perhaps, consider a new world system, but who could not accept that the moon was a rough, dark, and opaque body like the earth.[33] It is worth noting that Galileo attributed Clavius's doubts about his lunar theory not to an entrenched philosophical position, but rather to the poor eyesight and weakness of the ailing seventy-three-year-old astronomer,[34] for here as well he seems to have believed that if only his colleague were able to see certain phenomena, metaphysical considerations would oblige him to acknowledge the Copernican system.

Many among the readers of the *Considerations* would have recognized in the insistence which "Mauri" placed upon the importance of muted coloring and soft shadows in portraiture an opinion offered in Lodovico Dolce's "Aretino" or *Dialogo della pittura* of 1557, where Aretino, the main speaker and arbiter of taste, complained that in his view "many artists depict [flesh] so that it seems made of porphyry, both in color and in hardness; their shadows too are too harsh and most often end in pure black. Many make the [flesh] too white, and many too red. . . . The blending of the colors needs to be diffused and unified in such a way that it is naturalistic, and that nothing offends the gaze such as contour lines, which should be avoided (since nature does not produce them), and blackness, a term I use for harsh and unintegrated shadows."[35]

Aretino's observations about portraiture would have been of interest to Galileo for reasons not directly related to the issue of reflected light: the astronomer had his likeness painted often, particularly in the first decade of the seventeenth century. Cigoli's teacher Santi di Tito painted Galileo's portrait in 1601, Peter Paul Rubens portrayed him in a Neostoic *contubernium* in 1605, and Domenico Tintoretto painted him in 1605 or 1606.[36] Galileo was even said by Thomas Salusbury, the first English translator of the *Dialogue Concerning the Two Chief World Systems*, to have painted his own portrait, and though this story has an apocryphal ring to it, its very existence makes clear the interest he had in the genre.[37] At the moment in which he included the reference to portraiture in the *Considerations*, moreover, portraiture was undergoing something of a revolution in Tuscany at the hands of his friend Cristofano Allori.[38] It is not evident that the merits or flaws of these actual portraits had anything to do with the figurative portraits mentioned in the simile, though it is easy to imagine one of them—Domenico Tintoretto's, perhaps[39]—being criticized for its too bright colors and dark shadows, and another being praised for its more subtle handling of reflected light.

Other features of Dolce's dialogue would have appealed to Galileo: Aretino insisted, for example, that man—any man—was capable of distinguishing the beautiful from the ugly, and that such ability derived from "practical experience of the way things are."[40] This is the point of the simile in the *Considerations*: it was precisely the practical experience of the tailors, "Mauri" argued, that allowed them to detect aesthetic flaws in the portrait they were examining. Dolce also referred often to Horace, whose work Galileo held in high regard, commenting, in fact, on the simile of the painted monster,[41] and he especially liked Galileo's favorite poet, Lodovico Ariosto.[42] The principle object of the *Dialogo della pittura*—to convince the Florentine speaker Fabrini that Titian, not Michelangelo, was the greatest of painters—would have pleased Galileo in 1606, when he had spent fourteen years in the Veneto, and even in 1632, after two decades in Florence, he appeared unable to decide if he most preferred Titian, or Michelangelo, or Raphael.[43]

What is most important, however, is that the astronomer saw that opinions phrased in purely aesthetic terms in Dolce's dialogue—Aretino's distaste for fleshtones that resembled porphyry, for instance, and his aversion to the deep black shadows from which such vividly colored forms would suddenly emerge—involved the painter's treatment of secondary light. Thus the rest of Aretino's advice about the handling of light and color also corresponds, in a general way, to Galileo's view of the issue. Aretino acknowledged, for instance, that the artist would also need "to know how to imitate the color of draperies, silk, gold, and every kind of material," and moving beyond the realm of portraiture, he enjoined him

to learn "to simulate the glint of armor, the gloom of night and the brightness of day, lightning flashes, fires, lights, water, earth, rocks, grass, trees, leaves, flowers and fruits, buildings and huts, animals and so on."[44] This stock catalogue of painterly effects, each involving a different treatment of reflected light, is the analogue of Galileo's observation that most terrestrial objects were capable of reflecting some amount of light. The painter who could not master the differences between these various surfaces—and the ghastly glow of porphyry-like flesh in a portrait would be just one instance of this sort of failure—would be like that thinker earlier described by Galileo in his meditation on the nature of reflection, someone who would "say that gold, lead, wood, stone, ice, fruit, flesh, bones, and wax were all one and the same."

It is also clear that if, in the course of their meetings or correspondence of 1604–1605, Galileo and Peter Paul Rubens did exchange their views on the play of light and shadow in both paintings and statues, the conjectures of both men would have resembled the conclusions reached in this passage of Dolce's *Dialogo*.[45] As I mentioned in my second chapter, we have no way of knowing if such exchanges took place, though they would not have seemed out of place in a discussion of the nature of reflection and in a context where both aesthetic precepts and painterly techniques were routinely brought to bear on astronomical issues. It also seems likely that what Dolce condemned in depictions of the flesh, and what Rubens prized in ancient statues—a relatively bright color, deep shadows, and a hard, unnatural luster—confirmed in Galileo his abiding distaste for the hybrid forms of paintings and relief figures composed of *pietre dure*. While the arguments of Dolce, Galileo, and Rubens cannot be reduced to the single issue of their treatment of color, shadow, and reflected light, all share a preoccupation with a point which otherwise might strike us as no more than a technical detail.

Finally, there is the possibility that in this same period Lodovico Cigoli addressed the question of reflected light in painting in his lost manuscript on color. When Giovanni Battista Cardi described the work in 1628, he wrote that his uncle had put a collection of notes on color in a large ledger, and set it aside for future revision, only to have it stolen from his house, presumably by other painters.[46] Filippo Baldinucci, writing in the 1680s, asserted that he had seen "several fragments or rather several first drafts" of the treatise on loose sheets, but not even these survive today.[47] Two observations on color earlier considered to be part of the lost work have recently been reattributed to Cigoli's pupil Sigismondo Coccapani, who worked with him from 1610 to 1613 on the *Immacolata* at Santa Maria Maggiore in Rome, who helped him make sunspot observations, and who, like his brother Giovanni Coccapani, had a strong scientific background and friendly relations with Galileo.[48] Sigismondo

Coccapani's two notes on color are from a period well after the publication of the *Considerations of Alimberto Mauri* and are devoted to two different subjects, the one to the proper way of painting fleshtones, and the other to the manner in which draped and shimmering fabric reflects light. Taken together, however, they offer a technical paraphrase of the remarks of portraiture made by Dolce and adapted by Galileo in the *Considerations*:

> In coloring flesh, always make it a little bit bluish along the border between light and shadow, and in the highlighted area, it should tend towards pink, and in the darkest part, more towards the reddish-yellow tone of umber.
>
> Take care not to garble colors in depicting lights and shadows, as for example, reflected light in a shadowed area should never be so bright as the faint light of a shimmer, because we see first a little bit in the mid-tone, then the brightest area, then the mid-tone again, then the glimmering light, then a deep shadow, and finally the reflected light, which, being sent to it by nearby bodies in the shadowed area, can never be so bright as the shimmer.[49]

We have no indication that Cigoli's stolen treatise necessarily involved questions of either the proper way to depict flesh or draping, though both are likely subjects. The solutions that he would have offered, however, would have been very much in keeping with the conjectures later made by his student, and thus part of that general concern with reflected light developed to such advantage in an astronomical context by Galileo.

Subsequent Study with Paolo Sarpi

There is no further mention of the secondary light in Galileo's extant writings until 1610, when he introduced it in the *Sidereus Nuncius*, but the study he made of the phenomenon from 1606 until the publication of his treatise can be inferred from two letters written by Fra Paolo Sarpi to a correspondent in France. Here Sarpi and Cigoli stand opposed, for while it is evident that Cigoli depicted the ashen light on the surface of the moon as a means of showing his friendship with Galileo, it is also clear that Sarpi and Galileo quarreled over the same issue, and presumably over questions of influence and priority.

As I noted in the first chapter, Sarpi resolved the puzzle of the secondary light long before he met Galileo, though he drew no particular conclusions from the bare fact that the earth was a good reflector of sunlight, and certainly nothing of the significance of Galileo's later argument for Copernicanism. It also seems likely, as I mentioned in my second chapter, that in the early 1600s Sarpi understood primary and secondary light in terms consistent with the Stoic doctrine of rarefaction and condensation,

and that such conjectures may have been commonplace in the Paduan and Venetian circles of the astronomer and the theologian. It does appear possible that Sarpi explained the phenomenon of the ashen light to Galileo in early 1605, when the astronomer was investigating different types of reflection in connection with his observation of the new star, and that Galileo then demonstrated it to "close friends and pupils" at the Medici Court in the summer of 1605; it is equally plausible that Galileo reached his conclusions independently, or with Raffaelo Gualterotti, and then returned from Florence to tell Sarpi what the friar had already known for at least twenty years. More fruitful than this line of inquiry, however, is an examination of their subsequent study of the effect, which must date to 1606 or 1607 and is thus contemporary with Cigoli's *Deposition*. The efforts of Galileo and Sarpi to determine the nature of reflection—research of the sort the astronomer claimed to have conducted with "close friends and pupils"—can be reconstructed from Sarpi's letters to Jacques Leschassier and from the resemblance that these documents bear to several much later passages in Galileo's *Dialogue Concerning the Two Chief World Systems*.

On March 16, 1610, just after the last copies of the *Sidereus Nuncius* had been printed, Sarpi sent the treatise to his friend Leschassier, telling him in a brief letter what he might expect in this important work. He explained first of all that the telescope consisted of two lenses, one concave and the other convex, and he added that though the instrument had been invented two years earlier by a Dutchman, it had been perfected by "one of our mathematicians in Padua." Though he mentioned the telescopic appearance of neither the moon nor the Milky Way, he promised Leschassier that he would soon be able to read about the satellites of Jupiter and certain constellations in the treatise that Sarpi was sending to him.[50] It does not appear that Sarpi himself had yet had time to read the *Sidereus Nuncius*, for the work had only been available for two days, though by March 19, all 550 copies had been sold.[51]

Sarpi's next letter to Leschassier, dated April 27, 1610, was quite different in tone. It began with a dry statement, "About the moon: to tell you the truth, I haven't read what our mathematician wrote. I often discussed the issue with him and we exchanged many opinions. I will reveal to you what I know, speaking only, as is my custom, of those things that I have actually verified."[52] Sarpi's proclaimed ignorance of the contents of the *Sidereus Nuncius* seems to me extraordinarily unlikely: in a city where 550 copies sold in less than a week, surely the first man in Italy to have news of the telescope, the very person who had notified Galileo of the invention and persuaded the Venetian Senate of its military value, and an individual reputed, with some justification, "to read everything of any value that came off the presses" would have found time to examine this

brief treatise.[53] There would be no correspondence between Galileo and Sarpi for almost a year, until February 1611, when a letter from the astronomer to the theologian began, "It is time that I break a rather long silence; though I have neither spoken nor written, I have constantly thought of you, remembering at every moment the virtues and merits of your most Reverend Lordship, since I have an infinite number of debts to you."[54] This silence, too, suggests that some rift had occurred, as does a letter exchanged some six months later between two friends of Sarpi, one of whom asserted both that the theologian was the real *suasor*—that is, adviser—and *auctor et director* behind the invention of the telescope, and even that he regarded the material published in the *Sidereus Nuncius* as puerile foolishness.[55] The subject of their quarrrel was, I believe, the lunar discoveries described both in that treatise and in Sarpi's second letter to Leschassier.

What Sarpi affirmed about the moon can be divided into three parts: in the first and longest section he explained the secondary light, and then he discussed whether the earth's land masses or its oceans were the better reflector, and finally he turned to the question of the moonspots. His treatment of the first issue is a succint version of the meditations recorded so long before in the *Pensieri*. Thus, rather than affirming that the earth, if seen from the moon, would seem to have phases as well, appearing almost full when the lunar globe was newly crescent, and crescent when the moon was just past the full, Sarpi explained the inverse ratio of lighted portions in terms of digits, twelve-part units more commonly used to measure instead the dark part of an eclipsed body: "When two digits of the Moon appear lighted to us, ten digits of the Earth will appear lighted to the Moon, and when the waning Moon looks to the Earth as if ten digits of its surface are illuminated, then the waxing Earth will look to the Moon as if two digits were illuminated."[56]

Though Sarpi acknowledged the terrestrial origin of the moon's ashen light, he did not refer to it as "secondary," despite his earlier use of the term in the *Pensieri*. After describing the larger part of the darkened lunar disk as *subsplendidum* and *sublucidum*, he turned to the next issue, that of the reflective surfaces of land and water. Sarpi had noted more than twenty years earlier that land, not water, provided the more powerful reflection of sunlight. Galileo had suggested much the same in the *Sidereus Nuncius*, though somewhat obliquely, by arguing that "indeed for me there has never been any doubt that when the terrestrial globe, bathed in sunlight, is observed from a distance, the land surface will present itself brighter to the view and the water surface darker."[57] Because he made this observation well before stating that the earth was in its entirety a good reflector of light, and did not return to the point again,

relatively few readers of the treatise—Jacques Leschassier was perhaps among them—would have understood the remark as an implicit comment on the difference between the surfaces of land and water. Though Galileo expressed his views more forcefully in 1614 and again in the *Dialogue Concerning the Two Chief World Systems* by demonstrating that water poured on a pavement would offer only a single point of brilliance amid an otherwise dark surface, in 1610 he may still have had some doubts about the issue.[58]

Sarpi betrayed similar hesitations about the same problem in his second letter to Leschassier. In answer to his correspondent's question about land and water, Sarpi wrote that if he were to observe a large body of water exposed to the sun, he would see a certain part of it shine almost as brilliantly as the sun itself, while all that surrounded that area would be quite dark. If Leschassier were to look at an expanse of land of the same dimensions, Sarpi continued, all of it would appear equally bright: it would not be as luminous, of course, as that part of the water where the sun had been reflected, but it would be considerably less dark than the water surounding the reflected image. Sarpi then proposed an experiment to demonstrate how this general principle might apply to the question of the moon's secondary light.

> If you place a stone ball and a spherical mirror of the same size in the Sun and at some distance from you, you will see that the hemisphere of the stone ball is bright, while the mirror, by contrast, will be completely dark, apart from the minute area in which you will observe the tiny image of the reflected Sun. If you were to move further away, such that the visual angle was extremely small, you would barely be able to see the mirror, but the reflected Sun would appear very brilliant indeed. [The Earth's] oceans and land masses form a sphere, and the Moon has a bright part and a spotted part; apply these principles to the problem, and you will see the point.[59]

Sarpi's discussion resembles Galileo's in that they both represent the land masses of the earth and the moon as bright, and the seas of those bodies as dark. But the experiment described and so summarily terminated by Sarpi is curious because it implies that both the earth and the moon, if seen from a great distance, would each have one small and very bright area in which the sun would be reflected. This luster, in other words, would not be unlike that described by Leonardo da Vinci in "those gilt balls placed on the tops of high buildings," and rejected by him for its poor resemblance to the moon. Sarpi's awareness of the shortcomings of his explanation may account for the singularly abrupt and yet inconclusive manner in which he finished the argument.

But the most interesting feature of this rapidly sketched experiment is its great resemblance to those that would be published by Galileo some twenty-two years later in the First Day of the *Dialogue Concerning the Two Chief World Systems*. There the three speakers Salviati, Sagredo, and Simplicio discussed the nature and surface of the moon, later using what they concluded about the lunar body's ability to reflect light as an argument for the earth's ability to do the same. They first compared the reflections thrown off by a rough earth wall and a flat mirror, and observed that the former illuminated the entirety of the surface opposite it, and the latter only that small portion where its bright reflection fell. They then examined the reflection cast by a spherical mirror, and decided that only a minute area of its surface would appear illuminated to the observer, the rest remaining entirely dark. Given the great distance between the earth and the moon, Sagredo explained, "the whole moon would be invisible, [were it a spherical mirror], since that particle which gave the reflection would be lost by reason of its smallness and great distance."[60]

This last observation would have served Sarpi well in the analogous explanation offered by him to Leschassier in the letter of 1610, but what is of greater significance is the similarity of the experiments. It seems clear that Sarpi and Galileo were both describing the same incident, and that what Galileo offered in 1632 was a more elaborate and convincing account of experiments performed long before, and almost certainly around 1606–1607, since Sarpi had some trouble recalling them in 1610. Galileo, on the other hand, had recorded his findings, presumably in the prototype of the *Dialogue Concerning the Two Chief World Systems*, the now lost *De sistemate mundi*, modifying them to some extent before publishing them in 1632.

And there is much about this First Day of the *Dialogue* that evokes Galileo's early friendship with Paolo Sarpi, who died in January 1623. The three days of conversation between Filippo Salviati, Giovanni Francesco Sagredo, and the Aristotelian Simplicio take place in Venice, the city where Galileo and Sarpi spent most of their time together, and the villa in which the speakers carry out their experiments in the Palazzo Sagredo on the Canal Grande, a building which was very close to the Servite convent in which Sarpi lived, and a house frequented by him. Yet the actual experiments with mirrors, if they were performed in 1606–1607, were probably conducted in the nearby Palazzo Morosini, where Galileo and Sarpi often met, and they may not have involved Sagredo, who was in Palma for some of this period.[61] Though the Florentine Salviati had important ties to the most prominent families of Venice, there is no particular record of his participation in research of this sort.[62] In brief, the invisible Sarpi, the missing member of alliteratively named

triumvirate of absent friends, would have been first among those whom Galileo recalled when he converted this part of the *De sistemate mundi* into the *Dialogue Concerning the Two Chief World Systems*.

This is not to require that the *Dialogue* be a faithful record to actual events: it was, after all, a blend of a lifetime of scientific activity and discussions, and something of a memorial to many disciples now dead. And the deliberate exclusion of Paolo Sarpi from a *Dialogue* concerned with motion and tides, as well as experiments concerning reflected light, was surely justified on political rather than personal grounds. Galileo had been encouraged to write the *Dialogue* in the spring of 1624 by Pope Urban VIII, who believed that a fair and detailed comparison of the two chief world systems, approved by Church censors, would show Catholic and Protestant audiences alike that the Edict of 1616 did not hinder the practice of science in Catholic countries.[63] It would hardly do to have the flaws of the officially sanctioned Ptolemaic system exposed by the late Paolo Sarpi, known not so much as a scientist but as a tireless critic of the papacy.

And yet the suppressed presence of Sarpi in the *Dialogue* may serve to explain a curious aspect of the various mirror experiments. When Salviati and Sagredo discuss the nature of reflection with Simplicio, they rely on an invisible fourth person, someone who moves about flat and spherical mirrors in such a way to convince, or perhaps merely confuse, their benighted Aristotelian companion. This section of the *Dialogue* has an odd stagelike quality, an awkwardness that can be attributed only in part to the number of props and amount of motion and unseen observation that the experiments require. The intrusive nature of the references to the efforts of this fourth person, surprising in a writer of Galileo's skill, signals the presence of someone who knew exactly when and where to place and to remove the spherical mirror in the course of the demonstrations, and who understood as much as either Salviati or Sagredo about the reflections that would be cast by it. Such an individual can only be Paolo Sarpi, who had begun considering such matters fifty years earlier and who was present in 1606 and 1607 when Galileo first undertook his own study of the phenomenon.

I return, then, to Sarpi's letter to Leschassier, the third and last part of which concerns the traditional question of the moonspots. An eighteenth-century biographer of Sarpi, Francesco Griselini, affirmed that he had seen among the theologian's papers in the Servite Library various drawings of the moonspots, which he took to be observations made with the aid of a telescope.[64] Given that only the largest spots were indicated in the drawings, and that these are visible to the naked eye and had been observed by Galileo, among others, before the invention of the telescope,

I believe that it may be a question of drawings that Sarpi made prior to 1610, without the help of the optical instrument. In regard to the telescopic appearance of the large spots that had always been observed on the lunar surface and which composed its "face," Sarpi expressed the same lofty indifference to Galileo's treatise. Like Galileo, he stated that he had no real interest in them; his true concern was the immense number of lunar mountains and valleys lately revealed by the telescope.

> I turn now to your other question. I do not know whether the Mathematician explained himself clearly, but I will tell you how the matter stands. I will pronounce nothing about those spots that you see on the Moon: they appear through the telescope just as they do to the naked eye. But I will say that in the bright part of the Moon there are valleys and peaks. If you were to say that those things that look like cavities to me are really rarer parts of the Moon, and the apparent peaks its denser parts, I will prove to you that this is not so.
>
> A body's solidity, as you know well from optics, can only be perceived because of lights and shadows, and thus paintings imitate solidity through lights and shadows. I can make anything appear solid, as if it were three-dimensional, through lights and shadows altered in color [*luminibus, & umbris per colores variatis*]. I say now that the light and shadow of those parts prove that there are peaks and valleys.[65]

Sarpi went on to show, as Galileo had done in the *Sidereus Nuncius*, that if a crater were illuminated by the rising sun, its farther or westernmost wall would be illuminated first, then all of the crater as the sun passed overhead, and then its easternmost surface as the sun set. But what is puzzling in Sarpi's account is the relationship of the crater example to his comments on painting, and specifically his reference to "lights and shadows altered in color." It is possible that his explanation is a garbled version of that offered by Leon Battista Alberti in the *De pictura*, for there, too, we find a description of a concave surface illuminated first on one side and then on the other, and that remark was followed by the observation that "colors take their variations from light, because all colors put in the shade appear different from what they are in the light. Shade makes a color dark; light, where it strikes, makes color bright [i.e., it will tend more towards white]."[66] Comparison with Alberti's text does not explain, however, why Sarpi turned to the practice of painting to prove to Leschassier that the moon's surface was covered with peaks and valleys. In what follows I will try to show what is curious about the reference, and then give Sarpi's reasons for including it in his demonstration.

First of all, allusions to painting are quite rare both in his works and in his letters; only occasionally in the *Istoria del Concilio Tridentino*, for in-

stance, did Sarpi mention visual arts, and then merely as it related to the development of a doctrinal issue or to the question of the worship of images. Unlike Galileo, he displayed no interest in portraiture, and according to his biographers, had a particular horror of having his likeness made.[67] His distaste for all visual imagery in religious matters was so pronounced, in fact, that at least one of his many enemies within the Church associated it with his alleged Calvinist sympathies.[68] His letters of 1610 contained two descriptions of paintings, but it was not their artistic quality that interested him, but rather their strategic role in the ongoing battles between different clerical orders: "Your Excellency will have heard," he wrote to a friend about the arrest and Inquisitorial examination of a Franciscan friar, "that because they found on him a reliquary fashioned in the form of a cross, and with a picture of a beautiful saint in the middle of it, they maintain that it's the portrait of some mistress of his in Venice."[69] There was also the painting commissioned by the villainous Jesuits before their expulsion from the city in May 1606:

> In a certain room in their former house in this city, they had Hell painted, complete with every sort of fiery torment, such as frying pans and roasting spits and so forth, and with the poor souls who were being tortured there. The Jesuits would bring their faithful to this room in order to render them yet more subject to them, and they would show them the poor souls, and would name them whatever would most terrorize each individual, saying, "This is so-and-so, and over there is so-and-so," for which reason a popular saying grew up among us, "The Jesuits will paint you in the Devil's House."[70]

But for a man who frequented artistic circles and who lived among the splendors of Giorgione and Titian,[71] there is a surprising inattention to painting, and his reference to that art in the course of a discussion of the moon is an unexpected one. More importantly, it does nothing to advance his argument for the rough and mountainous moon, for it was those who believed that the lunar body was smooth and composed of unevenly illuminated rare and dense material, who normally advanced the comparison with painting. Drawing on a Plutarchan commonplace, and embellishing it with an observation made in a sixteenth-century Venetian treatise, they maintained that the mottled surface of the moon was an optical illusion just like that effected by painters on walls and canvases, where light and shadow were combined to create the impression of depth.[72] The argument that Sarpi cited to prove to Leschassier that the moon was *not* smooth, in other words, was precisely the one traditionally used to far greater effect by proponents of the polished lunar body.

The phrase *luminibus, & umbris per colores variatis,* "through lights and shadows altered in color," while it makes little sense in the context of the moon's peaks and valleys, does recall both Rafaello Gualterotti's use of the Vasarian term *abbagliata,* or muted in color, in his description of the ashen light, and Galileo's criticism of the bright colors and excessively dark shadows in the Ptolemaic world picture in the *Considerations of Alimberto Mauri.* The expression itself, while close to that used by Alberti to discuss the manner in which depth is perceived by the eye and counterfeited by the painter, also seems a shorthand version of the kind of process Vasari described in his analysis of *quattrocento* painting, where the best artists chose to "mute the colors, softening in the appropriate places the lights and the shadows of the figures."

I do not mean by this either that Sarpi knew or was referring to Vasari's work. It seems much more likely that he was recalling a phrase typical of those painterly discussions of the secondary light—and *luminibus, & umbris per colores variatis* is just such an expression—but had forgotten that the context in which it was used was that of the secondary light, not that of the moonspots, and that the issue involved reflection, not the perception of depth. Given that he, like Michael Maestlin, had long before understood the cause of the secondary light in a manner that was independent of painters' use of the same term (though not in conflict with it), and considering his scant interest in the practice of painting, it is not surprising that Sarpi had but a vague and imperfect memory of the analogies that others had seen between the lunar and artistic effects, and of the efforts that they had made to use terms and phrases favored by Vasari and Dolce in describing the ashen light.

The three parts of Sarpi's letter to Leschassier suggest that the theologian was recalling conversations he had had with Galileo about the moon a few years earlier, and experiments that they had conducted together, presumably around 1606 or 1607. Sarpi's cool tone and the apparent rift between the two men imply that the theologian felt that his role in Galileo's observations had gone unrecognized. This charge was repeated, albeit somewhat obscurely, by Sarpi's biographers in the seventeenth and eighteenth centuries, who credited him with a number of inventions and discoveries, who regretted his unwillingness to publish his scientific work and the scant regard he had for his *Pensieri,* and one of whom went so far as to claim that the letter to Leschassier was superior to the *Sidereus Nuncius.*[73] Whether we take their side in this matter is of little importance—though it does seem that the friendship faltered briefly over this issue—because the real significance of the letters to Leschassier is that Sarpi, like Lodovico Cigoli, was among the men with whom Galileo discussed the secondary light and someone who heard about (and then forgot) the artistic conventions with which that effect was compared.

Galileo's Lost Treatise on Sight and Colors

There are two additional clues in this section of the *Dialogue* that support my conjectures about Galileo's repeated association of the artistic with the astronomical in the context of reflection, and they suggest that such correlations were made in the period just prior to the invention of the telescope. When Salviati and Sagredo attempted to convince Simplicio that the scattered and diffuse reflection caused by a rough wall would better illuminate a surface opposite it than would the single bright reflection cast by a flat mirror, they showed him both the wall and the mirror from across a courtyard, and obliged him to confess that the latter was, from his vantage point, far darker. They did so, as one might expect, as if engaged in a discussion about painting:

> SALVIATI: Now, there you see two surfaces struck by the sun, the wall and the mirror. Which looks brighter to you, the wall or the mirror? What, no answer?
>
> SAGREDO: I am going to let Simplicio answer; he is the one who is experiencing the difficulty. For my part, from this small beginning of an experiment I am persuaded that the moon must indeed have a very badly polished surface.
>
> SALVIATI: Tell me, Simplicio, if you had to paint a picture of that wall with the mirror hanging on it, where would you use the darkest colors? In depicting the wall or the mirror?
>
> SIMPLICIO: Much darker in depicting the mirror.[74]

Later, after discussing the spherical mirror, Salviati turned to other types of reflection, and he explained why a burnished surface appeared darker and cast clearer images than an unburnished one. Burnishing removed superficial inequalities from the metal, he explained, and so light striking the surface would not be scattered in all directions, as would happen on unpolished metal, but would rather be sent to one place. A viewer would see one small and lustrous area, while the surrounding surface would appear to him quite dark. Here again Salviati explained the problem of reflection to his companions as if they were painters rather than natural philosophers, telling them to "note that the diversity of what is seen upon looking at a burnished surface causes such a different appearance that to imitate or depict burnished armor, for example, one must combine pure black and white, one besides the other, in parts of the arms where light falls equally."[75] The discussion of how armor should be painted is a commonplace in artists' manuals of the period,[76] though the precise physical explanation of why black and white were so effective in representing a silver surface is not. The crucial point in both of Salviati's

remarks is their possible relevance to Galileo's lost treatise on vision and colors, mentioned by the astronomer in a letter of May 1610 and otherwise unknown to us.[77] In what follows I will suggest what might have been the content of the *De visu et coloribus*, the circumstances of its composition, and the bearing it would have on the question of the secondary light.

Salviati's two references to painting precede several conjectures about the perception of light and dark that are clearly drawn from Leonardo da Vinci's *Trattato della pittura*, where the stock allusion to the rendering of silver armor in black and white pigment is also to be found. Salviati's affirmation that "the sun, looking at the earth or moon or any other opaque body, never *sees* any of its shady parts, *having no other eyes to see with than its light-bearing rays*"[78] has a surprisingly inelegant and anthropomorphic ring—for it is generally Sagredo, affable and breezily intelligent, who tends toward this sort of bonhomie—but one which is nonetheless a clear echo of an observation repeated several times over in the *Trattato della pittura*. "No luminous body ever *sees* the shadow caused by it," Leonardo explained, and added elsewhere, "as soon as a shadow is ever *seen* by the luminous body, it immediately destroys it." "When you look at things along the same line on which the sun *sees* them," he wrote, "that place will seem to you without shadow," and again, "if the sun is in the east and you look towards the west, everything illuminated by it will be entirely without shadow because you see what the sun *sees*."[79]

In other instances in this section of the *Dialogue*, Salviati's idiom is less that of the *omo sanza lettere* and more his own, but the observations themselves come from the *Trattato della pittura*. When he points out, for example, that "every bright body looks brighter when the surroundings are darker,"[80] he repeats Leonardo's assertion that "a white body will appear still whiter when it is in a dark field,"[81] and when refining this statement and demonstrating its particular application to the moon, he turns once again to Leonardo's work. Showing that it is only an optical illusion that makes the far edge of the lunar body look brighter than the middle part when the entire disk is covered with the ashen light, he notes that "on the side toward the sun, the light is bounded by the bright horn of the moon; on the other side, it has for its boundary the field of the twilight, in relation to which it appears lighter than the whiteness of the lunar disk,"[82] which is an elaboration of Leonardo's statement that "if the boundary of a white body . . . is placed in a dark field, this boundary will appear to be the whitest part of the luminous body."[83]

Finally, Salviati's conjecture about what it is that causes the dark spots in the moon is at once a revision of Leonardo's apparent belief that such

spots were land masses rather than water, and an adaptation of an extraordinarily detailed argument—scattered throughout the *Trattato*, and then later developed in a single section[84]—about precisely which trees cast the most shade on mountain tops, in what season, and why:

> I say then [Salviati began], that if there were in nature only one way for two surfaces to be illuminated by the sun so that one appears lighter than the other, and that this were by having one made of land and the other of water, it would be necessary to say that the moon's surface was partly terrene and partly aqueous. But because there are more ways known to us that could produce the same effect, and perhaps others that we do not know of, I shall not make bold to affirm one rather than another to exist on the moon.
>
> . . . On the ridges of mountains the wooded parts look much gloomier than the open and barren places because the plants cast a great deal of shadow while the clearings are lighted by the sun. . . . So if on the moon there were things resembling dense forests, their aspect would probably be like that of the spots we see.[85]

In brief, then, we can state that Galileo was quite familiar with the principles expressed by Leonardo in the *Trattato della pittura*, and that he was able to apply them to the perception of light and color in general, and occasionally to particular lunar phenomena as well. The relatively fluid structure of the *Dialogue Concerning the Two Chief World Systems*, and above all that of its First Day, with its copious examples and wealth of experiments, its leisurely pace and frequent detours, easily accommodates such allusions, but it is harder to imagine how some of the arguments, especially those that do not pertain strictly to the moon, might have fit into the narrower focus of the prototype of the *Dialogue Concerning the Two Chief World Systems*, the *De sistemate mundi*. Put bluntly, it is in large part because the 1632 work is a dialogue, rather than a straightforward exposition of astronomical problems—or because Simplicio is so thoroughly benighted, and Sagredo such a pleasant dilettante—that Salviati can offer his companions insights about how to paint mirrors and armor, about what it is that the sun "sees," and why mountainside forests appear so dark and gloomy. For this reason, I do not believe that all or even most of the conjectures drawn from Leonardo's *Trattato* figured in the *De sistemate mundi*, but rather that Galileo added them when working on the *Dialogue*, and that they came from a single source, which I take to be his lost treatise on sight and colors.

This process of revision, which involved combining material from the *De visu et coloribus* with that of the *De sistemate mundi* in the First Day

of the *Dialogue*, would necessarily have taken place between 1624, when Galileo conferred with Pope Urban VIII, and early 1630, when the work was completed. There is one clue that suggests that these changes were made around 1627 or 1628. In those years Galileo composed scathing annotations to a work by his old enemy, Orazio Grassi, S.J., the *Ratio Ponderum Librae et Simbellae*, an obscure endpoint to a quarrel about three comets that had come and gone almost a decade earlier. In one of these rambling marginal notes, which Galileo's friends had the wisdom not to see into print, the astronomer turned to an artistic observation to correct the work of his rival:

> If [Grassi] had used not just the eyes in his head, but those in his mind as well—as he says of me—to observe that when painters want to depict landscapes, the more and more distant they make the mountains, the more they make them like the color of the atmosphere, such that the most remote ones can hardly be distinguished from the medium, then he would have seen how the diaphanous medium progressively dyes the objects placed in it with its color, and so distant mountains appear blue and somewhat paler, though in reality they are just as dark as those that are nearer to us, and he would have understood that the blue of the sky is nothing other than the color of the vaporous medium, and so forth.[86]

Galileo's objection was not really to the point, which is precisely why it is more to our point, for it suggests that he was then looking over material drawn from Leonardo's *Trattato*, where the subject of the distant blue mountains is examined no less than thirteen times,[87] and that his preoccupation with the *De visu et coloribus*, rather than the logical demands of the argument, prompted this response. The formal structure of his annotation also resembles those artistic remarks made by Salviati in the First Day of the *Dialogue*, for in these instances he suggested that looking at a good painting—of a mirror struck by the sun, or of armor, or of distant mountains—would provide the best physical explanations of natural phenomena. (It is this same impulse, incidentally, that leads Paolo Sarpi to tell Jacques Leschassier to examine relief in a painting in order to understand craters on the moon.) The general precept comes from the *Trattato*, for there Leonardo urged young artists first to study perspective, then proportion, then the details in the work of some master painter, and finally nature itself in order to confirm through practice the principles of what he had learned.[88]

Thus far, then, I have suggested that Galileo's *De visu et coloribus* may have been a response to Leonardo's *Trattato*, and that while it had some relevance to astronomical matters, they were not the chief or sole concern of the work. Given the tenor of the observations that I have examined

thus far, the work might have been conceived, like Leonardo's *Trattato*, as a kind of guide for painters, one in which more and less traditional precepts about perspective, coloring, and composition were followed with rigorous physical explanations. Such aims would have been in keeping with the account offered by Vincenzo Viviani, Galileo's first biographer and the eventual owner of one of the best manuscripts of Leonardo's *Trattato*, who wrote that

> [Galileo] undertook drawing with great pleasure and admirable profit, and he showed such talent and skill that he himself used to tell his friends that if it had been in his power as a young man to choose his profession, he would surely have decided to become a painter. And in truth his inclination for drawing was so strong and natural, and his aesthetic sense became in time so exquisite, that the advice that he gave about paintings and drawings was preferred over the pronouncements of the greatest masters, even by the masters themselves, as for example Cigoli, [Cristofano Allori, known as "il] Bronzino," [Domenico Cresti, from] Passignano, and [Jacopo Chimenti] dall'Empoli, and other celebrated painters of his day, intimate friends of his, who very often asked his opinion about the presentation of the *istorie*, about the disposition of the figures, about various matters in perspective, in coloring, and in every other aspect that contributed to a perfect painting, recognizing in Galileo such flawless taste and such divine grace in this noble art that no one else, not even the greatest master, would be able to impart to them. Therefore the famous Cigoli, considered by Galileo to be the best painter of the age, attributed most of his success to the excellent instruction of Galileo himself, and he was particularly proud that he could say that in matters of perspective, Galileo alone had been his teacher.[89]

It seems feasible, then, that at least some of the instruction that Galileo gave to painters—a practice also described in the account of Filippo Baldinucci[90]—would have found its way into the treatise on sight and colors. As for the date of its composition, we know it to have been before 1610, when Galileo mentioned it and other manuscripts in a bid for employment at the Medici Court. How long before 1610 Galileo began working on the treatise is not clear to me, but it is certain that the *De visu et coloribus* would have had some relation to his contemporaneous investigations of the secondary light.

There were several individuals in Florence and Padua who could have introduced Galileo to Leonardo's *Trattato della pittura*. At least four copies of the treatise were to be found in Florence by 1590, and Cigoli may have been familiar with the work in the 1580s, when his fellow artist Gregorio Pagani was charged with illustrating it.[91] From 1585 there were

at least two copies in Padua as well, one of which was owned by Galileo's first friend and host in that city, Giovanni Vincenzo Pinelli, who was also interested in the question of colors and possessed a heavily annotated and prized volume called *De coloribus*.[92] In brief, then, it seems safe to say that Galileo would have had access to the *Trattato* early in his career, that he was well acquainted with those who valued the work in both Tuscany and the Veneto, that he would have had opportunity to discuss its merits and defects long before 1610, and that it may have seemed to him most useful and pertinent when he turned to questions about reflected light and color from 1605 forward.

Borrowed Light

In the *Sidereus Nuncius* Galileo introduced the ashen light as a "tenuous," "uncertain," and "faint" glow, and only midway through his discussion named it, writing "this secondary brightness, as I might call it."[93] Neither in this exposition of the issue nor in those that followed in 1613, 1632, and 1640 did Galileo insist upon the usefulness of the term to painters or to students of perspective, though his *ut ita dicam*, "as I might call it," like the expressions "if you will" and "so to speak," does suggest that both the astronomer and his audience recognized that the expression was borrowed from another context. Such an explanation did occur, however, in *Lo Inganno de gl'occhi, prospettiva prattica di Pietro Accolti, gentilhuomo fiorentino*, published in Florence in 1625. Accolti, secretary to Giovanni de' Medici, and an authority on perspective, is now believed to have borrowed somewhat too freely from two unpublished manuscripts, Leonardo's *Trattato della pittura* and Cigoli's *Prospettiva pratica*.[94] Whether we classify his work as merely highly derivative or as a thoroughgoing bit of plagiarism, Accolti's treatise does present, like theirs, an unusually sophisticated study of shadows and reflection, a subject rarely developed in such detail in manuals of this sort. There is but one reference to Accolti in Galileo's correspondence: it is made by Cigoli in a letter written to Galileo in 1611, and indicates merely that the artist knew Accolti and hoped to obtain information from him about Galileo's conflict with Lodovico delle Colombe over floating bodies.[95] Plagiarism, if it occurred, would presumably have taken place after Cigoli's death in 1613.

Accolti's first allusion to the secondary light involves the traditional opposition of primary light, which comes into an otherwise dark room through a window, to the reflection given off by those rays to the surface of nearby objects. The subsequent discussion of the phenomenon is,

however, more noteworthy, for here Accolti emphasized both the origin of the term "secondary light" and the resemblance of the lunar version of the effect to the more familiar terrestrial one:

At the same time we see that the area contained by the radiant circle [of the horns] is illuminated by a faint light, which cannot be said to come at that moment from the sun, for we believe that this light—*which men of science, borrowing a term from perspective, have named the "secondary light"*—comes to the moon from that part of the terrestrial globe that lies directly across from her. For this reason, since our globe is struck by primary light from the sun, it then reflects the secondary light onto the moon. It looks in fact like secondary light to our eyes, and [the theory] is confirmed by the fact that this faint glow is gradually diminished as the moon loses sight of the lighted hemisphere of the earth and [therefore] of the almost perpendicular reflection of the solar rays, as happens little by little as the moon moves ever farther away from conjunction with the sun.

Therefore if such an appearance were really caused by the penetration and actual entry of the solar rays into the lunar body—as some scientists, believing the moon to be not entirely opaque, have said—then we would be able to see such a light even at quadrature, which is not the case.[96]

Accolti's reference to the moon's motion away from the point in its orbit where it might be illuminated by reflected light recalls Raffaelo Gualterotti's discussion in the *Scherzi degli spiriti animali*. So, too, does his allusion to the alternative explanation of the secondary light, where the effect was attributed to a semi-diaphanous moon flooded with solar rays, for this theory was rejected in 1605 by Gualterotti and again in 1610 by Galileo in the *Sidereus Nuncius*. While Accolti's treatise evinces a general familiarity and sympathy with the scientific and artistic milieu in which Galileo lived,[97] at no point does *Lo Inganno de gl'occhi* mention the astronomer by name or return to other cosmological issues. This may be part of a studied unwillingness to give credit to Galileo. In his eulogy of Grand Duke Cosimo II de' Medici, Accolti described the renaissance in Florentine learning that had taken place during the dozen years of this ruler's reign; in passing, he alluded to those "Recent Ptolemies" who had discovered new lights in the firmament, at once suggesting that Galileo was but one of a great many noteworthy Tuscan astronomers and, worse still, portraying him in terms of the very thinker whose cosmological system the Pisan had long labored to overthrow.[98]

The sole reference to the contribution of students of perspective to the efforts of the astronomer in *Lo Inganno de gl'occhi* does, however, suggest much about the views of the artist who was closest to Galileo, Lodovico Cigoli. It is first to Cigoli's treatise, and then to the remarkable

Deposition of 1607, that I will now turn. I will show that Galileo viewed the secondary light as evidence of a Copernican universe before the invention of the telescope, and even more significantly, that at least one member of this early audience of "close friends and pupils" saw the astronomical argument not only as entirely compatible with religious faith, but as inseparable from it.

Sins of Omission

Lodovico Cigoli's *Prospettiva pratica*, routinely cited as one of the best early modern treatises on perspective, is at last being prepared for publication, some 380 years after its composition.[99] Cigoli himself planned on publishing the work, for the prime manuscript, now located in the Florentine *Gabinetto dei Disegni* and hereafter known as Uffizi 2660A, includes a certain number of printed (woodcut) illustrations made by the artist's brother Sebastiano to accompany the text.[100] In January 1629, sixteen years after Lodovico Cigoli's sudden death in Rome, his nephew Giovanni Battista Cardi took up the project of publishing the work. He added to the treatise—which is *not* in Cigoli's hand—a detailed *Vita* describing his uncle's artistic education, character, and greatest paintings, and then requested permission from the inquisitor general of Florence, Fra Clemente Egidi, to print both the biography and the *Prospettiva pratica*. Such permission was granted, but the project never came to fruition. The treatise and its attached *Vita* became part of the library of Cardinal Francesco Maria de' Medici (1660–1711), and in 1676 it was transcribed for Vincenzo Viviani, Galileo's first biographer and one of the leaders of that next generation of Tuscan scientists. In 1681 Filippo Baldinucci again praised the treatise and expressed some impatience over the long delays in its publication: "And I will not pass over in silence the fact that this work has been supposed to go to press since 1628."[101]

Nothing is known of the whereabouts of the autograph version of the *Prospettiva pratica*, but Cardi's version, Uffizi 2660A, presents a number of interesting characteristics. To begin with, there is no mention in the *Vita* of the close friendship of Cigoli and Galileo, and no indication that the artist had even the slightest interest in astronomy. That the two men were devoted to each other was, however, quite well known: in 1611, for instance, Galileo attached such flattering post scripta to his letters that Cigoli felt obliged to warn him that other friends, in reading them, would become envious.[102] In 1613 Galileo twice praised Cigoli's aesthetic judgments and his abilities as a painter, architect, and astronomical observer in his *Istoria e dimostrazioni intorno alle macchie solari*.[103] Cigoli, in his turn, discussed and defended his friend's celestial hypotheses. He wrote

to him frequently from Rome with sunspot observations, news of his rivals in the Eternal City, and brief reports of his progress in the cupola of Santa Maria Maggiore. He painted a much-admired portrait of Galileo, perhaps from memory, but as a letter of 1609 indicates, preferred to keep the image for himself rather than give it to the subject.[104] In the last years of his life he often professed to desire nothing so much as to return to Florence and enjoy the company of Galileo. Most significantly, Cigoli incorporated the astronomer's arguments into at least four of his paintings, the two *Adorations of the Shepherds*, the *Deposition*, and the *Immacolata*. Given the importance of the friendship, the convention of commemorating such relationships in biographies of the day, and the fact that Galileo was the most illustrious citizen of Florence, if not of all Italy, this omission in the *Vita* is striking.

It has been plausibly suggested that Cardi, who had many of his late uncle's belongings, was responsible for the fact that so little of Galileo's correspondence with Cigoli survives.[105] For the period from 1610 to 1613 there are twenty-nine letters from Cigoli to Galileo, and only two from the astronomer to the artist, despite frequent references to a more equitable exchange of missives between the two men.

Cardi's suppression of all mention of the friendship between his uncle and the astronomer in the *Vita* is complemented by certain material features of Uffizi 2660A itself. This prime manuscript is composed of 103 folio sheets, most of which have either text or illustrations on both sides. Folios 1 through 5 contain the *Vita*; the first of the three proemia of the *Prospettiva prattica* begins on folio 6.[106] Throughout the treatise there are sections of the folio sheets that have been covered with patchlike additions: these contain modifications of the text or the drawings, made in the same hand and pasted over the original material. At times such additions involve only a word or two, and elsewhere an entire paragraph. Because the ink used for the text and for some of the drawings tended to bleed through to the other side of the page, the patches often serve no other purpose than to provide a cleaner surface for new material.

The manuscript also contains many additions and suppressions made without these patches: the relevant material is simply added to the margins or above an existing line of text, while intended deletions are scribbled over. The presence of both sorts of modifications suggests that Cigoli had his work copied, and that that copy, Uffizi 2660A, was successively altered by the same hand as Cigoli polished his treatise, promising, perhaps, that each change would really be the last.

Two of the 103 folio sheets of Uffizi 2660A have been altered in an unusual manner. The original folios 12 and 14 were excised, such that the only part that remains of them is the margin, to which then sheets half as long as all the other pages in the manuscript have been added. The

page numbers at the top of these two folio sheets are clear and legibile, whereas those for the rest of the treatise have all been altered at least once, which suggests that this excision was made rather late in the process of preparing the work for publication, after at least one attempt at pagination had already been made.

The nature of the excised material on *luce*, a light source, and *lume*, its diffusion, is particularly interesting. Folio 11 verso contains a section entitled *Del lume*, the original title of which was *Del lume e qual sia la luce*, [*Of "lume" and what "luce" may be*,] the latter phrase being clearly visible through its patch of blank paper. The last sentence of the section prior to this title ends, moreover, with the same words, *perció diremo qual sia il lume, e la luce* ["therefore we will now relate what *lume* and *luce* may be"]. In the brief discussion at the very bottom of folio 11 verso, Cigoli stated that *lume* was neither corporeal nor spiritual in nature, nor a substantial form of *luce*, but rather an active quality of a celestial body, such that if this quality occurred in a diaphanous medium it would be called *lume*, while if it struck a lucid body, this rectilinear segment would be considered a ray, and if it changed form again through reflection, then it was *splendor*.[107]

The argument would seem to be leading toward a meditation on the secondary light, and almost certainly one involving its manifestation in an astronomical context, but at the top of the altered folio 12 recto we find ourselves in the midst of an entirely unrelated discussion entitled *Dell'oggetto visibile*. This suggests that the original top half of folio 12 was cut off, and that the bottom half of the page was simply moved upward and glued to the left margin. The promised explanation of *qual sia la luce* is not offered, nor does it appear elsewhere in the treatise. Two words remain visible, however, about five or six lines down and to the far left, in the original margin of folio 12: *tutto tenebros[o]*. Their position indicates that they were added, probably in a brief appositive phrase modifying a masculine noun, to the body of the excised discussion.

Though I realize that it would be difficult to prove (or disprove) any conjectures about the precise wording of a long-lost text, I assume that a censored explanation devoted to light, following a reference to reflection, written by one of Galileo's closest associates, and by someone who had already painted the ashen moon at least once, would have involved the astronomical version of the secondary light, and that the description involved the appearance of the lunar body when struck by solar rays reflected off the earth. Pursuing this line of speculation, I would argue that the two words *tutto tenebroso* were not part of the original text but were added to the left margin by Cigoli; given their position, they must have followed several others that would have been in the far right margin of the preceding line. The entire phrase would then have been copied by

Cigoli's scribe and added to the margins of Uffizi 2660A. It seems likely, moreover, that this addendum complemented or refined the artist's discussion of the reflection that fell upon the lunar body, and that the original statement would have made sense without the interpolated phrase. Moreover, since Cigoli preferred the masculine substantive *globo lunare* to the feminine *luna*, it seems likely that this was the noun that *tutto tenebroso* was meant to modify.[108] Finally, then, I would imagine that a sentence having all these characteristics might say something to this effect: "Circa il quarto giorno dopo la congiunzione, il globo lunare *non è tutto tenebroso* ma cosparso di un lume tenue o secondario." (Around the fourth day after conjunction, the lunar globe is not entirely dark but rather covered with a pale or secondary light.)

It is very likely that Cigoli mentioned Galileo's work in the course of this argument, and it is possible that the entire discussion was excised by Cardi around 1628–1629 because it explicitly supported the theory of a mobile earth, condemned in 1616 by a Decree of the Index. More trivially, the passage may have contained scathing references to explanations of the sort advanced by Galileo's rivals, most notably that of the stony blue and white moon, elements of which are evident in Lodovico delle Colombe's later lunar theory. The second excision, made on folio 14, occurs in the middle of an explanation of the structure of the eye. While the precise nature of the excised material is, once again, difficult to determine, it may be that Cigoli's consideration of the crystalline substance of the eye contained a second, and somewhat more oblique, reference to a Galilean conflict, that of the crystalline or heavenly spectacles ridiculed by "Alimberto Mauri" in his *Considerations* of 1606.

Lodovico delle Colombe had suggested, it will be recalled, that the crystalline heaven contained slight variations in density, and that parts of it would occasionally magnify the stars that lay beyond them, revealing already present phenomena, such as the so-called new star of 1604, for what seemed to be the first time. In the years in which Colombe concocted this theory, the crystalline substance of the eye, traditionally considered the seat of vision, was said by some—notably Felix Platter in 1583 and Johannes Kepler in 1604—to be no more than a lens that magnified images before they passed to the retina.[109] It seems to me unlikely that Colombe knew of such theories, and it may be that Cigoli was entirely ignorant of them as well, since he referred to the crystalline humor as the *strumento proprio del vedere*, "true instrument of sight."[110] What does appear plausible is that in this excised section of his treatise Cigoli made some reference to the absurdity of Colombe's understanding of the lens-like nature of the crystalline sphere, whether or not his own explanation of the crystalline substance of the eye ever conformed to the recent conclusions of Platter and Kepler.[111]

Cigoli's letters to Galileo from 1611 to 1613 indicate that the artist thoroughly disliked Colombe, to whom he often referred as "Pippione," a regional name for both a credulous person and a baby pigeon, roughly, "Pigeon Little."[112] Because Colombe and Galileo had several later conflicts on subjects ranging from floating objects to the nature of the moon's substance to the arrangement of the entire cosmos, and because a faction of anti-Galilean scholars in Tuscany headed by Colombe kept these controversies alive for years after their leader's death, it stands to reason that Cardi would have wanted to remove all traces of the original debate from his uncle's manuscript.[113]

To my knowledge, there is only one direct reference to the moon in the extant part of the manuscript, and it concerns what cannot, rather than what can, be observed in the lunar body. Given what we know of Galileo's activities in the years before the invention of the telescope, it may, however, be of some significance: "In the terrestrial globe, we can see clearly even the leaves on the trees, and other details, but we cannot tell that the earth is spherical in shape. By contrast, because of its enormous distance, we can see that the lunar globe is a sphere, but its features remain indistinct and vague to us."[114] There are several reasons why this remark has a Galilean echo. Cigoli's emphasis on the "leaves on the trees"—*le fronde degli alberi*—recalls that favorite passage in a poem which the artist knew well, and the astronomer, apparently, by heart: Astolfo's journey to the moon in Lodovico Ariosto's *Orlando Furioso*, where the traveler is told,

> You must believe, my son, no frond is stirred
> On earth that is not mirrored in this sphere,
> Every result of every act and word
> Its corresponding counterpart has here.[115]

The implied comparison of the leaves on the trees with the blurry features of the moon is also reminiscent of another work admired by both Cigoli and Galileo, Leonardo's *Trattato della pittura*, the inspiration, I have suggested, for the astronomer's later conclusion that the dark spots on the lunar globe might be not unlike gloomy regions in forests on earth. Finally, the passage recalls a derisive remark made by Galileo in the *Considerations of Alimberto Mauri*, when he ridiculed those thinkers who, insisting on the incorruptibility of the heavens simply because they could not observe any changes from the earth, offered as their main objection the fact that "even a distance of twenty miles loses mountains from our view, to say nothing of oaks and beeches."[116] But it is the observation itself, and not the odd detail about terrestrial vegetation, that is most noteworthy, because it implies that there are indeed lunar features of

some sort, and that only distance obscures them. Such features would be, in all likelihood, the mountains that Galileo knew to be on the moon since at least 1606, when he mentioned them in the *Considerations*. Their presence may have seemed to Cigoli one more instance of the alleged resemblance of the terrestrial and lunar bodies and evidence of their mutual exchange of reflected light.

Thus far I have suggested that the excised pages of Uffizi 2660A, like the omissions in the *Vita*, concern Galileo, that in one instance the missing portion of the manuscript is devoted to the question of the secondary light, and that the reference to the indistinct features of the moon may involve the related issue of the lunar mountains. While arguments built around such lacunae and allusions are of limited value, there is in the 1604 *Adoration*, fortunately, pictorial evidence that Cigoli was familiar with the phenomenon of the secondary light before the invention of the telescope, that he eventually saw it as proof of the Copernican world system, and finally, that he regarded the entire astronomical issue as an article of religious faith. The work in which these matters were best combined is the *Deposition* of 1607, to which I now turn.

Lessons Learned at Golgotha

The *Deposition*, commissioned in 1600 as an altarpiece for the church of Compagnia della Croce of Empoli, was not finished until late 1607 (see plate 5). A chronicle of the period relates that in January of 1608 the painting was brought "by boat [along the Arno] from Florence to Empoli, with the highest praises, and not just from the brothers of that Order, but also from the whole city, and with much ringing of bells and other festivities of the sort."[117] One of Cigoli's most beautiful works, the *Deposition* inspired not only those fortunate enough to live in Empoli and nearby Florence, but also Peter Paul Rubens, who used it as a model for his own *Deposition*, the Antwerp altarpiece of 1611–1614.[118] Cigoli's painting was renowned both for its sophisticated handling of color—especially for the contrast between the brilliant white of the shroud, the pallor of the lifeless Christ, and the warm fleshtones of the live men who hold him—and for the dramatic opposition of tension and movement in those mortals clustered about the Cross with the still center of their dead God.

Yet no writer has mentioned the astronomical particularities of the *Deposition*, and the relevance of these details to the overall effect that the great painting had on its every observer. Preparatory drawings show that Cigoli modified the work significantly, probably between 1605 and

1607,[119] and I will argue that he did so in order to present a Galilean argument along with the sacrifice at Golgotha, as if to implicate the scientific hypothesis in the doctrinal issue, and more precisely, as if to suggest that there was no conflict in belief in the man from Galilee and faith in Galileo himself. Moreover, the manner in which Cigoli altered conventions of composition and lighting can only be explained by the relevance of these changes to the question of the secondary light, and these modifications were made in the period in which Galileo, inspired by the debate over the nova of 1604, turned to astronomy with a new enthusiasm and explained certain lunar phenomena to "some close friends and pupils."

It is now generally agreed that Cigoli made definitive changes in the painting's composition during one of his visits to Florence from Rome, either during the summer of 1605 or after August 1607.[120] I would be inclined to accept the earlier date, but only because it coincides precisely with Galileo's stay in Florence—the summer in which he appears to have explained the secondary light to Cosimo II de' Medici—and the novel astronomical activities of that period, and because the alternative suggests that Cigoli, by no means a *fa presto* painter, would have completed the work less than six months after introducing significant changes in its composition.

Let me begin my discussion of the astronomical argument of the *Deposition* by pointing to a peculiarity in the composition of this painting. First of all, the sun and the moon do not normally figure in scenes depicting the Descent from the Cross.[121] They often appeared in medieval renditions of the Crucifixion, suspended like two medallions above the dying Christ, but the motif was already old-fashioned when Raphael used it in his 1502 masterpiece. In that *Crucifixion* and the many that preceded it, the iconlike symmetry of those heavenly bodies did not correspond to any known astronomical configuration: the darkened sun and moon stood not as luminaries but rather as unwilling witnesses to that event. Later Renaissance Crucifixions were more commonly portrayed in a penumbral darkness, since the sun's light was said to have failed, perhaps during a miraculous eclipse, on the afternoon of Christ's death. While the Descent from the Cross was also depicted as a shadowy spectacle, this was only because the actual events were understood to have taken place in the late afternoon or early evening, when an entirely natural twilight brought an end to that extraordinary day. Cigoli did not include the sun and the moon in his earliest known work, the *Deposition* of 1578, though many of the other compositional elements of that painting resemble his later effort.[122] And when he portrayed them in his *Deposition* of 1607, moreover, he embellished them with half-length mourning figures, a motif

common to Northern works of a century earlier, and adopted, as Miles Chappell has noted, by Michelangelo in his *Crucifixion* of 1540.[123] In sum, then, the sun and moon of Cigoli's work, set like matching emblems in frames of dark clouds, would have seemed to a *seicento* observer an iconographic imprecision and a retardataire touch.

The two great luminaries provide the most obvious references to the Copernican issue. While such a composition would not have been startling in older works where the iconlike sun and moon floated in an undefined region above the Crucifixion, it does seem inconsistent with the attention Cigoli normally devoted to questions of space and perspective, and it is particularly difficult to reconcile with his realistic depiction of the reddish sun and shadowy moon. But it is the dramatic position of the Cross that provides the strongest indication of a more sophisticated spatial arrangement. The oblique presentation of the Cross corresponds to Cigoli's desire to emphasize this symbol for his patrons in the Compagnia della Croce, but as I will argue, this modification of the original composition is also designed to provide the observer with a specific physical orientation, or rather a reorientation, one that most closely combines everyday astronomical details with the miracle at Golgotha.

Consider first the plane established by the Cross and its relation to the two heavenly bodies above it. The strong illumination that falls on the side of the Cross and its apparent alignment with the sun serve to break up the background plane in which both the solar and the lunar bodies first appeared to lie. The sun now seems to be farther away—a remote distant point toward which lines drawn from the side of the Cross would converge—and the moon somewhat closer, almost as if it lay not far beyond the beam of the Cross and the lifeless hand of the Saviour himself. The Cross, in other words, is no longer an icon of symmetry surmounted by the emblems of the sun and the moon, but a kind of pivot about which more complex spatial configurations might be arranged.

Since this modified pictorial configuration also corresponds to an actual celestial arrangement, it seems likely that other details in Cigoli's depiction of the sun and the moon are, from an astronomical viewpoint, equally significant. Because the Gospels relate that Christ died at three o'clock in the afternoon, the Descent from the Cross was generally thought to have taken place sometime in the early evening. In this *Deposition*, the exact place of the sun with respect to the horizon is somewhat ambiguously defined, for the thick clouds that surround both the solar and lunar bodies are virtually indistinguishable from the hilly terrain beneath them. On the other hand, the ruddy color of the sun and the dim atmospheric light of the painting both evoke the vespertine moment when the body of Christ was removed from the Cross and prepared

by Joseph of Arimathaea and Nicodemus for burial. There can be no doubt that Cigoli intended—insofar as it was compatible with miraculous events—a supremely realistic depiction of the evening of Christ's death.

The most important argument for the purely symbolic function of the sun and the moon was the fact that the feast of Passover, celebrated by Jesus and his disciples the day before he was to die, depended upon a lunar calendar and always took place during the full moon of the month of Nisan. The moon, therefore, would still have been opposite the sun the following afternoon, rather than next to it in the sky above Golgotha. This well-known calendrical detail presented a greater problem for scriptural exegetes, however, than it did for those intent upon illustrating the Crucifixion, for the latter were generally less constrained to provide physical explanations of miraculous and ambiguously described incidents.

The Gospels of Matthew, Mark, and Luke refer to a mysterious darkness that fell over the land from noon until three in the afternoon.[124] Some Patristic writers suggested that thick clouds had come between the sun and the earth and had remained around the solar body until Christ's death in order that the greatest luminary not witness the event. The majority of exegetes, however, followed the wholly inauthentic account of Pseudo-Dionysius, a late Antique writer who pretended to be the early Christian bishop and martyr Dionysius, and who claimed to have been that day an eyewitness to a celestial, rather than terrestrial, miracle.

Pseudo-Dionysius's celebrated *Letter to Polycarp* relates that at the time of the Crucifixion, he and a certain Apollophanes were in the ancient Egyptian city of Heliopolis. Toward the middle of the day, they saw the moon move backward in its course—for it was at this time at the full, and 180° distant from the sun—to cover the solar surface, where it remained for three hours, returning then by the route it had come to its natural place in the heavens. The *Letter to Polycarp* was significant in that it supported the scriptural affirmation that "darkness extended over the whole earth," Heliopolis then being regarded as greatly distant from Jerusalem, and it suggested that the Crucifixion of Christ was not just a tawdry political episode in a remote corner of the Roman Empire, but the central event of human history and the sacrifice on which the salvation of all men depended.[125]

While there was very little to corroborate Pseudo-Dionysius's account, exegetes generally regarded the particulars of this eclipse—the moment and manner in which it came about and its unusual duration—as proof of Christ's divinity rather than as cause for skepticism.[126] This is not to say that commentators entirely abandoned rational explanations of the miraculous event, for some turned to detailed discussions of eclipses in order to justify the absence of contemporary references to the day when the sun's light was said to have failed: only the killers of Christ at Jerusa-

lem fell within the path of totality, and the rest of the world, unaware of the sacrifice at Golgotha, experienced a kind of penumbral darkness on the afternoon of the Crucifixion.[127]

Insofar as pictorial conventions involving the Crucifixion would allow, those who illustrated the sacrifice at Golgotha often made some reference to the singular celestial occurrence. Thus, while the position of the sun and the moon above the Cross was not a realistic depiction of their spatial relationship, the lunar body was often adorned with a shadow cone, a clear allusion to the solar eclipse its unusual movement would cause. Alternatively, the surfaces of the sun and the moon were muted in color, as if their light were failing, and at times the two great luminaries were shown weeping over the events below them. Occasionally the sun was covered with a cloud, for there were still those who preferred this explanation to the more dramatic account provided by Pseudo-Dionysius in his *Letter to Polycarp*.

Lodovico Cigoli was surely among this number: the sun and the moon are surrounded by thick and dark clouds, these vaporous masses having receded just before Christ spoke his last words and died. As will become apparent, the lunar body is depicted in the *Deposition* in precisely the way Galileo would describe it several years later in the *Sidereus Nuncius*, and the Copernican argument of the painting is an anticipation of the more explicit statements of that first telescopic treatise. First of all, the moon is encircled not by horns—for the thick clouds prevent the passage of much sunlight—but by a kind of vaporous halo, one that appears diffuse and hazy on the rim nearer the Cross but thicker and more precise in its contours on the farther and upper edges. This is the substance that both Galileo and Rafaello Gualterotti had originally believed solely responsible for the secondary light, though by 1607 its function was somewhat altered. Since at least 1604 Galileo had thought that both the earth and the moon were wrapped in a mantle of vapor, and in 1610 he would write that there was "around the lunar body a certain orb of denser substance than the rest of the ether, able to receive and reflect a ray of sun, although not endowed with so much opacity that it can inhibit the passage of vision (especially when it is not illuminated)."[128] He used this argument—later discarded—to explain why it was that the mountainous moon did not look like a toothed wheel: when this mantle of vapor was seen straight on, as was the central part of the globe, he suggested, it was more or less invisible, but when observed obliquely, as would be the limb, it obscured the jagged peaks that lay beneath it.[129]

As I mentioned earlier, Galileo had believed that the moon had mountains much higher than those on earth since at least May 1606, when he alluded in passing to its rugged appearance in the *Considerations of Alimberto Mauri*. It was presumably at that point—several years before he ever

heard of the telescope—that he was obliged to find some explanation for the moon's smooth edges, and that he first decided that the mantle of vapor would not only reflect some light but would also conceal the ridged perimeter he expected to see.

It should be evident, then, that Cigoli's rendition of the moon in the *Deposition* of 1607 conforms to contemporaneous Galilean suppositions about that body: the parts of the lunar globe that are seen most obliquely, its upper and far limb, are shrouded in a thick layer of mist, while the vapor surrounding the edge closest to the Cross and the lower portions is hazy and tenuous, as if the eye of the observer were barely able to distinguish this part of the mantle from the field of ether in which it lies.

But it is the ashen glow on the face of the moon that is really noteworthy. A shade less blue than the sleeve of Joseph of Arimathaea—in whose richly colored clothing the sun and the moon seem to converge—this unnatural light is surely that reflected off the earth to the face of the otherwise unilluminated lunar body. Consider, too, the special circumstances that permit this event: the dark clouds around the two great luminaries have evidently just parted, and so half of the earth is struck by solar rays, which are in their turn reflected to the moon's surface. The clouds themselves, however, ensure that though night has not yet fallen in Jerusalem, the lunar body and the pale light reflected onto it can be seen in a field that would normally be too bright for the observation of such phenomena. It is as if the heavens themselves had conspired to make the secondary light manifest on the evening of Christ's death.

"Are You, Too, a Galilean?"

What purpose would be served by such an extraordinary manipulation of scriptural and iconographic details? Why, in other words, would Cigoli have insisted on the conflation of astronomical conjecture and the story of Christ's Passion, as if there were no better moment than the Descent from the Cross to display Galileo's most recent discoveries? The solution, I would suggest, is provided by another obscure point of the painting, the position and gesture of the turbaned figure behind the mourning women. As in Cigoli's early *Deposition* of 1578, the man in the turban appears on our left and somewhat behind the Cross. In the later painting, however, he points not toward the dead Christ but toward the ashen lunar surface,[130] his gesture being a more vigorous version of that of the lifeless Savior, whose outthrown arm directs us to look at the moon below it. The awkwardness of the man's pose—the hand with which he points is his left, while his right is on his hip—assures the observer, in fact, that he cannot be indicating Christ but the lunar body behind him. Just

as in a traditional *Crucifixion* scene the Good Centurion's conversion and his generous gesture toward the dead Christ were often understood to be an invitation to all observers outside of the picture frame, so the turbaned protagonist of Cigoli's *Deposition* would seem to encourage both religious piety and some attention to the astronomical configuration of the background.[131]

Who is this figure, and why has Cigoli presented him as at once central to the drama of the *Deposition* and yet so clearly preoccupied with the celestial, rather than strictly terrestrial, events of the moment? Though he has but one of the conventional attributes of Nicodemus—his turban, and not his basket, nails, tongs, or a jar of ointment—it can be shown that he is indeed that early convert, and that the older man with whom he converses is Gamaliel.[132] Miles Chappell has noted the resemblance of this turbaned figure to another one on the right-hand side of Cigoli's *Martyrdom of Saint Stephen* of 1597.[133] In that painting, the same individual is likewise engaged in conversation with a white-haired and bearded man some years his senior. The puzzling similarity can be explained by a document of 415 A.D., Lucian of Caphargamala's *De revelatione corporis Stephani Martyris*, in which the author, a priest living near Jerusalem, recounted a series of visions that led him to find the bodies of both Nicodemus and Stephen.[134] According to Lucian, the early Christian convert Gamaliel, a "tall old man, a priest full of dignity, with white hair and a long beard," appeared to him in three dreams and told him that when Stephen was stoned to death by Jews outside Jerusalem, he had buried that first martyr, mourned him for forty days, and erected a monument to him. Lucian's account, accepted by prominent Christian writers such as Augustine, Jerome, and Orosius, and adhered to even in the early modern period, would thus designate Gamaliel as one of the pious individuals described in Acts of the Apostles 8:2, where it is simply said that "Stephen was given burial by devout men, who made a great lamentation for him."[135] There is also some suggestion—clearly adopted in Cigoli's *Martyrdom of Saint Stephen*—that Nicodemus, too, was in this company, for Gamaliel proudly presented him as his constant companion, and even as his dependent, in the tumultuous early years of Christianity: "When the Jews learned of [my kinsman] Nicodemus' baptism [by Peter and John] after his meeting with Christ, they deprived him of his princely title, denounced him, and expelled him from the city. It was I, Gamaliel, who received him, a victim of the persecution of Christians, in my home. I provided his food and saw to his needs until the end of his days, and when he died [of wounds inflicted by the Jews], I had him buried with honors beside the venerable Stephen."[136]

While Lucian's *De revelatione corporis Stephani Martyris* identifies the old man and his turbaned conversant in both paintings, Nicodemus's

gesture and position in the *Deposition* remain puzzling. Normally shown
with the nails he was said to have extracted from Christ's body, or with
the mixture of myrrh and aloes which he brought to Christ's tomb, in
Cigoli's painting those attributes have been discarded in the foreground
or obscured entirely.[137] What has replaced them is Nicodemus's strange
preoccupation with the astronomical details of the backdrop, an attention
rendered all the more intriguing by comparison with the *Adoration of the
Shepherds*, where those same elements were clearly less important than the
central event of Christ's birth.

A close reading of Scripture itself provides some explanation of Cigoli's
curious portrait of Nicodemus, particularly of the early Christian's ges-
ture toward the ashen face of the moon. Despite the rich life and afterlife
he acquired both in Lucian's account and in the apocryphal gospel attrib-
uted to him,[138] Nicodemus appears only three times in the New Testa-
ment and is mentioned only by the fourth Evangelist. In 3 John it is said
that this Pharisee and member of the Sanhedrin approached Christ by
night and questioned him about the spiritual rebirth he promised. In
their long and somewhat inconclusive interview, Christ repeatedly re-
proached Nicodemus for a kind of spiritual failing, asking him, "If you do
not believe me when I talk to you about earthly things, how are you to
believe if I should talk to you about the things of heaven?" and admon-
ishing him to place his trust in God's only Son.[139] The fact that Nicode-
mus chose to visit Christ under the cover of darkness has traditionally
been interpreted as an index of the convert's initial timidity, and has been
opposed to the luminous imagery used by the Savior,[140] who warned his
latest follower that "the light has come into the world, but people pre-
ferred darkness to light because their deeds were evil. Wrongdoers hate
the light and avoid it, for fear their misdeeds should be exposed. Those
who live by the truth come to the light so that it may be clearly seen that
God is in all they do."[141]

John's second allusion to Nicodemus suggests—to some but not all
readers—a certain spiritual progress. When the Pharisees expressed their
growing distrust of Jesus, Nicodemus intervened, asking the members of
his former sect if their law allowed them to pass judgment on anyone
without giving him a proper hearing. The Pharisees, perhaps suspecting
that he was a follower of Christ, asked Nicodemus if he, too, was a Gali-
lean, and reminded him that Scripture did not say that the Prophet would
come from Galilee.[142] Not surprisingly, Nicodemus's mild remarks have
been interpreted by some as a defense of his Savior and by others as an-
other indication of his faintheartedness.[143]

The final reference to Nicodemus in the Gospel of John is no less am-
biguous. He is described as the companion of Joseph of Arimathea, who

is portrayed as "a disciple of Jesus, but a secret disciple for fear of the Jews," and his initial nocturnal visit to Christ is mentioned once again.[144] Nicodemus's contribution of a vast quantity of myrrh and aloes with which to anoint the body of Christ can be read either as a sign of his generosity and reverence for his Savior, or as evidence of his crippling fixation upon physical rather than spiritual matters.[145] Though artists who chose to include Nicodemus, the patron saint of sculptors,[146] in scenes evoking the Descent from the Cross, the Deposition, and the Entombment, generally portrayed him in a favorable light, his position was further complicated in the first half of the sixteenth century when various Protestant writers such as Otto Brunfels, Ulrich Zwingli, Martin Bucer, and Jean Calvin referred to those who sympathized covertly with the Reform movement as "the modern brethren of Nicodemus" and as *Nicodemi*.[147] The term *Nicodemite* took on a distinctly pejorative cast and widespread currency in the polemical *Excuse de Jehan Calvin à Messieurs les Nicodemites* of 1544. There is some evidence that among those criticized for religious dissimulation in this tract were the Italian *Spirituali*, an evangelical group particularly strong at the court of Ferrara and in Viterbo. On the basis of his involvement with the *Spirituali*, it has been recently argued, moreover, that Michelangelo's depiction of Nicodemus in his Florentine *Pietà* is a self-portrait, one whose basis is not merely the traditional association of the early Christian with sculptors, but also the more complicated matter of a desire for religious reform and a simultaneous tendency toward dissimulation.[148]

In another context, Miles Chappell has pointed to certain similarities between Michelangelo's depictions of the crucified Christ and Cigoli's *Deposition*, describing, for instance, the painting of 1607 as a "dynamic variation of the *Pietà*," and noting the resemblance between the archaizing iconography of the sun and the moon in both Michelangelo's *Crucifixion* of 1540 and Cigoli's canvas.[149] While there are doubtless other iconographical details shared by the two artists—the tight cords across Christ's chest in the Florentine *Pietà* reappear, for example, in the *Deposition*—it would appear unwise to argue that Cigoli's Nicodemus has the same resonance as Michelangelo's portrait of the same figure. On the other hand, it does seem likely that Cigoli, even without the influence of Michelangelo's model, would have recognized the question of Nicodemus's belief as a crucial one and would have fully developed this issue within the context of the *Deposition*, giving particular regard to the astronomical features of that painting. In what follows, therefore, I will argue for the relevance of the celestial configuration of the backdrop to our understanding of Nicodemus, the sole figure in the foreground who is concerned with them, suggesting that Cigoli used the problem of the

moon's secondary light not as an irrelevant detail but as a central motif of this work and as a harbinger of his increasing faith in the compatibility of science and Scripture.

It is clear that the motifs of darkness and light, traditionally exploited by all who comment upon the encounters of Nicodemus and the man he called his teacher,[150] have a distinct relevance to the issue of the moon's ashen glow. The banal equations of darkness with timidity and ignorance, and of light with strength and knowledge, find a novel dimension in Cigoli's version of the episode at Golgotha, for Nicodemus's preoccupation with the luminous face of the moon suggests progress that is at once spiritual and intellectual. Put differently, within the context of this particular painting—one where an early convert directs all viewers to contemplation of the secondary light—Christ's observation that "those who live by the truth come to the light" implies that there is genuine harmony rather than irrelevance or outright conflict between scientific knowledge and religious faith.

Christ's early admonition of Nicodemus—the stipulation that anyone who would believe his Savior's account of "the things of heaven" must first accept what he is told of earthly matters—has even more relevance to the astronomical issue evoked in the *Deposition*. As I have noted throughout, it was Galileo's contention, and indeed the basis of his extrapolation from an artistic precept regarding the treatment of reflected light in a painting to a scientific argument for the earth's status as a planet, that celestial principles were derived directly and exclusively from terrestrial ones. In this, of course, he differed considerably from the traditional view, which tended to emphasize the radical dissimilarity of heavenly and earthly phenomena and the inapplicability of the laws governing the supralunar region to all below the moon. What is crucial here, therefore, is that within the context of the *Deposition*, the Aristotelian perspective has effectively been displaced, for Cigoli's presentation of the gesturing Nicodemus suggests that this latest convert, no longer the timid skeptic, has progressed from an acceptance of Christ's often paradoxical explanations of the terrestrial to his even more startling version of the celestial.

Consider, finally, the Pharisees' scornful denunciation of Nicodemus's suggestion that they avoid prejudging Christ. Within the original context of the Johannine gospel, *Numquid et tu Galilaeus es?* was not so much a query about geographical origins—for these men know perfectly well that Nicodemus does not come from Galilee—as a reference to a believer.[151] But this is also how the phrase functioned in the early seventeenth century, when Galilee-Galileo wordplay began to emerge. Cigoli's portrait of Nicodemus as *Galilaeus* in both spiritual and intellectual matters may, in fact, be the earliest version of what would become a popular, if predict-

able, pun: in 1614, for instance, the Dominican Tomaso Caccini, one of the most important of the *Colombi*, would preach an anti-Galilean sermon based on this quip, using as a point of departure a passage from the Acts of the Apostles 1:11, "Ye men of Galilee, why stand ye gazing up into heaven?"[152] The pun would also appear in a letter from Lorenzo Pignoria to Paolo Gualdo in September 1610, where it was attributed to Johannes Kepler, and in a different form in Kepler's *Dissertatio cum Nuncio Sidereo* of May 1610, and in one of Thomas Seggett's epigrams of the same period.[153]

This is not to say, of course, that Cigoli actually believed that the encounters between the Savior and Nicodemus in any way concerned the issue of the secondary light. His depiction of Nicodemus as a Galilean in both the spiritual and intellectual sense does, however, insist on the absolute compatibility of religious faith and scientific knowledge, and in comparison with the *Adoration of the Shepherds* of 1602, constitutes a significant change in the painter's attitude toward the relevance of the two issues. It is safe to say that the *Deposition* is something of a midpoint between the *Adoration*, where the scientific and the doctrinal are so carefully circumscribed, and the *Immacolata* of 1610–1612, where the viewer who contested the Galilean conclusions of that painting would necessarily fall in the shadowy region of the damned. While the ashen light is a trivial detail in a remote corner of the 1602 *Adoration of the Shepherds*, a distraction from "this thing that has happened" in Bethlehem, it is clearly more central to the events at Golgotha, there being in that latter painting neither choice nor distinction between matters of faith and learning. Thus, while the ideal observer of the *Adoration* would see in the moon's curious appearance an interesting astronomical problem—one scarcely resolved by a late version of the Chaldean hypothesis—he would also be inclined to view the entire vignette and its range of lights as much less important than the brilliantly lit drama of Christ's birth. The same observer, however, would find in Nicodemus's gesture in the *Deposition* an appropriate turn toward the lighted face of the moon, as if the issues of religious belief and scientific knowledge could not but be presented together and the progression from terrestrial to celestial were unavoidable.

And yet something of the ambiguity traditionally associated with Nicodemus remains and is resolved only by the stronger stance of the *Immacolata*: the implicit question of the *Deposition*, "Are you, too, a Galilean?" does not suggest that those viewers to whom Galilean hypotheses seemed untenable or irrelevant were perforce lacking in religious faith. Put differently, Cigoli's attitude more closely resembles that of the new convert than that of the proselytizer, though, this, too, would change in

the course of the next five years. Whether Cigoli can be said to identify with his Galilean Nicodemus is debatable. Certainly the figure does not constitute a physical self-portrait, but the artist would have known that some early modern painters, as well as sculptors, did endow the biblical figure with their own features.[154] And it is here that Nicodemus's position, his resolute turn away from viewers, becomes as significant as his gesture toward the light, for this minimizes the question of his physical likeness to Cigoli, just as it emphasizes their intellectual and spiritual affinity.

"All Who Look at It Are Moved"

In his description of the painting in the *Vita*, it was the *Deposition*'s strange combination of motion and stasis, and of a burden at once physical and psychological, that struck Cigoli's nephew, Giovanni Battista Cardi: "The moment when our Lord was taken down from the Cross was portrayed with such great skill, that we see, quite apart from the composition and the coloring, so much emotion in the faces of those men who struggle and grieve in carrying Christ, and such grace and languor in the repose of His body, that all who look at it are moved."[155]

It does not seem to me that Cardi's brief comment on the *Deposition* necessarily represents another conscious suppression of his uncle's sympathy for Galilean hypotheses. The reference is only one of many in a long list of Cigoli's works, after all, and concision, not extensive analysis, characterizes most of these descriptions. Nor is there any reason to suppose that Cardi was particularly familiar with astronomy, other than to know that Galileo's contribution was not always viewed with favor.

Cardi did possess, however, the preparatory sketches for the painting, and he would therefore have been able to see the modifications the *Deposition* had undergone as his uncle strove to include the issue of the secondary light in the sacred image. It is possible, therefore, that Cardi knew that the painting made some reference to a mobile earth, and that certain unusual aspects of its composition and its coloring reflected the scientific argument. Since it was probably Cardi who made or oversaw the excisions in the *Prospettiva pratica* as well, he would presumably have encountered a brief written description of the ashen light, and he may even have seen later references to the issue in Galileo's now lost letters to the painter. Such knowledge might explain several features of his description: in the first place, Cardi's great emphasis on the emotion of both the figures around the Cross and that of the viewer effectively displaces attention from questions of composition and coloring, and from the manner in which the artist modified some of those conventions in order to depict

a Crucifixion that is, given Galileo's understanding of the astronomical evidence provided by the secondary light, Copernican in nature. Second, and more important, Cardi's choice of words to describe the observer's emotion—the somewhat redundant phrase "muove *l'interno* di chiunque lo mira," "whoever looks at it is moved *within*"—may veil his concern with that other and *external* motion that all men are said to undergo in a Copernican universe, where it is the earth, and not the sun, that moves.

1610–1612

IN THE SHADOW OF

THE MOON

G IVEN GALILEO'S future conflict with his Church, Lodovico Cigoli's *Deposition* of 1607 is impressive in its serene overlay of pious and scientific belief. Whether or not any of the earliest observers understood Nicodemus's gesture toward the ashen moon, within eighteen months of the painting's completion Galileo had begun using a telescope and finding yet more evidence of the new world system. Of all the phenomena discussed in the *Sidereus Nuncius*, what he had to say about the lunar substance was the most sharply contested, though neither the issue of the moon's secondary light nor that of its mountainous surface had the novelty of his description of Jupiter's satellites or the countless new stars in the Milky Way. The sudden revelation of four planetary satellites and thousands of stars was less surprising, apparently, than Galileo's depiction of a rough, solid, opaque, and spotted moon, for the latter assertion violated certain cultural presuppositions, ones based as much on religious conventions as on astronomical thought.

In this chapter and the final one I will discuss the conflict between the traditional association of a crystalline and semidiaphanous moon with the Virgin Mary, and Galileo's vastly different notion of the lunar body. As might be expected, such contentions were brought into sharp focus in the realm of sacred paintings, and especially those of the *Immaculate Conception*, where the Virgin was depicted standing on a moon whose latest description made it an unlikely icon of her purity. This chapter will be devoted to the manner in which Lodovico Cigoli resolved the potential conflict of Marian devotion and astronomical discovery in his *Immacolata*, painted for the Pauline Chapel of Santa Maria Maggiore in Rome from 1610 to 1612, during the height of the disputes over the lunar surface. Though the conceits of both his *Deposition* and his *Immacolata*

depend on a particular reading of Scripture—one that accommodates the sacred text to Galileo's latest findings—the latter painting is much more polemical in tone. Thus, while Cigoli may have hoped that all observers who were persuaded by the gesture of Nicodemus would undergo something of a spiritual and scientific conversion, there is no indication that those who did not understand or believe the reference to the moon's ashen glow were among those who, in Christ's words to this early follower, "preferred darkness to light because their deeds were evil." In the *Immacolata*, however, Cigoli specifically likened those who refused to accept Galileo's conclusions about the moon's substance and nature, either through ignorance or envy, to the impious, those who did not accept the "Woman Clothed in the Sun" of 12 Revelation as the Mother of God. Just as Copernicanism was the correlate of true piety, so the absence of such scientific belief implied a lapse in matters of faith.

The dispute over the moon lasted for more than a decade after Cigoli completed his *Immacolata*, and it influenced Francisco Pacheco and Diego Velázquez in their contemporaneous but very different *Inmaculadas*, the subject of my fifth and final chapter. In Seville as well as in the Roman church of Santa Maria Maggiore, the astronomical question appeared together with the complicated issue of the Immaculate Conception, to which I now turn.

Revelations Old and New

After that there appeared a great sign in heaven: a woman robed with the sun, beneath her feet the moon, and on her head a crown of twelve stars. She was about to bear a child, and in the anguish of her labor she cried out to be delivered. Then a second sign appeared in heaven: a great, fiery red dragon with seven heads and ten horns. On his heads were seven diadems, and with his tail he swept down a third of the stars in the sky and hurled them to the earth.

Revelation 12:1–4 has been regarded as both a figure for the Virgin Mary and an allegory of the Church itself since the third century. Within the commentary tradition, the sun was either the Godhead, or, more abstractly, the *sol iustitiae*; the twelve stars, the apostles, or the blessed, or "a zodiac of virtues"; the fiery red dragon, Satan or a particular form of evil ranging from the entire Roman Empire to individual members of Protestant cults.[1] In his *Moralia*, Gregory the Great described the moon beneath the woman's feet as the emblem of everything that the Church despised, *omnia mutabilia terrena ac caduca*, "all fallen, mutable, and

earthly things," and on this point most future commentators agreed.[2] Some exegetes, urging reform, compared the globe on which the woman stood to the temporal goods on which *Mater Ecclesia* too often rested; others, such as these later-seventeenth-century writers, contrasted the filth that the "unclean, dark, and inconstant" moon embodied to the Virgin's purity:

> The moon, because it has certain blemishes in its body, and undergoes eclipse, and scatters darkness here and there, signifies the failings and faults of corrupt [human] nature. Therefore the victorious Virgin Mary rightly crushes the moon beneath her feet, because she has triumphed in glory over every vice, over original sin and over all those that followed it, such that she is unable to be touched, even ever so lightly, by any defect.[3]

> The Church is constant in faith, doctrine, custom, persecutions, and martyrdom, and she crushes the moon beneath her feet. The moon therefore is not supporting the woman—for how indeed could she be borne up by that which is above all inconstant, changing, wandering, and unstable?— but rather it is understood to be tread upon by her. . . . The sun therefore is to be understood *in bono*, the moon, *in malo*, and she stands for all sublunary things, which are variable, in flux, in perpetual motion, subject to ebb and flow.[4]

Where the moon was not associated with temporal goods or miasma, it was the emblem of madness, and here many exegetes relied upon the dreary counsel of Ecclesiasticus, "a fool is as changeable as the moon."[5] In its crescent shape, finally, it was the icon of the Infidel, and early modern commentators sometimes recalled a distant defeat of the Ottoman Turks—at the hands of a Mongol warrior—to describe the body on which the triumphant Church rested: "And thus the [curved or crescent-shaped] back of Bajazet, Prince of the Turks, was like a footstool for his conqueror Tamerlane when the victor climbed on his horse."[6]

In this respect iconographical practices differed significantly from the commentary traditions, for in engravings and paintings of the *amicta sole*, the "Woman Clothed in the Sun," the moon beneath her feet was not treated as an object of contempt but rather as an icon of her beauty and her purity. The moon's spots—that ready index of its lowliness among commentators—were not emphasized, and in time other features such as its opacity and even its phases were erased and replaced by a substance that was crystalline and nearly transparent. Since such representations were often accompanied by a Marian emblem drawn from the Song of Songs—*pulchra ut luna*, or "as beautiful as the moon"—there was little ambiguity in the artist's intention.

The Development of a Doctrine

The Immaculate Conception of the Blessed Virgin Mary was defined as dogma only in 1854 with the publication of the papal bull *Ineffabilis Deus*, though the notion that the Mother of God had been preserved from original sin from the moment of her conception was by then centuries old.[7] At its origins was a parallel drawn by Patristic writers between Eve and Mary: the woman who brought about our Fall and she who ensured our Redemption had both been pure at the moment of their creation. While both Ambrose and his student Augustine recognized that the Virgin was free from original sin, they did not formulate the manner or the moment in which she was so liberated.

The feast of the Immaculate Conception was celebrated in the Eastern Orthodox Church as early as the end of the seventh century, but the question of the Virgin's purification continued to be debated in the Latin West. Though a popular medieval belief, the doctrine was opposed by Saint Bernard, who, despite his devotion to the Virgin, objected that the Immaculate Conception was a frivolous novelty, and that it would create more problems than it solved. The most important of these was an infinite regression of contagious Immaculate Conceptions extending back from Jesus to Mary to her parents, Saints Anne and Joachim, to their parents and eventually to Adam and Eve themselves. (Time proved Bernard more or less correct, for the increasing interest in the immaculacy of the Virgin's conception meant that her parents, especially her mother, came to be more and more venerated, and eventually an elaborate genealogy grew up around Anne, her sisters, her sisters' daughters, and their daughters.) The Immaculate Conception was also rejected by the greatest of the Scholastic writers—Alexander of Hales, Bonaventure, Albertus Magnus, Thomas Aquinas, and Henry of Ghent—none of whom saw any distinction between the sanctification allowed to the Virgin and that accorded *in utero* to Saint John the Baptist.

From the fourteenth century forward, the argument was debated with particular fervor by the Dominicans and the Franciscans. The former group, following Thomas Aquinas and insisting upon a *sanctificatio in utero*, maintained that the Virgin, like John the Baptist, had been absolved, but not exempted, from original sin; the latter, however, stated that no such sanctification was needed, and that none had taken place, because Mary had been immaculate since the moment of her conception. In the absence of explicit scriptural or Patristic texts, the Franciscans relied on opinions expressed by John Duns Scotus, and in particular on a syllogism attributed to the Subtle Doctor. The formula *potuit, decuit,*

fecit meant that God was able to fashion an individual at once human and exempt in body and soul from original sin; it was fitting, given the Virgin's role as Mother of Christ, that she be immaculate from the moment in which she was conceived; therefore, God did indeed create her thus. Maculists, on the other hand, pointed out that Duns Scotus had written elsewhere that God alone knew at what point, if any, the Virgin had been freed from original sin, and that the notion of the Immaculate Conception was no more than a "probable opinion."

Exegetical arguments of this period drew on Genesis 3:15, where the enmity that arose between the woman and serpent after the Fall seemed to foreshadow the conflict of the Virgin and Dragon in 12 Revelation, and on the manner in which the angel greeted Mary in Luke 1:28, *Ave, Maria, gratia plena*. Those devoted to the doctrine of the Immaculate Conception took the messenger's reference to grace both as an allusion to the event at hand, the Incarnation, and as evidence of the privilege by which the Virgin herself had been exempted from original sin when she was conceived by her mother. More trivially, the *Ave* with which she addressed was said to be a correction or rather a rereading of the fault incurred by her Edenic double *Eva*, or of *Vae*, Eve's cry of despair.[8] Other biblical allusions to Mary's purity were found throughout the Old Testament, chiefly in the Song of Songs, but also in Genesis, the Psalms, the Proverbs, Ecclesiastes, and Ecclesiasticus.

With the promulgation of the papal constitution *Cum praexcelsa* in 1477 Pope Sixtus IV approved the celebration of the feast of the Virgin's conception, but this did not mean that the question had been resolved, for the woman herself, and not necessarily her conception, was described as "Immaculate." In 1485, those who continued to insist upon discussion of either opinion were threatened with excommunication by the bull *Grave nimis*, and in 1546 the Council of Trent upheld the Sistine Constitution, but despite the enthusiasm of the Spanish delegation the Immaculate Conception was not proclaimed dogma. Certain measures taken by popes who were devoted to the doctrine were later revoked by their successors, the most celebrated instance being Innocent XI's suppression in 1678 of a ritual established in 1615 by Paul V, who had promised those who recited the Office of the Immaculate Conception of the Most Holy Virgin one hundred days' indulgence. A significant portion of the measures suppressed by Innocent XI, in fact, regarded the Virgin, and many involved the vexed question of her conception: the devout were no longer to be granted indulgences for "the image of the Immaculate Conception of the Virgin Mary, painted in a circle, with the moon under her feet," nor for reciting "the Crown, or Stellary, of the Immaculate Conception, consisting of Twelve Beads," and least of all for reciting a

"Rosary of Saint Anne . . . or the prayer which is wont to be printed with the Image of Saint Anne, *Hail full of grace*, etc."[9]

Until the mid-sixteenth century the iconography of the Immaculate Conception concerned Mary's physical, rather than spiritual, immaculacy, and the program involved events taken from the *Protoevangelium* of James and illustrating the probity of the Virgin's parents. Gradually, however, the Chaste Embrace of Anne and Joachim at the Golden Gate—the early emblem of the immaculacy of Mary's conception—gave way to a more abstract depiction of the doctrine, an iconographical program based on scriptural verses understood to be references to the Virgin's purity. In these representations, known as the *Tota pulchra* type, the Mother of God was surrounded by icons attesting to her immaculacy; she was said to be "a closed garden, a sealed fountain" (Song of Songs 4:12), "the Tower of David" (Song of Songs 4:4), "radiant as the sun, beautiful as the moon" (Song of Songs 4:10), "a spring of running water" (Song of Songs 4:15), "a lily of the valley" (Song of Songs 2:1), "a flower among thorns" (Song of Songs 2:2), "a dove" (Song of Songs 6:9), "Jacob's ladder" (Genesis 28:12), "a spotless mirror" (Ecclesiastes 7:26), "a cedar of Lebanon, a mountain cypress" (Ecclesiasticus 24:13), "a majestic palm, a beautiful olive tree" (Ecclesiaticus 24:14), and finally, the *Domus Domini*, the Temple of Solomon (3 Kings 6).

The *tota pulchra* type did not in every case portray the Mother of God as she appeared in 12 Revelation, clothed in the sun, crowned by stars, and standing on the moon. Conversely, not every depiction of 12 Revelation can be interpreted as a reference to the doctrine of the Immaculate Conception, for in Spanish paintings of the early sixteenth century the *amicta sole* was more commonly associated with the Madonna of the Rosary and with the Virgin's Assumption.[10] Those devoted to the Virgin of the Rosary were not necessarily Immaculists: indeed, it was the Dominicans, generally opposed to the doctrine, who most often portrayed the *amicta sole* with a rosary. The iconographies of the Assumption and the Immaculate Conception, on the other hand, were increasingly associated, in part because those who supported the latter doctrine tended to relate it to the former one, which was more widely accepted, in order to increase its popularity.[11] The conflation of the two beliefs may have been important to those who insisted on an immaculate, diaphanous, and vaporlike moon as the emblem of the Virgin's purity, for in the Assumption she was imagined in similar terms, as a spotless and weightless soul resting on clouds and borne upward to Heaven.[12]

Finally—and this point cannot be sufficiently emphasized—visual representations of the Immaculate Conception relied on emblems also associated with the Annunciation, as if the miracle by which Christ was

conceived and born of a virgin were the best evidence for His mother's special privilege of immaculacy. Many of these icons of Marian purity suggested more, in fact, about the events surrounding Christ's conception— the Incarnation and the Virgin Birth—than about the Immaculate Conception of Mary herself. Thus, while the epithet *Pulchra ut luna* was frequently cited by Immaculists as an allusion to Mary's exemption from original sin, it had long before been more forcefully and more vividly interpreted as a reference to the Incarnation by the influential (and maculist) Rupert of Deutz: "Then when the Holy Spirit came upon you, and you conceived a Son while yet a Virgin, and as a Virgin you gave birth, then from that time you were truly beautiful, and not just beautiful in any manner, but beautiful like the moon (*pulchra ut luna*). For indeed just as the moon shines and gives forth a light that is not hers, but is rather collected from the sun (*ex sole concepta*), so you, Most Blessed Virgin, shine by a light that does not come from you yourself, Virgin full of grace, but from divine grace!"[13] To summarize, then, many of the icons favored by the Immaculists—the Solomonic *Domus Domini* of *3 Kings 6*, for instance, and the sealed fountain and closed garden of the Song of Songs, as well as the allusion to the moon—referred proleptically to the central event of the Incarnation. This inevitable association of the two doctrines was familiar is nowhere more evident than in contemporary discussions of the moon, where the alleged immaculacy of that body was described in terms that explicitly recalled not the conception of Mary, but rather that of her Son.

Icons of Purity

There are two sorts of descriptions of the moon that are recognizable adaptations of Marian imagery, and they appear several times in the first years after the publication of the *Sidereus Nuncius*. Those who did not believe that the moon was rough, covered with jagged mountains and deep valleys, and illuminated by light reflected from the earth—in a word, maculate—compared it repeatedly either to a crystal ball or to a sunlit cloud, and explained its apparent spots as optical illusions. Despite the differences between a crystal body and a nebulous one, these descriptions were eventually treated as if they were interchangeable representations of the lunar globe. What is pertinent for our discussion is the fact that both a glass struck by sunbeams and a light cloud were also among the most common figures for the Incarnation and the Virgin Birth, meaning that meditations on the moon's purity were especially convincing to those artists engaged in depicting the *Immacolata*.

The underlying problem for all those who discussed the moon's appearance was the behavior of sunlight on the lunar globe. While it was generally agreed that the moon had no light of its own—theories like that of Erasmus Reinhold being comparatively rare—there was less consensus about whether it reflected, absorbed, or emitted solar rays. The arguments over exactly what kind of exchange of light took place lent themselves well to the metaphysical traditions surrounding the Incarnation and Virgin Birth. While the Incarnation was described in the gospels by Luke as "a cloud that would overshadow" the Virgin, the terms soon changed slightly, featuring radiance rather than nebulous obscurity. Thus Christ's conception was compared to a kind of mental or spiritual illumination provided by a light from the East:

> Therefore just as the mind is suffused with light in the formation of a word, and illuminated by it, so the Word was conceived by the Virgin. She conceived the Son of God just as the mind conceives a word, and then understands it, and is flooded by a light from above. That is why Christ is called "oriens," the rising sun, by the prophet. Thus indeed in Zechariah 6:12 it is written, "[Here is a man] whose name is 'Oriens.'"[14]

These abstractions found a happy confirmation in physical phenomena. Glass or crystal, that worn emblem of virginity, was of special appeal to those who described the Incarnation and the Virgin Birth, for there not only the fragility of the material but also its translucence could be evoked. The meditation of Father Luigi Novarini, author of a very popular mid-seventeenth century Marian treatise, and his appeal to Patristic sources is a typical combination of metaphysical and physical speculation:

> And thus Mary's virginity was like a mirror, or rather a clean crystal, and she gave birth unviolated to the Son of God, who is like a divine ray issuing from the divine sun, and in this she increased the beauty and suitability of her virginity. Saint Proclus tells us in his second *Oration on the Incarnation of the Lord* that Christ left the womb of the Virgin as would a ray of light. . . . The words of the Patristic writer are these: "Rays of light sprung from her womb, the sun incarnate emerged from her uterus." The most pure Virgin was therefore like a glass and a crystal in that she was illuminated, not shattered, by the light of the sun, or by Christ.[15]

The glass metaphor was applied to a variety of objects, with sunlit windows, lamps, bowls, vases being the most obvious symbols for the Incarnation and the ones generally depicted in paintings of the Annunciation. The detail about the rising sun dates to the ninth century: "Just as a house enclosed on all sides which has towards the east a clean thin glass window and, when the sun rises, its rays penetrating and passing through

the glass brighten the whole house, and again with the setting of the sun and the withdrawal of the rays the glass is not shattered, but remains un-damaged by the incoming and outgoing vibrations of the solar rays: thus you may understand the everlasting virginity of Mary."[16] In time, this, too, became a pictorial convention; the illumination in an Annunciation enters almost invariably through a window or an opening in a wall on the left-hand side of the painting, since the light was that of the rising sun, and came from Jerusalem, to the south and east.[17] The Virgin herself, long described as the *porta coeli* or "door of heaven," was also referred to as a *fenestra coeli*, the "window of Heaven," a metaphor both for her purity and the physical role she played in mankind's redemption.[18] The metaphor would have been particularly familiar to Italian audiences, for in the last and among the best known of the poems in his *Canzoniere*, Francesco Petrarch alluded to the Virgin as a *fenestra del Ciel lucente al-tera*, or "a noble and bright window of Heaven."[19]

The most intrepid of commentators conflated the *porta* and *fenestra coeli* imagery with the *porta clausa*, that mysterious Eastern gate men-tioned in Ezekiel 44,[20] and here as well they invoked the glass metaphor with unwearying enthusiasm. Thus Tomas de Villanueva, a sixteenth-century Spanish bishop of such great authority that he was beatified by Pope Paul V in 1618, wrote in a sermon on the Annunciation: "What else can be meant by that door in the Book of Ezekiel, that door that always remained shut, and through which no man can pass, since it was reserved for the passage of God? What else can be meant by that door but this, that the cloister of your [the Virgin's] purity will remain shut? And can a ray of light not leave that cloistered womb without damaging it? Well, we ourselves see that a ray of light passes through crystal without breaking it!"[21]

Exegetes also evoked clouds to describe the Incarnation. Again, the source of these arguments lay in Patristic writings, where a variety of Old Testament passages mentioning clouds or vapor were interpreted as mys-tical references to the Mother of God and spiritual leader of the Church. In both his *Exhortatio virginitatis* and his *De Institutione virginis*, for instance, Saint Ambrose read Isaiah 19:1, "The Lord comes riding swiftly on a light cloud," as a clear and rather graphic allusion to the Incarnation, where Christ was borne by the Virgin. Beginning with an etymological argument, Ambrose extended the Virgin's role from mother to mediatrix:

Those who marry are like heavy clouds, and indeed I believe that the word for those who are to marry—*nubentes*—is derived from the word for clouds, *nubes*, because those destined for marriage are covered with a veil, as if by clouds. And truly those who must bear the weight of matrimony are heavy clouds, for they must also be burdened by conception.[22]

Scripture calls Mary [in Isaiah 19:1] a "cloud" because she was made of flesh, but a "light cloud," because she was a virgin, and not burdened with weighty duties of marriage.[23]

It is written of her: "The Lord came riding on a light cloud." She who did not know the burden of matrimony is indeed light; she who lifted this world from the heavy burden of sin was truly weightless.[24]

The association of weightlessness with purity is surely a predictable one, and by no means specific to meditations on the Virgin Mary. But the fact that Ambrose drew on a particular scriptural reference to a "light cloud" is of greater significance, for other such passages in the Old Testament would be read as allusions to the Virgin. Either her role as mediatrix or her paradoxical maternal purity, so neatly combined by Ambrose, might be emphasized. Thus the pronouncement in Ecclesiasticus 24:6, "It was I who covered all men with a mist," became part of Marian imagery, the Virgin being described as a "cloud that casts a shadow over us" to protect men from the ardor of divine wrath.[25] Exegetes also treated the next verse of Ecclesiasticus, "My dwelling place was in high heaven; my throne was in a pillar of cloud," as a reference to the Virgin: the *thronum Dei* was considered an allusion to her physical role as Mother of God, the *columna nubis* a sign of her purity.

While any Marian index, most hymns to the Virgin, and a good many paintings celebrating some aspect of her life will show that the Mother of God was compared to an endless variety of natural and man-made objects, what is relevant about crystal and clouds is their supposed resemblance to the lunar body and the eventual incursion of doctrinal arguments in an astronomical context. There is also the fact, most striking in Italian, Latin, and Spanish texts, that the terms used to describe the physical attributes of the crystalline moon were precisely those associated with the Virgin. Thus the moon was said by some to be *pura*, meaning that it was composed of a single substance, *immacolata*, or without spots, and *pulita*, which might be translated as either "polished" or "clean." Those who argued for its utter difference from the earth and earthly things wrote that they "defended" it, just as did special devotees of the Virgin against the seeming detractors she found in the maculists. Moreover, they condemned those theories that allowed for lunar "corruption" or for the "filth of opacity." In a typical discussion of the moon and its curious spots, for instance, the Baroque poet Giambattista Marino criticized "those who believe that because Cynthia is so near to [terrestrial] elements that she must share in earthly nature," marveling that those thinkers who tried to "contaminate the immaculate glory" of the heavens would not see that "pure and noble celestial things" could hardly be "infected by lowly mixtures."[26] The specter of infection was frequently in-

voked in doctrinal discussions as well: Mary was said by the Immaculists to have been "cleansed of every spot of sin" and to enjoy a freedom from the "corruption" of the flesh. The manner in which she conceived Christ was also described as "without corruption," and as "absolutely spotless." So flawless, in fact, was she in both her conception and that of her Son that Tomas de Villanueva affirmed that "we would do better to consider her body as if it were not of flesh, but rather of silver or of crystal," adding "like the moon at the full, she emanated rays of virtue from her entire being, and illuminated with her light the entire Church."[27]

The Maculate Moon and Marian Imagery in the Telescopic Era

Before turning to those astronomical discussions where the Marian echoes are the strongest, I will show how Galileo's description of the rough and cratered moon violated certain cultural suppositions, and I will then offer one example of a Jesuit scientist's attempt to present the maculate body revealed by the telescope as a paradoxal icon of the Immaculate Virgin.

Among the early modern writers to delight in the connection of the moon and the Virgin was Johnannes Lucidus, author of an important calendrical treatise devoted to establishing the true date of the Crucifixion. Lucidus noted with satisfaction that the Incarnation had taken place at the time of the new moon, marveling, "It is indeed most fitting that Christ was conceived in His mother's womb on the very day of the moon's conjunction with the sun, because Christ is truly the Sun of Justice, and at that time He was joined to the moon, that is, to His Mother the Virgin, through His assumption of human form."[28] With less astronomical detail but equal enthusiasm, Giambattista Marino would explain that "the Sun allows the moon, more than any other star, the communication of its light, just as God gave to the Virgin, more than to any other creature, the fullest measure of His grace."[29]

This kind of association was occasionally deplored. One mid-sixteenth-century writer who strongly discouraged such interpretations was the celebrated Jesuit exegete Gerónimo Nadal, who sought to persuade his readers that the analogy between the Virgin and the moon was inappropriate, and perhaps indecorous as well:

> Oh Mary, you are the most holy and perpetual Virgin, wife and bountiful mother. God the Father clothed you in the Sun, that is, in the light of his Son, which light is the beginning and the end, when he joined this light to flesh in your womb. Indeed for all eternity, this light of his was predestined

in your womb, whence in all time and all generations of men the divine light was derived.

Therefore even before the mystery of the most perfect Incarnation you were enrobed in light, and clothed with even more grace when the angel greeted you and God destined you for the conception of his Son. The conception of your Son of God is truly what clothed you, by God himself, in the immense sun and light, which you yourself then enfolded with his humanity and wrapped in his garment. Truly you were clothed by the divine Sun Jesus as the Celestial Virgin and you stood next to your Son the King as his royal Mother in your robe of gold and white.

Where, therefore, is the moon in this picture of the Virgin? Where is the imperfection? Where are the constant changes? There are none. Where is the moon in the most splendid light of the sun? There is none, and there can be none. The moon has nothing to do with Mary, but rather it is thrown beneath her feet, in order that we understand the divine force in Mary, by which every sin, every imperfection, every spot and mutability was overcome and conquered through the light and virtue of her Son.[30]

As the exasperated and embattled tone of Nadal's statement makes clear, the tendency to associate the Blessed Virgin and the lunar globe, and especially every conceivable detail of the two bodies, was a very common one. This cultural climate explains in large measure both the shock of Galileo's description of the moon—though in this regard he said very little that had not been suggested by him and by others before the invention of the telescope—and his opponents' increasing insistence upon a smooth and semidiaphanous lunar body, one whose alleged immaculacy was an icon of the Virgin herself. It suggests much, too, about the initial reaction of the Jesuits at the Collegio Romano, some of whom were inclined to accept Galileo's findings but were also obliged to preserve the moon's Marian associations.

In the *Sidereus Nuncius* Galileo distinguished between two types of spots of the lunar surface: there were first the large and familiar *maculae antiquae* that formed the moon's face, and then many more smaller, changing ones, visible only to observers armed with a telescope. Galileo was not interested in the former, and he said little about them, other than to suggest that they were due to a genuine difference in the materials composing the moon, meaning that the lunar body was not pure, or homogeneous, in substance. He discussed the latter kind of spots at great length, however, for they were evidence of the mountains and chasms found on a globe that had been generally considered smooth and polished. He took particular care to portray the way the sun's rays fell across the rough lunar surface: they did not describe an unbroken curve, as they would on a smooth body, but rather lit up peaks at some distance from

the terminator, so that innumerable points of light were bordered by an expanse of darkness. Galileo also noted that when a valley was struck by the sun, its most distant wall would be strongly illuminated, while the part closest to the light still lay in shadow. The engravings that accompanied the treatise illustrated the effect nicely, but Galileo also chose to describe the moon's novel appearance through two unusual comparisons: "This lunar surface, which is decorated with spots like the dark blue eyes in the tail of a peacock, is rendered similar to those small glass vessels which, plunged into cold water while still warm, crack and acquire a wavy surface, after which they are commonly called *cyathi*, or 'ice-cups.'"[31]

The reasons for such analogies were, I believe, several: Galileo understood that the vast part of his audience had never used a telescope, and that clear engravings and forceful imagery would be the only means of persuading them that the moon was anything other than a polished sphere. At the same time, the comparisons were meant to be of some aesthetic appeal to such readers: the spots on the lunar surface were as beautiful as those on the peacock's tail, and the unending chain of peaks, valleys, and craters, like that on fine Venetian glassware, not a random production of nature but a pattern imposed by that *Miglior Fabbro*, the Best of Artisans. The fact that Galileo had first learned of the telescope while in the Veneto, that he had used Venetian glass for its lenses, and that he had given one of these instruments to the Venetian Senate and had demonstrated its military potential to them, may also have encouraged him to use a comparison that evoked that republic and one of its most important exports. Even when he freed himself of the potential obligation to the Venetian state by deciding to dedicate the work to another patron, Cosimo II de' Medici, Galileo may not have known of a more suitable way of describing the lunar surface.[32]

Like the proposed name of "Cosmian Stars" for the moons of Jupiter, the reference to the *cyathus* had the classicizing overtones typical of contemporary court taste. The process by which the irregular surface of the "ice cup" was made represented a kind of Mannerist development in glassmaking: bored with the limpid purity of crystal, the Venetian artisan turned to what historians of glass today disapprovingly describe as "technical feats and wilful contradictions,"[33] and he began producing a material that was rough, covered with innumerable fractures, and opaque. This glass seems to have had a particular appeal for the sophisticated and for the very rich, who had surely seen enough of crystal; the Spanish poet Garcilaso de la Vega had a large collection of Venetian "ice glass," and Philip II of Spain had sixty-five such items brought to his palace of El Pardo.[34]

The term *cyathus* itself involved more recondite knowledge; it was the Greek name for a small measuring cup, generally used for decanting wine from a larger bowl-shaped container known as a *crater*. The word *crater*

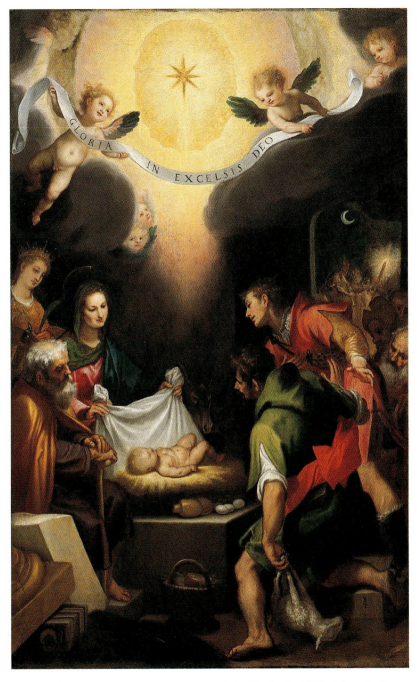

PLATE 1. Lodovico Cigoli, *Adoration of the Shepherds*, 1599. Metropolitan
Museum, New York. (Photo: Metropolitan Museum)

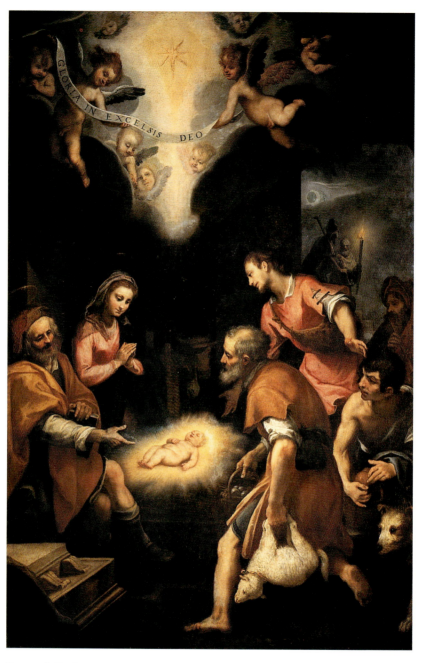

PLATE 2. Lodovico Cigoli, *Adoration of the Shepherds*, 1602. San Francesco, Pisa.
(Photo: Paolo Nannoni)

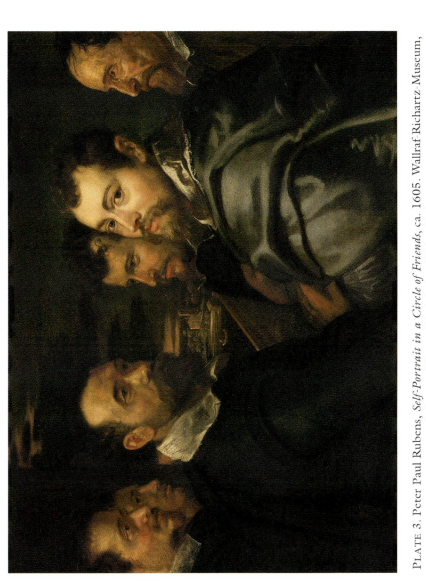

PLATE 3. Peter Paul Rubens, *Self-Portrait in a Circle of Friends*, ca. 1605. Wallraf-Richartz-Museum, Cologne. (Photo: Rheinisches Bildarchiv)

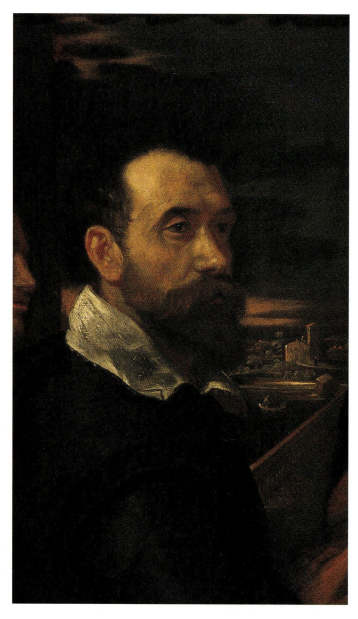

PLATE 4. Detail of Rubens, *Self-Portrait in a Circle of Friends.*
Wallraf-Richartz-Museum, Cologne.
(Photo: Rheinisches Bildarchiv)

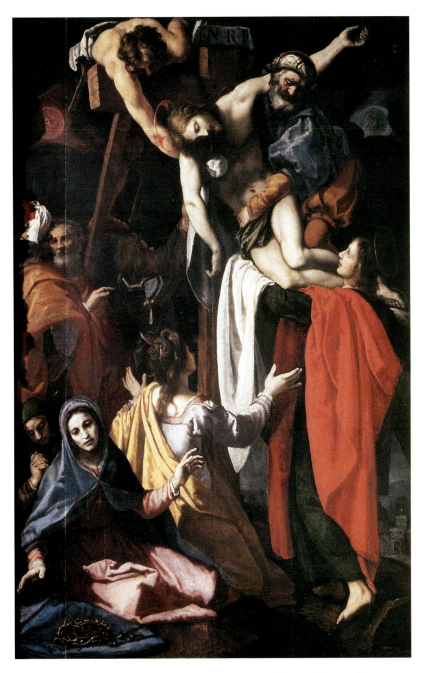

PLATE 5. Lodovico Cigoli, *Deposition*, 1607. Galleria Palatina, Florence. (Photo: Fratelli Alinari)

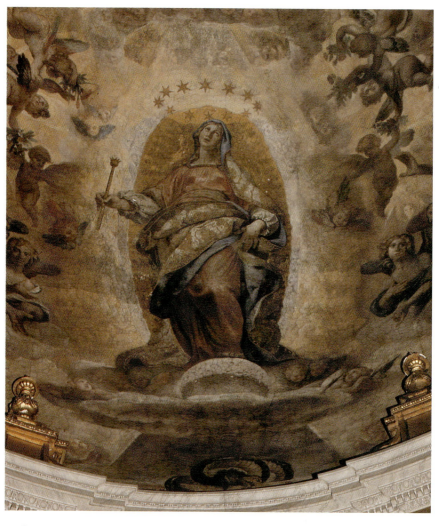

PLATE 6. Lodovico Cigoli, *Immacolata*, 1610–1612. Santa Maria Maggiore, Rome. (Photo: Vasari)

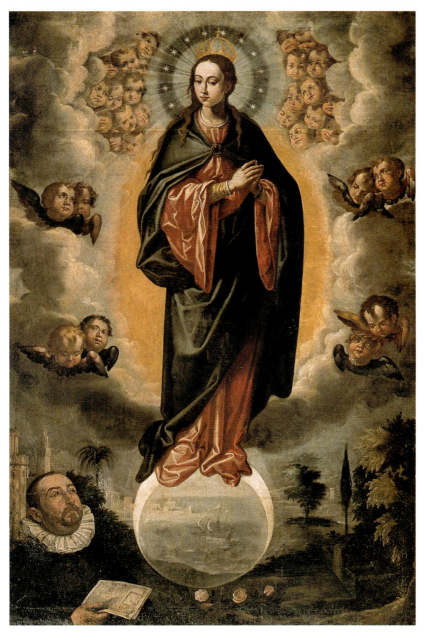

PLATE 7. Francisco Pacheco, *Inmaculada con Miguel Cid*, ca. 1619. Cathedral, Seville. (Photo: Arxiu Mas)

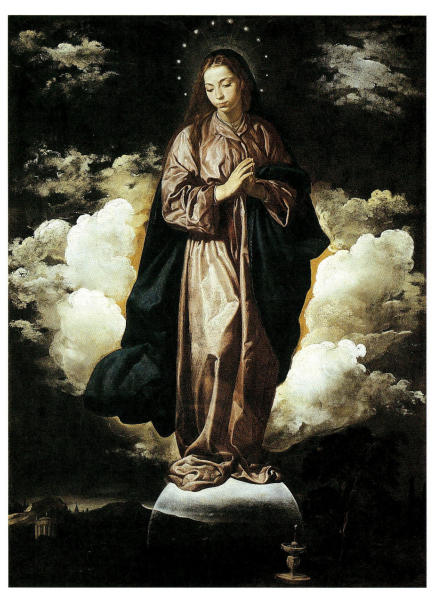

PLATE 8. Diego Velázquez, *Inmaculada*, ca. 1619. National Gallery, London.
(Photo: National Gallery)

had recently been used by Johannes Kepler to describe the depressions on the lunar surface,[35] and it had long appeared in classical Latin poetry and prose as a name for analogous sites in volcanoes on earth.[36] Within a decade Galileo would ridicule such mannered tropes in the astronomical treatises of his rivals, writing: "It is indeed delightful to read in [Orazio Grassi's work] of the birth, the cradle, the dwellings, and the funeral of the comet, and of its having been lighted to illuminate the supper meeting of the sun with Mercury. It has given us no offense that these lamps were lighted twenty days after the supper; still less, that we know that where the sun is, candles are superfluous and useless, and that this was no supper but merely a luncheon; that is, a feast by daytime and not by night, which time of day is unknown to the sun."[37] Here, however, the *cyathus* was part of an established convention, one that implied that the most rugged features on the lunar globe were in fact part of an immense and elaborately wrought dinner service.

In April 1611, just one year after Galileo published this description of the moon, Cardinal Bellarmine, S.J., addressed himself to four Jesuit scholars at the Collegio Romano, asking that they, as men "skilled in the mathematical sciences," confirm certain of the propositions made by Galileo in the *Sidereus Nuncius* and in his subsequent study of Saturn.[38] Less than a week after this request, Father Odo van Maelcote, S.J.,[39] writing on behalf of his colleagues Fathers Christoph Clavius, Christoph Grienberger, and Giovanni Paolo Lembo, stated that they agreed for the most part with Galileo's celestial observations, but that they demurred on two issues. Maelcote reported that the Jesuit astronomers were not sure that Saturn was tribodied, as Galileo had recently affirmed, rather than elliptical in shape, for no member of the commission had been able to detect the three separate spheres that the Pisan saw in a planet we now know to be ringed. Galileo had in fact predicted as much when he first observed Saturn: he had written to Giuliano de' Medici in November 1610 that those who used inferior telescopes would undoubtedly see a bulging "olive-shaped" planet, and very shortly thereafter Christoph Clavius confessed to him that Saturn appeared to him not tribodied but oblong.[40] Moreover, not one of the many scholars and scientists who had puzzled over the anagram in which the discovery was hidden, *smaismrmilmepoetaleumibunenugttauiras*, had been able to find the solution, *Altissimum planetam tergeminum observavi*, or "I saw that the highest planet was tribodied." The second objection, however, was one that Galileo had certainly *not* anticipated: Maelcote stated that Father Clavius, the senior member of the commission, believed that the moon's surface was not rough and covered with valleys, but round and perfectly smooth, and that the spots on it were caused by a single substance unevenly distributed throughout the lunar body.[41]

In mid-May 1611, during a ceremony designed to honor Galileo, then visiting in Rome, Father Maelcote read an address about the *Sidereus Nuncius* aloud to the entire Collegio Romano. The Jesuit scientist first discussed the newly invented telescope itself and the Euclidean proofs of the magnification it provided. Next he offered a brief but picturesque description of Galileo's observations of the lunar body—a point to which I will return—and then of the moons of Jupiter, the fixed stars, the phases of Venus, and the mysterious shape of Saturn. While the *Nuncius Sidereus Collegii Romani* does not appear to have been published, members of that audience mentioned it in letters to correspondents both within and outside the Society of Jesus, and two excerpts of the address were also prepared by Father Grienberger, presumably for distribution in the order.[42]

The manner in which Maelcote described the moon spots to the Collegio Romano seems today curious, and even ridiculous, but it is crucial as the first step in a conflict that involved astronomers and, in time, painters of the *Immaculate Conception*. After recounting the way the sun's rays lit up the highest points of distant lunar mountains and the farthest faces of remote valleys, Maelcote explained to his audience: "By that time one can observe at the tips of the moon's horns certain brilliant peaks, or rather, I might say, *small globules like the shining beads of a Rosary, some scattered amongst themselves, others strung together as if by a thread*. So, too, can many bubble-like spots be seen, especially around the lower horn: that part of the lunar surface is adorned and painted by them as if by the eyes of a peacock's tail."[43] Maelcote would not go so far as to confirm the actual existence of the peaks and craters. He told the Jesuits assembled at the Collegio Romano, in deference to the objections expressed weeks earlier by Christoph Clavius, that he himself was only a celestial messenger, and that they were free to interpret the phenomena as they thought best, and to attribute the new and old moon spots to the "uneven density and rarity of the lunar body, or to something similar," if they so chose.[44]

It is impossible to imagine what Galileo thought of Maelcote's representation of the moon, especially since it was for the most part a faithful synopsis of the observations presented in the *Sidereus Nuncius*. The remarkable metamorphosis of the *cyathus*, the gaudily decorated little wineglass, into the luminous beads of a Rosary is itself worth notice, however, because it signals a persistent preoccupation of many of those who discussed the maculate moon. Whereas the lunar body was for some an icon of the purity and perfection of the Virgin that rested upon it, its newly revealed peaks, valleys, and craters rendered the analogy dubious and even raucously inappropriate. And while Galileo's allusion to the *cyathus* was surely made without the slightest regard for the Marian convention, it would have seemed a curious parody of it: the moon was no longer

associated with transparent glass, that unsubtle emblem of virginity, but with something spotted, opaque, and everywhere covered with fractures.

It might be noted in passing that, as if in confirmation of the ribald connotations of the Venetian tumbler, nearly twenty years later Galileo's friend Niccolò Aggiunti wrote a clever Latin poem involving the *cyathus*. It consisted of an extended comparison of two gifts given him by the astronomer: a telescope and an undisclosed quantity of Greek wine. Aggiunti pointed out, for instance, that the instrument enlarged the images of things, while the drink in the *cyathus* multiplied everything he observed, and that two glasses—the lenses—took him to the stars, but four, above them, and that just as the telescope made all mysteries plain, so the wine rendered every secret public. The telescope made him learned, he found, but the beverage rendered him eloquent; the spyglass sharpened his sight, while the wineglass turned everything rosy; the first gift allowed him to see Venus's horns, and the second would show him how she gave them to Vulcan, her cuckholded spouse. It is difficult, given the associations provided by Aggiunti, to imagine an emblem less suitable for the Virgin than the *cyathus*.[45]

On the other hand, Maelcote's reference to the shining rosary beads was an attempt—perhaps not the most convincing one—to insist upon some connection between this rough globe and the woman who stood on it in 12 Revelation. His Marian allusion does not necessarily concern the doctrine of the Immaculate Conception, but the ambiguity of the remark is typical of the Jesuit order's attitude toward the issue. While various Jesuits were strongly inclined to accept the doctrine as true, the Society's traditional dependence upon Thomist precepts in matters of theology would have made the Immaculist position untenable. The strictures against "novelties" in philosophy and especially in theology, articulated in 1586 in the *Ratio studiorum* and reiterated in decrees of May 1611 and December 1613,[46] would have also discouraged Jesuits from supporting and elaborating reasons for belief in the doctrine, but the fact remains that many in the order were ardent Immaculists. A typical instance of the conflict lay in the proposal made by one Jesuit in the 1580s that the Society rigidly adhere to the views of Thomas Aquinas in *all* matters of theology except for that of the Immaculate Conception. Though the suggestion was not adopted, it is more or less true that in the coming decades the order tended toward Thomism in most issues, without, however, relinquishing support for the controversial Marian doctrine.[47] Not surprisingly, then, Maelcote's image evokes at once the Woman Clothed in the Sun of the Immaculists and the Madonna of the Rosary of the Maculists.

As the Jesuit scientist acknowledged, some in his audience might prefer the old hypothesis of a rare and dense moon, "or something similar,"

to his description of the beaded lunar surface. Such a theory, an updated version of that involving a globe in which a single substance was unevenly distributed, already had its proponents both within and outside of the Society of Jesus. During the next decade it became an alternative to the opinions expressed in the *Sidereus Nuncius* and an appealing hypothesis for anyone intent upon preserving the moon as an icon of the Virgin. As I will show through examination of several such astronomical arguments in this chapter and the next, the terms used to describe the lunar body increasingly resembled traditional Marian imagery. While it would be an exaggeration, of course, to suggest that all of these scientific writers were influenced solely by doctrinal discussions, it is surely safe to say that Marian considerations played a great part in their impressions of the moon and in the manner in which such observations were presented to the public.

White Enamel within a Crystal Sphere

The theory held by Father Clavius, that of a "rare and dense" lunar body, was a relatively old one, shared by most writers from the thirteenth to the seventeenth centuries. Averroes and Albertus Magnus, among others, had suggested that while the moon was made of a single substance, some of the material was so rarefied as to be unable to reflect light, and that the greater part of the globe, by contrast, appeared opaque to the earthly observer because it was denser in composition, rather than different in essence.[48]

In the preceding chapters I showed the way in which Galileo's notion of the secondary light was complemented by analogous considerations in painting. The early modern understanding of the lunar body itself—particularly of a globe of the rare and dense variety—was also dependent upon artistic conventions. Two comparisons of the surface of the moon to the surface of a painting were especially well known and appear repeatedly in discussions of the lunar substance in the first decade after the invention of the telescope. The older and more celebrated version of the topos of the painted moon derives from Plutarch's *De Facie quae in orbe lunae apparet*, in which one speaker argued that the dark spots on the lunar surface were like the shading an artist would use to counterfeit relief: "The layers of light upon shadow, assuming the semblance of height and depth, have produced a very close likeness of eyes and lips."[49] The apparent face in the moon, in other words, was a chiaroscuro mirage, and the smooth lunar body was entirely without peaks and valleys, just as a canvas, no matter how realistic the representation it bore, had nothing that protruded above or extended below its painted surface.

The second argument of this sort was presented by Giovanni da Fontana in a rambling treatise on natural phenomena written in the fifteenth century but not published until 1544. In an explanation that recalls the standard Aristotelian interpretation of the apparent chasm of the aurora borealis,[50] the author did not compare painted surfaces to that of the lunar globe, but insisted rather on the resemblance of frescoes to sunlit clouds:

> If a cloud is between us and the sun, that rarer part through which the solar rays come to us will seem bright, because it is filled with light. The denser part will be darker . . . and will appear at different times in the same cloud like a gaping hole or a whirlpool and a dark depth, and the darker the central part is, the deeper it will seem, and the surounding part all the lighter. Children and the unschooled, in fact, believe that these cloudy phenomena actually are real perforations, almost as if caves and caverns had sprung up in the bowels of the heavens. . . .
>
> From these examples in nature the art of painting has derived excellent precepts, as I have shown in a work written for the great Venetian painter Jacopo Bellini. I did so in order that he would know how to place dark and light colors so that different parts of an image depicted on a flat surface would seem to stand out in relief, and also so that the people depicted would seem ready to advance a hand or a foot, and so that those men or animals placed in the same background would appear to be miles and miles away. Thus the art of painting teaches us that the nearest objects should be bright in color, the distant ones darker, and things in between intermediate in shade.[51]

Fontana's description of the rare and dense landscape in clouds was sometimes applied to the moon, which several early modern authors presented as even more deceptive in appearance than the best of paintings. Curiously, no obstacle lay in the fact that Fontana associated density with darkness and rarefaction with light, while proponents of the semidiaphanous lunar globe generally held the converse; the apparent irrelevance of this problem may be some measure of the appeal of Fontana's argument.

The first author to evoke Fontana's analogy, if somewhat confusedly, was Galileo's longtime enemy, Lodovico delle Colombe, the man who had used the heavenly spectacles to explain the sudden appearance of the nova of 1604, and who had alluded to the "bruised color" of the moon in that period. Colombe's manuscript *Contro il moto della terra* began circulating in Tuscany around December 1610, some nine months after the publication of the *Sidereus Nuncius*. Borrowing from traditional discussions of optical perception, Colombe suggested that the lunar surface was a kind of illusion, one that was even more likely to deceive observers than a painting because it was tridimensional.

In the case of [common sensory perceptions] such as the shape, location, movement and position of things, the eye is easily fooled, and especially so in great distances. Here the square body will appear round, and the sphere flat; an array of colors, shadows, and light will lend a plane figure heights and depths, and nonetheless this will be a false appearance, as paintings show us. Returning, then, to our problem, we state that since the lunar body is composed of dense and rare parts—not just on her surface, like pigment on a painting, but scattered throughout her globe, where they have width, length, and depth, just as would mountains and valleys, if they were found on the moon—the eye at a very great distance may be subject to illusion.[52]

As I noted in my first chapter, Colombe accounted for the appearance of lunar peaks and chasms, and maintained the moon's perfect sphericity by arguing that

If someone were to take up a large ball of very clear crystal, within which a little Earth is fashioned of white enamel, complete with woods, valleys, and mountains, and he were to expose it to the Sun and hold it rather far from the eye of the observer, the ball would not look round and smooth, but rather rough and mountainous, and shadowed where not lit by the Sun, because the transparent part of the globe is invisible and so our lines of sight are terminated in those parts that seem colored. And therefore, whoever looks attentively at this ball and at everything in it, knows that it is perfectly smooth and spherical, though it appears otherwise, just as happens with the moon.[53]

This crystal ball is only one of the many described (and sometimes made) by Galileo's detractors.[54] Colombe saw the inner globe of white enamel as not greatly different from the crystalline material surrounding it, perhaps because both substances were vitreous and because he appears to have considered the terms "white" and "transparent" as synonymous. The lunar body that he described has, both in its guise of a "rare and dense" globe and in its glass and enamel reincarnation, a distinctly medieval flavor, as does the universe in which it is embedded.[55] But while his presuppositions about the lunar landscape led him to assert that the craters, mountains, and valleys crowding the moon's surface were not truly there, in discussing the entirety of the cosmos Colombe was compelled to describe phenomena that could be detected neither with nor without the telescope, but whose reality was for him indisputable. "But why are we searching out examples [of this crystalline substance] in things here below, when it is only too evident in the Heavens? Who does not know that celestial matter is so transparent in those parts where it is sparsely distributed and empty of stars that we can see right through the thickness

of seven spheres, just as if they did not exist, to the starry firmament that lies beyond them?"[56]

Colombe's anti-Copernicanism, the real reason for the entire treatise, compelled him to devote special attention to the moon's secondary light, which had been explicitly linked to Copernicanism in the *Sidereus Nuncius*, and implicitly associated with it as early as 1605. Colombe could not, of course, accept that this light was caused by the earth, or that the dark and rough terrestrial globe could somehow join "the dance of the stars." His explanation of the secondary light, unlike those that would follow, is unusual in that it involves no physical mechanism and depends only indirectly on the moon's movement and angular distance from the sun. For Colombe, less imaginative than later opponents of Galileo and more taken with pictorial comparisons, the ashen light that covered most of the moon's face near conjunction was merely an illusory contrast between the denser and rare parts of the lunar globe, and therefore not substantially different from the moonspots themselves:

> And if anyone were to ask why those parts in the lunar body that we call cavities look like a filthy shadow, rather than being celestial blue like the rest of the heavens, which are after all partly composed of the same rarified matter, we would answer that this difference is visible because of the great light and splendor that surrounds those rare spots. The contrast is even greater in areas untouched by light, that part being still darker, just as off-white looks black when next to milk-white, since "opposites if placed side by side shine forth more brightly."
>
> This is manifest in the body of the moon itself, when only a slim crescent is lit. Since there is not much light, and it does not circle the entire disk, that unilluminated part is bluish in color, not dark or shadowy, as it is when surrounded by a greater light.[57]

As unsatisfying as Colombe's arguments will seem today, they found a certain following in Tuscany, particularly among his disciples in the *Colombi*, the "Pigeon Patrol." In the year after the completion of the *Contro il moto della terra*, he appears to have modified his notion slightly—not enough!—because he realized that the illusory nature of the peaks and valleys of the moon was not precisely the same as that of a painting. In the former instance, as I noted earlier, the enamel craters and mountains really did exist, but happened to be encased in crystal, while the three-dimensional objects depicted on a canvas did not rise above or extend below the surface of the artwork. Thus when Colombe wrote to Father Clavius in May 1611 commending him for his reservations about Galileo's lunar theory, he confessed that he was "especially pleased that you have not accepted the possibility that the moon's surface is rough and mountainous, as Galileo believes and hopes to convince us.

Those mountains that appear in the moon might be real, because the changing pattern of shadows and light show that they exist and have corporeal dimension, and do not lie solely on the surface as if they were painted."[58] Nonetheless, Colombe continued, returning to his hypothesis, by saying they did not protrude above the surface but were sheathed in the purest crystal.

It is significant, finally, that Colombe combined his technical discussions—if they can be called such—with frequent biblical allusions, showing whenever possible that the *Sidereus Nuncius* in particular and Copernicanism in general violated both common sense and Scripture. The treatise ended by citing the Sevillian Jesuit Father Juan de Pineda's condemnation of Zúñiga's heliocentric interpretation of Job 9:6, and by dismissing most of Galileo's claims as a web of faddish inventions: "We conclude, therefore, that the Earth is in the center of the Universe, that because of its heaviness it is immobile, that the Sun, located in the Fourth Heaven, revolves about the Earth, and that the moon is speckled with rare and dense material, not with mountains and chasms, and that she is perfectly smooth and spherical, as everyone has always believed."[59]

Other Glass Globes

Despite significant differences in tone and substance, Colombe's work would have also complemented objections raised by Johann Brengger of Augsburg, one of several writers to contest Galileo's measurements of the moon's mountains. In the *Sidereus Nuncius*, Galileo had used a geometrical demonstration to show that a lunar peak lit by the sun but lying in the dark part of the globe reached a height of four Italian miles. Though neither Brengger nor another of Galileo's critics, the anonymous author of the "De Lunarium montium altitudine," devoted himself to the question of the actual substance of the moon, their disparagement of Galileo's calculations seemed to reinforce the arguments of those writers who, like Colombe, stated that the rough appearance of a crystalline and enamel lunar surface was due to an optical illusion.[60]

Brengger's objections were conveyed to Galileo by Mark Welser, a wealthy Augsburg banker with important ties to the Jesuit order and an amateur's interest in astronomy. Galileo responded to Brengger with a patient letter in November 1610,[61] but he was more irritated by the "De Lunarium montium altitudine," which circulated in manuscript and was the subject of a public debate held in Mantua in May 1611. He suspected that its author was Giuseppe Biancani, a Jesuit scientist living in Parma. Father Biancani, who would recapitulate many of these issues in 1620 with his *Sphaera mundi*, denied the charges and insisted that he had tried

to dissuade the writer, whom he apparently knew, from developing the arguments most offensive to the Pisan astronomer.[62] What is significant here is Galileo's readiness to associate the theory of a smooth lunar globe with the Jesuit order, a belief that may have been unfounded at that time, but one which would prove correct in the coming years. Galileo suspected criticism from still another Jesuit source when Mark Welser included a second set of objections to the *Sidereus Nuncius* in his letter of January 1611. This author, who remains unidentified even today, compared the moon to a crystal globe filled with stone:

> On the basis of these observations I would not yet agree that any mountains do indeed rise above the vast surface of the moon, since that great surface is occupied by peaks, rather than by the lower parts of mountains. This alone is agreed, that there are whirlpools within it, yet this does not mean that mountains rise up beyond the moon's great circle. These phenomena have not yet turned philosophers away from their widespread notion that the moon is perfectly spherical. Indeed they say that those jagged peaks are within, just as stones of various colors and masses of various shapes may lie within a glass or crystal globe, and so forth. Indeed this opinion has not yet been demolished by these lunar phenomena.[63]

The writer's allusion to the "widespread notion" of philosophers and the casual "and so forth" with which he ends his description suggest that he was referring to a common observation rather than to a novelty, and it is likely that the theory of the crystalline moon had a great many proponents, men wholly unmoved by the arguments of the *Sidereus Nuncius*. Galileo responded to his observations through a letter addressed to Mark Welser, where he noted that the effects of light and shadow noted in the *Sidereus Nuncius* would not come about if the moon were a crystal globe filled with opaque matter.[64] The brevity of his answer is probably due to other more absorbing activities, for he was then busy observing Saturn and establishing the phases of Venus, but the conflict over the lunar substance was far from being resolved.

Lunar Illusions

At this point yet another writer was at work on the retardataire theory of the crystalline moon: early in 1612 Giulio Cesare Lagalla, an old friend of Galileo's and professor of philosophy and logic at the University of Rome or "La Sapienza," published what is surely the most curious of all such treatises.[65] His *De Phaenomenis in orbe lunae* contains a few remarkably bad theories about lunar phenomena, one of which I will examine in some detail, less for its comic value, however, than for the types of expla-

nations to which Lagalla was inclined. Though it is certainly true that what logic Lagalla possessed he must have used in his lectures at La Sapienza and not in this extracurricular publication, his work is important in that it offers the best impression of the kind of lunar theories then flourishing in Rome. His hypotheses, like those of Colombe, were very familiar to Lodovico Cigoli, who saw Lagalla frequently and heard at least one of his public lectures.

Like any professor at La Sapienza, Lagalla regarded the faculty at the Collegio Romano as his rivals, for the intellectual center of Rome had clearly shifted away from his university to the newer establishment of the Society of Jesus.[66] Lagalla himself was a figure of fun for the Roman Jesuits—especially after he mistook smoke rising from a fire outside Rome for a new comet[67]—but his work proved of some value to other authors in the order working in more distant provinces. The *De Phaenomenis in orbe lunae* would be significant not just for its scientific aspects but also for its association of the moon's alleged immaculacy with female virginity. The point I would like to emphasize, however, is not just the manner in which Lagalla's thesis echoes that association, but also the valuable comment it offers on the Jesuits' Marian obsession.

As the title suggests, Lagalla regarded his treatise as a modern and more scientific version of Plutarch's *De facie quae in orbe lunae apparet*, and Galilean sympathizers were quick to deride the allusion.[68] In a muddled elaboration of Plutarch's celebrated comparison of the moon's face to the admixture of dark and light pigments in a painting, Lagalla implied that the mountains and craters that Galileo had observed on the lunar body were, like objects depicted on a canvas, an optical illusion of the sort practiced by painters.[69] The similarities of a rare and dense globe and the plane of a painting are not, I believe, overwhelming, but Lagalla's point was that the moon's peaks and valleys do not rise above its crystalline surface any more than do the various bodies depicted on a canvas. Like Colombe, Lagalla was untroubled by the fact that the lunar peaks and valleys really *are* three-dimensional—whether encased in crystal, as he believed, or not—while the daubs of paint on the canvas have breadth and height but no appreciable depth. Lagalla completed his comparison with a confused equation of the term "light" with "white," an obscurity that characterized Colombe's work as well.

As an instance of a single substance that was, like the moon, at once light and dark, and opaque and diaphanous, Lagalla relied on a familiar natural phenomenon, noting that "nowhere are greater illusions created than those that we see clearly in a cloud lit up by the sun."[70] For the moment I will ignore the Marian echoes in that phrase—though this is precisely the kind of imagery preferred by Andrea Vittorelli in his description of Santa Maria Maggiore in 1616[71]—and concentrate instead on the

artistic associations, for here Lagalla's dependence on the treatise of Giovanni da Fontana is evident. Whereas Galileo had distinguished between two sorts of spots on the moon—the large and dark ones, visible to the naked eye and never altered in appearance, and those smaller ones that were nothing but shadows projected by lunar peaks, subject to constant change and apparent only to observers armed with telescopes—Lagalla saw the matter differently, arguing that such effects might also be produced on the surfaces of frescoes and in sunlit clouds. "With all respect due to this most learned man [Galileo]," he wrote,

> his response is not satisfying to me, since on the smooth and even surfaces of walls we see white mixed with dark by painters skilled in the art of perspective in such a way that some things always appear the same to us, regardless of our position or distance, whereas others will be various and diverse. This is indeed particular to light and opacity where they have been mixed one with the other in order to bring about myriad and miraculous sights through different and artful combinations. From this it happens, as we stated in the beginning, that nowhere are greater apparitions created than those we see so clearly in clouds lit up by the sun.[72]

Galileo may have recognized that Lagalla was relying upon, or rather elaborating, the theories advanced by Giovanni da Fontana, where light, dark, and skillful foreshortening made painted protagonists appear on the point of "advancing a hand or a foot," for in a note associated with this section of the *De phaenomenis* he included the same comparatively rare reference to the human figure in the midst of a discussion of the limits of perspective. "See whether the author claims that painters can vary the appearance of flesh and colors according to the position of the observer," Galileo wrote, "for this is false and would not take place in the moon, which we never see from different angles."[73]

It is true that Galileo himself turned with remarkable frequency to clouds, vapors, "exhalations," and even to ether, and used them to describe several phenomena that seemed irregular in shape and movement, and variable in brightness and opacity. As I showed in my second chapter, he had characterized both the new star of 1604 and the aurora borealis as "exhalations," and he would compare sunspots and comets alike—as different as they are—to clouds. He had already explained his inability to detect mountains on the periphery of the moon by saying that the observer saw the edge of the lunar body obliquely, through a layer of vapor so thick that it obscured the peaks that were visible in the center of the globe. But if Galileo's various references to clouds and to cloudy substances had a kind of ad hoc quality[74]—these exhalations were always fooling his rivals, but Galileo knew exactly how fast the tricky vapors traveled, where they banded together and where they stayed apart, when they

reflected light, when they distorted it, and when they were translucent—Lagalla's cloudy moon was more extravagant still. It was a true *chiaro-scuro* mirage, he said, one in which the naive observer saw "mountains, valleys, whirlpools, seas, lakes, islands, peninsulas, and hills,"[75] all appearing as if painted on a perfectly smooth globe.

This remark is in itself worth comment, and certainly more valuable than the stock painterly comparison I mentioned earlier. The catalogue of lunar sights was a familiar one, for poets from Antiquity through the early modern era had been describing the moon and its many caves, mountains, houses, and cities.[76] But while Lagalla's depiction of that illusionistic lunar landscape—*montes convalles voragines maria lacus insula[e] peninsula[e] promontoria*—was an overt attack on what Galileo believed he saw through the telescope, it was also a covert critique of what other observers, among them certain Jesuits, perceived in the obscure marks of the lunar face: not *voragines maria*, but rather *Vergine Maria*. Put differently, Galileo's assumption that the cloudy and variously illuminated body of the moon meant that it bore "mountains, valleys, whirlpools, seas, lakes, islands, peninsulas, and hills" was only one kind of error; another and more pervasive illusion was that which routinely associated the semidiaphanous globe with the Virgin.

The position of the key words in Lagalla's comment on the Marian tendency is also significant: they are not in the exact center of the sequence, but come instead directly after the first third of it. This detail is important because it recalls the only other disagreement between Galileo and the Jesuits of the Collegio Romano, that involving the contours of Saturn. In the identical place in the celebrated anagram about the tribodied "highest planet" lay a single legible word: smaismrmilme*poeta*leumibunenugttauiras.[77] By early 1612 many observers believed that Saturn was composed of three separate bodies, and that the astronomers at the Collegio Romano had been wrong to question this finding. In modeling his encoded description of lunar illusions on the Saturn anagram, therefore, Lagalla pointed to an earlier instance of Jesuit misreading, implying that once again his rivals at the Collegio Romano were prey to errors in interpretation.

Lest the metamorphosis of *voragines maria* into *Vergine Maria* appear an anachronistic reading, let me show its echo in the work of another seventeenth-century author, the Jesuit theologian Bartolomeo Amico.[78] Writing in 1626 and familiar with the *De Phaenomenis*, Father Amico seems to have recognized the tendency of his age and of his order to associate the illusions of the lunar landscape with the Virgin, most especially with the Annunciation and the Incarnation. In discussing the role of the imagination in observation, he noted that many saw in the lunar

globe the face of a maiden, not because it was really there, he said, but because of the mind's habit of organizing random sensory impressions into coherent and significant configurations. "The imagination is what conceives those various parts as forming a face, or something similar," Amico noted, and as evidence of the way this faculty might fashion perception, he cited the classic story of a man who believed that the rumbling of a thundercloud was telling him, 'The Gauls are coming to Rome.'"[79] Turning then to a more pertinent illustration of why the moon would look to some like a maiden's face, Amico explained, "Indeed our imagination is what makes a sound like an articulation, or even like the desire of the listener, just as it is said that a woman, hearing the sound of a bell, used to say that it was bidding her to get married, for that is what she chose to hear."[80] Here Amico's analogy, ostensibly an illustration of the role of the imagination in the observation of moonspots, reverts as if by necessity to the Marian theme: for the bell that the eager woman would have heard daily would be the Angelus,[81] whose otherwise inarticulate tolling signaled the Annunciation, itself a moment where another woman "chose to hear" what some would have regarded as an absurd message about *her* unlikely nuptial arrangements, and in so doing conceived the Son of God. In other words, it is as if all examples of what was illusory and arbitrary about patterns glimpsed in the moon, including those of Amico and Lagalla, referred inevitably to that association of the lunar body with the Virgin.

Lagalla described the moon as "neither perfectly opaque nor perfectly diaphanous"—an expression that would later be used within Jesuit circles—and he compared its variegations not just to a sunlit cloud but also to a marble ball.[82] Though he insisted that the lunar body was composed of a single substance unevenly distributed and variously receptive to light—a vague formula that he believed could account for any number of effects—he also invoked the moon's distance and angular separation from the sun to explain the presence of the secondary light on its surface just before and after conjunction. Basing his argument in part on medieval optics,[83] Lagalla wrote that the secondary or ashen light was not due to a mutual exchange of illumination between the earth and its satellite—a notion "which the divine Galileo had contrived out of the opinion of the Pythagorean Philolaus"—but to the obliquity with which he believed the sun's rays struck and penetrated the semidiaphanous body of the moon at certain points in its orbit.

> When she is illuminated some time before the sextile [i.e., around the fourth night of the lunar month] all that remains of her body seems to be showered with a shadowy and tenuous glow; in fact, the moon is receiving

light from the oblique rays of the sun, and the amount of the lunar globe that is visible to us depends upon the thickness of the surface. That this should occur is manifest, for the secondary light is a little bit diminished as she recedes more and more from the sun and begins to receive the solar rays less and less obliquely, until, having passed the first quadrature, it vanishes entirely, with the sun's rays now more directly illuminating and shedding [primary] light on her surface.[84]

The idea is not a very good one at all, for Lagalla imagined that the solar rays, which issue from a body so distant that they are effectively parallel, were instead of varying incidence, almost as if the sun were a giant eye following the moon about in its orbit, shifting constantly to keep it in view. Though this detail required some correction—it is difficult to account for the moon's phases with such illumination—the notion that the contrast between the primary and secondary light might be ascribed to the distance the latter had to travel through the various layers of dense and diaphanous material in the lunar body would be repeated in later treatises. And while Lodovico delle Colombe had done no more than attribute the contrast between the two kinds of light to an optical illusion that he found especially misleading when the moon was near conjunction, Lagalla's explanation of the phenomenon had a physical and, presumably, a quantifiable basis, and it must therefore have seemed to its author all the more rigorous and satisfying.

The most curious of Lagalla's arguments concerns his discussion of the points of light scattered over the darker part of the lunar surface. Galileo had written that such features, not visible to the naked eye, were evidence of the moon's rugged landscape, and that they were either peaks or valley walls struck by the sun while everything around them still lay in darkness, although within a few hours this shadowed area would be flooded with light as well. As one might expect, Lagalla's interpretation is at once a rather poor physical explanation of the phenomenon, a lavish, even extravagant, appeal to the imagination of his readers, and an important commentary on their Marian tendencies:

In this instance we answer that it is not impossible that blind alleys of the diaphanous and permeable body stretch beneath the moon's opaque surface, with the diaphanous part emerging here and there out of the depths onto the surface. Through these ducts the light would erupt after a long interval, and spreading little by little to the surface it would become more brilliant and more widely propagated. In just this way they say that the waters of the River Arethusa, absorbed in the soil of Sicily, and flowing for a very long distance, and even under the sea itself, appear again in the faraway region of Boeotia, because they recognize objects thrown in the spring [in Sicily] that surface later in that remote [Grecian] spring.[85]

Lagalla's theory, bravely offered both in print and in a public lecture at the Sapienza in Rome,[86] requires some attention. His impression of the sluggish rate at which sunlight traveled through the diaphanous medium—those trapped rays winding their way about the tortuous underground channels and chasms of the moon until, emerging at last somewhere on the shadowed part of that globe, they slowly seeped like some great puddle of brilliance up to a clear spot on its surface—would have seemed a pleasant absurdity, especially since most of his audience believed in an instantaneous transmission of light.[87] Certainly the English author John Wilkins found it so in 1638, writing in his *Discovery of a World in the Moone*, "Because this is one of the chiefest fancies whereby [Lagalla] thinkes hee hath fully answered the arguments of this opinion, I will therefore set downe his answer in his owne words, lest the Reader might suspect more in them then I have expressed," before offering this passage from the *De phaenomenis*.[88] Wilkins's disbelief notwithstanding, there is indeed something "more" in this explanation, as I will now show.

Lagalla's reference to classical mythology is not entirely accurate, for the River Arethusa, like the story itself, originated in Greece and resurfaced in what was then the comparatively remote outpost of Syracuse, not vice versa, though perhaps only the residents of Boeotia, "a region whose inhabitants were known for their stupidity,"[89] would have been offended by this error. Consider, however, not what Lagalla forgot about the tale of Arethusa, but what he remembered, and why he offered it as an explanation of the uneven distribution of light on the lunar surface. As she tells Ceres in Ovid's *Metamorphoses*, Arethusa was one of Diana's nymphs and was bound like that goddess to an ideal of fierce chastity. Returning one summer day from the hunt, Arethusa "came upon a stream flowing without eddy, and without sound, crystal-clear to the bottom, in whose depths you might count every pebble, waters which you would think scarcely moving."[90] She discarded her robes and was playing in the water when she heard a noise deep in the pool, a sound that turned out to be only the first advance of the river god Alpheus. Finding her unpersuaded by his hoarse appeal, "Whither in haste, Arethusa?" Alpheus took on human form to pursue the nymph.

The chase Arethusa describes has a nightmarish combination of terror and despair, though nothing in this distinguishes it from the marmoreal cruelty of other such events in the Ovidian catalog, or explains its immediate relevance to Lagalla's discussion of lunar phenomena. They race over plains, mountains, rocks, and cliffs. Arethusa recalls: "The sun was at my back. I saw my pursuer's long shadow stretching out ahead of me—unless it was fear that saw it—but surely I heard the terrifying sound of feet."[91] At last she begs Diana for protection, and the goddess cloaks her devotee, rather foolishly as it turns out, in an "impenetrable mist."

Alpheus prowls about the "hollow cloud," watching it and calling out for
Arethusa. When, out of fear, the vaporized nymph turns into a stream of
water, the river god recognizes her even in this condensed state, and, re-
assuming his fluvial form, promiscuously blends his currents with hers.
Diana then opens the earth so that Arethusa might escape her assailant by
flowing under the sea and rising to the surface only in remote Syracuse.

Lagalla's reasons for invoking this episode in his discussion of the semi-
diaphanous globe are telling. In the first place, he would have associated
certain details of the misadventure—specifically, the various metamor-
phoses that the protagonists undergo—with the suggestions he had been
making about the different effects supposedly produced by a single sub-
stance unevenly distributed throughout the lunar body. Recall, for in-
stance, that Alpheus is described in precisely the terms traditionally used
to evoke diaphanous and opaque matter on the moon, since he changes
from a limpid pool of water to something solid enough to throw a dark
shadow across the rough terrain of the chase, just as Arethusa undergoes
that disastrous and unaccountable transformation from the "impenetra-
ble mist" to flowing fountain.

The peculiar admixture of supremely realistic with vague and even un-
intelligible details in the story—the genius of the Ovidian metamor-
phoses, though not a strong point in scientific explanation—is also a
constant feature of Lagalla's discussions of phenomena in the lunar
globe, where his initial insistence on physical, material, and even quan-
tifiable causes too often ends in obscurity. Thus the bizarrely sharp focus
of Arethusa's original depiction of the River Alpheus, what one might
flippantly term her "miscalculation" of that "stream . . . in whose depths
you might count every pebble" [*aquae . . . per quas numerabilis alte
calculus omnis erat*], gives way to impressions that become less and less
precise: a "long shadow" on the landscape that she believes might just as
well be her own hallucination, then an impenetrable but hollow cloud of
mist of unknown dimensions, and finally a river whose polluted source is
passed over in silence.

I have been suggesting that discussions of the way sunlight behaved on
(or in) the vaporous or vitreous lunar body are disconcertingly like expla-
nations of the Incarnation, since these usually depended on illuminated
clouds or crystal. It is difficult, however, to imagine a story more different
from the mystery of the Incarnation, an event that brought honor to the
Virgin and salvation to all men, than the tale of Arethusa, which seems to
have involved little other than loss and shame. If there is a common de-
nominator, it is a crude one—roughly, the sexual encounters of one- or
all-time virgins. Yet it is this that is most significant about Lagalla's effort
to outdo his Jesuit rivals. His brazen attempt to replace one vapor-

shrouded virgin with another, and one god-and-man with another, was not intended to provide early modern audiences with an accurate physical explanation of the properties of light on the lunar globe, but rather to awaken them, through the mild shock of this substitution, to their inevitable expectation of the Marian motif in their observation of the moon. In sum, then, there were two sorts of illusions in every lunar landscape: in Lagalla's view, the bright peaks and shaded valleys that Galileo had lately seen through his telescope; and the much more pervasive Marian vision that the Pisan's work contested. "Nowhere," as Lagalla had warned his readers with what now appears to be a studied reference to the icon of the Incarnation, "are greater illusions created than those we see in a cloud lit up by the sun."

The *Immacolata* and the Maculate Moon

Despite Galileo's criticism, the lunar body described by Colombe, the anonymous Jesuit, and Lagalla became ever more translucent: within the next two years three writers associated with the Society of Jesus depicted it as crystalline or vaporous and almost entirely free of what they called "the filth of opacity." While their theories greatly influenced the *Inmaculada* tradition in Spain—the subject of my fifth and final chapter—at this point I will be returning to the importance that the earlier arguments for the immaculate moon had for Lodovico Cigoli as he painted his greatest work, the *Immacolata* of the Pauline Chapel at Santa Maria Maggiore in Rome[92] (see plate 6).

There can be no doubt that Cigoli was influenced in this painting by Galileo's contemporaneous discoveries and by the controversy surrounding them. He began work on the Pauline Chapel in September 1610, just six months after the publication of the *Sidereus Nuncius*, and he completed it about two years later, during which time Galileo's lunar theories had been so greatly contested. The extant correspondence between Cigoli and Galileo for this period reveals that the artist was conversant with the work of those men who contested the claims made in the *Sidereus Nuncius*; indeed, it was Cigoli who kept Galileo informed about both the interest and the envy his celestial discoveries aroused in Rome. He heard at least one of Lagalla's public lectures, referred with amazement to Father Christoph Clavius's sometime preference for a semidiaphanous moon, and constantly warned Galileo against the enmity of Colombe. He also mentioned frequent visits with Father Christoph Grienberger of the Collegio Romano, one of the four Jesuit astronomers asked by Cardinal Bellarmine to verify the main points of the *Sidereus*

Nuncius and among the most intelligent and sympathetic of Galileo's fol-
lowers.[93] He read, copied, and bound together both the work of those
who believed in a semidiaphanous moon, and Galileo's several discus-
sions of the lunar substance,[94] and he enjoyed the astronomer's company
in Rome from the end of March 1611 until the beginning of June of that
year. It was at that time that Cigoli would have been able to discuss more
fully with Galileo how best to depict the moon that lay beneath the feet
of the Woman Clothed in the Sun.

It has long been recognized that the cratered moon is a slightly fore-
shortened version of an engraving in the *Sidereus Nuncius*, the one de-
picting the moon at first quarter, when it is about one week old. What
has not been studied, however, is the place that Cigoli's *Immacolata*
occupies in the debate over the lunar body and the manner in which
Cigoli used this painting to challenge lunar theories with Marian over-
tones. As I will show, Cigoli's presentation of the maculate moon is
above all an accommodation of Galileo's recent discoveries to Scripture
and one more instance of the artist's belief in the relevance of scientific
progress to matters of faith.

Some features of the moon at Santa Maria Maggiore recall Cigoli's
1602 *Adoration of the Shepherds* and his *Deposition* of 1607: in all three
cases, for example, a mantle of vapor surrounds the lunar body. Here it
clearly serves to reflect light onto the unilluminated portion of the
moon's face, for the uneven or scalloped border of the cloud bank below
the moon is mirrored in the darker part of the globe, showing that in
1611 Cigoli, like Galileo, attributed the secondary light both to the earth
and to whatever clouds clustered about the lunar body. It also seems to
me likely that Cigoli's juxtaposition of the moon and the cloud beneath
it was a deliberate and contradictory response to those who insisted on
the apparent similarity of those bodies. The moon is opaque and solid
enough to support the massive left foot of the Virgin; the cloud, by
contrast, is so tenuous in substance that cherubs hover within it. The fact
that both the lunar globe and its vaporous pediment are painted in a
fresco is important as well, for the common term in comparisons such
as that offered by Lagalla was the technique of the artist, where dark
and light pigments were traditionally understood to obscure, rather than
elucidate, any distinctions that others would see between the moon and
sunlit clouds.

But the most significant aspect of this portion of the cupola is neither
the moon nor the cloud beneath it but rather the immense shadow cone
that extends below them and covers the dragon of 12 Revelation. It is
evident that it is the moon—solid, dense, and opaque—that blocks out
the light and throws the area beneath it into semidarkness, but the source

of the illumination is less clear. The Woman Clothed in the Sun cannot be the origin of the light, for she, too, is illuminated from above, as the highlighted portions of her gown make plain. Inspection of a larger area of the cupola shows, however, that light comes down to her from the oculus, where the sunlike figure of God the Father is painted.

Cigoli's accommodation of real and artificial light is further refined by the addition of a ring-shaped cloud above the Virgin, one which appears to serve as a conduit between actual and painted illumination. This circle of vapor is that mentioned by Luke in the Annunciation, where the Angel Gabriel told the Virgin that she would conceive when "overshadowed by a higher power."[95] The cloud that covers her, in other words, signals the moment of Christ's conception, rather than that of her own, the miracle of the Incarnation being the single greatest reason to suppose that the Virgin, like her Son, had been conceived by extraordinary means.

It is important to recognize that Cigoli's presentation of the *Immacolata* relies on the Marian tradition without renouncing any of Galileo's recent conclusions about the maculate moon. There is an overwhelming symmetry in the entire arrangement, as if what Galileo had lately recounted in the *Sidereus Nuncius* were the complement of what Gabriel had explained at the Annunciation: at the summit of the configuration is the Godhead from whom all light comes, and at the bottom lies the dragon, enveloped in a shadow projected by the opaque moon; next, there is the cloud that overshadowed the Virgin at the moment of the Incarnation, balanced in size and in substance by the mass of vapor beneath the lunar body; finally, the elliptical crown of stars above Mary's head is mirrored by the foreshortened and lighted portion of the moon beneath her feet. The midpoint of the entire portrait of the Woman Clothed in the Sun is, predictably, the Virgin's womb, for as I have insisted throughout, most celebrations of her conception seemed to lead inexorably to that of her Son.

One might regard this pattern as a neat balance of good and evil, the radiant godhead being opposed to the shadowed serpent, the luminous and life-bearing ring of vapor to a cloud that can do no more than reflect light, the bright and symmetrical crown of stars to the dark, opaque, and randomly marked moon. What is more interesting than this arbitrary and unsubtle configuration—one where the Virgin's womb would be a kind of pivot about which good and evil are arranged—is the shadow cone beneath the moon, for it concerns Cigoli's vision of the scriptural and the scientific. To put matters another way, while the oppositions of good and evil, high and low, light and dark, evanescent and opaque are surely present in the *Immacolata*, it is unlikely that Cigoli viewed the lower part of the painting, largely concerned with Galileo's recent revelations, as an

inferior version of Revelation itself or of astronomy as the fallen equivalent of celestial knowledge, but rather as an integral part of any heavenly vision. In what follows I will show how the painter used the shadow cone beneath the moon to imply, as he had in the *Deposition* of 1607, that religious faith and scientific advancement were inseparable.

In the Shadow of the Moon

Even before Cigoli began working at Santa Maria Maggiore, contemporaries complained about the structure of the building, and a document of February 1608 suggests that the newly completed Pauline Chapel and especially the sacristy adjoining it were subject to particular criticism: "When His Holyness [Pope Paul V] went to see the construction of his chapel and the sacristy in Santa Maria Maggiore, they say that he was not at all satisfied, at least with the sacristy, which is much further along than the chapel. This is because it is dark and the rooms are somewhat crooked, and it's no wonder, because popes always want to use their masons as architects, and if things don't turn out well, we shouldn't be surprised."[96] The tall drum and steep walls of the cupola also presented a great challenge to the artist, for if seen by an observer standing at the exact center of the chapel, the painted figures of the Madonna and the apostles appear slumped over and awkwardly distorted.[97] Cigoli did, of course, take into account the fact that those who viewed his work would be far below it, and among the sketches that survive today are those detailing what sort of perspectival distortion would be needed.[98] In April 1612 he seemed confident that all the figures in the cupola would be legible when viewed from below, and he wrote to Galileo, "Everything [except for the Apostles] is done—the heavens, and the angels, and all the rest—and to the satisfaction of Cardinal [Iacopo] Serra and the others. Now for the hard part, that is, the reaction of His Holyness, and also for how it will look from below. I have really worked hard to paint it in brilliant colors, and not to make the principal figures mixed together as if piled one on the other, and where they are closely clustered, I have separated them with dark and light tones, and so I believe that the distance will prove no problem."[99] His optimism nothwithstanding, Cigoli was said to have been extremely disappointed with the final appearance of the chapel, protesting that he wanted to destroy the existing frescoes and begin it all anew, and being persuaded to leave his work in place only because of its great appeal to the pope. A contemporary writer, Giulio Mancini, even suggested that it was Cigoli's despair over the cupola that contributed to his sudden death in June 1613, less than one year after its completion.[100] Such an account appears exaggerated—though it is per-

fectly credible that the health of this frail fifty-four-year-old man was broken by overwork and the excessive heat and humidity of the cupola[101]—but it is quite true that the painting is not meant to be viewed from a single point at the center of the chapel. It has also been noted that the Madonna, the largest and most important figure in the work, is best observed laterally, from the entrance to the chapel just off the nave.[102] I will now try to establish that there is evidence within the painting itself that Cigoli intended to designate a lateral rather than central position for those who viewed his work, and that he did so in order to elucidate arguments both astronomical and religious in nature.

Consider the shadow cone beneath the moon. I have suggested that its primary function was to show the opacity and solidity of the moon at a moment in which Galileo's rivals were insisting that it was diaphanous, translucent, and, by 1612, completely transparent. But it is surely important that the dragon lies within the darkest part of the shadow cone—the umbra—and more significant still, that if the penumbra or lighter portion were extended downward through the drum and the clerestorey to the floor, it would cover all the viewers, but less those persons who stood at the chapel's perimeters and viewed the Madonna from this lateral position. Some of this configuration was of course determined before Cigoli ever began work on the cupola: the subject would have necessarily involved a score of figures, of which the Virgin is obviously the most important. The space she occupies, roughly one-eighth of the surface area of the cupola, and the size of the moon beneath her feet, would have been established by Cigoli himself, but the enormous height of the dome above the church floor, the size of the chapel, and consequently the great area covered by the moon's fictive shadow would not have been his to decide. Nor would the range of light and dark within the penumbra have been subject to his modifications. But as it happens, the *sbattimento* or cast shadow was the focus of a lengthy section of his *Prospettiva pratica*, an area in which he had developed the conclusions drawn by Leonardo in the *Trattato della pittura*.[103] In the case of the Pauline Chapel, the shadow cast by the moon would be lightest, of course, at its edges, and therefore those viewers who observed the *Immacolata* laterally would stand in a kind of half-light, while those who stood in the center of the chapel would see the Virgin as if through a much darker shadow. Those directly beneath her and in the darkest part of the penumbra would see nothing, their view being blocked by both the actual cornice above them and by the great obscurity of the fictive shadow.

Visual clues of this sort, ones that indicate where it is that an ideal observer would stand in order to see a painting without distortion or to belong somehow to the depicted scene itself, were by no means uncommon.[104] As regards perspectival considerations, such indications would

become increasingly dramatic later in the century: in the Jesuit church of
Sant'Ignazio, for instance, the viewer who kept his distance at the center
point of the nave would see a harmonious scene of painted architecture
and the heavens above him, while he who wandered about the church
had the impression that its walls were buckling, its columns bending, and
the sky falling in. But the shadow in Cigoli's *Immacolata* implies more
than this, I think. It suggests not just that those who are within the cen-
tral and darker part of its penumbra are unseeing, but that they are
blinded precisely because they do not recognize the opacity of the moon
and the relevance of the objective and rigorous depiction of the lunar
body to their vision of the *Immacolata*. Put another way, the best reason
for viewing the Woman Clothed in the Sun laterally and from a distance
is the acknowledgment that standing any closer is first to be enveloped in
the darkest part of the fictive shadow, and then to miss the lower and
astronomically precise part of the painting. Conversely, to see the entire
portrait of the *Immacolata* is to understand the particulars of Galileo's
argument—that the moon is rough, dark, and wholly impervious to
light—and the amplitude of Cigoli's vision, where the scientific cannot be
severed from the scriptural.

There are a variety of motives, none of them surprising, that might be
ascribed to those of Galileo's enemies who, insisting upon a crystalline or
semidiaphanous moon, refused to see the opacity of that body and who
would be, in Cigoli's view, trapped in the darkest part of the shadow it
cast. Ignorance, obviously, would make them benighted, but there is also
much to suggest that Cigoli attributed the apparent blindness of these
astronomers to *invidia*, or envy, traditionally interpreted as vision im-
paired by psychological factors.[105] In what follows I will explain the rele-
vance of this motif in the *Immacolata* to Galileo's contemporaneous diffi-
culties with his rivals and to the loyal advice he received from his friends,
particularly Cigoli and Federico Cesi, founder of the Lincean Academy.

On *Virtú* and *Invidia*

In an important article published in 1975, Miles Chappell suggested that
an allegory of Virtue's triumph over Envy drawn by Cigoli was intended
for Galileo, and that it referred at once to the astronomer's recent discov-
ery of the four Jovian satellites and to the animosity aroused by his late
success.[106] (See fig. 2.) Beneath one of the two sketches of this allegory
Cigoli had written: "Your Lordship's situation reminds me of this con-
ceit, that if work does not fear Jove's thunderbolts, then it will never be
conquered by Envy, since it seems to me that Virtue has its roots in strug-
gle. . . . In drawing this woman [Virtue] for you I show her slowly mak-

FIGURE 2. Lodovico Cigoli, *Allegory of Virtue and Envy*,
ca. 1611. Gabinetto Disegni e Stampe degli Uffizi, Florence.
(Photo: Savraintendenza dei beni culturali)

ing her way through rocks and thorns, and these will eventually redound
to her glory, as for instance you see her crown and her arms changing into
laurel branches."[107] Chappell argued that the allegory would have been
appropriate for Galileo, "whose path crossed those of Jove and *Invidia*,
[and] whom Cigoli addressed as V.S. or *Vostra Signoria*."[108] Drawing on

Cesare Ripa's *Iconologia*, Chappell also showed how closely Cigoli's Envy and—to a lesser extent—Virtue conformed to the standard Renaissance emblems.[109] Envy was traditionally an old, naked, and very thin hag, surrounded and perhaps bitten by a serpent and crowned with snakelike hair. She carried vipers as well and used them like poisonous darts to throw at Virtue. Cigoli's Envy even more closely resembles the *Invidia* of Lodovico Ariosto's *Cinque Canti*, which both the artist and the astronomer admired: like the figure in the sketch, that old woman lived in a "horrible cave," had a "livid stare," and was also cross-eyed. Though appallingly thin, she was constantly gnawing on some poisonous flesh, which may have been either her own heart or one of the serpents not used as a weapon or in her headdress.[110]

The other figure in Cigoli's allegory is somewhat more puzzling. She is much younger—for Virtue, at least according to Cesare Ripa, never grows old[111]—and she carries laurel or wears it as a crown in order to indicate that just as that plant may be menaced but not harmed by lightning, so she can withstand any violent onslaught.[112] I would suggest that Cigoli altered the traditional figure, for it is clear that his Virtue is neither carrying nor wearing a branch of laurel but actually turning into one. For this reason, in fact, the allegory was once identified as a representation of Daphne, transformed into a laurel by her father.[113] Apart from this deviation—one to which I will return—Cigoli's Virtue is like that described by Ripa: sturdy, vigorous, and majestic in her bearing, and utterly untouched by the vices around her.

Though Chappell rightly emphasized the allegory's connection with Galileo's study of the Jovian satellites, there is much in the Envy and Virtue motif that applies equally well to the even more passionate discussions about the moon. I will be arguing that both the *Immacolata* of Santa Maria Maggiore and the allegory are concerned with the issue of Virtue's triumph over Envy, and that some of Galileo's supporters liked the conceit well enough to make it a part of his next astronomical project, the dispute over the sunspots in 1612–1613. Let me begin by pointing out several general similarities between the contemporaneous figures of the *Immacolata* and Virtue. Both are young women of classical proportions, and both have uplifted heads, ecstatic gazes, and a contrapposto stance. Both conquer some form of evil, Virtue triumphing over Envy and her snakeskin apparel, the Virgin standing over the serpent and that shadowy region where I have suggested that the envious would cluster. In the *Iconologia*, Virtue, like the Woman Clothed in the Sun, has a sun emblazoned on her chest, and she holds in her right hand a spear, or a lance, or a blunted sword, all of these being instruments with which she, like the more regal Virgin, combats vice.[114] In brief, then, we might regard the two figures as variations on a single motif.

But Cigoli may have also relied on another description of Virtue and Envy that would have rendered his *Immacolata* even more like the allegorical figure, and her enemies—or Galileo's—more closely associated with those blinded by Envy. This was Leonardo da Vinci's meditation on the subject, repeated by Giovanni Paolo Lomazzo in his *Trattato*: "There will sooner be a body without shadow than Virtue without Envy."[115] The region beneath the moon, in other words, would perforce be inhabited by the serpent and the invidious, just as Envy and her snakes cluster in their dark cave near Virtue.

Thus far, then, I have adopted Chappell's conclusions about the association of Cigoli's allegory of Virtue and Envy with Galileo, and have extended that particular hypothesis to the *Immacolata* as well. It is in this connection that I will turn to the account of the allegorical sketch offered by Cigoli's nephew and biographer, Giovanni Battista Cardi. As one might expect, Cardi's uncannily inaccurate explanation avoids all mention of Galileo, but includes several details that apply as well to the situation of the astronomer as they do to that of Cigoli himself. Cardi wrote that his uncle had drawn the allegory for himself in a fit of rage over the envy of his colleagues, and though this hypothesis does not very well account for the address to "Your Lordship" on one version of the sketch, the story is worth consideration in its entirety.[116]

The strife between Cigoli and his rivals came about, Cardi explained, over the commission at Santa Maria Maggiore, and the work these envious men attacked was his monumental painting of *Saint Peter Healing the Cripple*, executed for the basilica in Rome between 1604 and 1606. This much associates the Virtue and Envy allegory with that not dissimilar motif in the *Immacolata*, but it is Cardi's version of the episode that provoked the sketch that is really remarkable. While the chronology he provides has been subject to questioning, it is, in fact, his conflation of discrete events on which I would like to focus:[117]

> Since at that time the construction of the Pauline Chapel of Santa Maria Maggiore had been finished, and it was ready to be painted, Cigoli was ordered to make drawings and models of the cupola, and so he presented his ideas, as had Gaspero Celio and Cherubino dal Borgo. On seeing and considering these drawings, His Holiness most preferred those made by Cigoli, and he gave him the commission, to the great disgust of the others. Cigoli was at this moment finishing the painting for Saint Peter's, a work which his envious rivals had seen only in preparatory sketches, but one whose completed state they dreaded, and so they went around thinking about how they could, in a manner of speaking, turn light into darkness.
>
> When they finally saw the finished painting, it was much more praiseworthy that they had dreamed upon seeing the sketch, and they knew they

had no hope of surpassing his *virtù* with their own work. They then con-
ceived a plan to treat him in a crafty and indeed dishonest fashion. They
rapidly sketched the painting in order to have it engraved, which they had
done by a Fleming, and then quickly printed the engraving on old and yel-
lowed paper. They went about showing this to people, and saying that
Cigoli had gotten [the composition] from a foreign print, and that since he
had merely traced the outlines visible on the back of the print, the only
change he had made was the inversion of right and left. This alteration arose,
in fact, because they had had it engraved just as it was in the painting, the
printed version of the engraving being reversed, the right-hand side now
being on the left.[118]

It is entirely credible that Cigoli's less talented rivals were envious of the
Pauline commission, that they found his painting at Saint Peter's even
more impressive than they had feared, and that they realized that they
were powerless to defeat him with their own work. It is possible, too, that
they actually had Cigoli's masterpiece copied by a Flemish engraver,
which may have suggested to all who saw it that the true source of the
composition was an otherwise unknown Northern painting. They may
also have told anyone who would listen that Cigoli's conception was not
original and that he had done no more than copy, improve, and enlarge
the work of an obscure artist in the Netherlands. But in all of this—and
there is no evidence of such a print—Cigoli's experience would bear an
interesting resemblance to Galileo's, for the astronomer was also criti-
cized for appropriating the work of a foreigner and refashioning, in this
case, not the engraving but rather the spyglass of "a certain Fleming."

Compare, then, Cardi's story with Galileo's celebrated account of the
invention of what was known as either the "Dutch" or the "Galilean"
telescope. In the *Sidereus Nuncius* the astronomer wrote that he had
heard that "a certain Fleming" had constructed a device whereby faraway
objects could be seen as distinctly as if they were near at hand. Some men
believed the news, he related, and others did not; he himself soon heard
a second and somewhat more specific description of the instrument, he
wrote, when he received a letter from "the noble Frenchman Jacques Ba-
douvert."[119] Thus far we can point to two similarities in these stories of
purloined inventions: the original source of the telescope was an obscure
Fleming whose find was then made known through the letters of foreign-
ers, just as the alleged creator of Cigoli's design was an unknown artist in
the Netherlands whose work quickly made its way into "foreign prints."

Note, too, Cardi's awkward insistence on the left-right inversion of the
pseudo-antique print, and the way it compares to Galileo's story of the
telescope. All that the Pisan knew about the Dutchman's spyglass, he af-
firmed in the *Sidereus Nuncius*, was that it consisted of a tube with two

lenses, the one plano-convex, the other plano-concave.[120] After some experimentation he came up with the proper combination and was able to observe objects at nine times their actual size. And in fact a strong plano-concave eyepiece and a weaker plano-convex objective lens, if separated by an interval of about twelve inches, will yield an enlarged, distinct, and erect image of a distant object. More interesting is what these lenses (among others) will do if separated by greater and greater intervals: the image first loses definition, then it returns to focus but is inverted, and finally it will diminish in size until it disappears entirely.[121] Galileo could claim, therefore, that his version of the telescope offered an image that was magnified, clear, and upright, the implication being that the many others who had heard of the device may have only come up with images that were smaller, blurred, or upside-down. In Cardi's story of the hoax of the envious, Cigoli's monumental canvas for Saint Peter's had precisely the same qualities: it was certainly larger than the alleged Netherlandish original, clearer than the image subsequently stamped on "old and yellowed paper," and an inversion of its humble prototype, not from top to bottom, but rather from left to right.

In sum, then, the two stories offer the same structure: there was first of all an unseen Flemish source of Galileo's and Cigoli's creations, a painting that was smaller than the prestigious canvas commissioned for Saint Peter's and a telescope that magnified objects far less than would the instrument described in the *Sidereus Nuncius*. Then there was a comparatively crude means of diffusion, the old and yellowed "foreign print" by which Cigoli allegedly came to know the original composition, and the letters like the one written by Jacques Badouvert, describing no more, Galileo implied, than two different lenses enclosed in a tube. Finally, there were certain adjustments and refinements made, apparently, by Cigoli and Galileo alone, while others contented themselves with images that were small, blurry, and either reversed or inverted.

There is also Cardi's use of the word *lucidare*, meaning "to shine or to polish," but in this context "to trace."[122] Cigoli's envious rivals claimed that the artist had "merely traced" the print's outlines; Galileo's detractors could say, with perhaps greater accuracy, that his success was due only to the "pellucid"[123] quality of the glass he had used in his telescope. The word *lucidare* is crucial in both stories, therefore, because in the one instance and the other it describes the minimal effort that each man had supposedly made to appropriate the invention of an obscure Fleming.

All these similarities between Galileo's case and the otherwise uncorroborated account offered by Cardi may have in fact existed, but the manner in which they are presented makes it difficult to believe that Cigoli's nephew was entirely ignorant of the celebrated story told in the *Sidereus Nuncius*. There is also another Galilean echo worth consider-

ing—Cardi's own characterization of the plot of the envious rivals as a desire to "turn light into darkness." The remark recalls both Leonardo's meditation on Envy's relation to Virtue and the conceit of the Pauline Chapel at Santa Maria Maggiore. This may mean that Cardi had read more explicit discussions of either the allegory or the cupola, perhaps in written statements left by Cigoli or in Galileo's lost letters to the artist. Like Cardi's brief comment on the *Deposition* of 1607, this explanation of the events that gave rise to the allegory of Virtue and Envy manages at once to avoid the references to the astronomer that we would expect in a more accurate account, and to include Galilean echoes where they do not belong.

There is finally Cardi's report that Cigoli, despairing over his rivals' attack of *Saint Peter Healing the Cripple*, changed the Dantesque verses *Come d'un stizzo verde ch'arso sia / dall'un de' capi, che dall'altro geme /E cigola per vento che va via* "as a green branch that is being burnt at one end will murmur and sputter [*cigola*] with the wind that escapes through the other" to *Cigoli per il vento va via*, "Cigoli escapes with the wind." As I noted in the previous chapter, the original lines come from *Inferno* XIII, and they regard Pier delle Vigne, who committed suicide when overwhelmed by envious rivals at the Imperial court. According to Cardi, Cigoli adapted the verses to reflect his own problems with invidious enemies soon after his return to Rome from his long stay in Florence. This would mean that if he did in fact utter these lines, he did so in the spring of 1606, after a period of extended contact with Galileo, who was in Florence in the summer of 1605 and whose theory of the nova of 1604 had included, as we have seen, a comparison of the vapor of which that new star was supposedly composed with the vast quantity of "exhalations" given off by an ignited bit of green wood. Though Galileo did not, at least in the fragmentary notes that survive today, use the verb *cigolare* to describe the hissing sound that green wood makes when burning, Cigoli's former collaborator and rival Raffaello Gualterotti did so, in the course of a discussion of atmospheric vapor in his second work on the nova, the *Scherzi degli spiriti animali*, published in December 1605. Thus we can say, at the very least, that the Cigoli-*cigola* puns known to us from Cardi and Gualterotti both emerge in the same period, and may both concern the artist's close and often envied relationship with Galileo.

Cigoli's address to "Your Lordship" on one version of the allegory suggests that the graceful figure of Virtue is a portrait of the ungainly astronomer. The implicit gender change is both unremarkable and, I think, unavoidable, for virtues in general were commonly masculine traits attributed to living men and embodied by allegorical women. Virtue, in particular, was especially manly, being described by Ripa as a vigorous and arms-bearing woman with a virile appearance because her name came

from *vir*, man, or from *vires*, men, a designation by which women, as much as animals and plants, would be naturally excluded.[124] But it is more interesting to consider who it was, if anyone, that Cigoli meant to portray in his sketches of Envy. As Miles Chappell has noted, in his last letter to Galileo Cigoli made what might have been a reference to his allegory of Envy and the likeness it contained, writing "I was at Prince [Federico] Cesi's house, and we laughed a bit at the conclusions drawn by those idiots; and if that drawing doesn't resemble any of them too much, they will attribute it to a chance resemblance, rather than blaming me."[125] The painter would have done well not to put all his talents as a portraitist into the figure of Envy, for he would surely have known that his colleague Domenico Passignano, then engaged in making sunspot observations with him while completing the decoration of the Pauline Chapel at Santa Maria Maggiore, had undergone trial and risked imprisonment in the early 1580s for supposedly portraying other painters who were his rivals as braying asses.[126]

But it is possible that Cigoli's Envy was a likeness of Galileo's chief rival Lodovico delle Colombe, to whom the artist often referred—never without hostility—in his letters to the astronomer. Cigoli associated Colombe, or as he called him, "Pippione," both with a shadowy sort of ignorance and with envy, describing him and his followers in 1613 as those benighted people "for whom it grows dark before evening comes." The perfect emblem for Colombe, he wrote to Galileo, would be a stopped-up chimney, for that would explain how the man managed to cover not only himself but also those who frequented his house in obscurity.[127] The cave in which Envy dwells in Cigoli's sketch would have been like Colombe's house, it seems, for it too is filled with smoke. It is also the case that the unfortunate Colombe bore a marked physical resemblance to Cigoli's Envy, as much, that is, as a particular man can look like an allegorical woman with a snake protruding from her midsection. The face of Envy was described by both Ripa and Ariosto as "even paler than boxwood, and thin and sickly, withered, dry, and disagreeable,"[128] while Colombe was said to be "thin, or rather extremely bony, with hollow eyes" and burdened with a "face like a ghost."[129] Ariosto and certain of the sources cited by Ripa attributed to Envy a "livid" or bruised color—this hue being either that of her eyes or her skin[130]—while this was Colombe's own term, it will be recalled, for the ashen face of the moon.

Most curious of all, finally, is a reference to Colombe's favorite haunt in Florence, a detail that applies not to the allegorical portrait of Envy but to the analogous group who would hover in the umbra of the shadow cone beneath the cupola at Santa Maria Maggiore in Rome. I have interpreted the area, painted and real, in the Roman cupola in astronomical terms; the same space in Santa Maria del Fiore, the cathedral of Florence,

had long been associated with celestial observation in general and with the play of light and darkness in particular, for the solar rays that passed through an aperture in the lantern of the cupola of this church fell not onto the Virgin and the moon, but rather onto the celebrated gnomon which Pietro Paolo Toscanelli had had constructed in the mid-fifteenth century in order to calculate the apparent motion of the sun.[131] Thus it is all the more appropriate that, according to a contemporary document, in the summertime Colombe was always to be found enjoying the cool air in a spot called the "Pigeon Coop": this was a high and remote passage-way just outside the doorway leading to the cupola of Santa Maria del Fiore, a shadowy refuge for those who wanted to avoid the sun and its revelations.[132]

"God Save You from Envy"

Thus far I have argued that the allegory of Virtue and Envy presented by Miles Chappell in 1975 was also a motif in Cigoli's *Immacolata*, and that the thematic insistence on light and shadow and good and evil comple-mented both Cigoli's vision of the Woman Clothed in the Sun and Gali-leo's discussion of a dark and wholly opaque lunar body. My supposition is that Cigoli either designed the *Immacolata* in consultation with Gali-leo, or at least told him about it when the astronomer visited Rome in the spring of 1611. It is not clear, however, that other individuals friendly with the two men were aware of the Virtue and Envy motif until some-what later. For one thing, Cigoli wrote to Galileo in April 1612 that he had neither shown nor discussed the cupola with anyone, though by this point he had been working on it for more than eighteen months.[133] On the other hand, what may seem to us a somewhat wooden description of human traits—despite our own dismal familiarity with Virtue and Envy—might have appeared a more natural association in the early seventeenth century, for any number of Galileo's correspondents wrote to compli-ment him on his "virtue" and to warn him about the envy of others. They did so, moreover, in terms that recall Cigoli's painted allegory and his *Immacolata*, though most of these writers could not have been familiar with either of those works. Because the *Sidereus Nuncius* opened with Galileo's own reference to the motif—a word of praise for those who sought to preserve from the ravages of envy the deeds of men who ex-celled by their *virtù*—it is likely that the astronomical treatise served to inspire them.

Early in 1611 the poet and glass manufacturer Girolamo Magagnati wrote a brief poem in praise of Envy, asserting it was that trait which had led the ambitious astronomer to triumph over all "the Ptolemies, Euclids,

Archimedes and Zoroasters" of ages past and which now guaranteed him a place among the stars.[134] This was an unusually favorable treatment of the issue: "*Macte virtute!*" Galileo's friend Lorenzo Pignoria wrote from Padova at the same moment, "Your name will be read, *in spite of Envy*, in the most celebrated histories of our age."[135] A month later Maffeo Barberini—the future Pope Urban VIII—wrote to Michelangelo Buonarotti the Younger that Galileo had "adorned himself with virtue," almost as if the astronomer were the laurel-bearing figure described by Cesare Ripa.[136] After the ceremony at the Collegio Romano in June 1611, Mark Welser praised Galileo for his "triumph" over "every spark of Envy."[137] The aging humanist Martino Sandelli wrote to Galileo twice in the fall of 1612 about the issue, calling Envy "the mortal enemy of Virtue" and predicting that neither Envy nor the passage of time would ever manage to obscure the astronomer's name, "which will pass with great brilliance onto future ages."[138]

There was one individual whose remarks about Virtue and Envy punctuate most of his letters for the years 1612–1613: this was Federico Cesi, founder of that first international society of scientists, the Lincean Academy, and an ardent supporter of all of Galileo's endeavors.[139] Cesi and Cigoli saw each other frequently in Rome, and as the former wrote Galileo in a letter of December 1612 after his first view of the cupola, "we are often together, combatting those who envy Your Lordship's glory."[140] While Cigoli mentioned professional rivalry several times to Galileo, saying in 1611 that he wanted to open his friend's eyes to the "great envy" that surrounded him and praying "may God save you from envy, because you will need this above all else,"[141] Cesi seemed positively obsessed with the question, referring to it increasingly often between September 1612 and February of the new year.[142] He was so convinced of the importance of the motif of Virtue's triumph over Envy that he even incorporated it in the title page of the *Letters on the Sunspots*, where the emblem of a laurel-crowned Virtue is above Galileo's portrait, and a pendulous-breasted, snake-covered Envy below it.[143]

The prefatory letters of that work, written by the Linceans Filippo Salviati and Angelo de Filiis, made several references to this wearied theme as well, almost as if it had become a hallmark of Galileo's every discovery.[144] There is some truth to that—Galileo *did* seem to excite an enormous amount of envy—but subsequent correspondence between the astronomer and Cesi indicates that the former had tired of the motif and that he found the prefatory letters pompous in tone and wanted them rewritten.[145] Thus the revised ending of Angelo de Filiis's address to the reader welcomed those members of his audience who were highminded and reasonable, and it added: "These letters [on the sunspots] are now made public for your use and pleasure. Let the envious and the detractors

abstain, however, from reading them, because they were not meant for their eyes. In fact, since they were sent by the author to one individual, someone endowed with great intelligence and an open mind, I should not relay them to those whose talents lie elsewhere."[146] In the longer original version, however, the wonderfully caustic de Filiis let the latter group know precisely what projects they might pursue instead of studying the sunspots; predictably, these involved the ongoing debate over the lunar substance and the vexed question of the invention of the telescope, both issues associated, as we have seen, with motifs of light and dark, and Virtue and Envy:

> Let others, if this doesn't please them, derive from these discoveries the benefit provided by the learned discussion of many details—ones which have long lain dormant in matters of philosophy and mathematics, and are now vibrant and exciting—questions involving the solidity and incorruptible permanence of celestial bodies, or the transparency, opacity, shape, and number of the stars, or light and its refuges, production, reflection, impediments, and so forth, and above all, the position and arrangement of the bodies in this immense universe. *Let them hear on the one hand about making the moon transparent, and on the other about cobbling it together with various and mixed spirits and colors, and let them enquire into the origin of the Lyncean telescope, and its difference from or confusion with other telescopes whose own pedigrees must be established, all of which are most learned or scholarly or delightful matters.* And if these things are not to their taste, let them do without. *But you, Reader, strive virtuously for the truth alone*, appreciating for this reason the efforts and studies of others. Farewell.[147]

Less effective than de Filiis was his fellow Lincean Francesco Stelluti, who composed and offered the following poem for publication with the *Letters on the Sunspots*: "That no one can give to another what he himself does not possess / Was once a true statement, / But your valor now renders it false: / For what light can have spots and shadows / If it outshines every other radiance? And yet the shadows and [sun]spots shed /A perpetual light on your great name."[148] Stelluti followed these verses with an apologetic and revealing note to Cesi about his obscure conceit: "And while it is true that the *Letters [on the Sunspots]* are not concerned with shadows, [Galileo] discussed them in his other book, when he talked about the shadows on the moon. And since there is neither time nor room for a longer composition, this one may be of use to you."[149] It wasn't. Galileo flatly rejected the poem, allowing Stelluti to come up with a sonnet in which there was no question of shadows on the sun. The motif was put aside for several decades, reappearing in a *canzone* intended for publication with the *Dialogue Concerning the Two Chief World Systems*, where the sunspots could be seen by all but "the dull commoner

/And he who whom Envy has stung," and where Galileo himself "unchains and sets free / Naked Truth, which shines eternally" while "Envy shakes with rage in the Infernal Valley."[150] It gained added appeal after the condemnation of that work and the abjuration of its author, when it appeared that the aged, sightless, and depressed astronomer did feel that he had at last been defeated by the invidious, and that Horace's observation—*heu nefas! virtutem incolumen odimus, sublatam ex oculis quaerimus invidi*—was indeed true.[151] In letters written in the 1630s by sympathetic friends, there are various references to "the fruits of Envy, born of the craftyness and wickedness of the Jesuits, who refuse to see virtue in anyone but themselves," to "the blind rage of the envious," to the failure of "Envy to triumph over Virtue," to the fact that Galileo's "Virtue and knowledge will always be envied," and, in a modification of Christ's speech to Nicodemus in 3 John, to those "who try to block out the light cast by the virtues of others, in order that their own faults not be discovered."[152]

But what is crucial in both these later developments of the theme and in the original prefatory matter of the *Letters on the Sunspots* is that they depended, albeit sometimes rather tenuously, on the motifs of light and shadow and Virtue and Envy identical to those of Cigoli's allegorical sketch and his depiction of the *Immacolata* at Santa Maria Maggiore, which in their turn were based on arguments for the moon's solidity and opacity recently presented in the *Sidereus Nuncius* but long familiar, as I have shown, to the artist who was among Galileo's closest friends. As the fifth and final chapter of this book will make clear, the quarrel over the lunar substance would soon emerge from the relatively small circle of the astronomer's friends and enemies in Florence and Rome, and figure more prominently as an issue openly debated by scientists and painters distant from Italy.

CHAPTER FIVE

1614–1621

THE *BUEN PINTOR* OF

SEVILLE

SEVENTEENTH-CENTURY Seville will seem an odd setting for
the final Galilean debate of this book: the Andalusian city is cele-
brated for its prosperous trade with the New World, for its devo-
tion to Immaculist beliefs, and for the painters associated with that
"gilded cage of Art," the Academy of Francisco Pacheco,[1] but not for
the attention it devoted to emerging scientific arguments. It will appear
more curious still to turn to a man who spent his entire career preparing
an exegesis of the last book of the Bible, the Sevillian Jesuit, Luis Alcázar,
for his comments on the more recent revelations of Nicholas Copernicus
and Galileo Galilei. Yet the *Vestigatio arcani sensus in Apocalypsi* of
1614, running to one thousand folio pages, tells us a good many things
about all celestial matters, most surprising among them the relevance
of Nicholas Copernicus and Galileo Galilei to the project of scriptural
interpretation.

Scholars have long recognized the importance that Alcazar's work had
for his friend Francisco Pacheco, whose posthumously published *Arte de
la Pintura* of 1649 and various *Inmaculadas* inspired, in turn, a whole
generation of artists, among them the great Diego Velázquez. As regards
the depiction of the *Inmaculada*, Alcázar's influence on Pacheco is
limited, however, to a single detail: both men agreed that the horns of
a crescent moon ought to point away from the sun. In every other aspect
of the lunar iconography particular to an *Inmaculada*, Pacheco followed
hypotheses explicitly rejected by Alcázar and favored by men who con-
tested the conclusions of Galileo's *Sidereus Nuncius*. Velázquez, on the
other hand, endorsed the Galilean arguments, so that a comparison of
the paintings of the student and his master reveals the two sides of a

quarrel that emerged in the first decade after the publication of the *Sidereus Nuncius*.

Pacheco is known today for his treatise, for his Academy, and especially for his gifted student and son-in-law; that he should bear any news whatsoever of issues in astronomy is in itself significant. Alcázar, as his commentary shows, was an interested and tolerably well informed witness of Copernicanism; Pacheco, I believe, was not. One looks in vain for references to the new (or old) world system in the *Arte de la Pintura*, and one finds virtually no mention of other and yet more pertinent issues such as recent advances in perspective, optics, architecture, or geometry. Pacheco's library was rich in the history of art and of the church, in studies of religious iconography, in saints' lives, in descriptions of the Holy Land, and in Humanist dialogues comparing poetry and painting. Yet it contained none of the more technical treatises of the sort later favored by Velázquez,[2] and nothing even remotely related to developments in astronomy. His painting, with the exception of the *Inmaculada* which I will examine, has no engagement of the optical themes for which his student's works are known,[3] and, again with the exception of the *Inmaculada*, makes no reference to scientific debates. Whether his unbroken silence about astronomical issues was a matter of taste or a conscious policy is impossible to judge, but what is noteworthy is that even this man, the last to hear Galileo's starry message, entered into the controversy over the moon's nature and substance.

Spanish Science

It is undeniable that Spain had by the late sixteenth century lost the preeminent role she had once played in the development of European astronomy. Yet the fact that she contributed no scientific figure of the stature of Copernicus, Kepler, or Galileo, for example, does not imply either individual or institutional indifference to emerging cosmological debates; on the contrary, by 1600 a number of Spanish thinkers had endorsed the new world system, as the following well-known examples will show.[4] Apart from the work of those mathematicians and navigators who studied Copernican theory for professional reasons, the most celebrated instance, one which I have mentioned in the preceding chapters, was the Augustinian monk Diego de Zúñiga's *Commentary on Job*, first published in 1584. In his discussion of Job 9:6, "It is God . . . who makes the earth start from its place so that its pillars are shaken," Zuniga offered a forceful and important excursus on the Copernican system:

In our time, Copernicus announced a motion of the planets, in accordance with this ancient [Pythagorean] opinion. Nor is there any doubt that from this doctrine are derived far better places of the planets than from the *Almagest* and other writings. For it is certain that Ptolemy could not explain the motion of the equinoctial points, nor establish a definite, stable initial point for the year. He himself said so in the *Almagest*, Book 3, Chapter 2, and he left the discovery of these things to those later astrologers who could compare observations over an interval greater than that available to him.[5]

Within three years of the publication of his commentary, Zúñiga's hypothesis underwent fair modification. Confronted by the kind of arguments that Galileo would address in the Second Day of his *Dialogue*—why, if the earth rotated from west to east with such rapidity, did a rock thrown straight up into the air appear to fall straight back down, rather than somewhere to the west of its starting point?—Zúñiga reverted to a Ptolemaic position, noting that "certain motions that Copernicus and others have attributed to the earth are not so unlikely. But one, however, is extremely improbable, and it is this that renders the entire opinion absurd, that the earth could undergo a complete rotation in the space of twenty-four hours."[6]

Two years later Pedro Simón Abril argued that both the Copernican and the Ptolemaic world systems "saved the appearances," that is, accounted equally well for visible phenomena, but that the familiar latter opinion was the more likely one.

All astronomers place the earth in the center of the universe, and the sun in the fourth heaven, and the other heavens in their order, and they predict conjunctions, oppositions, eclipses, and the like. The appearances are saved, and their astronomical predictions come true.

Nicholas Copernicus came along and outwitted fate: he made the sun the center of the universe, he raised the earth to the fourth heaven, and he made her mobile. He, too, saved the appearances, and he made the same planetary predictions, and they came out true as well.[7]

During this same period in Seville a number of cosmographers employed at the Casa de Contratación, or House of Trade, were using tables provided in Copernicus's *On the Revolution of the Heavenly Spheres* to find the declination of the sun, the medieval value now being judged outmoded. This did not mean, however, that they favored a heliocentric system, but merely that they recognized, as had both Zúñiga and Simón Abril, that in some instances the novel hypothesis more readily saved the appearances.[8]

It is also in Seville that we find the earliest Spanish commentaries on telescopic observations. Benito Daza de Valdés's *Uso de los Antojos*

of 1623 avoided all mention of Galileo's name and work, but offered an interesting discussion of what the spyglass revealed about the moon's surface:

> ALBERTO: The other night I observed the moon with a telescope that was three palms in length, and though it was not one of the best instruments, I could still make out the valleys that you mention. They are most evident when the moon is waxing or waning, for which reason it appears that they are the surface facing us rather than on the circumference, since when it is at the full, we see it completely smooth and perfect.
>
> DOCTOR: In my opinion what seem to be the eyes and mouth of the moon are its heights and depths, though until telescopes were invented we believed that they were caused by the mere fact that the moon is rare in some parts and dense in others. Yet seen through the telescope, when it is waxing or waning, we find that certain rays or luminous parts stand out on the darkened area, the sight of which made a disciple of the master decide that the moon had long hair.[9] But this head-dress cannot always be seen, but only on those days when the moon is waxing or waning. Generally, however, we see it as very rough and sponge-like and pockmarked, with some points of greater light in the loftiest places, for which reason a good painter will know better than I do if those are really heights and depths.[10]

Daza's failure to mention Galileo is normally attributed to his position as notary for the Inquisition. While I believe that this view is substantially correct, it surely merits some refinement. As I will argue in the following pages, the passage is a significant commentary on the *Inmaculadas* of Pacheco and Velázquez, and evidence that both painters were influenced by the debate between Galileo and his enemies over the nature of the moon. The work that had drawn the artists' attention to the issue of reconciling all manner of starry messages was Father Luis Alcázar's *Vestigatio arcani sensus in Apocalypsi*, and it is to this important exegetical work that I now turn.

Alcázar's commentary on 12 Revelation, the celebrated allusion to the Woman Clothed in the Sun, is something of a hybrid of two traditions. While many in his order believed that the moon was, like other celestial bodies, a diaphanous globe mostly or entirely free of "the filth of opacity," Alcázar insisted otherwise. In his opinion it did not share in the celestial nature of the highest heavens, and it could not be penetrated by solar rays. These apparent imperfections notwithstanding, he suggested that the configuration in 12 Revelation was that of a solar eclipse, and that the moon, far from being the icon of temporal goods, filth, instability, the vanquished Infidel, or lunacy, was the emblem of Christ's human form. Just as the moon lies between the earth and the sun during a solar

eclipse, he explained, so Christ had acted as mediator between man and the Godhead. In dying, Christ lost none of his divinity, or "superior" and "luminous" nature, but showed only the "inferior part of the soul," or his humanity, to mortal eyes: so during conjunction only the darkened face of the moon, and not its radiant upper surface, is visible to earthly observers. And though a solar eclipse (*defectus solis*) submerges the world in darkness, Alcázar wrote, the sun does not undergo any change, nor does it lose any of its brilliance; still less is the Godhead diminished by the sacrifice of his Son.[11]

Alcázar's Copernican Revelation

Of much greater significance than Alcázar's interpretation of those verses, however, is his explicit support of Copernicanism, and it seems likely that it was this stance that limited his influence on Pacheco and other painters of the *Inmaculada*. During an extended discussion of allegory, Alcázar drew first a familiar contrast between the exegesis of Origen and Jerome—one where the former ignored a literal reading of Scripture in order to present a mystical interpretation of the story of the false prophets in 27 Jeremiah—and then a surprising comparison between his own style as Biblical commentator and the interpretative method of Nicolaus Copernicus.

> Many people do not doubt that the legitimate context of meaning is that which the words seem to say at a first reading, and that the mystical meanings that follow this literal interpretation are nothing other than a departure from solid ground and a flight through the air, as if one *were playing like birds in the heavens*, to use the expression of 3 Baruch. Thus it is that Jerome often censures the strained allegories in the work of Origen. He speaks of Origen's exegesis of 27 Jeremiah in this way: "The allegorical interpreter is always fleeing the true level of the story. I follow the simple and true story and do not wrap myself in what one might call clouds or illusions." And Jerome repeats in this place and in the two following chapters, "Here the allegorical interpretor both raves like a madman [*delirat*] and dozes." And elsewhere he observes Origen creating out of his own imagination the meaning of Sacred Scripture.
>
> I must confess that some people suspect the same of me. However much I try to make all agree with the context, and to explain it in a continuous series as if there were one narrative thread, some people will believe that I am offering not a solid explanation but shadows and phantasms, that I do violence to the designs of men and of nature in order that all elements of the story agree, and that through zeal I change divine wrath into mercy.

This is indeed not unlike the audacity of Nicolaus Copernicus who, having made a curious and unbelievable discovery, placed the sun fixed and immobile in the center of the universe in order that the phenomena or appearances of astronomy make sense, and led the earth around it in what might be called a constantly turning epicycle. And though with as much artifice as you please he showed that all eclipses and revolutions of the stars agreed among themselves, he persuaded no one in his right mind of the truth of this figment of his imagination, because he had assumed absolutely outrageous things as premises. No less outrageous than his effort is the fact that what we call the wrath of God is that which reconciles enemies to him, and what makes pious and saintly men out of blasphemous and criminal ones.[12]

Among the curious features of this discussion are its rapid shift in tone and concern, its rough mixture of pious and scientific arguments, its sudden and still resolution in the "outrageous premise" of God's mercy. Yet more surprising is the relationship that Alcázar establishes between four thinkers: Jeremiah, Origen, the Jesuit himself, and Nicolaus Copernicus are part of a lineage of "true" prophets. The comparison is a troubling one for a variety of reasons. In the first place, it flatly contradicts the recent judgment of the influential Cardinal Bellarmine, who had also opposed the two exegetes in his *Disputationes de controversiis*, had praised Jerome's literal reading of Scripture, and had described Origen's tendency to metaphorical interpretation and his avoidance of "the truth of history" as an example of "the gravest of errors."[13] Alcázar's support for the wrong side, or his instinct for the quasi-heretical argument, is thoroughgoing: Jerome probably associated Origen's allegorical reading of 27 Jeremiah with his belief in astral souls, a doctrine which would be declared anathema in the sixth century,[14] and Copernicus's insistence on a mobile earth, long suspect in Rome, would be formally condemned by the Holy Congregation within two years of the publication of the *Vestigatio*.[15]

Both Origen and Copernicus were identified, moreover, with the same ancient influences and with similar effects on Christianity. To begin with, the early exegete was said "to be familiar with the most distinguished of the Pythagoreans and with the Stoics Cornutus and Chaeremon," and more significantly, he was accused, somewhat unjustly, of being the first thinker to submit Scripture to allegorical techniques taken over from Stoic writers, who had insisted that the most puzzling narratives of divine activity actually concealed elaborate doctrines concerning the physical world.[16] Copernicus, as we have seen, was also routinely identified with both the Pythagoreans and the Stoics, and it is clear that among the most alarming tendencies of at least some of his followers was their belief that close readings of Scripture would yield interpretations

compatible with the cosmological systems they favored. And while Origen and Copernicus were recognized even by their detractors as men of great learning and culture, their positions were often described as a form of madness.

In the particular instance mentioned by Alcázar, Origen's error derived from his failure to consider the "simple and true story" of 27–28 Jeremiah, where the Jews were ordered to submit to the Babylonians until the latter in turn were conquered. His offense thus resembled theirs, for in reading allusions to Babylon and Jerusalem as references not to physical places and political entities but rather as allegorical descriptions of states of mind and of the heavenly cities in which the astral souls resided, he suggested that the "simple and true," or literal and historical submission to the chosen people to their enemies could somehow be avoided.[17] Copernicus had made similar choices, for he, too, had relied on *umbra et imago* in his astronomical observations and had proposed an explanation of no great appeal to the Church, and on the verge of condemnation. Just as Origen's interpretation ignored that mandated submission to Babylon, so Copernicus's argument, particularly the detail about the earth that he led around the sun "in a continuously turning epicycle," disregarded the authority held by what some would call the "sister Church in Babylon," or Rome. And Luis Alcázar, rejecting in his turn the judgment of Bellarmine, offered "shadows and phantasms," *umbra et imago* being a figurative depiction of his allegoresis, and a literal description of the eclipses mentioned in his work and in that of the "audacious" and "mad" Copernicus. Given his preference for Origen over Jerome, and for Copernicus over Ptolemy, Alcázar's submission to Rome was by implication less than absolute. Ironically, his argument and especially his comparisons recalled the earlier cosmological hypotheses of Bellarmine, for his references to the sort of exegesis he favored as "a flight through the air, as if one *were playing like birds in the heavens*" evoke the well-known Stoic description of planetary movement just as surely as they echo the less familiar passage from *Baruch*. While it is likely that Alcázar was unaware that Bellarmine had once held such views, he probably knew that the hypothesis had been criticized by other members of his Order, namely Fathers Benedict Pereira and Christoph Clavius.[18]

It is easy to see that Jeremiah, the false prophets, Origen, Jerome, Alcázar, and even Copernicus and those who opposed him can all be broadly designated as *interpretes*, the term referring to those who bore celestial messages, whether prophet, translator, commentator, or astronomer (*interpres caeli*). Despite Alcázar's implied lineage of "true prophets," I do not know that he meant to designate those who detracted from

Jeremiah, Origen, Copernicus and himself as "false prophets," especially since this ill-starred group would include the venerable Jerome, Cardinal Bellarmine, and most of Alcázar's fellow clergymen. On the other hand, Alcázar surely hoped to modify, rather than condemn as false, the views of those who opposed the "outrageous premises" of Copernicus and saw in them a kind of madness. There were, moreover, within the Society of Jesus many such men, but his remarks seem especially appropriate for one particular Jesuit *interpres* from Seville.

It is quite possible that Alcázar knew of Clavius's late acceptance of most of the findings of the *Sidereus Nuncius*, and we might even argue that his exegesis is very much in the spirit of the statement made by the Jesuit scientist in 1611, that "astronomers ought to consider how the celestial orbs may be arranged in order to save these phenomena."[19] Among Jesuits in Seville, however, there was no overt enthusiasm for the new hypothesis, and Father Juan de Pineda—like Alcázar, an associate of the Academy of Francisco Pacheco[20]—was widely known for his condemnation of Copernicanism within the context of scriptural exegesis. In his commentary on Job, published between 1597 and 1601, Pineda had written in reaction to his compatriot Zúñiga's early endorsement of Copernicanism: "Others rightly term this science insane, worthless, audacious, and dangerous to faith; they say it is an opinion of those ancient philosophers revived by Copernicus and Celio Calcagnino, and rather more proof of cleverness than something good and useful to philosophy and astrology."[21] And in his exegesis of Ecclesiastes 1:4, "Generations will come and generations will go, but the earth remains forever," Pineda had objected to William Gilbert's work on magnetism, criticizing the English scientist for neglecting Scripture in the course of his investigations.[22] Like Clavius, Pineda was an authoritative and respected writer. His passing comments against a mobile earth would be repeated in treatises devoted not to biblical exegesis but to astronomical matters, most notably in Lodovico delle Colombe's condemnation of the *Sidereus Nuncius*, Robert Burton's *Digression of Ayre*, and John Wilkins's *The Earth May Be a Planet*.[23]

Whatever its effect on Pineda, it is worth noting that Alcázar's assertion goes considerably farther than those of Zúñiga and Simón Abril— and more closely resembles the efforts of Lodovico Cigoli—for the exegete makes heliocentrism the correlate of salvation. Just as the Copernican world system is the only one accounting for all eclipses and sidereal revolutions, or "saving all appearances," so divine mercy, however undeserved, is the only means of saving all souls. In this curious comparison, rejection of Copernicanism becomes not the prudent habit of the devout man, but the analogue of the sin of despair.[24]

Alcázar as Starry Messenger

Alcázar's letter to Pope Paul V, the document with which the *Vestigatio* begins, contains several oblique references to the work of Galileo. Writing in March 1612, Alcázar compared his exegesis to the squaring of the circle and suggested that the "news" he bore in the *Vestigatio* was susceptible to mathematical proof. The reference to the *quadratura circuli* was not original, but Alcázar's insistence on the word *nuncius* is extraordinary, even in this age of rhetorical flourish and excess. He used it and the verb *nunciare* five times in four sentences:

> Therefore I (whose insignificance and modesty would otherwise be utterly deterred by Your Majesty from making an appearance) neither can nor should contain myself, since by a felicitious outcome of my studies I have met with something such that I can be a bearer of good and even most welcome news [*nuncij baiulus*]. Rather, I would approach you yourself through this letter; exulting and rejoicing, I would announce [*nunciarem*] everything, and imagining myself prostrate at your feet I submit all reasons for my persuasion, and as a suppliant I would offer to you in this *Commentary* everything of the foundation or groundwork on which that persuasion rests. Nor indeed is it that kind of news [*nunciorum*] where in order that one trust anything of one's own convictions, he who bears the news [*nunciat*] is allowed to postulate. Nor am I that man who would dare demand the slightest measure of belief without offering proof. But just as if anyone were to announce that he himself had discovered the squaring of the circle, it would be received not otherwise than the reasons he offered, for the solid demonstrations found by him would serve as apodictic proofs to mathematicians. Thus in order that he be able to answer to the charge of frivolity, he who would dare offer to you news [*nuncium*] of the forementioned dedication, Holy Father, should bring and at the same time exhibit manifest proof of the whole thing, in which prudent judges of these things must acquiesce.[25]

Alcázar's repetition of the word *nuncius*, his readiness to portray himself as a kind of newsbearer, and his insistence on the apodictic nature of his work all evoke the sensation Galileo had created just two years earlier in publishing the *Sidereus Nuncius*. The ambiguity of the title of that astronomical treatise—Galileo originally conceived of it as a "Starry *Message*," but Johannes Kepler, among others, understood it to mean "Starry *Messenger*"[26]—is also echoed in Alcázar's simultaneous emphasis on both the celestial news contained in the *Vestigatio* and his own role as newsbearer.

More importantly, the mathematical proof to which Alcázar alluded, as inappropriate as it might seem in the context of scriptural exegesis, had

been conferred upon Galileo's *Nuncius* by members of Alcázar's own order, when four *mathematici* or astronomers from the Collegio Romano confirmed the greater part of the claims made in that treatise and honored its author in a ceremony in Rome in the springtime of 1611. Like Alcázar, moreover, Father Van Maelcote had portrayed himself as a messenger in his *Nuncius Sidereus Collegii Romani*, and had also favored the same heavy-handed repetition of the *nuntius* and its cognates. Because Maelcote's address was mentioned in letters written by those present at the ceremony and was probably distributed in excerpted form within the order, it is likely that Alcázar knew of his fellow Jesuits' initial regard for the news borne by Galileo, and that he considered the confirmation offered by the four mathematicians the analogue of the apodictic evidence on which he, as scriptural exegete, hoped to base his own celestial message.[27]

Immaculist Art

Unfortunately, Alcázar had chosen a poor moment in which to present himself as a follower of Copernicus and Galileo. In March 1616 *On the Revolutions of the Heavenly Spheres* was, by Decree of the Index, "suspended until corrected," Galileo was warned to "abandon the opinion he had held until then," and all future efforts to reconcile the new world system with Scripture were strongly discouraged. While the *Vestigatio* as a whole was of great significance within the commentary tradition, the author's Copernicanism met with silence or disapproval. The conclusions that Alcázar drew about the moon's opaque and imperfect substance were opposed several times over both by other Jesuit authors, and by the Sevillian painters who followed them. One discussion, however, proved very influential, and this was Alcázar's criticism of contemporary artists for the uninformed manner in which they painted the heavenly bodies of 12 Revelation:

> Besides this, I see that the conjunction of the sun, moon, and stars is often poorly rendered in common paintings. For artists usually paint the feet of the woman on the moon and both horns turned upwards, but it is apparent to anyone skilled in astronomy [*ars mathematica*] that if the sun and the moon are in conjunction, and the moon is seen from below and from one side, the two horns or points of the moon will appear to point downwards, such that the woman would be above not the concave, but the convex, part of the moon. It was thus fitting that it came about this way, so that the moon might illuminate the woman standing above it.[28]

As is well known, Francisco Pacheco repeated Alcázar's admonition—which depended on neither a Ptolemaic nor a Copernican worldview—in the chapter of the *Arte de la Pintura* devoted to the depiction of the

Immaculate Conception. By the time Pacheco wrote this section of his treatise, he had been appointed Overseer of Sacred Images by order of the Seville Inquisition, had completed the *Inmaculada con Miguel Cid* (see plate 7), and had presumably influenced his student and son-in-law, Diego Velázquez, in the execution of an *Immaculate Conception* (see plate 8) in this same period. As I will show, the manner in which the paintings diverge from Alcázar's recommendations is as important as their apparent fidelity to the arguments of the *Vestigatio*, for the work of the two Sevillian artists stands as a record of the exchange between Galileo and his rivals over the nature and substance of the moon.

The directives enumerated in the *Arte de la Pintura* were clear, detailed, and offered rather little in the way of compromise. Pacheco stated first of all that the Virgin should not in this instance be holding her Child, and that she should be "in the flower of her age, between twelve and thirteen years old, very beautiful, with lovely and solemn eyes, a perfect nose and mouth, rosy cheeks, and with hair as close to gold as the paintbrush will allow." Turning to the configuration of the solar and lunar bodies, Pacheco repeated Alcázar's suggestions, after adding a curious modification of his own:

> ... beneath her feet, the moon, and although it is a solid globe, I take the liberty of making it lucid and transparent above the landscape; the upper part is very bright, and the middle visible, with the horns turned downwards. If I am not mistaken, I believe that I am the first to have bestowed such majesty on these embellishments, which other artists will now be following.
>
> As regards the moon in particular, I have complied with the learned opinion of Father Luis Alcázar, a glorious native of Seville, who wrote the following, "Painters generally place the moon beneath the woman's feet so that its horns turn upwards; however, it is clear to those skilled in mathematics that if the sun and the moon are in conjunction, the horns should be seen pointing downward, in such a way that the woman stands not on a concave but rather on a convex surface." This is required if the moon is to shed light on the woman standing above it, the lunar body receiving light from the sun. And standing firm on a solid globe, as he has said, however luminous it is, she has to be established on the outside [i.e., the convex side] of the sphere.[29]

The *Immaculate Conception with Miguel Cid* combines the reasonable suggestions made by Alcázar with Pacheco's almost whimsical insistence on a clear, nearly transparent moon, a position explicitly condemned in the *Vestigatio*. The gauzy, bubble-like lunar globe floats across the landscape and obscures nothing of the city where Immaculist fervor was the strongest; the Guadalquivir River flows across the foreground, and Se-

ville's famous Torre del Oro stands in the lower left-hand corner.[30] The setting is also adorned with a few Marian icons: a Tower of David rises next to the Torre del Oro, palm and olive trees grow on either side of the water, and a fountain and an enclosed garden can be made out in the lower right-hand corner. With the exception of the roses strewn beneath the lunar globe, however, most of these attributes blend into the Sevillian landscape. Miguel Cid, author of verses devoted to the Immaculate Virgin, sits below horns that point away from the sun.[31]

Pacheco's *Inmaculada* is routinely compared with that of Velázquez; the master's work is considered stiff, formal, lifeless, "gothic," stilted and inexpressive, and the student's effort, by contrast, realistic, natural, luminous, and full of promise.[32] Such assessments are, of course, difficult to dispute, but the point I would like to make is elsewhere. Velázquez's *Immaculate Conception* adheres for the most part to the iconographic suggestions later published in the *Arte de la Pintura*; as an apprentice and member of Pacheco's household since 1611, the younger painter would have been familiar with these rules long before they found codification in the treatise. What is most striking, however, is the manner in which Velázquez departs from, rather than follows, the suggestions of Pacheco. The horns, if they can be called such, do point downward, but the terminator—the arc on the lunar disk that separates the light part from the dark—is actually formed by a mountain in the landscape in the background. Somewhere within the globe, a small boat hovers on a shadowy body of water and beneath the *stella maris*, another icon of Marian purity. The Virgin's robe, for all its bulk, seems to rest on a disk rather than on the solid sunlit sphere described by Pacheco and Alcázar.

It would be foolish to ascribe the peculiar features of the lower portion of this painting to inability: even at this early stage in his career, Velázquez had already shown tremendous technical virtuosity, particularly in the depiction of the play of light and shadow on transparent bodies.[33] What difficulties there were in rendering the mass and shape of a clear glass filled with water were easily mastered in *The Waterseller of Seville* (1619?). Here Velázquez presented against a dark background not just the contours of a brimming goblet, but those of a fig lying at its bottom and those of water drops on its exterior surface. The differences between the crystal glass, the water in it and the water on it, between the dark brown fig and the dark brown garment of the boy holding the glass are painstakingly rendered. Yet the analogous objects in his *Immaculate Conception* are either pitched into one plane, like the crystalline moon and the mountain behind it, or isolated in some undefined space, like the tilted fountain in the foreground and the lonely boat in the dimensionless gulf beneath the horns. It is as if whatever Velázquez knew about the effects produced by light in *The Waterseller of Seville* had been forgot-

ten, while even the commonsensical observations of Pacheco stand as lessons unlearned.

The moon as Pacheco depicted it in his *Immaculate Conception* seems, by comparison, more skillfully executed: it is slightly more spherelike in contour, and the landscape beneath it, sufficiently remote, does not seem enclosed by the horns. I would not argue, of course, that Pacheco's is by any means the better work, or even that the technique of the older artist was in this astronomical detail particularly realistic, for the diaphanous globe that floats above Seville appears decidedly unnatural. I would suggest, however, that Pacheco's insistence on the moon's transparency was an allusion to a controversy that began with the publication of the *Sidereus Nuncius*, and an index of his allegiance to the men who contested the claims of that treatise. I believe, moreover, that what is stiff, stilted, and unrealistic in the lower portion of Velázquez's *Immaculate Conception* is meant to be so, and that these flaws stand as a commentary on an artistic convention and astronomical argument—that of the transparent moon—which he found unacceptable. In sum, the two works take opposite sides of a current debate: Pacheco's painting portraying and endorsing the conclusions drawn by Galileo's rivals, that of Velázquez deriding and in effect contesting them.

The Immaculist beliefs of the Franciscan, Jesuit, and Carmelite orders were particularly significant in early modern Seville.[34] On September 8, 1613, the Feast of the Birth of the Virgin, a Dominican preacher in that city reiterated the wholly unpopular notion of the *sanctificatio in utero*, arguing, in other words, that the Mother of God was not immaculate since conception, but rather that she had had the blemish of original sin removed from her prior to her birth. His pronouncement was disputed, of course, by all other Sevillian orders and led to an intense campaign in favor of the Immaculate Conception. Various feasts and ceremonies celebrating the Virgin took place in the next years, among them a series of processions in which Sevillian children sang an Immaculist hymn composed by the poet Miguel Cid. A statute of 1617 enjoined all graduates of the University of Seville, no matter what discipline they had chosen or degree they had earned, to take an oath that they would uphold the doctrine of the Immaculate Conception.[35] In 1621, members of the Franciscan orders in Seville even pledged to defend the doctrine with their lives.[36] Those suspected of maculist sympathies, such as the Sevillian poet Juan de Espinosa, nephew of a well-known Dominican, were warned of the danger of their opinions.[37] It is reasonable to conclude, therefore, that Seville offered the perfect climate for the debates that emerged with the invention of the telescope and the publication of the *Sidereus Nuncius*, and it can be no accident that discussions of the lunar substance often had Marian echoes.

Aguilon's *Opticorum libri sex*

The conflation of astronomical and doctrinal arguments occurs most frequently in works written by Jesuit authors: all three of the writers I will examine in this chapter were associated with the Society of Jesus. While it is tempting to see in the growing Jesuit insistence on a luminous and absolutely immaculate moon an instance of the notorious Ignatian dictum, "I will believe that the [black] that I see is [white], if the hierarchical Church so defines,"[38] or a literal example of Cardinal Bellarmine's *Treatise on Blind Obedience*,[39] several factors make the Society's involvement difficult to assess. In the first place, where we are dependent upon extant documents, there is not infrequently a preponderance of Jesuit authors, the order itself being well educated and its works being relatively well preserved and accessible to later scholars. Second, while it is undeniable that many Jesuit writers deferred to the opinions of others within the order, there are examples of those who exhibited more independence of spirit. The most interesting of such authors is Giuseppe Biancani, S.J., with whose work I will conclude this chapter. In brief, then, while the hypothesis of the crystalline moon found its most significant development in Jesuit writings of 1613–1615, it would be incorrect to assume that such theories were either limited to the Society of Jesus or that they were shared by every member of that order.

In 1614 François de Aguilon, S.J., included an extended description of a crystalline lunar globe in the seven hundred pages of his *Opticorum libri sex*. Regarded by the Society of Jesus as their greatest authority in the science of optics, Aguilon was associated with several members of Galileo's earliest audience.[40] He had met Father Odo van Maelcote—the man who would see rosary beads on the cratered moon—in 1598 in Antwerp, and he may even have been responsible for the latter's interest in astronomy. Maelcote went to Rome to study with Christoph Clavius in 1602, but returned to Belgium in 1607 and again in 1612, where he renewed contact with his mentor. Aguilon was in still closer touch with Christoph Scheiner, a Jesuit professor of mathematics living in Ingolstadt and then engaged, under the name of "Apelles," in the sunspot controversy with Galileo, and also a proponent of the theory of the crystalline moon. Aguilon exerted a certain influence on a student of Scheiner's as well; this was Johann Locher, who would devote part of his thesis to a description of a perfectly smooth lunar globe. Apart from his scientific contacts, Aguilon would have been well known to the large Spanish and Italian communities of Antwerp, for he had been their confessor since 1598.

The *Opticorum libri sex*, an immense work adorned with six engravings designed by Peter Paul Rubens,[41] were issued by Plantin in 1613. The

publication privileges granted by the censor and the provincial superior date from December 1611 and January 1612. A reference made in Book Five, which was devoted in part to discussion of the lunar globe, suggests that this material was written just before the work went to press: Aguilon mentioned the sunspot observations and pseudonym of his colleague Christoph Scheiner, who wrote his first letters on this subject in the same period, November and December of 1611.[42] Thus while the *Opticorum libri sex* were the object of years of work, and concerned for the most part optical debates dating from Antiquity and the later Middle Ages, the discussion of the moon would have seemed to most of the audience the most up-to-date of astronomical arguments.

Aguilon began his examination of the moonspots by discarding a familiar older theory: they could not be the reflection of objects on earth, for example, because they were always in the same place, while the moon and the earth were constantly changing their position with respect to each other. Nor did he believe that the brighter parts of the lunar face were mountains and the darker spots valleys, because this would mean, it seemed to him, that the bright Milky Way was similarly covered with lofty peaks and ridges. Aguilon liked, but could not accept, the notion that "the moonspots were not the images of those things on earth, but of the spots that earlier this year Christoph Scheiner of our Society and professor of mathematics at the Academy in Ingolstadt, now under the penname of 'Apelles behind the canvas,' was the first to see on the face of the sun."[43] It seems to me improbable that this theory had in fact enjoyed much currency in the six months that Scheiner had been observing solar phenomena; Aguilon's apparent need to correct it is in all likelihood an attempt to reinforce Scheiner's claim to priority.

Aguilon also condemned as "absurd" the opinion of those who believed that the polished lunar globe somehow had valleys but no mountains, and then he indicated the view to which he was most inclined. It appears to be a modification of Berosus's notion of the bipartite globe, which was scorned even in Antiquity because it accounted so poorly for the phases. As I mentioned earlier, it was in Augustine's *Ennarationes in Psalmos* that the theory gained what little respectability it had, chiefly because its dark and light hemispheres provided a nice allegory for the Church, "whose spiritual side was luminous, and whose carnal side was dark."[44] This was the first step in Aguilon's attempted redefinition of the moon in terms of the decorously abstract *Mater Ecclesia*, rather than the flesh and blood Mother of Christ:

> The far side of the moon is absolutely diaphanous, while this one is rather semidiaphanous, since in fact it is clear that it shows to us the image of a human face; that is, it is sprinkled with some opacity, which transmits some

light, such that it retains the greater part of light not just on its outermost surface, but also within its depths. . . . The semidiaphanous part always faces toward the center of the earth, not because it is made heavier by the admixture of opacity—for we conclude that in heaven the filth of the elements is entirely absent—but because it was thus pleasing to God the Creator of all things, and also so that the waxing and the waning of the moon might be more easily explained. For the sun's light is borne around the globe of the moon, and it lights up some parts all the time, and now, for example, all that part which is opaque, now only that part which is perfectly translucent, now some of both those parts together, since it is seen to be now full, now dark, now horned, now gibbous on the one side and now on the other, now half full.[45]

Aguilon then turned to a traditional analogy, that of the cloud illuminated by the sun, to explain how the single substance of the moon's body could appear at once bright and dark. Unlike Lagalla, but like Colombe and most other proponents of the rare and dense lunar globe, he believed that the whitest portions of the moon were composed of the denser and more opaque material, and conversely that the darker spots were in fact translucent, being "most free from the contamination of opacity."[46] The argument that he developed, one which Galileo unwisely ridiculed in the *Dialogue Concerning the Two Chief World Systems*,[47] began with a rather commonplace observation about the relative brilliance of the sun and the moon and ended with a long meditation on a passage from *Exodus* that Aguilon and many of his readers saw as the best evidence for his notion of the cloudlike lunar body.

Furthermore when we see both great luminaries, that is, the sun and the moon, at the same time during the day, as happens not infrequently on longer days, even during their opposition, then because of the sun's splendor, the moon appears not luminous, but bleached and like a little cloud, so much so, in fact, that were it not for the shape, no one would doubt that it was a remnant cut off from a larger cloud bank. For this reason we say that the sunlight is borrowed partly by the moon and partly by the clouds.

Moreover we have something of the sort handed down to us from Sacred Scripture, in the column of cloud and fire which led the children of Israel through wilderness and unknown places for forty years until they at last arrived at the Promised Land. On these matters see 13 Exodus. That column was therefore composed of a certain rarer substance or vapor or a cloud-like exhalation, so that it was rightly called a "column of cloud" in Sacred Scripture, that is, a cloud formed in the shape of a column. It had a certain divine light within it, much weaker than the brilliance of sunlight, but equal to the moon's splendor, that is, not to her own light, but to that faint glow which she sheds on us at the greatest extent of her orbit, in order that the

effulgence not strike the eyes of the sleeping Israelites too forcefully at night and thus disturb their sleep, since we scarcely ever read that they had to make their way after dark.[48]

Aguilon developed his comparison of the moon and the column of fire and cloud at some length. As if in answer to those few who might argue that Scripture was no place to turn for astronomical data—and theirs would have been a fairly novel objection—he finished his discussion by stating that the Creator generally used natural processes in working his miracles, and that no substance was more like the column of fire and cloud than the moon, since it, too, was less brilliant than the sun but splendid enough to overcome the darkness of night.

Though Lagalla had compared the moon to both a cloud lit by the sun and to a crystal ball filled with white enamel, Aguilon avoided suggesting that these phenomena were identical. Despite his dependence on the glass globe of Berosus, he makes only one explicit allusion to a crystalline moon. As was common, Aguilon attributed the moon's obscurity during a solar eclipse to its thickness, reminding his readers that the lunar globe was infinitely larger than the greatest bank of clouds and arguing that a body's transparency depended at least in part on its dimensions. After suggesting that it was also for this reason that the old moon was not visible at conjunction, Aguilon turned to the glass ball analogy favored by other writers: "The other factor is the spherical figure that the moon surely possesses: it is as if the solar rays that sail over the diaphanous part of the moon then converge at one point, and from there are diffused in all parts and are lost far from our sight. This effect is manifest in small crystal balls, which, if observed in like manner, show the image of darkness rather than that of splendor."[49]

Aguilon's tendency to compare the lunar body with the scriptural column of cloud, rather than with some crystalline substance pierced by rays of light, complements his insistence on ecclesiological rather than strictly Marian interpretations. This makes for a fairly sober discussion, one mercifully devoid of troubling echoes of the Incarnation and Virgin Birth. When, in fact, Aguilon described the old moon's conjunction with the solar body, so often portrayed in terms recalling the Incarnation, he *did* refer to its partial absorption of sunlight in its immense depths but added that it threw most of this radiance back to the source. Thus, he noted, *in coitu non cernitur*, which would normally be translated as "it is not seen in conjunction," but which also conveys precisely the kind of propriety Aguilon sought to promote, "it is not seen in coitus," and suggests there was some happy correspondence between decorum and astronomical observation.[50] In this aspect Father Aguilon differs significantly from Christoph Scheiner, S.J., who had chosen in a dramatic

description of a solar eclipse to emphasize the association of the glass globe with the *amicta sole* of 12 Revelation. And finally, while it is possible to argue that Aguilon saw his ecclesiological interpretation of the moon's substance as an elaboration rather than an outright replacement of the Marian icon, his more abstract reading pales—like the Exodic sign itself—besides Father Scheiner's depiction of a wholly luminous lunar globe, to which I now turn.

The Masked Apelles

In 1612, in the midst of the sunspot controversy, Galileo had to return once more to the issue of the crystalline moon. His quarrel was with Christoph Scheiner, S.J., who had published observations of the sunspots in January 1612 under the quaint name of "Apelles" so as not to embarrass his order. Scheiner, a professor of mathematics at Ingolstadt, had written three letters in late 1611 concerning the sunspots to Mark Welser in Augsburg; the latter printed these and sent them to Galileo for his opinion. In three responses addressed to Welser and printed in 1613, Galileo responded politely but critically to the work of "Apelles." To begin, he found fault with the Jesuit's impressions of the size, motion, direction, darkness, and substance of the sunspots. He also professed surprise at Apelles's unaccountable ignorance of the moonlike phases of Venus, so cleverly presented by Galileo himself two years earlier in the anagram, "In vain have I gathered together these premature matters," which, when properly decoded, stated that "[t]he mother of love [Venus] imitates the shape of Cynthia [the Moon]."[51] He flatly contradicted Apelles's estimate of the apparent surface area of Venus as well: it was not one one-hundred-thirtieth that of the sun, but something less than one forty-thousandth that of the solar body. Finally, he was unimpressed with the confusing arrangement of "eccentrics, deferents, equants, epicycles, and the like" with which the author's universe was embellished, and he stated his preference for a planetary system that was "unique, true, [and] real," in sum, "one which could not possibly be otherwise."[52] His criticism of the man he persisted in calling "my friend" and "the masked and mysterious Apelles" was refined, relentless, and devastating.

Scheiner entitled his response to Galileo the *De maculis solaribus et stellis circa Iovem errantibus accuratior Disquisitio*, or "A More Accurate Investigation of the Sunspots and Bodies Moving about Jupiter." The comparison and implied improvement did not, however, involve his own earlier work, but rather Galileo's *Letters on the Sunspots*: a fair portion of the *Accuratior disquisitio* was devoted—as is understandable, if not laudable—to attacking conclusions reached by his new enemy. Whereas the

Jesuit astronomer had originally called himself "Apelles hiding behind his painting," in reference to that ancient artist's eagerness for candid appraisal, here, in a more martial mode, he signed his work "Ulysses, under the shield of Ajax." While Galileo naively expected that the furor over the lunar mountains would subside in the face of the new solar issue,[53] his opponent was reexamining the arguments for a rough and opaque moon and the explanation of that body's secondary light.

Scheiner's discussion of the solar eclipse of May 1612, for instance, had more to do with the substance of the moon than with the spots around the sun. A classic difficulty faced by those who described the moon as diaphanous or semidiaphanous was its appearance when it passed directly in front of the sun, for one might expect that the translucent globe would be most brightly lit, rather than sensibly darkened, on those occasions. After acknowledging that the lunar disk was at first obscured by the absence of sunlight, Scheiner recounted the novelties revealed to him by the telescope:

> [At the beginning of the eclipse] the telescope showed no [great] difference between that part of the moon that covered the sun, and that part that protruded, with respect to darkness, but neither did it distinguish the whole moon in any manner from the rest of the sky surrounding the sun, or finally, from any body whatsoever. *Around the middle of the eclipse, however, the telescope revealed to us, over the course of a half-hour, that the perimeter of the moon covering the sun was cloaked as if by a golden border, and encircled on both sides by a golden arc protruding beyond the sun by [about] one digit in length.* Nor was this apparition to be scorned. . . . Indeed [at the end of the eclipse] we saw all that we were striving to see: *that part of the moon that covered the sun was completely pellucid like crystal or some other glass, but unequally so, thus in one place it all became white, and elsewhere it [was just becoming] white.* Thus I saw all of the sun evenly, but with great differences, for the part covered by the moon shone through very weakly, and with a greatly refracted light.[54]

Scheiner's discussion recalls the configuration of 12 Revelation, where the sun, moon, and earth were sometimes thought to be in the perfect alignment of a solar eclipse, as in the exegetical meditation of Alcazar. The description of the pellucid body of the moon is, while inaccurate, particularly significant, for the edge of the moon is robed in the golden border of the sun—*aurea quodammodo circumferentia amicta*—precisely in the manner of the *amicta sole* of 12 Revelation. Thus far, I have suggested that the crystalline moon has served as a symbol for the Virgin, the transparency of that body as an allusion to the Incarnation, and the gradual disappearance of its spots as an icon of her Immaculacy. Now, however, the association of the moon with the Virgin is greater still;

pellucid, spotless, and *amicta sole*, in Scheiner's vision it has taken her place entirely.

It may not be a coincidence that in April 1612 Lodovico Cigoli had just completed and displayed the Madonna in his *Immacolata* for the Pauline Chapel at Santa Maria Maggiore in Rome, where the Virgin stands on a most maculate moon and wears a white-on-white mantle bordered with gold. The sun extends around her in two golden arcs, and in this painting the woman, and *not* the spotted moon beneath her, is *amicta sole*: her cloak, and *not* the lunar body, is edged in gold and "white or just becoming white." Cigoli's correspondence with Galileo indicates that the painter saw the astronomers of the Collegio Romano, particularly Father Christoph Grienberger, S.J., with some frequency, and that he knew from them much about the activities of "Apelles" in Ingolstadt.[55] It is very likely that Scheiner knew something of Cigoli's explicit defense of Galileo's maculate moon, and that he intended his apocalyptic description of the eclipse of May 1612 as a response to what the artist had painted just one month earlier.

It is also clear that the Jesuit astronomer's account anticipated efforts like that of Andrea Vittorelli, who published a lengthy description of Santa Maria Maggiore in 1616, and who presented the Woman Clothed in the Sun as a luminous sphere not unlike the crystalline moon seen by Scheiner. Though Vittorelli knew the *Sidereus Nuncius* and perhaps its author as well,[56] he had nothing whatsoever to say about Cigoli's depiction of the opaque and spotted moon,[57] but much to relate about the Virgin herself in her guise as *amicta sole*:

> The Sanctuary of the Most Holy Trinity, free of all spots, she surrounded the eternal Sun with her mortal flesh, and was enfolded in Its immeasurable light. She had this eternal Sun around, above, and within her; she was encircled by thousands of rays, protected from above, and impregnated within, both in spirit and in body, such that she was full of God the Lover in her mind, and of God the Lover Incarnate in her womb. The solar robe that covered her was white, brilliant, and glowing, and there was nothing dark in her, nothing obscure, for "you are beautiful, my love, and there is no spot in you." There was no room for spiritual coldness in that heart, for it was all ablaze in the immense warmth of such a lovable and strong Sun. As the gold and ivory throne of Solomon, Mary is clothed in the Sun, imitating God, and lovingly conveying to us the warmth and light of His favor.[58]

As is evident, the description conforms far less to Cigoli's painting than to Scheiner's vision of the crystalline moon. It is safe to say, moreover, that requests for decorum such as those made explicitly by Gerónimo Nadal and implicitly by François Aguilon went largely unheeded by the fervent Vittorelli.

Scheiner followed his singular report of the eclipse with a discussion of
the moon's secondary light. Here he was interested in showing that the
ashen light that covered the moon's disk a few days before and after con-
junction came directly from the sun, rather than being reflected from
the earth, as Galileo had claimed. The problem was not so much to ex-
plain how the light traveled through the semidiaphanous moon, but to
account for the difference in its appearance on the horns and on the rest
of the globe, for the crescent was a brilliant white, while the greater part
of the lunar surface had an ashen or bluish cast. Scheiner solved the prob-
lem by appealing to a vaguely defined distinction between reflection and
refraction:

> The moon—because it is both beset with many spots, and should be pre-
> served from the laceration of most of them—is completely translucent, more
> and less so according to greater and less density. Given this, the vexed
> question of the secondary light of the new moon is now easily resolved: it
> is indeed nothing other than the light of the sun spreading through the
> moon, and being refracted by it to our eyes. This [secondary] light is weak
> because it is refracted and because it has to pass through the moon, and
> the other [primary] light, because it is reflected from the surface of the
> moon to us, is stronger and brighter. When, moreover, the moon recedes
> further from the sun, because of this, that refraction becomes even weaker
> and by contrast, the reflection even stronger. On the basis of these two
> things the cause of the diminished [secondary] light and the increased [pri-
> mary] one is apparent.[59]

Scheiner's explanation of the difference between the primary and sec-
ondary lights was not a particularly clear one, but over the course of the
next few years his position was elaborated by other authors associated
with the Society of Jesus. What is most interesting about the argument is
the gradual metamorphosis of the lunar body. Anything that constituted
darkness, whether the spots themselves or the dramatic difference be-
tween the horns and the rest of the globe, or the ashen shadow that ap-
peared just before and after conjunction, was being little by little erased,
as if naked eye observations of its mottled surface, its phases, and the sec-
ondary light might be set aside in favor of telescopic observations that
showed a perfectly pellucid body in which all that was not reflected was
said to be refracted. Thus, while other proponents of the theory of a crys-
talline moon such as Colombe, Lagalla, and Aguilon, in worrying over
the "filthy shadow" of its spots, the "contagion" of opacity, and the
contrast of black and white, had acknowledged that the moon offered
at times an obscure appearance to the eye, Scheiner turned promptly to
consideration of a "completely translucent" lunar body, one whose every

feature was bathed in some kind of light. And while Aguilon had written, tellingly, that the moon was "not luminous but *bleached*," neither Scheiner nor his disciples would indicate that the spotless body had ever needed such cleansing in the first place.

A Student of Scheiner

In 1614 the otherwise unidentified Johann Georg Locher, a pupil of Scheiner's at the Jesuit Academy in Ingolstadt, wrote a treatise whose ambitious title promised a "mathematical" approach to the recent astronomical controversies. The *Disquisitiones mathematicae de controversiis ac novitatibus astronomicis* appear to have had a wider circulation than do most theses; this brief treatise was cited, for instance, by Giuseppe Biancani, S.J., in 1620, by Galileo in 1632, by Marin Mersenne in 1636, by Johannes Hevelius in 1647, and by Giovanni Battista Riccioli, S.J., in 1651.[60] Biancani attributed the *Disquisitiones* to "Father Christoph Scheiner, of our Society," Hevelius, to "the distinguished Christoph Scheiner," Riccioli, to "our Scheiner," and Mersenne to someone called "Schener." Galileo wrote contemptuously and at some length of "this philosopher." The diffusion it enjoyed within the Society of Jesus was due in large part to the moment of its publication, which came in the year following the the exchange between Galileo and Scheiner over the sunspots. Finally, since both Locher and Scheiner referred to their works as a *Disquisitio* or "investigation," readers would have associated their efforts, and insofar as the two works were intended to contest Galilean arguments, such conclusions would not have been incorrect.

Locher, like Aguilon and Scheiner, opposed Galileo's description of a rough lunar body, and he especially disliked his theory of the secondary light, where the moon is illuminated by sunlight reflected off the earth. In Locher's view, the ashen glow with which the moon was adorned shortly before and after conjunction was not in essence different from the brighter light that fell on the horns: the apparent differences in illumination were to be attributed to both the moon's semidiaphanous substance and its dimensions. His notion is clearly a slavish imitation (or, more charitably, a faithful endorsement) of his mentor's distinction between the light reflected off the crescent and that penetrating the rest of the globe and being "refracted" within it. Locher also used the traditional comparison of crystal and clouds, by now judged synonymous, to depict a luminous and entirely immaculate moon: "I say therefore that this brilliance on the moon is produced by the Sun, not so much by the radiation and reflection from which the primary light of the moon is

born, but by a glowing within and throughout the globe; thus as the rays of the Sun are absorbed by the moon and terminated in it, *so the moon becomes a wholly luminous body, and therefore looks to us like a cloud or a crystal.*"[61]

Christoph Scheiner had sent a courteous letter and Locher's treatise to Galileo in February 1615,[62] perhaps in the same spirit as modern scholars who nonchalantly offer their books and articles to colleagues whose work they condemn. Nearly twenty years later, in his *Dialogue Concerning the Two Chief World Systems*, Galileo singled out the above passage as especially deserving of ridicule, and his efforts to show the inconsistencies and inadequacy of the technical argument are mixed with speculation about the author's intentions. He concluded that Locher knew that nothing in this gauzy and completely luminous moon corresponded with the way that body appeared on the fourth day before or after conjunction, when the secondary light was most evident, and that the writer understood that such light was caused by reflection from the earth, but that a desire for novelty inspired him to create a globe entirely without spots or shadows. He also suggested that what was old in Locher's theory—and I have shown its evolution from the recent notion of a crystalline or cloudlike moon, which in turn derived from the rare and dense globe—would have appeared new to the masses, for it mattered little whether "inventions were new to men, or men new to inventions."[63] This observation, though made without regard to the importance Locher's theory would have for the visual arts, had an uncanny application to the *Inmaculada* tradition in Spain, to which I now return.

Pacheco's Innovation

The evolution of the semidiaphanous moon in the first four years after the publication of the *Sidereus Nuncius* meant that its rough and dark features were erased one by one, and that it retained nothing but a luminous "refracting" interior enclosed by a brilliant "reflecting" crescent. It should be evident that the theories of Scheiner and Locher—if a distinction can be made between the ideas of the mentor and those of his student—were followed by Francisco Pacheco in his *Inmaculada con Miguel Cid*, as well as in his other works devoted to the same subject. Thus, while Pacheco followed Luis Alcázar in placing the Virgin above downturned horns, he rejected the Jesuit exegete's unusual belief in an opaque globe, preferring rather the increasingly luminous body described by others in the Society of Jesus. In writing "although [the moon] is a solid globe, I take the liberty of making it lucid and transparent above the land-

scape; the upper part is very bright, and the middle visible, with the horns turned downwards," Pacheco offered a close approximation of Scheiner's discussion, where a "completely translucent" body was adorned here with reflection and there with refraction. The pun is too difficult to resist: "Apelles" really *was* behind this painting.

Proud of his innovation and its subsequent adoption by future painters, Pacheco had written, "If I am not mistaken, I believe that I am the first to have bestowed such majesty on these embellishments, which other artists will now be following." This statement, not published until 1649, confirms Galileo's cynical observation about the alleged novelty of Locher's work, for as I have shown, there is more that is old than new in the hypothesis presented in the *Disquisitiones mathematicae*, the wholly luminous moon being no more than a refurbished dense-and-rare globe, and the logical endpoint of an illogical notion.

How much Pacheco knew about the development of the argument is difficult to judge: he may have actually read the relevant pages of Scheiner's or Locher's treatises or come across a synopsis of the argument elsewhere, or had the issue explained to him by someone familiar with the debate. In the latter case, the opinions of Father Juan de Pineda, S.J., another visitor to Pacheco's academy, author of many different sermons on the Immaculate Conception, and a strong opponent of Copernicanism, may have been crucial.[64] At any rate, Scheiner's and Locher's "invention" would have seemed entirely new to Pacheco, and the rapid evolution of the theory of the crystalline or cloudlike moon might have persuaded the painter that he was depicting the very latest of scientific notions. Given the dramatic difference between what he painted and the actual appearance of the four-day old moon, where the bulk of the globe is ashen in color, Pacheco seems to have believed that the pellucid inner area would be apparent to an observer armed with a telescope, and that he, like John of Patmos himself, was revealing something that would not be perceptible to most viewers. His stipulation that the middle of the moon be clear and visible, rather than covered with an ashen shadow or completely invisible, would make the *Inmaculada con Miguel Cid* a telescopic vision, one that affirmed the purity both of the Virgin and of the body on which she rested.

Pacheco was correct, of course, in the matter of his influence on the *Inmaculada* tradition. The translucent moon with the down-turned horns was imitated by many, and we might even say that someone like Francisco de Zurbarán, who depicted glassy crescents and invisible interior globes in his *Inmaculadas*, finished the gradual process of erasure begun by Galileo's rivals. It is less easy, however, to place Velázquez in this tradition, despite the apparent similarity between his *Inmaculada*

and that of Pacheco. In returning to this early and interesting work, I will
argue that the arguments that found such ready acceptance in Pacheco's
painting were actively contested by the younger artist, who believed that
the moon was just as Galileo had said: rough, dark, opaque, and full of
concavities and mountains.

"A Good Painter"

Velázquez completed his *Inmaculada*, as did Pacheco, between 1618
and 1621. The work is generally thought to have been commissioned by
the Shod Carmelites of Seville, an order known for its devotion to the
doctrine of the Immaculate Conception: the first mention of this painting
and a pendant representing John of Patmos occurs when they were found
in the Carmelite Chapter House in 1800.[65] Such a commission would
explain certain details in the *Inmaculada*. Carmelites had long related the
vision of Elijah on Mount Carmel to that of John of Patmos: the cloud
that Elijah saw rising from the sea in 3 Kings 18:44, for instance, was
thought to contain the woman of 12 Revelation, and in time the cloud
itself was used as an exegetical argument for the Virgin's purity. Vexilla of
the order often conflated the two visions as well, such that the Woman
Clothed in the Sun, crowned by stars, and standing on the moon hovered
in a cloud above Mount Carmel.[66]

It seems likely that Velázquez knew of such conventions, and that he
painted a mountain directly behind the transparent moon in order to em-
phasize the order's devotion to the Immaculate Conception. The whitish
area right above the mountain would then represent at once the lighted
part of the moon, and the cloud that Elijah saw above Mount Carmel.
The dark body of water enclosed by the moon, a bay on which we can just
make out the sails of a small boat, would also be part of this Carmelite
landscape, for the cloud of 3 Kings 18:44 rose from the sea. In this set-
ting Velázquez combined, then, three distinct iconographic traditions,
for it includes elements from the visions of both John of Patmos and
Elijah, and a Marian icon of purity. The presence of that other Marian
emblem, the *Domus Domini*, in the left foreground reinforces such iden-
tification, for the Solomonic Temple, like the cloud and the mountain, is
depicted in 3 Kings 6.

Consider, however, one difference between the configuration in the
painting and that on a Carmelite vexillum: in the latter case, the stylized
mountain is always directly beneath the cloud and the vision of the Vir-
gin, whereas no such symmetry characterizes Velázquez's work, the
mountain being off to the left and extending well beyond the transparent
lunar globe. This detail would not be worth comment—vexilla tend to-

ward axial symmetry, but paintings need not—except that it recalls the very arguments from which the theory of the crystalline moon developed. Did the moon have mountains, or not? Did they protrude far beyond its surface? Were they so opaque as to cast shadows? Were they what formed the uneven border between light and dark on the lunar globe? All that Galileo had affirmed about the moon's mountains in the *Sidereus Nuncius* is as if confirmed in the foreground of the *Inmaculada*: the peak on that pale moon extends far beyond its surface, it blocks out most of the light behind it, and it serves as a terminator on the lunar body itself. In other words, here in a painting so frequently compared to the *Inmaculada con Miguel Cid*, a few details serve to contradict in every particular the hypothesis endorsed by Galileo's Jesuit rivals and by Pacheco himself.

Were it not clear that Pacheco's work was an explicit endorsement of Scheiner's position, we might look upon this apparent superposition of astronomical argument and artistic convention as a matter of coincidence. It seems that at least one seventeenth-century Sevillian bystander did not, and here I return to the remarks that the Inquisitorial notary Benito Daza de Valdés made in 1623 in his treatise on eyeglasses: "Generally, however, we see the moon as very rough and sponge-like, with some points of greater light in the loftiest places, for which reason *a good painter will know better than I do if those are really heights and depths.*" The allusion to the *buen pintor* is nicely ambiguous: it may refer to either an upright and virtuous painter, or to a particularly talented one. Either reading would restate, but not resolve, the problem, for we would be left with the opposition of the pious mediocrity of Pacheco, and the less orthodox virtuosity of his student and son-in-law. While it is probably significant that such comments come from the learned "Doctor" of the dialogue, I cannot tell in which sense he used the words *buen pintor*, I cannot say whether Daza de Valdés saw Pacheco or Velázquez as the better painter, and I do not know whose version of the lunar globe he preferred. If Pacheco appears to our eyes much the inferior artist, he was nonetheless already Overseer of Sacred Images for the Inquisition and at the center of Seville's intellectual and artistic life. Velázquez, on the other hand, had left Seville for Madrid in April 1622 in order to gain the attention and favor of Philip IV, had met with only modest success there, and had returned home by the end of that year.[67] He would have still been at the court in September 1622, the month in which Daza de Valdés was granted the privilege to publish his *Uso de los antojos*, but even that short-lived venture might have occasioned envy rather than admiration. In short, it is impossible for me to decide which of the two painters was, in the eyes of Daza de Valdés, the "good" one and thus better able to judge if the apparent peaks and craters of the moon were really there. More crucial than the aesthetic preference of this Inquisitorial no-

tary is, however, the fact that he explicitly related the artist's representation of the moon to the controversy surrounding the *Sidereus Nuncius* less than two years after Pacheco and Velázquez completed their very different *Inmaculadas*.

Velázquez may also have wanted to show certain inconsistencies between the notions put forth by Scheiner and Aguilon, the most well-known proponents of the crystalline moon. Recall, for instance, that Scheiner boldly stated in the *Accuratior Disquisitio* that during a solar eclipse the part of the moon covering the sun revealed itself to him as "completely pellucid like crystal or some other glass, but unequally so, thus in one place it all became white, and elsewhere it was just becoming white." Earlier that same year, however, Aguilon had acknowledged the dark appearance of the moon during a solar eclipse and had relied on the crystal ball comparison to explain the obscurity of something so transparent. "It is as if the solar rays that sail over [*praetervehuntur*] the diaphanous part of the moon then converge at one point, and from there are diffused in all parts and are lost far from our sight. This effect is manifest in small crystal balls, which, if observed in like manner, show the image of darkness rather than that of splendor." The moon as Velázquez painted it is both crystalline and extraordinarily dark; apart from the vaguely indicated horns, the only point of light is the very bright *stella maris* that appears over the boat. We would not know what it was meant to represent, in fact, if it were not for the barely perceptible curve of two sails just beneath it, and the illuminated stretch of water in which the vessel rests.

Though the canvas has surely darkened over time, I believe that this portion of the painting was intended to present problems in legibility, for the manner in which we decide what the *stella maris* is recalls formally and thematically the very argument offered by Aguilon. We reason, in other words, "in this very dark globe, there is something like a sailboat in the foreground, and so there must be one bright spot, the *stella maris*, whose beaconlike light should be diffused everywhere"; Aguilon had written that in an otherwise dark globe, it was as if sunlight converged by "sailing" rays, and that it was then diffused and lost to our view. The similarity between these two conjectures, moreover, emphasizes if not the outright inadequacy of the hypothesis of the *Opticorum libri sex*, at least the flimsy *ad hoc* quality that the sailing metaphor confers, for the coherence of the configuration in the painting—the fact that what is depicted not only looks like a boat but turns out to be one—reminds us that the simile on which Aguilon's argument rests, that *ut . . . praetervehuntur-radij*, must by contrast remain a mere figure of speech. This interpretation depends—in a way that my discussion of the mountain behind the moon

does not—on a close reading of the pertinent passage of Aguilon's *Opticorum libri sex*. While we cannot be sure when he acquired it, or how often he consulted it, the work was part of Velázquez's library.[68]

There is, finally, one more allusion to the lunar issue in the cloud bank surrounding the Virgin. In earlier *Inmaculadas* of the *tota pulchra* type, the various emblems of her purity were usually placed, as if in niches, in these clouds. Though he substituted placards for the sun and the moon, Zurbarán, for instance, retained most of these features in his *Inmaculada* of 1632, the Virgin being encircled by Heaven's Gate, Jacob's Ladder, the star of the sea, and the spotless mirror. The order in which these emblems were arranged came to be based, as best I can judge, on the place they would occupy in a landscape, so that normally the sun and the moon appeared in the upper reaches of the canvas, followed by paths to heaven such as Jacob's Ladder and Heaven's Gate, then by objects such as the star of the sea and the Tower of David that might figure in a distant background, and finally by Solomon's Temple, and the fountains, flowers, and enclosed gardens that composed the foreground.

The vapor-borne emblems disappeared, for the most part, in the seventeenth century, or they occupied a more natural place in the landscape, as in Pacheco's *Inmaculada con Miguel Cid*. There are no Marian icons in the aerial zone surrounding the Virgin in the work of Velázquez, but there is one group of clouds unlike the rest. Consider the contrast between the unremarkable cumulus type that dominates the painting and the section just beyond her right arm, where the *Porta Coeli* was generally placed: the latter region looks more like the cratered surface of the moon. This is perhaps no more than we might expect, given that those who argued for a crystalline moon often explained its mottled appearance by comparing it to a cloud. That analogy was frequently accompanied by another one, as I have noted, where the illusion of height and depth in clouds was likened to that found in paintings. Thus Giulio Cesare Lagalla had written:

It happens that these phenomena are made in another way, out of the mixture of light and opaque materials; as we see painters using different combinations of these things, show on a completely flat and smooth surface the images of bodies, some lofty, some low, some high, others humble, some solid and continuous, others pierced and gaping with holes. We can see this most clearly in clouds lit up by the sun: since they do not admit the solar rays everywhere, these mixtures offer various spectacles made of the lucid and the opaque. Indeed, since we also accept that the lunar globe is composed of lucid and opaque material, it will not perhaps be difficult to assign a cause to these phenomena.[69]

Meditations such as these implied an easy equivalence between the
dark and light surfaces of the moon, of a cloud, and of any painting, al-
most as if the three *chiaroscuro* mixtures might substitute for each other
anywhere. And while it is true that Velázquez has shown "on a com-
pletely flat and smooth surface the images of bodies, some lofty, some
low, some high, others humble, some solid and continuous, others
pierced and gaping with holes," his clever procedure does not stand as
an endorsement of the alleged similarity between vaporous and lunar
bodies, but rather as a ready index of how different in appearance they
are. For if we decide that the patch of clouds to the Virgin's right looks
like the cratered face of the moon, we arrive at this conclusion only by
opposing it to the rest of the clouds around it, and by insisting on their
dissimilarity, as I have done. If, on the other hand, we assume that *all*
the vaporous masses surrounding the Virgin represent clouds, we will
have found little or no evidence of the resemblance of this patch to the
moon. In either case, the painterly comparison that had been of such im-
portance to writers like Lagalla and Colombe is subverted, as if to imply
that the moon is much more like the mountainous globe below than the
clouds above.

Undue Influence

Until this point I have been discussing the influence that the astronomical
arguments had on artists whose task it was to depict the Immaculate
Conception, and I have shown in this chapter how the Immaculist cli-
mate of Seville made a painter like Francisco Pacheco particularly recep-
tive to theories of a crystalline moon. By way of conclusion I will examine
a different kind of question, the extent to which astronomers explicitly
acknowledged the importance of Marian icons for their discussions of the
lunar substance. While references to religious matters are not infrequent
in the context of early modern science—indeed, passages from Scripture
sometimes figure as the final word in an astronomical debate—it is diffi-
cult to show that philosophers consciously adapted their arguments
about the moon to reflect doctrinal issues. There are, however, a number
of indications that such tendencies were at work and that astronomers
felt they had somehow to accommodate the features of the moon to the
attributes of the Immaculate Virgin. The crudest index of this impulse
would be, of course, Odo van Maelcote's description of the moonspots as
a bunch of rosary beads, where the craters and chasms that he saw on the
globe were converted into a devotional object. I offer two instances in
which this conflation of Marian and astronomical arguments is explicitly
protested: one is a letter written by Galileo himself, which I will examine

in the context of contemporary accounts left by Isaac Casaubon and Fra Paolo Sarpi; and the other is a passage from a treatise whose author, Giuseppe Biancani, S.J., was well acquainted with all proponents of the hypothesis of the crystalline moon.

King Solomon's Purple Couch

As I noted in my third chapter, in the weeks directly after the publication of the *Sidereus Nuncius* Paolo Sarpi wrote several letters explaining lunar phenomena to friends living outside Italy. In that same period he received one or perhaps two letters from the great Protestant scholar Isaac Casaubon, but these had to do with other celestial matters.[70] Though these missives do not survive, their subject can readily be inferred through comparison with Sarpi's reply and with entries drawn from Casaubon's own diary. Casaubon was at that point considering conversion to Roman Catholicism, but was repulsed above all by the cult of the Virgin Mary. On March 20, 1610, he had gone to Mass at the Jesuit novitiate church in Paris, Saint Paul's, to celebrate the Feast of the Annunciation and was horrified by the extravagances he heard there.

"Since the day was dedicated to Blessed Mary," Casaubon noted in his diary, "the entire sermon of [a certain Father Varaderius, a former Jesuit, and now free of that Order] was devoted to praises of her, and criticism of those who believe otherwise. I shudder to remember what I heard there."[71] Not only did Casaubon remember what he heard at that service, he devoted a full five pages of his *Ephemerides* to its description. He noted that "the people" had been taught that the Virgin, because she had borne Christ, was the equal of God the Father. Casaubon saw that she was now the superior of her Son, and he recalled that Varaderius attributed to the Mediatrix a nagging little litany in which she accused him of ingratitude: "I am the one who made You what You are; without me, You would not exist. Didn't You obey me when You were young? All the more reason that You should obey me now! When You were young, I used to bid You, 'Do this,' and You did it, and I would say to You, 'Kiss me,' and You would. I would tell You to fetch me some water, or to carry something to the neighbors, and You would do it. Why will You not do it today?"[72] Varaderius had also revealed that "when Mary was in the womb of her mother, that she was more learned, and wiser, and blessed with nobler visions, than any of the prophets or apostles."[73] He had even gone so far, apparently, as to concoct a new bit of ancient history: when they returned from their long voyage, he said, the Argonauts made a statue of precious marble and built a temple, and upon consultation with the Oracle learned that this edifice was to be dedicated to a

virgin who would be the mother of a great God, *mater Dei magni*. For this reason, Varaderius explained, there was an ancient temple of Mary in the city of Athens, and many of her shrines nearby. As the learned Casaubon dryly observed, "This madman had somewhere heard or read of the *mater Dei* of Pessunus"—an ancient city in Galatia known for its worship of the Phrygian goddess Cybele—"and like a fool, he changed her into the Blessed Virgin Mary."[74]

This was not all that Varaderius had to offer: he said that there were six hundred prophetic references to Christ in Scripture, and that each and every one of these could be attributed to the Virgin Mary as well. Casaubon recorded one of these exegetical maneuvers, where the Virgin was compared to the couch of King Solomon:

> But at last he got stuck on these verses from the *Song of Songs*, "He made its columns of silver, and its headrest of gold, its seat of purple cloth, [and its lining of leather]" and so forth. That fellow pondered every single word in Hebrew, then in Greek, and then in Latin, and in the foolish fashion of modern poetry anything that he had ever seen, or read, or heard about columns, or headrests, or gold, he now recalled to mind, and he attributed all of it to the Blessed Virgin. He said a lot about gold, and about the marvellous art of pounding out great quantities of gold leaf from the smallest amount of that metal, and so forth. This is the doctrine by which he shook the people hanging on his wretched words.[75]

One can only imagine what Father Varaderius had to say about the "Marian" meaning of the purple seat and leather lining of Solomon's couch after he finished his meditation on what his contemporary John Donne would call "gold to aery thinness beat," for here the disgusted Casaubon turned to other aspects of that memorable sermon. A few days later Casaubon heard more marvels attributed to the Virgin,[76] and soon he appears entirely to have abandoned the prospect of conversion. He had written to Paolo Sarpi about his spiritual crisis, complaining about the manner in which the present-day Roman Catholic Church had deviated from the purity of that community first assembled by Christ. It is unlikely, given his great revulsion for the ceremony at Saint Paul's and his reserved nature, that Casaubon provided a detailed account of Varaderius's performance, but none of what he had witnessed would have been surprising to Sarpi, as the discussion below will suggest. In his reply the Venetian theologian reminded Casaubon that "Christ surrendered himself so as to render the Church immaculate, not in this day and age, but in the future, and as it is progressing toward that goal which mortals are not permitted to witness, it seems to me that you want a Church free of all spots, and unless you raise your eyes to the heavens, I cannot show you that."[77]

What Casaubon indignantly attributed to the former Jesuit Varaderius was typical of many Catholic devotees to the Virgin. Such Marian obsessions were in fact commonly considered to be fostered by the Society of Jesus, as a contemporary treatise like the *Bespotted Jesuite* makes clear, and they were also said to have flowered from 1605 to 1621, under the papacy of Paul V, who was known to be particularly worshipful of the Virgin.[78] What is more pertinent, however, is the way that Casaubon's description of a sermon preached at Saint Paul's in 1610 compares to what Sarpi, his plea for Casaubon's patience notwithstanding, was then engaged in writing about the original late Antique and early medieval development of the doctrine of the Immaculate Conception.[79]

Casaubon had noted that the cult of the Madonna had made the Virgin equal to God the Father, that such devotion meant that she had effectively displaced her Son, that these beliefs had been passed on to "the people" and were sustained by unbridled popular fervor, and that entirely unrelated Eastern notions like that of the Phrygian *mater Dei* had been subsumed by irresponsible Marian enthusiasts like Varaderius. In an infamous section in the second book of his *History of the Council of Trent*, which was smuggled in manuscript form out of Italy in 1616 and brought to press in 1619 by a group of Protestant allies, Sarpi devoted himself to a very similar discussion.[80] He emphasized the maculist objections to the doctrine of the Immaculate Conception, stating that in its cultic origins in the Eastern church, the figure of *Maria mater Dei* had become the equal of her Son and that she eventually displaced him, that such beliefs were kindled by the popular imagination, and that it was argued that denying the privilege of immaculacy to the Virgin would be "an ingratitude, and a denial of the honor due to she through whom Christ's grace was transmitted to mankind."[81] What Varaderius related about the Virgin— the supposed reference to her in the Oracle, her ascendancy over her Son, her appeal to "the people" and her speech to her brattily ungrateful Child—would be, in other words, just a supremely vulgar instance of those early tendencies. Just as the purist Casaubon had found no evidence for any of these claims in the Bible, so Sarpi wrote that the Dominican resistance to the doctrine was founded upon Scripture.[82] And just as the Marian enthusiast Father Varaderius had said that all that was ascribed to the Father or the Son in Scripture was also true of the Virgin, so Sarpi reminded his readers that supporters of the issue read every biblical reference to the Godhead as a tribute to Mary.[83]

Sarpi also noted—unlike Casaubon, who appears not to have entertained the logical contradictions in the doctrinal question—that the maculist Saint Bernard had stated that the privilege of immaculacy might be wantonly extended not just to the Virgin, but to her parents, and to theirs, and to all those for whom Christ had died.[84] The Venetian went on

to point out that the Franciscan argument of *potuit, decuit, fecit* depended on what men thought God could do. In short, without pronouncing his own opinion, Sarpi suggested that the entire issue of the Virgin's Immaculate Conception was at once an ancient superstition and a web of "novelties and inventions."[85]

Now these are also precisely the kind of objections that Galileo would raise in his arguments for the maculacy, not of the Virgin, but of the moon on which she stood. As I mentioned earlier, Galileo wrote a letter in mid-July 1611 to Gallanzone Gallanzoni, secretary to François Cardinal Joyeuse, the French prelate in Rome, in which he tried to refute the lunar theories of his rivals. His objections concern for the first time something other than the mere fact that the crystalline moon does not fully account for telescopic phenomena: in this letter, his arguments begin to resemble those offered by the maculists to their adversaries in the realm of doctrine.

Echoing theologians who opposed the Immaculate Conception, Galileo called his enemies' thesis a "pure and arbitrary invention," a "chimera," a product of the imagination, and one that created far more difficulties than it solved.[86] The maculists had suggested that the singular exemption from sin accorded to the Virgin meant that on the one hand, there was too little distinction between her and her Son and, on the other, if her conception was immaculate, why not that of her parents, and of theirs, and of all men? Galileo used similar arguments to question the distinction between the lunar sphere and all both above and below it. How, Galileo asked, was the moon's crystalline surface different from the ether that surrounded the lunar body and the rest of the heavens? Since no difference was said to exist, then the distinction between the moon and all above it lay not in the crystalline shell, but in the *concepito globo di smalto bianco*, in that "contrived ball of white enamel" itself. And why, for instance, could the pellucid crystalline substance not be said to surround the earth as well, so that our planet, like all above it, participated in this celestial perfection?[87] In other words, the distinction between the moon and those bodies around it seemed to Galileo as arbitrary and as illogical as did the special privilege of purity reserved by some for the Mother of God.

Galileo also reminded those who insisted that the moon had to be completely spherical because the sphere was "the most perfect of shapes" that they were making their own intellect the measure of the divine mind; this was the objection of theologians who found in the *potuit, decuit, fecit* syllogism an absurd anthropomorphic circumscription of God's power.[88] Even the language that Galileo used, with its unusual insistence on the supposed "divinity" of the moon, and especially on its alleged "purity," recalls the doctrinal discussion:

And I really believe that it would be much less harmful if those who are so protective of the *purity, excellence, and divinity* of this [lunar] substance would just allow some irregularity in the shape [of the globe]—for this is accidental, not essential—rather than proposing so many differences in rarefaction, density, diaphaneity, and opacity. And I am certain that if the actual sight of the large and ancient moonspots had not [first] constrained them to invoke the rarity and density of her material, our philosophers would never have posited such accidents in the *imagined purity* of her substance.[89]

Furthermore, he noted that if the traditional distinctions between the celestial and the terrestrial, between perfection and corruptibility, and between circular and rectilinear movement were all discarded, the resulting hypothesis would be "a doctrine that was not only more solid, but more in agreement with Sacred Scripture."[90] This was the classic defense of the maculists, who insisted that their doctrine was both superior in logic and more in conformity to the Bible than was the fiction of the Immaculate Conception.

Casaubon had described Father Varaderius's performance at Saint Paul's as a curious combination of Antique belief and elaborate novelty, and Sarpi had viewed the doctrinal position of the Immaculists in much the same light. Galileo likewise warned the proponents of a "pure" and "divine" lunar sphere that they were at once enslaved to inveterate opinions and guilty of the most alarming innovations. It was nothing but an old superstition that led men to suppose that perfection resided in sphericity and homogeneity, he noted, and though Peripatetic philosophers had handily encouraged associations of this sort, there were neither necessary nor demonstrable reasons to support such beliefs.[91] At the same time, Galileo observed, the proponents of the semidiaphanous moon were required to add novelty upon novelty—or "fiction upon fiction," as he put it—to account for the inadequacy of their hypothesis, encasing jagged mountains and valleys of white enamel in crystal in order to maintain the perfect sphericity of the lunar body in the posttelescopic era. As he wrote in the margins of his *Letter to Gallanzoni*, "Some people might abhor my position for its novelty, but it is worth noting that what my adversaries are saying is newer still."[92]

There is, moreover, Galileo's reference to a pool of water which, if more than a few yards deep, will conceal from the viewer "all the secrets of its bed."[93] While the association of female chastity with the moon is entirely traditional, the context suggests that this remark has a particular importance to the Marian issues raised by Casaubon and Sarpi. In his diary entry Casaubon did not note the sexual aspects of the Annunciation sermon at Saint Paul's—indeed, he stopped short of recording what was

so "Marian" in the luxurious purple seat and leather lining of the kingly couch—but here the florid Varaderius surely placed some emphasis on the Virgin's womb. Nor did Sarpi mention in his criticism of the doctrine of the Immaculate Conception that the "novelties and inventions" surrounding the notion often included some prurient speculation about her own conception of Christ.[94] And though I would say that sexual references of any sort in Galileo's work are very few, it does seem that this allusion to "all the secrets of its bed" in a substance that was always described as "immaculate," "divine," "pure," and surrounding a "conceived globe" does indeed have Marian echoes, and that here the lunar body favored by Galileo's adversaries is described by the astronomer as if it were the Virgin herself.

There is some evidence to suggest that Galileo intended the *Letter to Gallanzoni* as a specific reply to his real or imagined Jesuit rivals, and that this Marian portrait of the moon was a means of persuading them of the utter unlikelihood of the transpicuous lunar body that some in their order described. He had decided to write to the secretary of Cardinal François Joyeuse just after he left Rome in 1611 upon learning that his perennial enemy, Lodovico delle Colombe, had written some six weeks earlier to Father Christoph Clavius congratulating the Jesuit astronomer on his belief in the semidiaphanous moon. Colombe's letter had been passed on to Galileo, who mentioned his detractor's theory of the enamel and crystal globe in the beginning of his letter to Gallanzoni, compared it to the thesis sent to him by the pious Mark Welser of Augsburg and allegedly maintained by "some philosophers from that area," and then added that the idea had a great many proponents in Rome. It is worth noting that Galileo suspected that Welser's contacts were Jesuits, that he was concerned with the effect that Clavius's preference for a semidiaphanous moon might have on members of his order in Rome, and that Cardinal Joyeuse was well known both for his scientific interests and for his ties to the Jesuit community.[95] Given these considerations—ones which make the regrettable Colombe little more than a pretext and suggest that the Society of Jesus was Galileo's true concern—the emphasis placed on the novelty of the crystalline moon becomes particularly interesting.

The perils of innovation, especially in matters of faith, were repeatedly emphasized in Jesuit documents. The *Constitutions* themselves flatly stated "New doctrines are not to be accepted." In the *Ratio studiorum*, the statutes of Jesuit education, professors of theology were enjoined to defend only what had been approved by the Church, and those members of the Society who proved "inclined to novelties . . . would unquestionably be removed from teaching."[96] They were also warned not to "heedlessly think up new reasons [to support a given doctrine], unless such reasons were supported by the most unchangeable and solid

principles."[97] The entire order was reminded that it "should abhor, and had always abhorred both novelty in any matter, and laxity in the realm of morality."[98]

Yet the Society of Jesus was known, both within and outside of the Catholic world, for the problems posed by the contrast between its official opposition to innovation and its evident attraction to novelty. Thus the English clergyman and amateur scientist John Wilkins would note, in regard to the question of the reconciliation of Scripture with theories of a mobile earth, that "the Jesuits, who are otherwise the greatest affectors of those opinions which seem to be new and subtle, do yet forbear to say anything in defence of [Copernicanism]; but rather take all occasions to inveigh against it."[99] And within the Society, directives against all manner of novelty clearly needed reiteration, and this came in circular letters written by the order's general, Father Claudio Acquaviva. On May 24, 1611, some six days after the ceremony in Galileo's honor at the Collegio Romano and several weeks before the astronomer's return to Florence, Acquaviva issued a stern decree emphasizing once more the need for "solid and uniform doctrine" in matters of theology and philosophy. He criticized in particular all doctrines involving "variety" and "novelty," and he went so far as to describe the disorderly accretion of beliefs as a gaudy garment "woven together of many different colors," noting that no one familiar with Thomistic principles would see these innovations as "the single surface of a uniform body."[100]

General Acquaviva's recommendations find an odd echo in the *Letter to Gallanzoni*, which offers a similar condemnation of novel and insubstantial theories. More curious still is the reference to the "variegated" body of new doctrines; though it is clear that Acquaviva's figure involves something woven of bright-hued threads, the phrase itself recalls the Jesuits' sometime reliance on a glassy and particolored lunar globe in their disputes with Galileo. Thus in January 1611, as I mentioned in my fourth chapter, Mark Welser had relayed to Galileo a brief letter where the anonymous author, almost certainly a member of the Jesuit order, noted that certain "philosophers say that those jagged peaks are within [the moon], just as stones of various colors and masses of various shapes may lie within a glass or crystal globe."[101] And in 1613, in the midst of Galileo's conflict with Father Scheiner, the Lincean Angelo de Filiis would mock such thinkers for "cobbling [the moon] together with various and mixed spirits and colors," as if this version of the lunar body were the equivalent of the variegated cloth denounced by Acquaviva.[102]

But it is the abstract doctrinal issue and the way that it compares to the illogical notion of the crystalline moon that is most important. I have suggested thus far that the *Letter to Gallanzoni* was intended primarily for the opponents, or potential opponents, that Galileo believed he had

among the Jesuit Order, and that his objections to the theory of a "pure," "perfect," and "divine" lunar body strongly resembled criticism voiced by those who were opposed to the doctrine of the Immaculate Conception. It is certain that Galileo rejected the theory of the crystalline moon because it was illogical and failed to account for phenomena observed by him long before the invention of the telescope. It is feasible, I believe, that he rejected the doctrinal issue because it seemed to him equally improbable, for reasons similar in both structure and tone. In emphasizing the association between the two beliefs, and in portraying one theory in terms appropriate to the other, Galileo hoped to dissuade his adversaries of both the astronomical and the doctrinal suppositions. Less surprising than his probable disregard for the issue of the Immaculate Conception is his recognition that the notions were associated in the minds of many.

Galileo's presentation of the flawed lunar hypothesis in terms of the flawed doctrine was, I believe, a rhetorical tactic, one designed to diminish support for the theory of the semidiaphanous moon, particularly among Jesuits. It does not spring from a sense that the moon should be an icon of the Virgin and that something about its newly revealed attributes could and should be recognizably "Marian." There is none of the accommodating spirit that characterized Maelcote's Rosary-strewn globe or Cigoli's *Immacolata*, where biblical vision and telescopic revelation formed a harmonious whole. Indeed once Galileo had emphasized the Marian associations of the crystalline moon, he returned to his earlier description of it as an object wholly unrelated to the Virgin and more appropriate to the dinner table of some enormous pagan gods. This time he did not compare the lunar globe to the festive *cyathus* of the *Sidereus Nuncius*, but rather to elaborately wrought dishes at that same feast, writing "with a little burnishing [the philosophers] could make it into a silver service."[103] Thus, while the unfortunate metaphor of the fractured and opaque wineglass was set aside, another was immediately taken up from that raucous banquet table where the Virgin surely never supped, as if to insist on the absolute separation of astronomical and sacred imagery.[104]

Finally, while I have argued for a certain confluence of ideas between the doctrinal abstractions of Sarpi and the more technical objections raised by Galileo, there is also the possibility of the theologian's direct influence upon the astronomer. While there are no extant letters between the two men after February 1611, those written by mutual friends such as Giovan Francesco Sagredo and Fulgenzio Micanzio make it clear that they remained in contact, and an accusation brought against Galileo in 1615 by the Dominican Tommaso Caccini suggests that they had maintained a clandestine (though evidently not entirely secret) correspon-

dence.[105] Thus it is worth noting, in addition to the similarities in the rhetoric of the arguments outlined above, a common reliance upon the metaphor of the spotless celestial body of the future and the impure and mottled one observed by men in this life. Recall that Sarpi, while deploring the excesses of Marian worship described by Casaubon, had nonetheless assured him in June 1610 that the pure and immaculate Church for which he was searching was "a goal which mortals are not permitted to witness." It is not surprising that Sarpi translated the specifics of Mariolatry into an abstraction about the Church itself, and his evocation of the figure of the moon in this connection is, as we have seen, entirely traditional. What is perhaps less expected is Galileo's use of a similar metaphor in the third of his *Letters on the Sunspots*, written in December 1612 and directed to Mark Welser. In the first pages of that letter, the astronomer professed himself ready to wait for Welser's final judgment of the arguments he had made about the sunspots, and he declared that he would content himself with that opinion "until, as Your Lordship most prudently says, we are allowed by the grace of the one, pure, and immaculate Sun to learn, along with all other truths that reside in Him, what we are now searching for, like dazzled and blind men, in that other impure and material Sun."[106] While it is clear that Sarpi and Galileo were considering related but not identical issues—a future and perfect communion of saints and the knowledge which the blessed shall achieve at that moment—it is surely significant that they described those states in terms of spotless celestial bodies, maintaining steadfastly that what was accessible to mortals—whether Church, visible phenomena, or scientific endeavor—was undeniably corrupt, mottled, and though imperfect, all that humans would ever know in this life, and, in the case of both men, what they themselves had established earlier, to their own satisfaction, through logical conjecture and observation.

A Second Annunciation

A different sort of evidence for the association of astronomical conjecture and Marian devotion is found in Giuseppe Biancani's *Sphaera Mundi*. A Jesuit who taught mathematics at Parma,[107] Biancani was suspected by Galileo to have been the author of one of the first works criticizing the *Sidereus Nuncius*, the "De lunarium montium altitudine"; though he protested the charge, Biancani made it clear that he knew the anonymous writer and was familiar with the treatise before it came to Galileo's attention.[108] Biancani was also in close correspondence with both Aguilon and Scheiner, and believed, at least in 1613, that Scheiner, rather than Galileo, was the first to have made telescopic observations of the sunspots. Yet

Biancani cannot be treated as the last in the line of Jesuits ready to believe that "black was white," if so told by their superiors. His *Sphaera Mundi*, completed near the end of 1615—just months before the Congregation of the Index issued its formal Decree against Copernicanism—was not published until 1620, precisely because censors demanded that the author correct his arguments for the motion of the earth.[109]

Despite the scrutiny of the censors and despite his long association with Scheiner and Aguilon, Biancani's account of the debate over the lunar globe is overwhelmingly favorable to Galileo. He agreed that the moon's surface was rough, for instance, and he used the optical arguments from the *Sidereus Nuncius* to prove it. He also adopted Galileo's method of measuring the lunar mountains, employing the same diagram, estimates, and proofs to obtain the identical figure of four Italian miles.[110]

This is not to say that Biancani avoided the work of his Jesuit colleagues: he mentioned both Scheiner and Aguilon, presenting the former in his guise of the sunspot observer and as the author of Locher's *Disquisitiones*, and citing the latter very frequently but treating him as a greater authority on optics than on astronomy. When Biancani gave a summary of the hypothesis of the rare and dense globe, he relied on the formulas that had evolved in the first years of opposition to the *Sidereus Nuncius*. The moon was "neither wholly opaque nor wholly transparent"; it absorbed the sun's light in its depths; it could be compared to "water or semidiaphanous things such as crystal, glass, or a glass ball."[111] Biancani even recounted Scheiner's remarkable description of the solar eclipse— elaborated in Locher's thesis—where the sun was covered with a globe whose circumference was so transparent as to be invisible.[112] Like Odo van Maelcote in his address to the Collegio Romano, Biancani seemed to favor the conclusions of the *Sidereus Nuncius*, but left to the reader the task of deciding between the Galilean hypothesis and that of his Jesuit brethren.[113]

Biancani is at his most interesting when discussing Galileo's work, and here comparison with Maelcote is particularly instructive. As the rosary-bead simile made clear, Maelcote felt obliged to accommodate the newly discovered lunar features to the Virgin, as if the moon in 12 Revelation had to reveal something about the *amicta sole*, or, in a figurative reading of Francisco Pacheco's words, "was required to shed light on the woman standing above it." Biancani went much further in comparing Galileo's maculate moon with Marian icons, though I believe that he did so in a spirit that differed significantly from that of Odo van Maelcote or even Lodovico Cigoli. While Maelcote may have believed in 1611 that some accommodation of astronomical and doctrinal issues was possible—that whatever the telescope disclosed about the moon, the new phenomena could ultimately be presented as Marian attributes—by 1615 Biancani

would have realized that such developments were unlikely, and his experience with the censors would have only confirmed such an impression. As I will show, his description of Galileo's discoveries makes it clear that the *Sidereus Nuncius* rivaled, rather than replicated, the web of Marian emblems, and that the opponents of the treatise saw it both as a new Annunciation and a new Revelation.

When Biancani recounted Galileo's arguments for a rough, opaque, and maculate moon, he began with a reference to the suppositions violated by such a position. Here, however, the tiresome hypothesis of the rare and dense globe has a new focus, for the language Biancani used in this extraordinary passage makes clear its doctrinal associations:

> The general opinion of philosophers is that these spots are the rarer or most transparent parts of the moon; because of this transparency they admit the light of the sun but do not block it, and therefore reflect little of it back to us. Hence they are less light but more black than the other parts of the moon, which on account of their density reflect light better, and thus appear more brightly illuminated. Because of a similar cause small windows or openings in a white wall appear to be black or darker spots. See the *Sidereus Nuncius* of Galilei, who announces many other new things. Here in passing I want to warn the reader that in the figure of celestial things, as I remarked earlier, the right side refers to the West, and the left in fact to the East. I call "right" what is to our right. The reason for this is that in their contemplation and observations astronomers usually turn themselves around toward the south, where the planets pass, and thus to them west is to the right, and east to the left. Things are arranged in the opposite manner for an opposite reason in the pictures of geographers, as will be explained in its place.[114]

There is much that is unusual in Biancani's observations. The comparison of the moon's dark spots to glass is commonplace; the specific reference to windows and openings in white walls is not. That odd architectural detail recalls, of course, the Annunciation, where light piercing windows and openings in eastern walls of the Virgin's temple offered both a physical explanation and an icon of the Incarnation itself. Were this not explicit enough, the abrupt allusion to that other Starry Messenger, not that "Gabriel who was sent to the city of Galilee,"[115] but "Galilei, who announces many other new things," suggests that the *Sidereus Nuncius* constituted a new kind of Annunciation, one incompatible with the old.

Next, the awkward insistence on a convention governing astronomical maps—because an observer faced south, east was on his left and west on his right—is precisely that of the Annunciation, where the orientation is always to the south, and Gabriel, like the rising sun, invariably on the

viewer's left. More significant still are the terms that Biancani uses to convey the astronomer's simple turn toward the south: *contemplatio, observatio*, and above all *se convertere* have a religious resonance, as if the "Annunciation" of Galileo were a new cult and his followers its fanatical new devotees, a belief exemplified by the various Galilei-Galilee puns of the day.[116] Finally, while the allusion to the "pictures of geographers" clarifies the discussion of orientation, because early modern maps of large areas generally had north at the top, the expression *picturae Geographorum* is curious,[117] and if it opposes the maps of geographers to that of the astronomers, it also implies that the vision of Galileo was also a kind of *pictura*, a novel scene painted right over the older Annunciation.

Biancani also portrayed Galileo's work in terms of 12 Revelation, as if what the astronomer had seen in the heavens was indeed a far "greater sign" than that recorded by John of Patmos. Both the lunar configuration Biancani describes and the language he uses recall the iconography of an *Inmaculada* of the *tota pulchra* type, where placards surrounding a crescent moon proclaimed *Tota pulchra es, amica mea, et macula non est in te*, and *pulchra ut luna*, except that here, of course, *maculacy* rather than purity is the whole point: "Many other equally astonishing things can be observed, and beautiful things [*pulchra*] can be seen through the telescope, and first of all, even when the moon is crescent, the terminator appears to be a broken and jagged and rough line."[118] Biancani discussed the appearance of partially illuminated craters on the bright side of the moon, and he noted, as had Galileo, that the wall closest to the sun was always the last to be flooded with light. The drawing he provided of the phenomenon was not particularly inspired—the craters are no more than lightly shaded circles on a crudely sketched moon—but the word he used to describe these depressions was more interesting. While Galileo had called them *plagae*, a neutral term for a region or zone, Biancani preferred the much less common noun *areola*, whose original meaning of "small area" became, in two of the three instances of its scriptural usage, a "small *garden*" in the Song of Songs.[119] Here, in other words, was a term that indicated at once a featureless circular area that Galileo had observed on the lunar surface, and the kind of enclosed garden invariably represented in both an *Annunciation* and an *Immaculate Conception*.

Biancani described the phenomenon of the secondary light as if it were another *Inmaculada* as well, and one that rivaled the contemporaneous works of painters who, like Pacheco, had resisted the conclusions drawn in the *Sidereus Nuncius*. Galileo had noted that while the brilliance of the horns of a four-day-old moon prevented some observers from detecting the paler secondary light, anyone who obstructed his view of the crescent

with "a roof or a chimney or another obstacle" would then be able to see the rest of the disk.[120] Biancani repeated this remark, but he paraphrased it so that the tone more closely resembled a revelation, and the setting an *Inmaculada*:

> [The secondary light] is to be observed when the moon is still new, and from a site and place such that *the crescent-shaped part of the moon, which is lit by the sun, is hidden behind the top part of some tower or some house* distant from us by at least sixty or eighty arm-lengths. Now the other part, which is not yet struck by the sun's rays, will appear nonetheless as if it were illuminated. Thus this experience once so deceived me that I believed that this light, which struck so suddenly and unexpectedly in the time of the new moon, had been made [*factum est*] that of the full moon, *as if by some new miracle*.[121]

Biancani's allusions to the obstacle provided by "some tower or some house," while a perfectly plausible part of his explanation, also recall the middleground of an *Inmaculada*, invariably occupied by either the Tower of David or the Solomonic *Domus Domini*. The crescent moon, too, would be that of a typical painting of the Immaculate Conception, and Biancani's breathless reference to the "new miracle" the counterpart to that other and older one, the "great sign" of 12 Revelation. The *factum est* is also scriptural rather than strictly scientific in tone. The most crucial part of the entire description, however, is the way it compares to the efforts of Galileo's rivals. I have argued that the consistent goal of the theories of Colombe, of the anonymous Jesuit friend of Mark Welser, of Lagalla, of Aguilon, of Scheiner, and of Locher was to "bleach" the lunar body of its every spot, shadow, feature and phases, and to convert even the crescent moon into one luminous globe, as Pacheco did in his *Inmaculada*. It is clear, however, that Biancani managed the same effect, and with much less artifice, given that the "miraculous" vision was one that the writer saw by accident, and a sight accessible to any reader, now as then.

NOTES

Introduction
The Artist and the Astronomer

1. Stillman Drake, *Galileo at Work: His Intellectual Biography* (Chicago: University of Chicago Press, 1978) 158, 164. In the same letter Michelangelo mentions that he has been trying to observe the phases of Venus, albeit with no success. See Galileo Galilei, *Le Opere*, ed. Antonio Favaro, 20 vols. (Florence: Giunti Barbera, 1965) XI: 96.

2. Galileo Galilei, *Le Opere*, XI: 96. This and all subsequent translations are mine, unless otherwise noted.

3. John Milton, *Paradise Lost*, I: 287–291.

4. Galileo Galilei, *Le Opere*, XI: 287.

5. *Discoveries and Opinions of Galileo*, translated and with an introduction and notes by Stillman Drake (New York: Anchor Books, 1957), 135 n. 18.

6. Galileo Galilei, *Le Opere*, XI: 362. A French visitor to Rome used the term to describe the process as he observed it during a visit to the Collegio Romano in 1614; see Jean Tarde, *À la rencontre de Galilée: Deux voyages en Italie*, edited and annotated by François Moureau and Marcel Tetel (Geneva: Slatkine, 1984), 80. The metaphor of the "solar paintbrush" was subsequently elaborated by Christoph Scheiner, S.J., in his *Rosa ursina* of 1630; see page 6 and note 12 below.

7. Galileo Galilei, *Le Opere*, XI: 316. For a brief overview of Ligozzi's skill as an early master of still-lifes, see Mina Gregori, "Linee della natura morta fiorentina," in Mina Gregori, ed., *Il Seicento fiorentino: Pittura, Disegni, Biografie*, 3 vols. (Florence: Cantini, 1986) I: 31–35.

8. See Galileo Galilei, *Le Opere*, XI: 205, 219–220, 225–226, 249–250, 328–330, 346–347, 390–391, 441–443. On Agucchi's exchanges with Galileo, see Drake, *Galileo at Work*, 175–176, 211–212. On Agucchi's life, see the entry of R. Zapperi and I. Toesca, *Dizionario Biografico degli Italiani*, 44 vols. to date (Rome: Istituto della Enciclopedia Italiana, 1960–1994) I: 504–506. On Agucchi's importance as a theorist, see Dennis Mahon, *Studies in Seicento Art and Theory* (London: Warburg Institute, 1947), and for the extant version of his treatise itself, 241–258. For a portrait of the man, see Silvia Ginzburg, "The Portrait of Agucchi at York Reconsidered," *Burlington Magazine* 136 (Feb. 1994) 4–14.

9. Christoph Scheiner, *Pantographice, seu Ars Delineandi Res Quaslibet per Parallelogrammum* (Rome: Luigi Grignani, 1631), Proemium. For an English translation of this section of the *Pantographice*, see William Wallace, "An Account of the Inventor of the Pantograph," *Transactions of the Royal Society of Edinburgh* 13 (1836) 418–439. On the pantograph itself, see Martin Kemp, *The Science of Art: Optical Themes in Western Art from Brunelleschi to Seurat* (New Haven: Yale University Press, 1990) 180–183.

10. Pliny, *Natural History*, XXXV: 36.

11. Galileo Galilei, *Discourse on the Comets*, in *The Controversy on the Comets of 1618*, translated by Stillman Drake and C. D. O'Malley (Philadelphia: University of Pennsylvania Press, 1960) 24.

12. Christoph Scheiner, *Rosa Ursina* (Bracciani: Apud Andream Phoeum Typographum Ducalem, 1630) 9–11, 14, 23, 35, 40–42, 53–54, 59, 61, 65.

13. Vincenzo Viviani, *Racconto istorico*, in Galileo Galilei, *Le Opere*, XIX: 602.

14. Galileo Galilei, *Le Opere*, XIX: 604.

15. On the Academy and its importance to artistic education, see Charles Dempsey, "Some Observations on the Education of Artists in Florence and Bologna during the Later Sixteenth Century," *Art Bulletin* 62 (1980) 552–569.

16. Miles Chappell, "Cigoli, Galileo, and *Invidia*," *Art Bulletin* 57 (1975) 91 n. 4. Galileo commissioned a copy of Francesco Furini's *La Poesia e la Pittura*, for example, in the 1620s. See Anna Barsanti, "Una vita inedita del Furini," *Paragone* 289 and 291 (1974) 67–86, 79–99; see 85–86, 95–96 in particular.

17. Galileo Galilei, *Le Opere*, XI: 281; XIV: 110–15, 134, 148, 157; XVI: 318–319. It is not clear to me whether the "giovane zitella Romana molto virtuosa, che, oltre al sonare e cantare, si dilettava di disegnare," praised by Galileo and mentioned by Paolo Giordano Orsini in a letter of March 1612, is Artemisia Gentileschi, then engaged in bringing charges of rape against another painter, Agostino Tassi. On Galileo's friendship with Artemisia after her move to Florence in 1613, see Mary D. Garrard, *Artemisia Gentileschi: The Image of the Female Hero in Italian Baroque Art* (Princeton: Princeton University Press, 1989) 37–38. For additional recent information on the artist, see Elizabeth Cropper, "Artemisia Gentileschi, La 'Pittora,'" in *Barocco al Femminile*, ed. G. Calvi (Rome: Laterza, 1992) 191–218, and "New Documents for Artemisia Gentileschi's Life in Florence," *Burlington Magazine* 135 (Nov. 1993) 760–761.

18. Galileo Galilei, *Letters on the Sunspots*, in *Discoveries and Opinions*, 127.

19. Galileo Galilei, *Assayer*, in *The Controversy on the Comets of 1618*, 215.

20. Galileo Galilei, *Dialogue Concerning the Two Chief World Systems*, trans. Stillman Drake (Berkeley: University of California Press, 1967²) 109. Emphasis mine.

21. On the Florentine conventions surrounding Michelangelo's death and Galileo's birth—events separated, in truth, by some three days—see Michael Segre, *In the Wake of Galileo* (New Brunswick, N.J.: Rutgers University Press, 1991) 116–122.

22. Galileo Galilei, *Sidereus Nuncius or the Sidereal Messenger*, translated and with an introduction, commentary, and notes by Albert Van Helden (Chicago: University of Chicago Press, 1989) 57.

23. Robert Burton, "A Digression of Ayre," in *The Anatomy of Melancholy*, ed. Nicolas K. Kiessling, Thomas C. Faulkner, and Rhonda L. Blair, 3 vols. (Oxford: Clarendon Press, 1990) II: 51. On Burton's increasing sympathy for the Copernican arguments presented in the "Digression of Ayre," see Richard G. Barlow, "Infinite Worlds: Robert Burton's Cosmic Voyage," *Journal of the History of Ideas* 34 (1973) 291–302. For a very helpful survey of the impact of Galileo's work upon English scholars, see Mordechai Feingold, "Galileo in England:

The First Phase," in Paolo Galluzzi, ed., *Novità celesti e crisi del sapere: Atti del Convegno Internazionale di Studi Galileiani* (Florence: Giunti Barbera, 1984) 411–420. Finally, for a later and extreme instance of the sort of astronomical conjectures to which Burton's treatise alludes, see Pierre Borel, *Discours nouveau prouvant la pluralité des mondes, que les astres sont des terres habitées, & la terre une étoile, qu'elle est hors du centre du monde dans le troisiesme cile, & se tourne devant le soleil qui est fixe, & autres choses tres-curieuses* (Geneva: N.p., 1657), a work strongly influenced by both Galileo's early hypotheses and their subsequent development in an English context.

24. John Milton, *Paradise Lost*, VIII: 122–125, 137–149. Emphasis mine.

25. On Galileo and Plutarch, see Casini, "Il *Dialogo* di Galileo e la luna di Plutarco," in *Novità celesti e crisi del sapere*, 57–62.

26. Plutarch, *Concerning the Face Which Appears in the Orb of the Moon*, in *Moralia*, trans. Harold Cherniss and William C. Helmbold, 15 vols. (Cambridge, Mass.: Harvard University Press, 1957) XII: 38–43.

27. Plutarch, *Concerning the Face Which Appears in the Orb of the Moon*, 38–39.

28. Plutarch, *Concerning the Face Which Appears in the Orb of the Moon*, 42–43.

29. Plutarch, *Concerning the Face Which Appears in the Orb of the Moon*, 40 n.a.

30. The expression *non tamquam pictor sed tamquam mathematicus* comes from Henry Wotton's letter to Francis Bacon in 1620 describing his encounter with Kepler in Linz. See *The Life and Letters of Sir Henry Wotton*, ed. Logan Pearsall Smith, 2 vols. (Oxford: Clarendon Press, 1907) II: 206.

31. Johann Kepler, *Opera Omnia*, ed. Ch. Frisch, 8 vols. (Frankfurt: Heyden & Zimmer, 1858–1870) VIII (1): 104–105.

32. Galileo Galilei, *Le Opere*, III: 395–396.

33. Filippo Baldinucci, *Notizie dei professori del disegno da Cimabue in qua*, edited and annotated by F. Ranalli, 7 vols. (Florence: V. Batelli e Compagni, 1847) V: 30–31.

34. Galileo Galilei, *Le Opere*, XVII: 205. For other documents pertaining to this painter's depiction of the moon, see XVI: 517 and XVII: 35, 186, 192, 208–209, and 384, as well as Pierre Gassendi, *Vita Peireskii*, in *Opera Omnia*, 6 vols. (Lyon: Laurence Anisson & Jean Baptiste Devenet, 1658), reprinted in a facsimile edition, ed. Tullio Gregory (Stuttgart: Friedrich Frommann Verlag, 1964) V: 322. On Claude Mellan's use of an earlier version of this painter's lunar representations, see David Jaffe, "Mellan and Peiresc," *Print Quarterly* 7 (1990) 168–175, especially 172–175.

35. Francesco Fontana, *Novae coelestium terrestriumque rerum observationes* (Naples: Apud Gaffarum, 1646) 80–83. On Fontana, see Gino Arrighi, "Gli 'Occhiali' di Francesco Fontana in un carteggio inedito di Antonio Santini nella Collezione Galileiana della Biblioteca Nazionale di Firenze," *Physis* 6 (1964) 432–448.

36. Galileo Galilei, *Le Opere*, XVII: 204. These engravings were also criticized by Benedetto Castelli (XVII: 192) but warmly praised by Fulgenzio Micanzio (XVII: 363–364), and possibly by Bonaventura Cavalieri (XVII: 384).

37. Galileo Galilei, *Le Opere*, XVIII: 18. Fontana was elsewhere described as "without any background in mathematics, but guided and led solely by the inclination of his native intelligence"; see XVII: 375.

38. Galileo Galilei, *Le Opere*, XVII: 126–127.

39. For a summary of his lunar conjectures of 1637–1638, see Galileo Galilei, *Le Opere*, XVII: 291–297, especially 294; for briefer notices, see XVII: 212, 214–215.

40. Milton was in Florence in the summer of 1638, and it was presumably then that he "found and visited the famous Galileo, grown old, a prisoner to the Inquisition for thinking in astronomy otherwise than the Franciscan and Dominican licensers thought," as he related it in the *Aeropagitica*. On the question of Milton's visit to Italy, see Mario Di Cesare, ed., *Milton in Italy: Contexts, Images, Contradictions* (Binghamton, N.Y.: Medieval and Renaissance Texts and Studies, 1991).

41. Galileo Galilei, *Le Opere*, XVII: 292.

42. See Galileo, *The Dialogue Concerning the Two Chief World Systems*, 100–101, and Gassendi, *Vita Peireskii*, in *Opera Omnia*, V: 323.

43. Gassendi, *Vita Peireskii*, in *Opera Omnia*, V: 323.

44. See Max Rooses and Charles Ruelens, *Correspondance de Rubens et documents épistolaires concernant sa vie et ses oeuvres*, 6 vols. (Antwerp: J. E. Buschmann, 1887–1909) V: 153. The expression, as Rubens acknowledged, is Machiavelli's and suggests that distance augments rather than diminishes stature. In the same letter Rubens also noted that it was said that Drebbel had done nothing in recent years besides perfect a microscope.

45. On Drebbel, see Rosalie Colie, "Cornelis Drebbel and Salomon de Caus: Two Jacobean Models for Solomon's House," *Huntington Library Quarterly* 18 (1954–1955) 245–261; L. E. Harris, *The Two Netherlanders Humphrey Bradley and Cornelis Drebbel* (Cambridge, U.K.: W. Heffer and Sons, 1961); Svetlana Alpers, *The Art of Describing: Dutch Art in the Seventeenth Century* (Chicago: University of Chicago Press, 1983) 4–5, 12–13, 23; Robert Grudin, "Rudolf II of Prague and Cornelis Drebbel: Shakespearean Archetypes?" *Huntington Library Quarterly* 54 (1991) 181–205. As Mordechai Feingold points out, the question *An luna sit habitabilis?* was taken up by university scholars immediately after the publication of the *Sidereus Nuncius* when it was assigned to the incepting masters of art at Convocation at Oxford; see "Galileo in England: The First Phase," 416. The issue was a frequent topic in British plays and masques of the period; see, for example, Ben Jonson's *News from the New World Discovered in the Moon* of 1620, which also includes two references to Drebbel.

46. Erwin Panofsky, *Galileo as a Critic of the Arts* (The Hague: Martinus Nijhoff, 1954), and "Galileo as a Critic of the Arts: Aesthetic Attitude and Scientific Thought," *Isis* 147:1 (March 1956) 3–15.

47. See Anna Ottani Cavina, "On the Theme of Landscape: Elzevir and Galileo," *Burlington Magazine* 118 (1976) 139–144; Miles Chappell, "Cigoli, Galileo, and Invidia," *Art Bulletin* 57 (1975) 91–98; Samuel Edgerton, "Galileo, Florentine *Disegno*, and the 'Strange Spottednesse' of the Moon," *Art Journal* 44 (1984) 225–248; H. Mann, "Die Plastität des Mondes—zu Galileo Galilei und Lodovico Cigoli," *Kunsthistorisches Jahrbuch Graz* 23 (1987) 55–59; Mar-

garet M. Byard, "A New Heaven: Galileo and the Artists," *History Today* 38 (1988) 30–38; Martin Kemp, *The Science of Art*, 93–98; Steven F. Ostrow, "Cigoli's Immaculate Virgin and Galileo's Moon: Astronomy and the Apocalyptic Woman in Early *Seicento* Rome," *Art Bulletin* 78 (1996) 218–235. I am grateful to Professor Ostrow for sharing the manuscript with me.

48. Elizabeth Cavicchi, "Painting the Moon," *Sky and Telescope* 82 (1991) 313–315.

49. Mary G. Winkler and Albert Van Helden, "Representing the Heavens: Galileo and Visual Astronomy," *Isis* 83 (1992) 195–217.

50. Galileo Galilei, "Considerazioni al Tasso," in *Le Opere*, IX: 69.

51. Paolo Gualdo had hosted the poet in Padua in 1578, and decades later Lorenzo Pignoria would write the *Notizie storiche sopra la Gerusalemme del Tasso*, revealing a perception of the epic that differs remarkably from that of Galileo. On Gualdo and Pignoria's relationship to Galileo, see Claudio Bellinati, "Galileo e il sodalizio con ecclesiastici padovani," and Giorgio Ronconi, "Paolo Gualdo e Galileo," in Giovanni Santinello, ed., *Galileo e la cultura padovana* (Padova: CEDAM, 1992) 327–357, 359–371. For an informative study of Pignoria and many members of the Paduan and Venetian circles of Galileo, see Francesca Zen Benetti, "Per la biografia di Lorenzo Pignoria, erudito padovano," in Maria Chiara Billanovich, Giorgio Cracco, and Antonio Rigon, eds., *Viridarium floridum: Studi di storia veneta offerti dagli allievi a Paolo Sambin* (Padua: Editrice Antenore, 1984) 315–336.

52. See Jacopo Filippo Tomasini, *V.C. Larentii Pignorii Pat. Bibliotheca et museum* (Venice: Giovanni Pietro Pinelli, 1632). On Gualdo's artistic tastes, see Gaetano Cozzi, "Intorno al cardinale Paravicino, a monsignor Paolo Gualdo e a Michelangelo da Caravaggio," *Rivista storica italiana* 73 (1961) 36–68.

53. *Lettere d'uomini illustri: Che fiorirono nel principio del secolo decimosettimo: Non piu stampate* (Venice: Baglioni, 1744) 150.

54. *Lettere d'uomini illustri*, 167.

55. Galileo, *Le Opere*, IX: 63.

Chapter One
1599–1602: First Reflections on the Moon's Secondary Light

1. Michael Maestlin to Johannes Kepler, in Antonio Favaro, ed., *Le Opere di Galileo Galilei*, 20 vols. (Florence: Giunti Barbera, 1965) X: 428. This translation and all subsequent ones in this chapter are mine unless otherwise indicated. The motif of the plumed Galileo may have originated with Georg Fugger, who had complained to Kepler the previous April, "That man can and does make a practice of gathering up the feathers of others, so that he can adorn himself with them, like the crow in Aesop. . . ." See Georg Fugger to Johannes Kepler, in *Le Opere*, X: 316.

2. Galileo Galilei, *Sidereus Nuncius or the Sidereal Messenger*, translated and with introduction, conclusion, and notes by Albert Van Helden (Chicago: University of Chicago Press, 1989) 53.

3. John Wilkins called the secondary light "a duskish leaden light" in *The Discovery of a World in the Moone* in 1638. See the facsimile edition of his work, *The*

Discovery of a World in a Moone, introduced by Barbara Shapiro (Delmar, N.Y.: Scholars' Facsimiles and Reprints, 1973) 75. On the term's relationship to Neostoicism, see pages 89–90 below.

4. Francesco Patrizi, *Nova de universis philosophia* (Ferrara: Benedetto Mamarello, 1591) 112v.

5. Logan Pearsall Smith, *The Life and Letters of Sir Henry Wotton,* 2 vols. (Oxford: Clarendon Press, 1907) I: 486–487.

6. Henry Wotton, *Elements of Architecture* (London: Printed for John Bill, 1624) II: 66.

7. See Johannes Kepler, *Dissertatio cum Sidereo Nuncio* in *Gesammelte Werke,* ed. Max Caspar and Walther von Dyck, 20 vols. (Munich: Beck, 1937–) IV: 300; and *Astronomiae Pars Optica,* II: 223–224.

8. John Pecham, *Perspectiva communis,* edited and with an introduction, English translation, and critical notes by David C. Lindberg (Madison: University of Wisconsin Press, 1970) 74–75.

9. *Paradiso,* I: 49–50, in Emilio Pasquini and Antonio Quaglio, eds., *Commedia* (Milan: Grandi Libri Garzanti, 1986) 5.

10. Leon Battista Alberti, *On Painting,* translated and with introduction and notes by John R. Spencer (New Haven: Yale University Press, 1966) 51.

11. *The Notebooks of Leonardo da Vinci,* compiled and edited from the original manuscripts by Jean Paul Richter, 2 vols. (New York: Dover Publications, 1970) II: 163–165.

12. Leonardo, *Notebooks,* II: 153.

13. Leonardo, *Notebooks,* II: 161.

14. Leonardo, *Notebooks,* II: 144.

15. Leonardo, *Notebooks,* II: 157.

16. Leonardo, *Notebooks,* II: 160.

17. Leonardo, *Notebooks,* II: 166–167; II: 165.

18. Leonardo, *Notebooks,* II: 160.

19. For a brief history of the manuscripts and their dispersal, see Richter's appendix in vol. II of *Notebooks,* 479–484, and *The Literary Works of Leonardo da Vinci,* compiled and edited from the original manuscripts by Jean Paul Richter, with commentary by Carlo Pedretti, 2 vols. (Oxford: Phaidon Press Limited, 1977) II: 393–402.

20. On the history of the *Trattato della pittura* and its diffusion, see Carlo Pedretti's commentary on *The Literary Works of Leonardo da Vinci,* I: 12–43.

21. *Treatise on Painting* ⟨Codex urbinas latinus 1270⟩, translated and annotated by A. Philip McMahon, with an introduction by Ludwig H. Heydenreich, 2 vols. (Princeton: Princeton University Press, 1956) II: 229.

22. Jacopo Barozzi da Vignola, *Regole della prospettiva Prattica,* with a preface by Ciro Luigi Anzivino (Sala Bolognese: Arnaldo Forni, 1985) 6; emphasis mine. In his *Lectionum Antiquarum,* the sixteenth-century scholar Coelius Rhodiginus also referred to the terms "primary light," "secondary light," and "tertiary light" as phrases used by *mathematici,* that is, mathematicians and astronomers. See L. Coelius Rhodiginus, *Lectionum Antiquarum* (Basel: Per Hier. Frobenium et Nicol. Episcopium, 1542) Liber XVII: vii, 633. The association of

such phrases with *mathematici*, as opposed to the more common "direct and oblique light," was reiterated once more in Bernardo Cesi's *Mineralogia* (Lyon: I. & P. Prost, 1636) 182.

23. Leonardo, *Treatise on Painting*, I: 29–31.

24. Giovanni Paolo Lomazzo, *Trattato dell'arte de la pittura* (Milan: Paolo Gottardo Pontio, 1584) 219–220. For a recent discussion of Lomazzo's work, particularly of his notions of perspective and his color theory, see Martin Kemp, *The Science of Art* (New Haven: Yale University Press, 1990) 83–84, 269–272.

25. Lomazzo, *Trattato dell'arte de la pittura*, 222.

26. See Stillman Drake, *Galileo at Work* (Chicago: University of Chicago Press, 1978) 138–140; and Albert Van Helden, "The Invention of the Telescope," in *Transactions of the American Philosophical Society* 67:4 (1977) 5–64. For a general study of the relationship of Galileo and Sarpi, see Gaetano Cozzi, "Galileo Galilei, Paolo Sarpi, e la società veneziana," in *Paolo Sarpi tra Venezia e l' Europa* (Turin: Piccola Biblioteca Einaudi, 1979) 137–234; and Vincenzo Ferrone, "Galileo tra Paolo Sarpi e Federico Cesi: premesse per una ricerca," in Paolo Galluzzi, ed., *Novità celesti e crisi del sapere* (Florence: Giunti Barbera, 1984) 239–253.

27. On Pinelli, see Paolo Gualdo, *Vita Ioannis Vincentii Pinelli* (Augsburg: Christoph Mangus, 1607), reprinted in Christian Gryphius, ed., *Vitae selectae quorundam eruditissimorum ac illustrium virorum* (Vratislavae: Christiani Bauchii, 1711). See also Marcella Grendler, "A Greek Collection in Padua: The Library of Gian Vincenzo Pinelli (1535–1601)," *Renaissance Quarterly* 33 (1980) 386–416; and Aldo Stella, "Galileo, il circolo culturale di Gian Vincenzo Pinelli e la 'Patavina Libertas,'" in Giovanni Santinello, ed., *Galileo e la cultura padovana* (Padua: CEDAM, 1992) 307–325.

28. Paolo Sarpi, *Scritti filosofici e teologici editi e inediti*, ed. Romano Amerio (Bari: Giuseppe Laterza & Figli, 1951) 7 (*pensiero* 11).

29. Sarpi, *Scritti filosofici e teologici*, 10 (*pensiero* 26).

30. Sarpi, *Scritti filosofici e teologici*, 10 (*pensiero* 27).

31. Sarpi, *Scritti filosofici e teologici*, 10 (*pensiero* 28).

32. Galileo Galilei, *Dialogue Concerning the Two Chief World Systems*, trans. and with revised notes by Stillman Drake (Berkeley: University of California Press, 1967²) 98.

33. Michael Maestlin [*Disputatio de eclipsibus*], cited in Johannes Kepler, *Astronomiae Pars Optica*, in *Gesammelte Werke*, II: 223.

34. See the statement made by Maestlin in 1609, "Duos m[eos] filios, qui hinc profecti sunt, superesse puto M. Ludov[icum] medicum, et Michaelem, pictorem: ubi autem locorum hi sint, proh dolor! nescio," in Hermann Staigmueller, "Württembergische Mathematiker," in *Württembergische Vierteljahrshefte für Landesgeschichte* 12 (1903) 235; and Maestlin's letter of 1600 to Kepler, *Gesammelte Werke*, XIV: 157, 354.

35. In the following account I differ somewhat from Stillman Drake's *Galileo: Pioneer Scientist* (Toronto: University of Toronto Press, 1990) 1–132, and his *Galileo against the Philosophers* (Los Angeles: Zeitlin and Ver Brugge, 1976), particularly in regard to the period 1604–1606 and the controversy over the new star, the focus of my second chapter.

36. On Ricci, see Thomas Settle, "Ostilio Ricci, a Bridge between Alberti and Galileo," *12ᵉ congrès international d'histoire des sciences* (Paris, 1971) III B: 121–126.

37. In regard to Galileo's early development as a scientist, particularly in regard to his manuscript notes of 1590 on logical questions and the evident influence of Jesuit professors then employed at the Collegio Romano, see William Wallace, *Galileo and His Sources: The Heritage of the Collegio Romano in Galileo's Science* (Princeton: Princeton University Press, 1984). On the importance of this background in logic for courses he taught at Pisa in 1589–1591 in particular, see 91–96; for a general discussion of this influence on his scientific works prior to 1610, see 220–254.

38. See Paolo Gualdo, *Vita Ioannis Vincentii Pinelli*, in Christian Gryphius, ed., *Vitae selectae quorundam eruditissimorum ac illustrium virorum* (Vratislavae: Christiani Bauchii, 1711) 336. Gualdo offers his reference to Galileo's letter as an example of the cataloging system of Pinelli's library. On the relationship of Galileo and Mazzoni, see Frederick Purnell, Jr., "Jacopo Mazzoni and Galileo," *Physis* 14 (1972) 273–294.

39. For this general argument, see Drake, *Galileo against the Philosophers*, 12–13, despite that author's somewhat different conclusions regarding Galileo's conception of the origin of the new star.

40. *Important Old Master Paintings* (New York: Piero Corsini Incorporated, 1990) 58.

41. "Descrizione delle Opere di Giorgio Vasari," in *Le Opere di Giorgio Vasari*, with new annotations and comments by Gaetano Milanesi, 9 vols. (Florence: G. C. Sansoni, 1906) VII: 663.

42. Galileo Galilei, *Trattato della sfera ovvero Cosmografia*, in *Le Opere*, II: 250.

43. Galileo Galilei, *Trattato della sfera*, II: 250.

44. Galileo Galilei, *Trattato della sfera*, II: 247.

45. *Aristotelis de Coelo cum Averrois Commentariis* (Venice: Giunti, 1562) V: 131v. The passage in question is from Averroes's *Commentary* on Book II, sec. 48, of Aristotle's *De Caelo*.

46. Agostino Nifo, *Aristotelis Stagiritae De Caelo et Mundo* (Venice: G. Scoto, 1549) 93v.

47. Galileo Galilei, unpublished fragments pertaining to the *Lettera al Principe Leopoldo di Toscana*, in *Le Opere*, VIII: 554.

48. *On the Revolutions of the Heavenly Spheres*, I: x, trans. A. M. Duncan (Newton Abbott, U.K.: David and Charles, 1976) 50.

49. Umberto Baldini, Anna Maria Giusti, and Annapaula Pamploni Martelli, *La Cappella dei principi e le pietre dure a Firenze* (Milan: Electa Editrice, 1979) 336. For a favorable contemporary assessment of *pietre dure*—made, however, in the context of the death of one of its greatest admirers, Grand Duke Cosimo II—see the eulogy of Galileo's friend Michelangelo Buonarroti the Younger, "Delle Lodi di Cosimo II," in *Raccolta di prose fiorentine*, 6 vols. (Venice: Domenico Occhi, 1730–1735) VI: ii: 106–107, 109. Buonarroti particularly admired the fact that with *pietre dure* "men had found a way of making painting eternal." For an eighteenth-century appraisal of the Florentine *pietre dure*, both

in terms of its scientific and aesthetic merit, see Giovanni Targioni Tozzetti, *Notizie degli aggrandimenti delle scienze fisiche accaduti in Toscana nel corso di anni lx. del secolo XVII*, 3 vols. (Florence: Giuseppe Bouchard, 1780) III: 14–15, 20, 77–81, 234.

50. Giovanni Battista Cardi-Cigoli, *Vita di Lodovico Cardi-Cigoli*, in Anna Matteoli, *Lodovico Cardi-Cigoli pittore e architetto* (Pisa: Giardini Editori, 1980) 27.

51. See, for example, the passing observation of Michel de Montaigne about the future Grand Duke Ferdinando I de' Medici in 1580: "Le mesme jour nous vismes un palais du duc, où il prend plesir a besoingner lui-mesmes, à contrefaire des pierres orientales et a labourer le cristal: Car il est prince soingneus un peu d'archémie et des ars mécaniques, et surtout grand architect." Michel de Montaigne, *Journal de Voyage en Italie*, edited and annotated by Maurice Rat (Paris: Editions Garnier Frères, 1955) 85–86.

52. Galileo Galilei, *Istoria e dimostrazioni intorno alle macchie solari*, in *Le Opere*, V: 235.

53. On the Cappella itself, see Domenico Moreni, *Delle tre sontuose Cappelle Medicee situate nell'Imp. Basilica di S. Lorenzo* (Florence: Carli e Comp., 1813); *La Cappella dei principi e le pietre dure a Firenze*, plates 205–292, pp. 306–336; and Luciano Berti, *Il Principe dello studiolo* (Florence: Editrice Edam, 1967) 123–125, 198–209. On Cigoli's involvement in the project, see Karla Langedijk, "A New Cigoli: The State Portrait of Cosimo de' Medici, and a Suggestion Concerning the Cappella de' Principi," and Miles Chappell, "Some Works by Cigoli for the Cappella de' Principi," *Burlington Magazine* 113 (Oct. 1971) 575–579 and 580–583, respectively.

54. See *La Cappella dei Principi e le pietre dure a Firenze*, plate 48 and pp. 265–266.

55. Cesare Tinghi, *Diario di Corte*, cited in Giovanni Targioni Tozzetti, *Notizie*, III: 234.

56. "Those who so greatly exalt incorruptibility, inalterability, etc., are reduced to talking this way, I believe [*credo che si riduchino a dir queste cose*] by their great desire to go on living, and by the terror they have of death. They do not reflect that if men were immortal, they themselves would never have come into the world. Such men really deserve to encounter a Medusa's head which would transmute them into statues of jasper or of diamond, and thus make them more perfect than they are." Galileo Galilei, *Dialogue Concerning the Two Chief World Systems*, 59.

57. Galileo Galilei, *Dialogue Concerning the Two Chief World Systems*, 403. I have altered the Drake translation slightly.

58. For typical descriptions, see Filippo Baldinucci, *Vocabolario toscano dell'arte del disegno* (Florence: Per S. Franchi, 1681), under *diaspro* and *pietra serena*.

59. Galileo Galilei, *Dialogue*, 409.

60. On the European economic crisis of 1619–1622, especially in Tuscany, see Furio Diaz, *Il Granducato di Toscana: I Medici* (Turin: Unione Tipografico-Editrice Torinese, 1976) 328–329, 344–345, 383–385; Carlo Cipolla, "The Decline of Italy: The Case of a Fully Matured Economy," *Economic History Review*,

2d ser., V:2 (1952) 178–187; and Ruggiero Romano, "Tra XVI e XVII secolo. Una crisi economica: 1619–1622," *Rivista storica italiana* 74: 3 (1962) 480–531. Even a decade earlier, casual visitors to the Cappella de' Principi were commenting on its extraordinary cost; as Roberto Lio, Venetian resident in Florence, remarked to his republic's doge and Senate, "The Grand Duke [Ferdinando I]'s body was taken to San Lorenzo, where he had begun to build a chapel which will take more than half a million of gold to finish." See Rawdon Brown et al., eds., *Calendar of State Papers and Manuscripts, Relating to English Affairs, Existing in the Archives and Collections of Venice, and in Other Libraries of Northern Italy*, 38 vols. (London: Longman, 1864–1947) XI: 232.

61. For this venture, see Chappell, "Some Works by Cigoli for the Cappella de' Principi," 580 and note 3.

62. Cited in Galileo Galilei, *Dialogo sopra i due massimi sistemi del mondo*, ed. Libero Sosio (Turin: Giulio Einaudi Editore, 1970) 559.

63. Lucretius, *De Rerum natura* V: 713–714, 720–722, ed. William E. Leonard and Stanley B. Smith (Madison: University of Wisconsin Press, 1942) 705–706.

64. See Vitruvius, *De Architectura* IX: ii (Pisa: Giardini Editore, 1975) 261–263.

65. Apuleius, *De Deo Socratis*, in *Apuleii Opera Omnia ex editione oudendorpiana*, 7 vols. (London: A. J. Valpy, 1825) II: 955–957.

66. Augustine, *Ennarationes in Psalmos*, in *Opera Omnia*, 11 vols. (Paris: Migne, 1841) IV: i, col. 132.

67. Augustine, *Ennarationes*, col. 132.

68. Albert of Saxony, *Quaestiones et decisiones physicales* (Paris: J. Badius Ascensius et Conrad Resch, 1518), folios cxiv verso, cxv recto.

69. See Rhodiginus, *Lectionum antiquarum*, 763.

70. Tycho Brahe, *Astronomiae Instauratae pars tertia* in *Scripta Astronomica*, ed. J.L.E. Dreyer, 15 vols. (Hveen, Denmark: Gyldendaliana, 1913–1929) III: 256.

71. Caspar Bartholin, *Exercitatio de stellarum natura, affectionibus et effectionibus* (Wittemberg: Gormann, 1609³) 49.

72. Caspar Bartholin, *Exercitatio*, 55. Augustine used the word *nugae* to evoke former mistresses in a celebrated passage of Book VIII of his *Confessions*, and he also relied on the comparatively rare *nugacitas* and *nugatorius* in other works.

73. Willebrord Snellius, *Descriptio Cometae Anni 1618* (Louvain: Elzevir, 1619) 45–46.

74. Bartolomeo Amico, S.J., *In Aristotelis libros de caelo et mu[n]do* (Naples: Roncaliolo, 1626) 360.

75. Pierre Gassendi, *Physica* L. IV: sec. ii, c. ii, in *Opera Omnia*, 6 vols. (Lyon: Laurence Anisson & Jean Baptiste Devenet, 1658), reprinted in a facsimile edition, ed. Tullio Gregory (Stuttgart: Friedrich Frommann Verlag, 1964) I: 653.

76. On *bigio* and its sometime association with ashes and the earth, see John Gage, *Color and Culture: Practice and Meaning from Antiquity to Abstraction* (Boston: A Bullfinch Press Book, Little, Brown, and Company, 1993) 118–119.

77. F. W. Weber, *Artists' Pigments* (New York: D. Van Nostrand Company, 1923) 15.

78. Filippo Baldinucci, *Vita di Lodovico Cardi-Cigoli*, in Anna Matteoli, *Lodovico Cardi-Cigoli pittore e architetto*, 61–62. On verdigris, see Weber, *Artists' Pigments*, 116–117. For a general study of Santi di Tito, see Jack J. Spalding, "Santi di Tito and the Reform of Florentine Mannerism," *Storia dell'arte* 47 (1983) 41–52.

79. Lodovico delle Colombe, *Discorso* (Florence: Giunti, 1606) 23–24.

80. For the phrase's possible relevance to the Neostoic theories which Galileo upheld in 1604 and 1605, see pages 89–90.

81. See the entries of Miles Chappell and M. Muccillo, respectively, *s.v.* "Lodovico Cardi" and "Lodovico delle Colombe," in *Dizionario biografico degli italiani*, 44 vols. to date (Rome: Istituto della Enciclopedia Italiana, 1960–1994) 19: 771–776 and 38: 29–31; Chappell, "Lodovico Cardi," in Mina Gregori, ed., *Il Seicento fiorentino: Pittura, Disegni, Biografie*, 3 vols. (Florence: Cantini, 1986) I: 55–58; and "Cigoli, Galileo, and *Invidia*," *Art Bulletin* 57 (1975) 91–93, nn. 4 and 5. On Gualterotti, see Antonio Favaro, *Amici e corrispondenti di Galileo*, 3 vols. (Venice: Officine Grafiche di C. Ferrari, 1894–1914) now in a modern re-edition with a foreword by Paolo Galluzzi (Florence: Libreria Editrice Salimbeni, 1983) II: 649–669; and Ferdinando Jacoli, "Intorno a due scritti di Raffaele Gualterotti fiorentino," in *Bullettino di biliografia e di storia delle scienze matematiche e fisiche* VII (August 1874) 377–405.

82. On Galileo's early acquaintance with Gualterotti, see the letter written by Gualterotti in 1610, in Galileo Galilei, *Le Opere*, X: 341–342. On the dates of Gualterotti's and Cigoli's involvement in the project at San Lorenzo, see Matteoli, *Lodovico Cardi-Cigoli pittore e architetto*, 436–437, and Moreni, *Delle tre sontuose Cappelle Medicee*, 304–306. On Gualterotti's abiding interest in *pietre dure* and astronomy, see his letter to Galileo in 1607, in Galileo Galilei, *Le Opere*, X: 182, and his *Discorso sopra l'apparizione de la nuova stella* (Florence: Cosimo Giunti, 1605) 25, 52.

83. See *Sonetti di Francesco Ruspoli*, with the commentary of Andrea Cavalcanti, in *Scelta di curiosità letterarie* (Bologna: Commissione per i testi di lingua, 1968) 20–21, 27–28.

84. Gualterotti, *Discorso sopra l'apparizione de la nuova stella*, 14–15.

85. Gualterotti, *Scherzi degli spiriti animali* (Florence: Cosimo Giunti, 1605) 16–17.

86. Georg Peurbach, *Theoricae Novae Planetarum*, ed. Erasmus Reinhold (Wittemberg: I. Lufft, 1553) 164v–165r. I owe this and the following reference to Albert Van Helden's edition of the *Sidereus Nuncius*, p. 54, nn. 51 and 53.

87. Vitello, *Perspectiva* IV: 77, in Friedrich Risner's *Opticae Thesaurus* (Basel: Per Episcopios, 1572) 151.

88. Giovanni Antonio Magini, "De astrologica ratione," in *Commentarius in Claudii Galeni de Diebus Decretorijs Librum Tertium* (Venice: D. Zenarij, 1607) 6v.

89. Lodovico delle Colombe, *Contro il moto della terra*, in Galileo Galilei, *Opere*, III: 253–289, esp. 286–288. See the complete discussion of this theory,

which was more popular than ever in the first decade after the publication of the *Sidereus Nuncius*, and its importance for depictions of the *Immacolata* in my fourth and fifth chapters.

90. Colombe, *Contro il moto della terra*, III: 287.

91. Colombe, *Contro il moto della terra*, III: 287.

92. Galileo Galilei, *Sidereus Nuncius*, Van Helden edition, 55.

93. For an English translation and a discussion of Zúñiga's arguments, see Juan Vernet Gines, "Copernicus in Spain," *Colloquia Copernicana* 1 (1972) 271–291, especially 275–277.

94. See the discussion in Victor Navarro Brótons, "Contribución a la historia del copernicanismo en España," *Cuadernos Hispanoamericanos* 283 (1974) 3–23.

95. See R. Hooykaas, *G. J. Rheticus' Treatise on Holy Scripture and the Motion of the Earth* (Amsterdam: North-Holland Publishing, 1984).

Chapter Two
1604–1605: Neostoicism and the New Star

1. Galileo Galilei, *Le Opere*, II: 278–279. This and all subsequent translations in this chapter are mine unless otherwise noted.

2. For a thorough discussion of the background of the *Dialogue* and the *Considerations*, as well as arguments for attributing them to Galileo, see the introductions provided by Stillman Drake in his annotated translations of both works, *Galileo against the Philosophers* (Los Angeles: Zeitlin and Ver Brugge, 1976) 1–32 and 55–71, especially 22–32 and 61–71. For a recent attribution of the *Dialogue* to Girolamo Spinelli, see Marisa Milani, " Galileo Galilei e la letteratura pavana," in Giovanni Santinello, ed., *Galileo e la cultura padovana* (Padua: CEDAM, 1992) 179–202.

3. On Neostoicism in a nonscientific context see especially Mark Morford, *Stoics and Neostoics: Rubens and the Circle of Lipsius* (Princeton: Princeton University Press, 1991), and Gerhard Oestreich, *Neostoicism and the Early Modern State* (Cambridge, U.K.: Cambridge University Press, 1982).

4. Galileo Galileo, *Difesa contro alle calunnie ed imposture di Baldessar Capra*, in *Le Opere*, II: 520.

5. Galileo Galilei, *Le Opere*, X: 134.

6. For helpful discussions of both the new stars of 1572 and 1604, see David H. Clark and F. Richard Stephenson, *The Historical Supernovae* (Oxford: Pergamon Press, 1977) 172–206, and Michael Hoskin, *Stellar Astronomy: Historical Studies* (New York: Science History Publications, 1977) 22–28. For a valuable presentation of the context of the Lyncean Joannes Van Heeck's work on the new star of 1604, see Saverio Ricci, "Federico Cesi e la *nova* del 1604," *Rendiconti, Accademia nazionale dei Lincei, Classe di scienze morali storiche e filologiche*, 8th ser., 43 (1988) 111–133. For an equally informative discussion of the interpretation of the new star at the Collegio Romano, see Ugo Baldini, "La nova del 1604 e i matematici e filosofi del Collegio Romano," *Annali dell'Istituto e Museo di Storia della Scienza* 6 (1981) 63–97.

7. Galileo Galilei, *Le Opere*, II: 278.

8. Seneca, *Natural Questions*, VII: i, in M. N. Bouillet, ed., *Opera philosophica* (Paris: Bibliotheca Classica Latina, 1830) V: 629.

9. On *contubernium* in both classical and early modern Stoicism, see Morford, *Stoics and Neostoics*, 15–19, 28–33.

10. Galileo Galilei, *Le Opere*, II: 278.

11. Seneca, *Natural Questions*, VII: i, in Bouillet, *Opera philosophica*, V: 631.

12. On Hercules as the heroic ideal for Stoic and Neostoic thinkers, see Morford, *Stoics and Neostoics*, especially 18, 141, 208–210, and plates 2 and 3, which feature Hercules on the title pages of Lipsius's editions of Seneca's works.

13. See Galileo Galilei, *Le Opere*, X: 134–135. The letter is translated into English by Stillman Drake in his *Galileo against the Philosophers*, 20–21, but I believe that one passage has been rendered incorrectly, and that this mistranslation, among other factors, encouraged Drake to believe that the letter in question was written after the end of January 1605 rather than in late 1604, as I argue below. Specifically, Galileo's assertion that he needed to "di nuovo osservare con gran diligenza quali mutazioni [la nuova stella] *habbia fatto*" should be translated, as the subjunctive mode suggests, as "so as to observe anew and with great care what changes it *may make*," rather than as a reference to observations already made.

14. On the identity of the recipient of the letter, see Drake, *Galileo against the Philosophers*, 19. On Mercuriale's importance at the Medici Court and his sponsorship of Galileo during the earlier years of the younger man's career, see Mario Biagioli, *Galileo, Courtier* (Chicago: University of Chicago Press, 1993) 21–23, 164, 167.

15. Galileo Galilei, *Le Opere*, II: 282.

16. Galileo Galilei, *Le Opere*, II: 282.

17. Galileo Galilei, *Le Opere*, II: 282.

18. Galileo Galilei, *Le Opere*, II: 283.

19. See Peter Barker and Bernard R. Goldstein, "Is Seventeenth-Century Physics Indebted to the Stoics?" *Centaurus* 27 (1984) 148–164; Peter Barker, "Jean Pena (1528–58) and Stoic Physics in the Sixteenth Century," in Ronald H. Epp, ed., *Spindel Conference 1984: Recovering the Stoics*, The Southern Journal of Philosophy 23, suppl. (1985) 93–107; Peter Barker, "Stoic Contributions to Early Modern Science," in Margaret Osler, ed., *Atoms, Pneuma, and Tranquility* (Cambridge, U.K.: Cambridge University Press, 1991) 135–154. On Stoic science, see Samuel Sambursky, *Physics of the Stoics* (London: Routledge and Kegan Paul, 1959), and David E. Hahm, *The Origins of Stoic Cosmology* (Columbus: Ohio State University Press, 1977). For a useful compendium of Stoic doctrines relating to cosmology, see Margherita Isnardi Parente, ed., *Stoici antichi*, 2 vols. (Turin: Unione Tipografico-Editrice Torinese, 1989) II: 927–1007.

20. Seneca, *Natural Questions*, III: ix–x, in Bouillet, *Opera philosophica*, V: 299–302.

21. See especially Barker, "Stoic Contributions to Early Modern Science," 143–149. On the metaphor of the birds of the air and the fish of the water, see below, pages 76–79.

22. Galileo Galilei, *Le Opere*, II: 284. The passage to which Galileo refers, mentioned by Tycho Brahe in his *Astronomia Instaurata Progymnasmata* of

1602, originally appeared in Johannes Praetorius Ioachimicus, *De cometis, qui antea visi sunt, et de eo, qui novissime mense novembri apparvit, narratio* (Nuremberg: In officina typographica Catharin Gerlachin, & haeredum Iohannis Montani, 1578) 11–12.

23. In the *Sidereus Nuncius* Galileo referred to the Pythagorean notion that the moon was another earth; in the *Letter to the Grand Duchess Christina* and the Second Day of the *Dialogue Concerning the Two Chief World Systems*, he invoked the Pythagorean belief in the stability of the sun and the mobility of the earth. In the *Discourse on the Comets* he defended Pythagorean conjectures about the comets against Aristotle, and in the opening pages of the *Dialogue Concerning the Two Chief World Systems* he applauded the Pythagorean reverence for the science of numbers, but scorned the mysteries associated with it. According to his biographer, Niccolo Gherardini, Galileo "esteemed Pythagoras above any other thinker on account of his manner of conducting natural philosophy." See Galileo Galilei, *Le Opere*, III: (1) 65, V: 321, VI: 48, 63–64, VII: 34–35, 215, XIX: 645.

24. Galileo Galilei, *Le Opere*, II: 283. Galileo repeated this passage around 1615 in his *Considerazioni circa l'opinione copernicana*; see *Le Opere*, V: 352.

25. Galileo Galilei, *Le Opere*, II: 281.

26. Galileo Galilei, *Le Opere*, II: 281.

27. For a technical explanation of the aurora, see Neil Davis, *The Aurora Watcher's Handbook* (Fairbanks: University of Alaska Press, 1992). For a general discussion of theories of the aurora from Antiquity to the present, with particular emphasis on Scandinavian mythology and research, see Asgeir Brekke and Alv Egeland, *The Northern Light: From Mythology to Space Research* (New York: Springer-Verlag, 1983), and Harald Falck-Yetter, *Aurora: The Northern Lights in Mythology, History, and Science* (Spring Valley, N.Y.: Anthroposophic Press, 1983). For Aristotle's discussion of the aurora, see *Meteorologica* I: v (342 a 34–342 b 16). On aurorae in Ancient Greece and Rome, see Richard Stothers, "Ancient Aurorae," *Isis* 70 (1979) 85–95, and on related phenomena, D. Justin Schove, "Sunspots, Aurorae and Blood Rain: The Spectrum of Time," *Isis* 42 (1951) 133–138. A valuable early catalog of ancient and early modern aurorae and the theories associated with them is found in J.J.D. Mairan, *Traité physique et historique de l'aurore boréale* (Paris: Imprimerie Royale, 1733). For modern catalogs of aurorae see Frantisek Link, "Observations et catalogue des aurores boréales apparues en occident de -626 à 1600," *Geofysikalni Sbornik* (Prague) X (1962) 297–387, and "Observations et catalogue des aurores boreales apparues en occident de 1601 à 1700," *Geofysikalni Sbornik* (Prague) XII (1964) 501–547, as well as the more general discussion provided by the same author in "On the History of the Aurora Borealis," in *Vistas in Astronomy* 9 (1967) 297–306. For a discussion of the origin of the term *aurora borealis*, see George L. Siscoe, "An Historical Footnote on the Origin of 'Aurora Borealis,'" *Eos* 59 (1987) 994–997; while it is true that the commonly used name of the phenomenon dates to Galileo's *Discourse on the Comets* of 1619, the astronomer's explanation of the aurora is some fifteen years older.

28. *Meteorologica*, I: v (342b), trans. H.D.P. Lee (Cambridge, Mass., and London: Harvard University Press, 1962) 36–39.

29. *Commentarii Collegii Conimbricensis, Societatis Iesu, in quatuor librs De Caelo, Meteorologicos & Parva Naturalia Aristotelis* (Cologne: Heirs of Lazarus Zetzner, 1618) col. 40. For similar discussions, see Francisco Vicomercati, *In quatuor libros Aristotelis Meteorologicorum commentarii* (Paris: Vascosanus, 1556) ff. 24–26; Ioannes Lodovico Havenreuter, *Commentaria in Aristotelis Meteorologicorum libros quatuor* (Frankfurt: "E Collegio Musarum Paltheniano" [Zacharias Palthenius], 1605) 53–55; Nicolas Cabeo, S.J., *Commentaria in Aristotelis Stagiritae Meteorologicorum* (Rome: Heirs of Francisco Corbelletti, 1646) 140–145.

30. For the biblical account, see 2 Maccabees 5:1–4. For the description of the naval battle above Amsterdam, see Willebrord Snellius, *Descriptio cometae qui anno 1618 novembri primum effulsit* (Louvain: Elzevir, 1619) 61–62, who was skeptical of his childhood impression of the sea fight, calling it a *puerilis naumachia*. For a derisive account of the warlike scenes popularly associated with the aurora borealis of 1621, see Pierre Gassendi, *Vita Peireskii*, in *Opera Omnia*, 6 vols. (Lyon: Laurence Anisson, 1658), in a modern facsimile edition, ed. Tullio Gregory (Stuttgart: Friedrich Frommann Verlag, 1964) V: 290.

31. On auroral sound, see Davis, *The Aurora Watcher's Handbook*, 183–203.

32. Vicomercati, *Commentaria*, 26.

33. The nova's color was said by Chinese observers to be "reddish yellow," and "yellowish red" or on occasion "yellow" by Korean observers, "like Mars," "like half a ripe orange," "like Jupiter," and "white, not red" by European observers. See Clark and Stephenson, *The Historical Supernovae*, 192–198. In the exordium of his first lecture on the new star, Galileo described it as *fulgentissima et admodum rutilans atque scintillans*, "most brilliant and very red and shining," and he also noted that in hue it imitated at once the "golden color of Jupiter and the flamelike appearance of Mars." See Galileo Galilei, *Le Opere*, II: 277.

34. Galileo Galilei, *Discourse on the Comets*, in Stillman Drake and C. D. O'Malley, eds. and trans., *The Controversy on the Comets of 1618* (Philadelphia: University of Pennsylvania Press, 1960) 54–55.

35. See Clark and Stephenson, *The Historical Supernovae*, 196–202.

36. This concerns Tycho Brahe's criticism of Elias Camerarius. Galileo Galilei, *Le Opere*, II: 281–282.

37. Galileo Galilei, *Le Opere*, II: 279–280.

38. "[Pignoria] said that the star was a new one, and that it had been observed by Galileo, and this even when it had changed its place from an evening to morning star." Gassendi, *Vita Peireskii*, in *Opera Omnia*, V: 261.

39. For Capra's treatise and Galileo's marginalia see Galileo Galilei, *Le Opere*, II: 288–305; for Galileo's subsequently published response, the first pages of which contain many of the arguments mentioned in his fragmentary notes on the new star, see *Difesa contro alle calunnie ed imposture di Baldessar Capra*, in *Le Opere*, II: 515–601.

40. Galileo Galilei, *Le Opere*, XVI: 247. Peiresc told Galileo that Rubens would be going to Liège to examine the machine, and he described the artist as a "great admirer of your genius." On the importance of this machine, see Cecilia Rizza, *Peiresc e l'Italia* (Turin: Giappichelli Editore, 1965) 228–229, 233–234.

41. Max Rooses and Charles Ruelens, *Correspondance de Rubens et documents épistolaires concernant sa vie et ses oeuvres*, 6 vols. (Antwerp: J. E. Buschmann, 1887–1909) I: 63.

42. For Galileo's letter, see *Le Opere*, XI: 340–343, and the discussion of it in Erwin Panofsky, *Galileo as a Critic of the Arts* (The Hague: Martinus Nijhoff, 1954) 6–11; and Martin Kemp, *The Science of Art* (New Haven: Yale University Press, 1990) 98. For a helpful study of the *paragone* in general, see Claire Farago, *Leonardo da Vinci's Paragone: A Critical Interpretation with a New Edition of the Text in the Codex Urbinas* (Leiden: Brill, 1991). For the extant fragment of Rubens's treatise, thought to have been written after his return to Antwerp in 1608, see Roger de Piles, *Cours de peinture par principes* (Paris: Jacques Estienne, 1708) 139–148; and for discussion of it, see Jeffrey M. Muller, "Rubens's Theory and Practice of the Imitation of Art," *Art Bulletin* 64 (1982) 229–247.

43. Peter Paul Rubens, *De imitatione statuarum*, 141.

44. *De imitatione statuarum*, 146, where Rubens refers to Mercuriale's *De arte gymnastica*. Mercuriale was a mentor to Lodovico Cigoli as well as to Galileo and Rubens; for Cigoli's "citation" of Mercuriale's *De arte gymnastica* in a painting of 1596, see Miles L. Chappell, "Cigoli, Galileo and *Invidia*," *Art Bulletin* 57 (1975) 95, n. 14; and *Disegni di Lodovico Cigoli*, ed. Miles Chappell (Florence: Leo S. Olschki, 1992) 57, 60–62.

45. For relevant bibliography and a history of the conjectures regarding the sitters in the portrait and the occasion it commemorates, see Frances Huemer, *Portraits*, in Ludwig Burchard, ed., *Corpus Rubenianum* (London: H. Miller, 1977) XIX, I: 163–166.

46. Frances Huemer, "Rubens and Galileo 1604: Nature, Art, and Poetry," *Wallraf-Richartz-Jahrbuch* 44 (1983) 175–196.

47. On Perez de Baron and Richardot, see Morford, *Stoics and Neostoics*, 33–35.

48. On Lipsius, see especially Jason Lewis Saunders, *Justus Lipsius: The Philosophy of Renaissance Stoicism* (New York: The Liberal Arts Press, 1955); Anthony Grafton, "Portrait of Justus Lipsius," *American Scholar* 56:3 (1987) 382–390; Oestreich, *Neostoicism and the Early Modern State*, esp. 13–117; Morford, *Stoics and Neostoics*.

49. For a thorough examination of the *Four Philosophers* in light of Lipsius's Neostoicism, see Morford, *Stoics and Neostoics*, esp. 3–13. For an approach that emphasizes other aspects of the work, see Simone Zurawski, "Reflections on the Pitti Friendship Portrait of Rubens: In Praise of Lipsius and in Remembrance of Erasmus," *Sixteenth Century Journal* 23:4 (1992) 727–753.

50. Huemer, "Rubens and Galileo 1604," 175, 192–193 n. 3.

51. For a valuable presentation of Mantuan maps of the early modern period, see Ercolano Marani, "Le rappresentazioni cartografiche rinascimentali della citta di Mantova," in *Mantova e i Gonzaga nella civiltá del Rinascimento* (Mantua: Accademia Virgiliana e Arnaldo Mondadori, 1977) 453–470.

52. In the case of Mantua, the point of view was generally taken from the Ponte San Giorgio. For a comparison of the orientation of three Renaissance maps of the city, see Marani, "Le rappresentazioni cartografiche rinascimentali della citta di Manova," 470, fig. 6.

53. Justus Lipsius, *Physiologia Stoicorum* (Antwerp: Plantin, 1610) 121–122. For a general discussion of Lipsius's view of Stoic physical theory, see Saunders, *Justus Lipsius,* 117–217.

54. M. Warnke, *Kommentare zu Rubens* (Berlin: De Gruyter, 1965) 22–24, cited in Huemer, "Rubens and Galileo 1604," 175–176; and Marjon van der Meulen, "Petrus Paulus Rubens Antiquarius," (Ph.D. diss., Yorktown Heights, N.Y., 1975), 75, cited in Zurawski, "Reflections on the Pitti Friendship Portrait," 736 n. 25.

55. Galileo Galilei, *Le Opere,* X: 106. On this group and their enthusiasm for occult sciences, see Stillman Drake, *Galileo at Work: His Scientific Biography* (Chicago: University of Chicago Press, 1978) 48.

56. Galileo Galilei, *Le Opere,* II: 280, 281, 282, 283–284. Some of the same information appears in his *Difesa contro alle calunnie ed imposture di Baldessar Capra,* and even in the *Dialogue Concerning the Two Chief World Systems.*

57. Tycho Brahe, *Astronomiae instauratae progymnasmata,* in J.L.E. Dreyer, ed., *Scripta Astronomica,* 15 vols. (Hveen, Denmark: Gyldendaliana, 1913–1929) III: 279–288. On Busch, see also C. Doris Hellmann, *The Comet of 1577: Its Place in the History of Astronomy* (New York: AMS Press, 1971) 225–233.

58. See Brahe, *Astronomiae instauratae progymnasmata,* 282, 285, 287.

59. Grassi, *The Astronomical Balance,* 87, 89, 104, and Galileo Galilei, *The Assayer,* 233, 248, 250, 273, both in Drake and O'Malley, *The Controversy on the Comets of 1618.*

60. Galileo Galilei, *Discourse on the Comets,* 57, in Drake and O'Malley, *Controversy on the Comets of 1618.*

61. Galileo Galilei, *Le Opere,* XIII: 71.

62. See Roberto Francesco Romolo Bellarmino, *The Louvain Lectures (Lectiones Lovanienses) of Bellarmine and the Autograph Copy of his 1616 Declaration to Galileo,* ed. and trans. Ugo Baldini and George V. Coyne, S.J. (Vatican City: Specola Vaticana, 1984), especially 18–20, 38 n. 88; and Barker, "Stoic Contributions to Early Modern Science," 144–145. On Bellarmine's cosmological views in general, see Ugo Baldini, "L'astronomia del Cardinale Bellarmino," in Paolo Galluzzi, ed., *Novità celesti e crisi del sapere: Atti del Convegno Internazionale di Studi Galileiani* (Florence: Giunti Barbera, 1984) 293–305; and Richard J. Blackwell, *Galileo, Bellarmine, and the Bible* (Notre Dame, Ind.: University of Notre Dame, 1991), especially 40–45. For a helpful discussion of the question of the fluid heavens and the views of Bellarmine as well as of other prominent Jesuit thinkers, see James M. Lattis, *Between Copernicus and Galileo: Christoph Clavius and the Collapse of Ptolemaic Cosmology* (Chicago: University of Chicago Press, 1994) 94–102, 211–215.

63. Bellarmine, *Louvain Lectures,* 19–20, and Cicero, *De Natura Deorum,* II: 42, in M. van den Bruwaene, trans. (Brussels: Latomus, 1978) 64–65. Lattis, *Between Copernicus and Galileo,* 95, has found the earliest use of the fish simile in a commentary on the *Sphere* of Sacrobosco authored by Andalo di Negro (ca. 1270–1340), an astronomer praised by Boccaccio.

64. Bellarmine, *Louvain Lectures,* 38 n. 88, 42–43 n. 94, and Lattis, *Between Copernicus and Galileo,* 96–98, 214, 239 n. 47.

65. See Gaetano Stano and Francesco Balsimelli, "Un illustre scienziato francescano amico di Galileo," *Miscellanea Francescana* 43 (1943) 81–129; and G. Odoardi, "Altobelli, Ilario *senior*" in *Dizionario biografico degli italiani*, 44 vols. to date (Rome: Istituto della Enciclopedia Italiana, 1960–1994) II: 567–568.

66. Galileo Galilei, *Le Opere*, X: 117.

67. Galileo Galilei, *Le Opere*, X: 119.

68. For the document in the original Latin, see Stano and Balsimelli, "Un illustre scienziato francescano," 105–106, or Antonio Favaro, *Galileo Galilei e Lo Studio di Padova*, 2 vols. (Florence: Le Monnier, 1883) II: 343–345, where, however, the phrase "Planetae vagantes deprehenduntur sicut *situs* in aqua" should be emended to "Planetae vagantes deprehenduntur sicut *pisces* in aqua." Stillman Drake, using a copy of the original manuscript document, made such an emendation in *Galileo against the Philosophers*, 8. As he acknowledges, the manifesto probably accompanied Altobelli's letter of November 25, 1604, rather than a missive of April 7, 1610, as Stano and Balsimelli, following Favaro, assert.

69. It is worth noting that in one of the passages to which Altobelli specifically refers in his discussion of planetary movement, the Franciscan Saint Bonaventure (1221–1274), uses the birds and fish simile to describe not the movement of planets but rather the related question of the place of Christ, the Virgin, and the Blessed in the highest heaven: "This image is the more easily pictured if one were to imagine birds in their place in the air, and fish in the water; thus bodies are understood to be located in the Empyrean." See Bonaventure, *Commentaria in quatuor libros sentiarum magistri Petri Lombardi*, in *Opera Omnia*, 10 vols. (Quaracchi, Italy: Ex Typographia Collegii S. Bonaventurae, 1882–1902) II: 85.

70. On this point, see Barker, "Stoic Contributions to Early Modern Science," 145.

71. Robert Burton, "Digression of Ayre," in *The Anatomy of Melancholy*, ed. Nicholas K. Kiessling, Thomas C. Faulkner, and Rhonda L. Blair, 3 vols. (Clarendon Press: Oxford, 1990) II: 47.

72. Stillman Drake, who owned a manuscript version of Gualterotti's *Discorso*, mentioned but did not otherwise describe the nature of such revisions in *Galileo against the Philosophers*, 59.

73. Cicero, *De Natura Deorum*, II: 19, in van den Bruwaene, trans., 45, 47. Gualterotti insists on the similarity of the earth and the moon in *Discorso*, 12, and on the homogeneity of the cosmos in *Discorso*, 8, 16, 19, 20. The sustained (if sharply contested) series of parallels between the earth and the moon is a feature of the Stoic arguments presented in Plutarch's *On the Face in the Moon* as well. For a discussion of such parallels in the context of cosmic sympathy and Stoicism, see Sambursky, *Physics of the Stoics*, 9, 42–43.

74. Gualterotti, *Discorso*, 16, 20.

75. Cicero, *De Natura Deorum*, II: 42, in van den Bruwaene, trans., 64–65.

76. Gualterotti, *Discorso*, 20; and Plutarch, *On the Face in the Moon*, 928d, in Cherniss, trans., 94–95.

77. See Seneca, *Natural Questions* III: ix–x, in M. N. Bouillet, trans., *Opera philosophica*, V: 299–302, and Gualterotti, *Discorso*, 16, 19.

78. Gualterotti, *Discorso*, 21, 23, 25–26.

79. Gualterotti, *Discorso*, 28. This was a common observation.

80. Gualterotti, *Discorso*, 28.

81. Frantisek Link, "Observations et catalogue des aurores boréales apparues en Occident de 1601 à 1700," 504–505.

82. Solar activity, which occurs in cycles of 250 years, peaked around 1610. On the modern correlation of sunspot cycles and aurorae, see Davis, *The Aurora Watcher's Handbook*, 61–64, and Brekke and Egeland, *The Northern Light*, 127–130. On the observation of the phenomena in Antiquity, see Schove, "Sunspots, Aurorae, and Blood Rain: The Spectrum of Time."

83. On free will, see Gualterotti, *Discorso*, 9, 33; Sambursky, *Physics of the Stoics*, 132, 136–137; and Saunders, *The Origins of Stoic Cosmology*, 147. For an argument based on *krasis*, see *Discorso*, 29, and the discussion in *Physics of the Stoics*, 12–17.

84. Gualterotti, *Scherzi degli spiriti animali*, 14, 15.

85. Gualterotti, *Scherzi degli spiriti animali*, 14.

86. It is perhaps worth noting that in a poem dedicated to Galileo and celebrating the discoveries published in the *Sidereus Nuncius*, Gualterotti's son Francesco Maria Gualterotti wrote that his father had already written of the riches (*gioie*) found by astronomers, but that he had done so in obscure fashion, or as Francesco Maria put it, "under the cover of a fine veil," and also that in this matter his father had preceded Galileo as "the dawn (*aurora*) does the sun." It is possible that Francesco Maria, whose poetic talents do not exceed those of his father, intended these lines as a reference to his father's coherent explanation of the moon's secondary light as a kind of dawn light; it seems to me less likely that the allusion involves the aurora borealis, of which Raffaello Gualterotti appears to have had virtually no understanding. See the "Vaghezza di Francesco Maria Gualterotti," in Nunzio Vaccaluzzo, *Galileo Galilei nella poesia del suo secolo* (Milan: Remo Sandron Editore, 1910) 40.

87. Galileo Galilei, *Le Opere*, II: 283.

88. Gualterotti, *Scherzi degli spiriti animali*, 5.

89. See Giovanni Battista Cardi-Cigoli, *Vita di Lodovico Cardi-Cigoli*, in Anna Matteoli, *Lodovico Cardi-Cigoli pittore e architetto* (Pisa: Giardini Editori, 1980) 29. On the issue of Envy, see Miles Chappell, "Cigoli, Galileo, and *Invidia*," *Art Bulletin* 57 (1975) 91–98, and chapter 4, below. Significantly, the verse taken from *Inferno* XIII, "E cigola per vento che va via," is used to describe Pier delle Vigne, a tragic figure who attributed his downfall and eventual suicide to the reign of Envy. See *Inferno* XIII: 64–67, in Emilio Pasquini and Antonio Quaglio, eds., *Commedia* (Milan: Grandi Libri Garzanti, 1982) 138.

90. Gualterotti forced Cigoli to give him two of his landscape paintings, alleging they had been promised him by the artist in an earlier and happier phase of their acquaintance. On this incident and Cigoli's distrust of Gualterotti, see his letters of 1611 and 1612 to Galileo in *Le Opere*, XI: 211, 291.

91. See especially Gualterotti, *Scherzi degli spiriti animali*, 9–10.

92. Gualterotti, *Scherzi degli spiriti animali*, 37.

93. Galileo Galilei, *Assayer*, 293.

94. The observation is also in keeping with the spirit of the controversy over the comets of 1618, where the titles of the works of Galileo's enemy Orazio

Grassi, the *Astronomical and Philosophical Balance* and the *Reckoning of Measures for the Balance and the Small Scale*, as well as those by Galileo and his disciple Giovanni Battista Stelluti, the *Assayer* and the *Fathomer*, suggested that each author was using a more refined scale to weigh his conjectures against the crude assertions of his rival.

95. Giovanni Battista Marino, "Il Cielo, Diceria Terza," in Giovanni Pozzi, ed., *Dicerie Sacre e La Strage de gl'innocenti* (Turin: Giulio Einaudi, 1960) 402. For letters documenting the ties of both Raffaello Gualerotti and his son Francesco Maria Gualterotti with Marino, see Giambattista Marino, *Lettere*, edited by Marziano Guglielminetti (Turin: Giulio Einaudi, 1966) 159–160, 164, 321–322.

96. Galileo Galilei, *Le Opere*, II: 281.

97. On Peiresc, see especially Pierre Gassendi's biography, *Viri illustris Nicolai Claudii Fabricii de Peiresc, Senatoris Aquisextiensis Vita* (Paris: Cramoisy, 1641). The *Vita Peireskii*, as it is commonly known, was translated to English in the seventeenth century: see *The Mirror of True Nobility and Gentility*, trans. W. Rand (London: Printed by J. Streater for Humphrey Moseley, 1657); recently translated into French as the *Vie de Peiresc* by Roger Lassalle and Agnes Bresson (Paris: Belin, 1992). I have used the version in volume 5 of Gassendi's *Opera Omnia*, cited in n. 30 above. On his friendship with Richardot, which began when both men were in Padua, see Raymond Lebegue, *Les correspondants de Peiresc dans les anciens Pays-Bas* (Brussels: Office de Publicité, 1943) 6. It is likely that Peiresc knew Philippe Rubens, Richardot's tutor, at this point as well. On his Italian connections, see Antonio Favaro, "Nicolas Fabri de Peiresc," in Paolo Galluzzi, ed., *Amici e corrispondenti di Galileo* 3 vols. (Florence: Salimbeni, 1983) III: 1537–1581; also see Cecilia Rizza, *Peiresc e l'Italia* (Turin: Giappichelli Editore, 1965), and "Galileo nella corrispondenza di Peiresc," *Studi francesi* 5 (1961) 433–451. On Peiresc's close relationship with Sarpi, though without reference to any scientific interests they may have shared, see *Peiresc e l'Italia*, 13–14, 20, 167–184. As Rizza notes, Peiresc was specifically compared to Sarpi by a contemporary, "in his way he was a Fra' Paolo and one of the lights of this century"; see Rizza, "Galileo nella corrispondenza di Peiresc," 451.

98. Gassendi, *Vita Peireskii*, in Gassendi, *Opera Omnia*, V: 257. For a helpful survey of all sorts of luminescence, see E. Newton Harvey, *A History of Luminescence from the Earliest Times until 1900* (Philadelphia: American Philosophical Society, 1957).

99. The man who found the stone, Vincenzo Casciarolo, took it to the alchemist Carlo Antonio Magino, who in his turn sent it to Galileo's sometime rival, the astronomer Giovanni Antonio Magini of the University of Bologna. Magini had, in addition to Galileo, a number of acquaintances in Padua. On the discovery of the Bolognese stone, see Harvey, *A History of Luminescence*, 94–95; Pietro Redondi, "Galilée aux prises avec les théories aristoteliciennes de la lumière (1610–1640)," *Dix-Septième Siècle* 136 (1982) 267–283; and Susana Gomez, "The Bologna Stone and the Nature of Light," *Nuncius* 6 (1991) 3–32.

100. On the relationship of Gualdo and Pignoria to Torquato Tasso, see pp. 19–21 of my introduction; on their early association with Peiresc, see Rizza, *Peiresc e l'Italia*, 14–16, 51–61.

101. Torquato Tasso, "Alle gatte de lo spedale di Sant'Anna," in Angelo So-lerti, ed., *Le Rime di Torquato Tasso*, 4 vols. (Bologna: Romagnoli-dall'acqua, 1898–1902) IV: 18–19. Some years later, in "Desiderio di luna," Tommaso Stigliani would appeal to a cloud-covered moon on a night when "[he] no longer had a cat and could find no glow-worms" to illuminate his page.

102. The Roman emperor Tiberius was traditionally credited with this ability. As Acquapendente noted, others such as Girolamo Cardano and Giambattista della Porta also claimed to have extraordinary nocturnal vision. See Girolamo Fabricio d'Acquapendente, *De visione*, in *Opera Omnia* (Leipzig: Sumptibus Johannis Friderici Gleditschi, Excudebat Christianus Goezius, 1687) 206. For biographical information on Acquapendente, see M. Muccillo, "Fabrici d'Ac-quapendente," in *Dizionario biografico degli italiani*, 43: 768–774. For a general description of Acquapendente's work on vision and the anatomy of the eye, see Huldrych M. Koelbing, "Anatomia dell'occhio e percezione visivia nell' opera di G. Fabrizi d'Acquapendente," *Acta medicae historiae Patavina* 35–36 (1988–1989) 29–38. On his library, see Francesca Zen Benettti, "La libreria d Girolamo Fabrici d'Acquapendente," in *Quaderni per la storia dell'Universita' di Padova*, 9–10 (1976) 161–183. On his relationship with Pignoria, see Francesca Zen Benetti, "Per la biografia di Lorenzo Pignoria," in Maia Chiara Billanovich, Giorgio Cracco, and Antonio Rogon, eds., *Viridarium Floridum: Studi di storia veneta offerti dagli allievi a Paolo Sambin* (Padua: Editrice Antenore, 1984) 322.

103. Acquapendente, *De visione*, 206–207.

104. See, for example, Aristotle, *De Anima*, II: 7 418 b, in Hugh Lawson-Tancred, trans., *On the Soul* (Harmondsworth, U.K.: Penguin Books, 1986) 173–174.

105. Acquapendente, *De visione*, 206.

106. Acquapendente, *De visione*, 207.

107. For more on luminous lambs (of Padua and elsewhere), see Harvey, *A History of Luminescence*, 87–88, 145–146, 462–469, 471–476.

108. Gassendi, *Vita Peireskii*, 253.

109. Gassendi, *Vita Peireskii*, 256.

110. Gassendi, *Vita Peireskii*, 257. On Paci, see Rizza, *Peiresc e l'Italia*, 51, 60, 62–66.

111. See the description of their largely unpublished correspondence about astronomical matters after the publication of the *Sidereus Nuncius* in Rizza, *Peiresc e l'Italia*, 63–64; and Rizza, "Galileo nella corrispondenza di Peiresc," 436–437.

112. They probably included luminous jellyfish, the sea pen (a type of polyp), and the piddock (a marine bivalve mollusc), all of which had been described and illustrated by Guillaume Rondelet in his *De piscibus marinis* of 1554 and his *Universae aquatilium historiae* of 1555. Rondelet, like Peiresc's host Paci, lived in Montpellier and may have obtained some of the fish and invertebrates he described from the nearby Golfe du Lion. See Harvey, *History of Luminescence*, 72–73.

113. Gassendi, *Vita Peireskii*, 257.

114. Gassendi, *Vita Peireskii*, 257.

115. See Panfilo Persico to Monsignor Luigi Lollino, April 6, 1617, in *Lettere inedite del secolo xvi-xvii*, Ms. Ital. 204, Rare Book Room, University of Pennsylvania, no. 56. Lollino and Sarpi encountered each other in the circle of Pinelli; see Fulgenzio Micanzio, *Vita del padre Paolo*, in Paolo Sarpi, *Istoria del Concilio Tridentino, seguita dalla Vita del padre Paolo di Fulgenzio Micanzio*, ed. Corrado Vivanti, 2 vols. (Turin: Giulio Einaudi Editore, 1974) II: 1312.

116. Sarpi's biographer Fulgenzio Micanzio describes the theologian as something of a Stoic sage, and mentions that Caspar Scioppius, author of the *Elementae philosophiae stoicae moralis* of 1606, visited Sarpi in order to talk with him about "the doctrine of the ancient Stoics"; see *Vita del padre Paolo*, 1346, but also the qualifications of this Stoicizing portrait in Vittorio Frajese, *Sarpi scettico* (Bologna: Il Mulino, 1994) 110–112, and in the introduction of Paolo Sarpi, *Opere*, ed. Gaetano and Luisa Cozzi (Milan: Riccardo Ricciardi Editore, 1969) 31. The Senecan references in the *Pensieri* dealing with medical and moral matters are noted in this edition, 72–94, though no such critical apparatus has been provided for the philosophical and scientific *Pensieri*, 39–71. For a discussion of Sarpi's library and a list of the books he owned as of 1599—several of which reflect an interest in Stoicism—see G. L. Masetti Zannini, "Libri di fra Paolo Sarpi e notizie di altre biblioteche dei Servi (1599–1600)," *Studi Storici dell'ordine dei Servi di Maria* XX (1970) 174–202.

117. Acquapendente, *De visione*, 229. Not surprisingly, Sarpi flatly contradicted Acquapendente's description of their lamplike eyes in his *Pensieri*, noting that it would be enough to be in the presence of those endowed with nocturnal vision to see at night, for their eyes would illuminate everything they examined. See Paolo Sarpi, *Scritti filosofici e teologici*, ed. Romano Amerio (Bari: Giuseppe Laterza, 1951) p. 6 (*pensiero* 10).

118. Micanzio, *Vita del padre Paolo*, in Sarpi, *Istoria del Concilio Tridentino, seguita dalla vita del padre Paolo di Fulgenzio Micanzio*, 1293; emphasis mine. For more on Acquapendente's supposed debt to Sarpi, a view shared by Gassendi in his *Vita Peireskii*, see also Francesco Griselini, *Memorie anedote spettanti alla vita ed agli studi del sommo Filosofo e Giuresconsulto F. Paolo Servita* (Lausanne: M. Michel Bousquet et Compagnie, 1760) 22–23, 26.

119. Seneca, *Natural Questions*, III: ix–x, in M. N. Bouillet, ed., *Opera philosophica*, V: 299–302.

120. On Costozza, see Filippo Pigafetta, *La descrizione del territorio e del contado di Vicenza (1602–1603)*, ed. Alvise da Schio e Franco Barbieri (Vicenza: Neri Pozza, 1974) 53–54; Gassendi, *Vita Peireskii*, 256, where it is called "Gustosa"; Antonio Favaro, *Galileo Galilei e lo studio di Padova*, II: 49–51; Drake, *Galileo at Work*, 75; Annalisa Moriconi, "Il Covolo di Costozza nella storiografia," in *Costozza*, ed. Ermengildo Reato (Vicenza: Cassa Rurale e Artigiana di Costozza e Tramonte-Praglia, 1983) 476–490, especially 487–488, and Girolamo Arnaldi et al., *Storia di Vicenza*, 4 vols. (Vicenza: Accademia Olimpica, 1989) III: 1 264–265.

121. Paolo Sarpi, *Scritti filosofici e teologici editi e inediti*, p. 17 (*pensiero* 53). See also p. 7 (*pensiero* 12), where Sarpi states that the rarefaction of solar rays far from their source weakens them, and that they are most dense when closest to the sun itself. For *pensieri* concerned with the nature and behavior of vapor,

see p. 12 (*pensieri* 33 and 35), p. 22 (*pensiero* 71), p. 86 (*pensiero* 391), p. 99 (*pensiero* 465), and p. 109 (*pensiero* 530).

122. Seneca, *Natural Questions*, VII: xxvii, in N. M. Bouillet, *Opera philosophica*, V: 680–681.

123. *The Workes of Seneca*, newly inlarged and corrected by Thomas Lodge (London: W. Stansby, 1620) 901; and John Wilkins, *The Discovery of a World in the Moone* (London: Printed by E. G. for M. Sparke and E. Forrest, 1638), also in a facsimile edition introduced by Barbara Shapiro (Delmar, N.Y.: Scholars' Facsimiles and Reprints, 1973) 74.

Chapter Three
1605–1607: Mutual Illumination

1. Galileo Galilei, "Frammenti sulla nuova stella," in *Le Opere*, II: 283.

2. See Galileo Galilei, *Dialogue Concerning the Two Chief World Systems*, 89.

3. Galileo Galilei, *Le Opere*, II: 282. This and all subsequent translations are mine, unless otherwise indicated.

4. Galileo Galilei, *Le Opere*, II: 282.

5. See Galileo Galilei, *Le Opere*, II: 282 n. 4.

6. Galileo Galilei, *Le Opere*, X: 151.

7. Galileo Galilei, *Le Opere*, X: 155.

8. Galileo Galilei, *Le Opere*, X: 153–154.

9. Galileo Galilei, *Le Operazioni del compasso geometrico et militare*, in *Le Opere*, II: 367.

10. Lodovico delle Colombe, *Discorso*, 29.

11. Galileo Galilei, *Dialogo sopra i due massimi sistemi del mondo*, in *Le Opere*, VII: 92.

12. Giovanni Paolo Lomazzo, *Trattato dell'arte de la pittura* (Milan: Paolo Gottardo Pontio, 1584) 189–190.

13. Galileo Galilei, *Le Opere*, X: 107.

14. For the explanation of this kind of modeling in Alberti, see *On Painting*, 48–50, 82–83. For Vasari's discussion, see "Della Pittura," chapters 15, 16, and 18, in *Le Vite*, edited and annotated by Rosanna Bettarini and Paola Barocchi, 7 vols. (Florence: Sansoni, 1966–1976) I: 111–114, 124–127. For a very helpful survey of Renaissance color theory in general, see Marcia B. Hall, *Color and Meaning: Practice and Theory in Renaissance Painting* (Cambridge, U.K.: Cambridge University Press, 1992), with special attention to down-modeling on pp. 48–55.

15. Giorgio Vasari, *Vita di Giottino*, in *Le Vite*, II: 229.

16. For a survey of the viewpoints of Galileo and his rivals in the controversy over the new star of 1604, see the introductions in Stillman Drake, *Galileo against the Philosophers*, 1–32, 55–71; for evidence concerning the identification of Alimberto Mauri as Galileo, see in particular 62–71. Except where otherwise indicated, I will be using Drake's translation of the *Considerations of Alimberto Mauri*, 76–130, in *Galileo against the Philosophers*.

17. [Galileo Galilei], *Considerations*, 124.

18. [Galileo Galilei], *Considerations*, 117.

19. [Galileo Galilei], *Considerations*, 91.

20. [Galileo Galilei], *Considerations*, 106.

21. [Galileo Galilei], *Considerations*, 103–104.

22. [Galileo Galilei], *Considerations*, 104.

23. On Galileo's precarious position at the University of Padua and his attempts to secure employment elsewhere, see *Galileo against the Philosophers*, 56, 62–63. It has recently been shown that Inquisitorial proceedings were also begun against Galileo in 1604, more or less at the instigation of his own mother. See Antonino Poppi, *Cremonini e Galilei Inquisiti a Padova nel 1604* (Padua: Antenore, 1992).

24. On Lorenzini, see *Galileo against the Philosophers*, 9–15. For Ilario Altobelli's assessment of Lorenzini's *Discorso della Nuova Stella*, see his letter of January 1605 in Galileo Galilei, *Opere*, X: 135–136.

25. As Saverio Ricci points out, Lorenzini also gained a certain fame, or rather infamy, among European astronomers when Johannes Kepler attacked both the *Discorso intorno alla nuova stella* of 1605 and his *De numero, ordine, et motu coelorum, adversus recentiores* of 1606 in his widely read *De stella nova in pede serpentarii*. See Ricci, "Federico Cesi e la *nova* del 1604. La teoria della fluidità del cielo e un opusculo dimenticato di Joannes van Heeck," *Rendiconti dell'Accademia Nazionale dei Lincei. Classe di scienze morali storiche e filologiche*, 8th ser., 43 (1984) 123 n. 33.

26. On Clavius and his influence, see Ugo Baldini, "La scuola di Clavio e la crisi della teoria astronomica," and "La *theorica solis* di Cristoforo Clavio," in *Legem impone subactis: Studi su filosofia e scienza dei gesuiti in Italia, 1540–1632* (Rome: Bulzoni Editore, 1992) 123–281, 469–564 and *passim*; James M. Lattis, *Between Copernicus and Galileo: Christoph Clavius and the Collapse of Ptolemaic Cosmology* (Chicago: University of Chicago Press, 1994); Rivka Feldhay, *Galileo and the Church: Political Inquisition or Critical Dialogue?* (Cambridge, U.K.: Cambridge University Press, 1995) 214–223, 249–251.

27. On the knowledge that Magini and Clavius had of the Tychonic system, see Christine Jones Schofield, *Tychonic and Semi-Tychonic World Systems* (New York: Arno Press, 1981) 95–97, 277–278, but also the more recent and somewhat different assessment of the relationship of Clavius and Tycho in Lattis, *Between Copernicus and Galileo*, 87, 150–151, 160–163, 201, 205–213.

28. [Galileo Galilei], *Considerations of Alimberto Mauri* (Florence: Giovanni Antonio Caneo, 1606) 3.

29. Nicholas Copernicus, *On the Revolutions of the Heavenly Spheres*, translated, introduced, and annotated by A. M. Duncan (Newton Abbot, U.K.: David and Charles, 1976) 25. For a discussion of the figure, see Robert S. Westman, "Proof, Poetics, and Patronage: Copernicus's Preface to *De revolutionibus*," in David C. Lindberg and Robert S. Westman, eds., *Reappraisals of the Scientific Revolution* (Cambridge, U.K.: Cambridge University Press, 1990) 166–205, especially 181–186.

30. See Baldessare Castiglione, *Il Cortegiano* I: xlix, ed. Giulio Preti (Turin: Giulio Einaudi, 1960) 96. Benedetto Varchi modified the statement slightly in the second "Disputa" of his second *Lezione sulla pittura e scultura*, pointing

out—as did Copernicus in the Proemium to Book I—that the heavens could be called "sculpted" as well as "painted," for they were at once *caelum* and *caelatum*, or "carved." Marco Boschin developed the painted universe figure at length in the fifth "Vento" of his *Carta del navegar pitoresco*; see Anna Pallucchini, ed., *Carta del navegar pitoresco* (Venice and Rome: Istituto per la collaborazione culturale, 1966) 329. Significantly, in the *Capitolo contro i Peripatetici*, a satire of Aristotle's followers written in 1623 by Galileo's friend Jacopo Soldani, the whining Peripatetic speaker Bozio compared Galileo's supporters, with their readiness to extrapolate from data such as moonspots and sunspots, to someone who, examining an immense painting "inch by inch," would find fault with its particulars and miss in his ignorance the grandeur of its totality. Thus for the Peripatetic, details such as spots and shadows would bear no relation to the overall design and would perhaps constitute its flaws, while for Galileo's followers these elements would bestow both verisimilitude and beauty on a work of art. See Jacopo Soldani, "Capitolo contro i Peripatetici," in Nunzio Vaccaluzzo, *Galileo nella poesia del suo secolo* (Milan: Remo Sandron, 1911) 24.

31. Horace, *Ars Poetica* vv. 1–5, in George Long and Reverend A. J. Macleane, eds., *Horatii Opera Omnia*, 2 vols. (London: Whittaker and Company, 1853) II, 700.

32. For Galileo's argument about the importance of the Jovian satellites to Copernicanism, see p. 84 in Van Helden's translation of the *Sidereus Nuncius*. On the episode with Magini, see Drake, *Galileo at Work*, 159–160; Van Helden, trans., 92–93; Lattis, *Between Copernicus and Galileo*, 177–179.

33. On Clavius's remark about considerations that future astronomers might undertake, see Lattis, *Between Copernicus and Galileo*,198–202. For the Collegio Romano's reaction to the *Sidereus Nuncius*, see Galileo Galilei, *Opere*, III: 293–298. In the following two chapters I discuss the significance of Father Clavius's preference for a smooth, semi-opaque moon.

34. Galileo Galilei, *Le Opere*, XI: 151.

35. Lodovico Dolce, *Dialogue on Painting*, translated, introduced, and annotated by Mark W. Roskill in *Dolce's "Aretino" and Venetian Art Theory of the Cinquecento* (New York: College Art Association, New York University Press, 1968) 153–155. On Galileo's alleged fondness for the works of Pietro Aretino— albeit in the latter's guise as pornographer rather than art critic—see Poppi, *Cremonini e Galileo Inquisiti*, 59, where an informant living in Galileo's house in 1603 charged, among other things, that he had seen the astronomer reading Aretino's letters. The *Letters*, prohibited because of their scandalous nature, contained aesthetic judgments as well as salacious material.

36. On portraits and sculptures of Galileo, see J. J. Fahie, *Memorials of Galileo Galilei* (London: Courier Press, 1929); and Ada Alessandrini, *Documenti lincei e cimeli galileiani* (Rome: Accademia Nazionale dei Lincei, 1965).

37. "He did not contemn [*sic*] the other inferior arts, for he had a good hand in sculpture and carving; but his particular care was to paint well. By the pencil he describes what his telescope discovered—in the one he exceeded art, in the other nature. . . . Galileus . . . made so great a progress in this curious art that he became his own Buonarota, and, because there was no other copy worthy of his

pencil, he drew himself." Thomas Salusbury, "Life of Galileo," in *Mathematical Collections and Translations*, 2 vols. (London: 1661) II: ii, cited in Fahie, *Memorials of Galileo*, 8.

38. See Miles Chappell, "Portraits and Pedagogy in a Painting by Cristofano Allori," *Antichità Viva* 16:5 (1977) 20–33, and more generally, with particular reference to Galileo's friendship with Allori, see Claudio Pizzorusso, *Ricerche su Cristofano Allori* (Florence: Leo S. Olschki Editore, 1982) 13–15, 57–62.

39. Domenico Tintoretto is generally said to have exaggerated his father's handling of dark and light in portraiture. See, for example, Anna Matteoli, "Apporti a Jacopo e Domenico Tintoretto," *Antichità Viva* 25: 5–6 (1986) 45–50, especially 49; Paola Rossi, "Alcuni Ritratti di Domenico Tintoretto," *Arte Veneta* 22 (1968) 60–71, especially 64–65; Paola Rossi, "I ritratti femminili di Domenico Tintoretto," *Arte Illustrata* III (June–Sept. 1970) 93–99, especially 95. Already in 1605 Federico Zuccari had expressed his distaste not so much for the art of Jacopo Tintoretto but for that of the Tintoretteschi; see Rodolfo Pallucchini, *La pittura veneziana del Seicento*, 2 vols. (Venice: Alfieri, 1981) I: 23–27.

40. Dolce, *Dialogue*, 101.

41. Dolce, *Dialogue*, 123–125, 147, 157.

42. Dolce, *Dialogue*, 93–95, 131–135, 161.

43. Galileo Galilei, *Dialogue Concerning the Two Chief World Systems*, 104–105. These tastes may have been formed years earlier, during Galileo's Paduan period, for in his biography of Giovanni Vincenzo Pinelli, Paolo Gualdo states that these three painters were also recommended as exemplars for the aspiring artist in the circle of the learned Pinelli. See Paolo Gualdo, *Vita Ioannis Vincentii Pinelli*, in Christian Gryphius, ed., *Vitae selectae quorundam eruditissimorum ac illustrium virorum* (Vratislavae, Poland: Christiani Bauchii, 1711) 389.

44. Dolce, *Dialogue*, 155.

45. For more on the early modern discussion of the imitation (slavish or otherwise) of statues in painting, see Jeffrey M. Muller, "Rubens's Theory and Practice of the Imitation of Art," *Art Bulletin* 64 (1982) 229–247, especially 230–321, 240–242.

46. Cardi, *Vita*, in Matteoli, *Lodovico Cardi-Cigoli*, 22.

47. Baldinucci, *Vita*, in Matteoli, *Lodovico Cardi-Cigoli*, 62.

48. On Sigismondo Coccapani, see Giuseppe Cantelli, "Per Sigismondo Coccapani 'celebre pittore fiorentino' nominato il maestro del disegno," *Prospettiva* 7 (1976) 26–38; Elisa Acanfora, "Sigismondo Coccapani, un artista equivocato," *Antichità Viva* 29 (1990) 11–25; on the reattribution of the fragmentary treatise to him, see Elisa Acanfora, "Sigismondo Coccapani disegnatore e trattatista," *Paragone* 477 (1989) 71–99; Miles Chappell, "Proposals for Coccapani," *Paradigma* 9 (1990) 183–190.

49. Cited in Chappell, "Proposals for Coccapani," 187, 188–189. For a slightly different version of the fragments, see Matteoli, *Lodovico Cardi-Cigoli*, 317, where they are attributed to Cigoli and thought to be part of the lost treatise on color.

50. *Le Opere di Fra Paolo Sarpi*, 8 vols. (Helmstadt [Venice]: Per Jacopo Mulleri, 1761–1768) VI: 75.

51. Galileo Galilei, *Le Opere*, X: 300.

52. *Le Opere di Fra Paolo Sarpi*, VI: 80.

53. On Sarpi's influence in this matter see Drake, *Galileo at Work*, 138–140, and *Galileo: Pioneer Scientist*, 132–133, and Van Helden's introduction to his translation of the *Sidereus Nuncius*, 4–9. On Sarpi's reading habits, see the account of his biographer Fulgenzio Micanzio in Paolo Sarpi, *Istoria del Concilio Tridentino seguita dalla Vita del padre Paolo di Fulgenzio Micanzio*, ed. Corrado Vivanti, 2 vols. (Turin: Giulio Einaudi Editore, 1974) II: 1301.

54. Galileo Galilei, *Le Opere*, XI: 46. Though there appears to be no further extant correspondence between the two men, this apparent absence of documents may be misleading. Letters written by Fulgenzio Micanzio, Giovanni Francesco Sagredo, and other friends of Sarpi suggest that relations between the astronomer and the theologian soon improved, and even that they continued to comunicate with each other. See, for example, Galileo Galilei, *Le Opere*, XI: 58, 70, and XII: 139, 445, 455.

55. Philippe Duplessis-Mornay, *Mémoires et correspondance*, 12 vols. (Paris: Treuttel et Wurtz, 1824) X: 261. For a helpful discussion of the letter, as well as some textual emendations of it, see Cozzi, *Paolo Sarpi tra Venezia e l'Europa*, 195–196.

56. *Le Opere di fra Paolo Sarpi*, VI: 80.

57. Galileo Galilei, *Sidereus Nuncius*, 43.

58. See the experiment reported in Jean Tarde, *À la rencontre de Galilée: Deux voyages en Italie*, edited and annotated by François Moureau and Marcel Tetel (Geneva: Slatkine, 1984) 65, and in Galileo Galilei, *Dialogue*, 97–98.

59. *Le Opere di fra Paolo Sarpi*, VI: 80.

60. Galileo Galilei, *Dialogue*, 75.

61. On the meetings at the Casa Morosini, see Fulgenzio Micanzio, *Vita del padre Paolo*, 1305–1306; Antonio Favaro, "Giovanfrancesco Sagredo," in Paolo Galluzzi, ed., *Amici e corrispondenti di Galileo Galilei*, 3 vols. (Florence: Salimbeni, 1983) I: 196–201; Antonio Favaro, "Un ridotto scientifico in Venezia al tempo di Galileo Galilei," in *Nuovo Archivio Veneto* 5 (1893) 196–209; and Gaetano Cozzi, "Galileo, Sarpi e la società veneziana," in *Paolo Sarpi tra Venezia e l'Europa* (Turin: Giulio Einaudi Editore, 1979) 137–138. On Sagredo's stay in Palma and then in Syria, see Favaro, *Amici*, I: 205, 268–315.

62. On Salviati, see Niccolò Arrighetti, *Orazione delle lodi di Filippo Salviati*, in *Raccolta di prose fiorentine*, 6 vols. (Venice: Domenico Occhi, 1730–1735) III: i, 115–133; and Mario Biagioli, "Filippo Salviati: A Baroque Virtuoso," *Nuncius* 7 (1992) 81–96.

63. See Drake, *Galileo: Pioneer Scientist*, 185–187.

64. Francesco Griselini, *Memorie anedote spettanti alla vita ed agli studi del . . . F. Paolo Servita* (Lausanne: M. Michel Bousquet et Compagnie, 1760) 164.

65. *Le Opere di fra Paolo Sarpi*, VI: 81.

66. Leon Battista Alberti, *On Painting*, 49.

67. Fulgenzio Micanzio, *Vita del padre Paolo*, in Paolo Sarpi, *Istoria del Concilio Tridentino seguita dalla Vita del padre Paolo di Fulgenzio Micanzio*, II: 1373; and Francesco Griselini, *Memorie anedote spettanti alla vita ed agli studi del . . . F. Paolo Servita*, 2.

68. See the letter of the Capuchin Fedele San Germano to Cardinal Lanfranco in Pietro Savio, "Per l'epistolario di Paolo Sarpi," *Aevum* X (1936) 55 n. 2.

69. *Lettere di Fra Paolo Sarpi*, edited and annotated by F. L. Polidori, 2 vols. (Florence: Giunti Barbera, 1863) II: 23.

70. *Le Opere di fra Paolo Sarpi*, VI: 74.

71. Sarpi visited with some frequency a gathering place of German Lutherans residing in Venice, the Fondaco dei Tedeschi, the exterior of which was at that time decorated with frescoes of Giorgione and Titian. On these paintings, see George M. Richter, *Giorgio da Castelfranco called 'Giorgione'* (Chicago: University of Chicago Press, 1937) 242–244; and Francesco Valcanover, "Gli affreschi di Tiziano al Fondaco dei Tedeschi," *Arte Veneta* XXI (1967) 266–268.

72. See Plutarch, *Concerning the Face Which Appears in the Orb of the Moon*, in *Moralia*, translated and annotated by Harold Cherniss and William C. Helmbold, 15 vols. (Cambridge, Mass.: Harvard University Press, 1957) XII: 38–43; and Pompilius Azalus [Giovanni da Fontana], *De omnibus rebus naturalibus quae continetur in mundo videlicet coelestibus et terrestribus* . . . (Venice: Ottavio Scoto, 1544) 74r–75r. On the latter work and its artistic importance, see Giordana Mariani Canova, "Riflessioni su Jacopo Bellini e sul libro dei disegni del Louvre," *Arte Veneta* 26 (1972) 9–30, especially 21–24. I will treat the relationship of the rare and dense moon to painting in the following two chapters.

73. See Fulgenzio Micanzio, *Vita del padre Paolo*, 1304, 1372–1373; and Francesco Griselini, *Memorie anedote spettanti alla vita ed agli studi del . . . F. Paolo Sarpi*, 3–4, 18–29, 163–174. On the question of Sarpi's scientific competence as judged by his biographers and the material extant in the *Pensieri*, see Liberio Sosio, "I 'Pensieri' di Paolo Sarpi sul moto," *Studi veneziani* XIII (1974) 315–392, and Luisa Cozzi, "La tradizione settecentesca dei 'Pensieri' sarpiani," *Studi veneziani* 13 (1974) 393–450.

74. Galileo Galilei, *Dialogue*, 72. The comparison of the moon's surface with a rough wall, though not the painterly aspect of the experiment, was familiar to the Scholastics. See Galileo Galilei, *Le messager céleste*, translated, annotated, and introduced by Isabelle Pantin (Paris: Les Belles Lettres, 1992) lvi–lvii n. 27.

75. Galileo Galilei, *Dialogue*, 79.

76. See the instances listed in Jonas Gavel, *Colour: A Study of Its Position in the Art Theory of the Quattro- & Cinquecento* (Stockholm: Almquist and Wiksell International, 1979), 103–104.

77. Galileo Galilei, *Le Opere*, X: 352.

78. Galileo Galilei, *Dialogue*, 81–82.

79. Leonardo, *Trattato*, 149, 200, 203, 209.

80. Galileo Galilei, *Dialogue*, 90.

81. Leonardo, *Trattato*, 151.

82. Galileo Galilei, *Dialogue*, 93.

83. Leonardo, *Trattato*, 72.

84. Leonardo, *Trattato*, 77–78, 198, 243–268.

85. Galileo Galilei, *Dialogue*, 99.

86. Galileo Galilei, annotations to Lothario Sarsi [Orazio Grassi], *Ratio Ponderum Librae et Simbellae*, in *Opere*, VI: 432. In his marginal annotations of Grassi's *Libra astronomica ac philosophica* of 1619, Galileo had relied on a related

issue: he compared his rival's ability to change the terms of an argument to the technique of a painter who, in depicting the sky at dawn, represented in a narrow band of the horizon the range from the palest white to the deepest blue, passing surely but imperceptibly from one shade to the next. See Galileo Galilei, *Le Opere*, VI: 128.

87. See E. H. Gombrich, "Leonardo on the Science of Painting: Towards a Commentary on the 'Trattato della Pittura,'" in *New Light on Old Masters* (Chicago: University of Chicago Press, 1986) 32–60, 36–41.

88. On this precept, see E. H. Gombrich, "Light, Form and Texture in Fifteenth-Century Painting," in *The Heritage of Apelles: Studies in the Art of the Renaissance* (Ithaca, N.Y.: Cornell University Press, 1976) 19–35.

89. Vincenzio Viviani, *Racconto Istorico*, in Galileo Galilei, *Le Opere*, XIX: 602.

90. See Baldinucci's passing references to the help Galileo gave to painters and sculptors in his *Notizie* of Baccio del Bianco, Sigismondo Coccapani, and Pietro Tacca.

91. The Belt Manuscript of the *Trattato della pittura* was illustrated by Pagani in 1582; see Richter-Pedretti, *The Literary Works of Leonardo da Vinci*, I: 15–16.

92. On the different versions of the *Trattato della Pittura* that would have been available to Galileo in Florence and Padua, see Richter-Pedretti, *The Literary Works of Leonardo da Vinci*, I: 12–36. For Pinelli's efforts to obtain the *Trattato*, see 29–31. For the otherwise unknown *De coloribus*, not identical with the pseudo-Aristotelian work of the same name, and Pinelli's annotations, see the letter from Giuliano de' Medici to Paolo Gualdo in *Lettere d'uomini illustri* (Venice: Baglioni, 1744) 424–425.

93. Galileo Galilei, *Sidereus Nuncius*, 53–54.

94. On Accolti's supposed debt to Leonardo, see Richter-Pedretti, *The Literary Works of Leonardo da Vinci*, I: 35, and to Cigoli, see Luigi Vagnetti, "Prospettiva," in *Studi e Documenti di Architettura* 9–10 (March 1979) 384. For another treatment of the relationship of Leonardo, Accolti, and Pietro Testa, see Elizabeth Cropper, *The Ideal of Painting: Pietro Testa's Düsseldorf Notebook* (Princeton: Princeton University Press, 1984) 130–137.

95. Galileo Galilei, *Le Opere*, XI: 133. Giovanni de' Medici was present for at least some of the discussions between Galileo and Colombe about floating and sinking bodies, and there is some evidence that he was more on the side of Colombe (who dedicated his treatise to him) than of Galileo. See Drake, *Galileo at Work*, 132–133, 169–174.

96. Pietro Accolti, *Lo Inganno de gl'occhi* (Florence: Pietro Cecconcelli, 1625), reprinted in Theodore Bestman, ed., *The Printed Sources of Western Art* (Portland, Ore.: United Academic Press, 1972) 104.

97. Two passages are particularly striking: Accolti considered the best painters of his day to be Domenico Passignano, Lodovico Cigoli, Cristofano Allori, Jacopo da Empoli, and Giovanni Bilivert; all but the last were specifically named by Viviani as close friends of Galileo. Elsewhere, Accolti described anamorphosis as a kind of "enciphered" drawing; Galileo compared allegory, also a sort of code in that it involves "speaking of something else," to anamorphosis, meaning that

it was only coherent from one viewpoint. Both definitions seem to me the type that would flourish in an Academy. See Accolti, *Lo Inganno de gl'occhi*, 21, 49.

98. Pietro Accolti, *Delle lodi di Cosimo II Granduca di Toscana*, in *Raccolta di prose fiorentine*, 6 vols. (Venice: Domenico Occhi, 1730–1735) VI: ii: 60.

99. Lodovico Cigoli, *Prospettiva pratica*, ed. and trans. Filippo Camerota, Miles Chappell, and Martin Kemp, forthcoming.

100. See Martin Kemp, "Lodovico Cigoli on the Origins and *Ragione* of Painting," *Mitteilungen des Kunsthistorischen Institutes in Florenz* 35:1 (1991) 133–152, 133.

101. Baldinucci, *Vita di Lodovico Cardi-Cigoli*, in Matteoli, *Lodovico Cardi-Cigoli*, 87.

102. Galileo Galilei, *Le Opere*, XI: 176.

103. Galileo Galilei, *Le Opere*, V: 140, 191. In the latter reference, Galileo had originally mentioned Domenico Cresti (il Passignano) as well, but had subsequently removed this painter's name from the text, probably after their disagreement over the movement of the sunspots.

104. Galileo Galilei, *Le Opere*, X: 239–240.

105. Anna Matteoli, "Macchie di Sole e Pittura, Carteggio, L. Cigoli–G. Galilei (1609–1613)," *Bollettino della Accademia degli Euteleti della Città di San Miniato* 32 (1959) 14, cited in Chappell, "Cigoli, Galileo, and *Invidia*," 97 n. 28.

106. Kemp, "Lodovico Cigoli on the Origins and *Ragione* of Painting," 133–134; an introduction, transcription, and translation of the three proemia follow on pp. 134–148.

107. Lodovico Cigoli, *Prospettiva pratica*, 11v.

108. Thus on folio 15v, Cigoli wrote "veggiamo che il globo lunare è di figura sferica e rotondo." I will discuss the importance of this passage below.

109. See David C. Lindberg, *Theories of Vision from Al-Kindi to Kepler* (Chicago: University of Chicago Press, 1976) 175–177, 194–202.

110. Kemp, "Lodovico Cigoli on the Origins and *Ragione* of Painting," 139.

111. Raffaelo Gualterotti also compared the crystalline matter of the eye to the substance of the heavens, and the fact that this rather derivative thinker did so in 1605 suggests that he was influenced, at least to some extent, by Colombe's theory of the lenslike crystalline sphere. See *Scherzi degli spiriti animali* (Florence: Cosimo Giunti, 1605) 22.

112. See, for example, Galileo Galilei, *Opere*, XI: 176, 229, 502.

113. On the *Colombi* or "Pigeon Patrol," see Giorgio de Santillana, *The Crime of Galileo* (New York: Time, 1962) 38; Drake, *Galileo at Work*, 117–120, 214–219; William Shea, *Galileo's Intellectual Revolution* (New York: Science History Publications, 1977) 19–44, 113–116; Richard J. Blackwell, *Galileo, Bellarmine, and the Bible* (Notre Dame, Ind.: University of Notre Dame Press, 1991) 59–75.

114. Lodovico Cigoli, *Prospettiva pratica*, 15v.

115. Lodovico Ariosto, *Orlando Furioso*, XXXV: 18: i, translated and with an introduction by Barbara Reynolds (London: Penguin, 1977) 340. On Galileo's love for Ariosto, see Viviani's *Racconto istorico* in *Le Opere*, XIX: 627.

116. [Galileo Galilei], *Considerations of Alimberto Mauri*, 83.

117. Cited in Matteoli, *Lodovico Cardi-Cigoli*, 150.

118. On the relationship of Cigoli to Rubens, see Walter Friedlaender, "Early to Full Baroque: Cigoli and Rubens," in *Studien zur toskanischen Kunst: Festschrift für Ludwig Heinrich Heydenreich*, ed. Wolfgang Lotz and Lise Lotte Moller (Munich: Prestel-Verlag, 1964) 65–82, and Chappell, *Disegni dei Toscani a Roma (1580–1620)*, 111–113, and on the *Deposition*, in particular, 76–80; Michael Jaffe, *Rubens and Italy* (Oxford: Oxford University Press, 1977) 51–52; Mina Gregori, "Rubens e i pittori riformati toscani," in *Rubens e Firenze* (Florence: La Nuova Italia, 1983) 45–47.

119. See the drawings and discussion in Miles Chappell, ed., *Disegni di Lodovico Cigoli* (Florence: Leo S. Olschki, 1992) 148–150 and plate 7; the color reproduction of the painting and the entry in Marco Chiarini, Serena Padovani, and Angelo Tartuferi, eds., *Lodovico Cigoli tra Manierismo e Barocco* (Fiesole: Amalthea, 1992), plate 23 and pp. 107–108; and Chappell's entry in Mina Gregori, ed., *Il Seicento fiorentino: Pittura, disegni, biografie*, 3 vols. (Florence: Cantini, 1986) II: 126.

120. Thus Chappell in *Disegni di Lodovico Cigoli*, 149: "La nuova grandiosità della concezione e la drammacità della luce suggeriscono che l'opera fu concepita o definita dopo che il Cigoli era venuto a contatto di nuove correnti artistiche a Roma, e probabilmente durante i suoi soggiorni fiorentini, o nel 1605 o anche dopo l'agosto del 1607." See also Angelo Tartuferi's entry in *Lodovico Cigoli tra manierismo e barocco*, 107: "La grandiosità della composizione, la sua classicità romana, l'acuta comprensione del patetismo carraccesco e l'innegabile riflesso luministico-cromatico del Caravaggio presuppongono per l'opera una messa a punto definitiva in ogni caso posteriore all'esperienza romana."

121. On the iconography of the *Deposition*, see Louis Réau, *Iconographie de l'art chrétien*, 3 vols. (Paris: Presses Universitaires de France, 1957) II: 513–518; Gertrud Schiller, *Iconography of Christian Art*, trans. Janet Seligman, 2 vols. (Greenwich, Conn.: New York Graphic Society, 1971) II: 164–168.

122. On this *Deposition*, see Antonio Natali, "La 'Deposizione' giovanile del Cigoli," in *Paragone* 38, n.s. no. 4: 449 (July 1987) 75–80, and his entry in *Lodovico Cigoli tra manierismo e barocco*, 81–82, and color plate 1 in the same work.

123. Private communication of June 1994.

124. See Matthew 27: 45; Mark 15: 33; Luke 23: 44.

125. For an English translation of the *Letter to Polycarp*, see Pseudo-Dionysius, the Aeropagite, *The Complete Works*, trans. Colm Lubheid; foreword, notes, and translation collaboration by Paul Rorem; preface by René Roques (New York: Paulist Press, 1987) 267–269.

126. Thus in his commentary on Matthew XXVII: 45, Cornelius a Lapide, S.J., found seven miraculous aspects of the eclipse to celebrate, rather than seven reasons to doubt that it had taken place. See Cornelius a Lapide, S.J., *Commentaria in Sacram Scripturam*, 26 vols. (Paris: Ludovicus Vives, 1866–1868) 15: 626–628.

127. For typical early modern exegetical readings of the three hours of darkness, see Dionysius Carthusani, *In Quattuor Evangelistas, Ennarationes* (Lyon: Bartholomeus Honoratus, 1579) 163–164; Gerónimo Nadal, S.J., *Adnotationes*

et meditationes in Evangelia (Antwerp: Martin Nutius, 1595²) 351, 355, 369; Juan de Maldonado, S.J., *Commentaria in quattuor Evangelistas* (Venice: Apud Ioan. Baptistam, & Ioannem Bernardum Sessam, 1597) cols. 720–723; Adam Contzen, S.J., *Commentaria in Quattuor Sancta Iesu Christi Evangelia* (Colonia Agrippina: Ioannis Kinckius, 1626) 568–570.

128. Galileo Galilei, *Sidereus Nuncius*, 49–50.

129. Galileo Galilei, *Sidereus Nuncius*, 50–51.

130. I thank Martin Kemp for pointing out to me that the turbaned man looks more directly at the moon than he does at the dead Christ.

131. On the centurion in Renaissance art, see the helpful discussion of John R. Hale, *Artists and Warfare in the Renaissance* (New Haven: Yale University Press, 1990) 226–247.

132. On Nicodemus and his attributes in religious painting, see Wolfgang Stechow, "Joseph of Arimathea or Nicodemus?" in *Studien zur toskanischen Kunst*, ed. Lotz and Moller, 289–302.

133. Private communication of June 1994. The man with the turban and his bearded interlocutor also appear on the left-hand side in Cigoli's *Deposition* of 1578.

134. For the document itself, given in two Latin recensions, the first of which was made in 416 from the Greek original by a Portuguese priest named Avitus, see *Sancti Augustini Opera Omnia*, in Jacques Paul Migne, ed., *Patrologiae cursus completus Series Latina*, 221 vols. (Paris: Migne, 1844–1864) vol. 41, cols 807–818. For a discussion of its history and subsequent influence, see Henri Leclerq, "Etienne (Martyre et Sépulture de Saint)," in Fernand Cabrol and Henri Leclerq, eds., *Dictionnaire d'Archéologie et de Liturgie*, 15 vols. (Paris: Librarie Letouzey et Ané, 1907) V (1), cols. 624–671; and Charles Mommert, *Saint Etienne et ses sanctuaires à Jérusalem* (Jerusalem: S.n., 1912).

135. For Augustine's various references to the finding of Stephen's body and the miracles associated with it, see his 120th *Tractate on the Gospel of John*, his "Epistolae" 166.1.2, 169.4.13, 172.1, 175.1 and 202A.1, in Migne, *Patrologia Latina*, vol. 33, cols. 720–721, 747–748, 752, 759, and 928; his "Sermones" 317.1, 318.1, 319.6, and 323.2, in Migne, *Patrologia Latina*, vol. 38, cols. 1435, 1437–1438, 1441–1442, 1446, and Book 22 of *The City of God*. For Jerome, see "Epistola" 131.1, in Migne, *Patrologia Latina*, vol. 22, col. 461, and on Orosius's relay of both the news of the discovery and some relics, see Avitus, "Epistola ad Pachomium," in Migne, *Patrologia Latina*, vol. 41, cols. 805–808; and Gennadius Massiliensis, "De scriptoribus ecclesiasticis," in Migne, *Patrologia Latina*, vol. 58, cols. 1080–1081. I owe the above information to the notes provided in John Rettig's translation of Augustine's *Tractates on the Gospel of John*, 5 vols. (Washington, D.C.: Catholic University of America Press, 1995) 5: 52–53, n. 14. For an instance of the seventeenth-century acceptance of Lucian's story, see Cornelius a Lapide, S.J., *Commentaria in Ioannem* III: 1, and XIX: 39, in *Commentaria in Sacram Scripturam*, vol. 16, cols. 337–338, 622.

136. "De revelatione corporis," in Migne, *Patrologia Latina*, vol. 41, cols. 809–810. The material in the brackets is found only in Latin Recension B.

137. In Cigoli's earlier *Deposition*, in fact, the Nicodemus figure is not even the person engaged in removing the nails from Christ's feet.

138. For the *Gospel of Nicodemus*, also known as the *Acta Pilati* and the primary document for the medieval tradition of the Harrowing of Hell, see W. H. Hulme, *The Middle English Harrowing of Hell and the Gospel of Nicodemus* (London: Early English Text Society, 1907). For the text and discussion of an Italian version preserved in Florence, see Cesare Guasti, ed., *Il passio o vangelo di Nicodemo* (Bologna: Romagnoli, 1862). For medieval French versions, see *Trois versions rimées de l'Evangile de Nicodème* (Paris: Firmin Didot et Cie, 1885).

139. John 3:12.

140. For recent discussions of the nocturnal motif, see Jean-Marie Auwers, "La nuit de Nicodème (Jean 3, 2; 19, 39) ou l'ombre du langage," *Revue biblique* 97: 4 (1990) 481–503; and Jouette M. Bassler, "Mixed Signals: Nicodemus in the Fourth Gospel," *Journal of Biblical Literature* 108:4 (1989) 635–646, especially 638.

141. John 3:19–21.

142. John 7:50–52.

143. See Bassler, "Mixed Signals," 639–641.

144. John 19:38.

145. Bassler, "Mixed Signals," 640–643.

146. Stechow, "Joseph of Arimathea or Nicodemus?" 300; and Corine Schlief, "Nicodemus and Sculptors: Self-Reflexivity in Works by Adam Kraft and Tilman Riemenschneider," *Art Bulletin* 75:4 (1993) 599–626.

147. On Nicodemism and its relevance to sixteenth-century Italy, see the various opinions of Delio Cantimori, *Eretici italiani del Cinquecento* (Florence: Sansoni, 1939), and "Submission and Conformity: 'Nicodemism' and the Expectations of a Conciliar Solution to the Religious Question," in Eric Cochrane, ed., *The Late Italian Renaissance* (New York: Harper and Row, 1970) 244–265; Carlo Ginzburg, *Il Nicodemismo* (Turin: Giulio Einaudi Editore, 1970); Antonio Rotondò, "Atteggiamenti della vita morale italiana del Cinquecento: La pratica nicodemitica," *Rivista storica italiana* 79 (1967) 991–1030; Carlos M. N. Eire, "Calvin and Nicodemism: A Reappraisal," *Sixteenth-Century Journal* 10:1 (1979) 45–69, and *War against the Idols: The Reformation of Worship from Erasmus to Calvin* (Cambridge, U.K.: Cambridge University Press, 1986) 234–275; and John Martin, *Venice's Hidden Enemies: Italian Heretics in a Renaissance City* (Berkeley: University of California Press, 1993) 125–146.

148. See Jane Kristof, "Michelangelo as Nicodemus: *The Florence Pietà*," *Sixteenth-Century Journal* 20: 2 (1989) 163–182; and Valerie Shrimplin-Evangelidis, "Michelangelo and Nicodemism: The Florentine *Pietà*," *Art Bulletin* 71:1 (1989) 58–66.

149. *Il seicento fiorentino*, II: 126, and private communication of June 1994. Cigoli's reverence for Michelangelo seems particularly strong in those years. He defended Michelangelo's designs for Saint Peter's in 1606–1607, and the composition of his *Sacrifice of Isaac*, ca. 1607, is said to derive from Michelangelo as well. On these and other aspects of Michelangelo's influence, see A. Gambuti, "Lodovico Cigoli architetto," *Studi e documenti di architettura* 2 (1973) 37–136, especially 42–43 for eighteenth- and nineteenth-century impressions of Cigoli as a follower of Michelangelo, and 96–110 for Cigoli's efforts at Saint Peter's; Anna Matteoli, "Cinque lettere di Lodovico Cardi Cigoli a Michelangelo

Buonarroti il Giovane," *Bollettino della Accademia degli Euteleti della Città di San Miniato* 28 (1964–1965) 31–42; Adriaan Vliegenthart, *La galleria Buonarroti: Michelangelo e Michelangelo il Giovane* (Florence: Istituto Universitario Olandese di Storia dell'Arte, 1976) 158–162 and plate 22, for discussion of Cigoli's presence in Niccodemo Ferrucci's *Le Opere di Michelangelo studiate dai pittori, scultori e architetti* of 1615–1616; Miles L. Chappell, ed., *Disegni dei Toscani a Roma (1580–1620)* (Florence: L. S. Olschki, 1979), 111; *Disegni di Lodovico Cigoli*, 118, 136–138, 142; and *Il seicento fiorentino*, I: 111, and II: 117.

150. John 3:2.

151. On this point, see Jouette M. Bassler, "The Galileans: A Neglected Factor in Johannine Community Research," *Catholic Biblical Quarterly* 43 (1981) 243–257.

152. As Stillman Drake observes in *Discoveries and Opinions of Galileo*, 154, such a pun would have been "the only really clever thing Caccini was ever reported to have done." The appearance of the Medici edition of Giovanni Pierluigi da Palestrina's *Missa Viri Galilaei* in 1614 might have suggested the witticism to the ponderous preacher.

153. See *Lettere d'uomini illustri*, 116, and the *Dissertatio*, in Galileo Galilei, *Le Opere*, III: (I) 107, and III: (I) 189.

154. In "Nicodemus and Sculptors," 611–612, Corine Schleif notes that the instances of such identification recently proposed by art historians include the examples of Hugo van der Goes, Rogier van der Weyden, Girolamo Savoldo, Tintoretto, and Titian.

155. Giovanni Battista Cardi, *Vita di Lodovico Cardi-Cigoli*, in Matteoli, *Lodovico Cardi-Cigoli*, 26–27.

Chapter Four
1610–1612: In the Shadow of the Moon

1. I have consulted the following early modern commentaries on *Revelation*: Luis Alcázar, S.J., *Vestigatio arcani sensus in Apocalypsi* (Lyon: Pillebotte, 1618); Cornelius a Lapide, S.J., *Commentarius in Apocalypsin* in *Commentarii in Sacram Scripturam*, 26 vols. (Paris: Ludovicus Vives, 1866–1868) vol. 21; Juan Mariana, S.J., *Scholia in vet. et novum Testamentum* (Paris: Ad Agnum Novis, 1620); Francisco de Ribera, *In Sacram beati Joannis apostoli et evangelistae Apocalypsim commentarii* (Lyon: Ex Officina Iuntarum, 1593); João da Sylveira, *Commentarii in Apocalypsim* (Lyon: Anisson et Posuel, 1687–1701); Jacques Tirinus, S.J., *Commentaria*, 3 vols., (Antwerp: Apud Martinum Nutium, 1632); Blasius Viegas, *Commentarii exegetici in Apocalypsin* (Venice: Apud Societatem Venetam, 1608); *Biblia Magna Latina Commentarior. Litteralium*, 5 vols. (Paris: Michel Soly, Matthieu Guillemot, Denis Bechet, et Antoine Bertier, 1643) vol. 5.

2. Gregory the Great, *Moralia* XXXIV: xii in Jacques-Paul Migne, *Patrologiae cursus completus series latina*, 221 vols. (Paris: Migne, 1844–1864) LXXVI: col. 731.

3. João da Sylveira, O. Carm., *Commentarii in Apocalypsim* (Lugduni, France: Anisson et Posuel, 1694) II, 23.

4. Cornelius a Lapide, S.J., *Commentaria in Apocalypsin*, in *Commentarii in Sacram Scripturam*, 21: 237.

5. João da Sylveira, *Commentarii in Apocalypsim* II, 11.

6. João da Sylveira, *Commentarii in Apocalypsim* II, 23.

7. For my summary of the development of the doctrine of the Immaculate Conception, I am indebted to Gabriele Roschini, Giuseppe Low, and Emilio Lavagnino, "Immacolata Concezione" in Giuseppe *Cardinal* Pizzardo et al., eds., *Enciclopedia Cattolica*, 12 vols. (Vatican City: Ente per l'Enciclopedia Cattolica e per il libro Cattolico, 1948–1954) VI: cols. 1651–1663; Melchiore a Pobladura O.F.M. Cap., ed., *Regina Immaculata* (Rome: Institutum Historicum O.F.M. Cap., 1955); Edward Dennis O'Connor, C.S.C., ed., *The Dogma of the Immaculate Conception* (Notre Dame, Indiana: University of Notre Dame Press, 1958). In "The Immaculate Conception in Spanish Renaissance and Baroque Art" (Ph.D. diss. New York University, 1983), Suzanne Stratton provides an especially valuable survey of the question and its relationship to Spanish art.

8. Thus the second stanza of the Marian hymn *Ave maris stella* proclaims, "Sumens illud 'Ave'/ Gabrielis ore,/ Funda nos pace / Mutans Evae nomen."

9. For the measures suppressed by Pope Innocent XI, see *Decrees of Our Holy Father Pope Innocent XI, Containing the Suppression of an Office of the Immaculate Conception of the Most Holy* VIRGIN; *and of a Multitude of* INDULGENCES (Oxford: Printed by Leonard Lichfield, 1678).

10. Stratton, *The Immaculate Conception*, 108–136.

11. Stratton, *The Immaculate Conception*, 136.

12. In his mid-sixteenth century discussion of meteors, William Fulke noted in fact that when they saw beams of light streaming through a cloud, "the common people cal it the descending of the Holy Ghost, or our Ladies *Assumption*, because these things are painted after suche a sort." See *A Goodly Gallerye: William Fulke's Book of Meteors (1563)*, edited and with an introduction and notes by Theodore Hornberger (Philadelphia: American Philosophical Society, 1979) 78–79.

13. Rupert of Deutz, cited in Cornelius a Lapide, *Commentaria in Canticum Canticorum* VI 636. On Rupert of Deutz's commentary and its influence, see John H. Van Engen, *Rupert of Deutz* (Berkeley: University of California Press, 1983) 291–298.

14. Luigi Novarini, C.R., *Umbra Virginea* (Verona: Typis Rubeanis, 1653⁵) 30.

15. Luigi Novarini, *Umbra Virginea*, 37. In the tenth book of his *De Laudibus Beatae Mariae Virginis*, Albertus Magnus offered two rhymes—the second of which he attributed to Saint Augustine—to explain the miracle: "Si crystallus sit humecta, / Atque soli sit subjecta, / Scintilla igniculum: / Nec crystallus rumpitur, / Nec in partu solvitur / Pudoris signaculum." "Ut solis radius / Intrat innoxius / Fenestram vitream: / Sic Dei Filius / Imo subtilius / Aulam virgineam." The glass metaphor was extremely popular from the eleventh through the seventeenth centuries, though its sometime attribution to Athanasius and Augustine was spurious. For a valuable source of such comparisons in medieval Latin and German literature, see Anselm Salzer, *Die Sinnbilder und Beiworte Mariens*

in der deutschen Literatur und die lateinischen Hymnpoesie des Mittelalters (Darmstadt: Wissenschaftliche Buchgesellschaft, 1967) 71–76.

16. Pseudo-Athanasius, *Questiones aliae*, cited in Millard Meiss, "Light as Form and Symbol in Some Fifteenth-Century Paintings," *Art Bulletin* 27 (1945) 177.

17. On the pictorial convention of the light in Annunciations, see Millard Meiss, "Light as Form and Symbol in Some Fifteenth-Century Paintings," *Art Bulletin* 27 (1945) 175–181; Samuel Y. Edgerton, Jr., "*Mensurare temporalia facit Geometria spiritualis*: Some Fifteenth-Century Italian Notions about When and Where the Annunciation Happened," in *Studies in Late Medieval and Renaissance Painting in Honor of Millard Meiss*, ed. Irving Lavin and Georges Plummer (New York: New York University Press, 1977) 115–130; Georges Didi-Huberman, "L'hymen et la couleur, Figures médiévales de la Vierge," *La Part de l'Oeil* 4 (1988) 7–21.

18. On the Virgin as *Fenestra Caeli* in art, see Carla Gottlieb, *The Window in Art* (New York: Abaris Books, 1981) 67–71; Hana Hlavackova and Hana Seifertova, "La Madone de Most: Imitation et symbole," *Revue de l'Art* 67 (1985) 59–65.

19. Francesco Petrarch, "Vergine bella, che di sol vestita," v. 31, in Piero Cudini, ed., *Canzoniere* (Milan: Grandi Libri Garzanti, 1974) 473.

20. The gynecological interpretation of the Eastern Gate of 44 Ezekiel dates to the fourth century, when it was used by Saint Ephraim in one of his hymns to the Virgin and in scriptural commentary; the *porta clausa* was also mentioned by Saint Jerome as an argument for Mary's virginity postpartum. See Francesco Spedalieri, S.J., *Maria nella Scrittura e nella tradizione della Chiesa primitiva* (Rome: Herder Editrice, 1968) 349–351, 384–385. The Eastern Gate was also discussed by Saint Augustine in his *Eighteenth Sermon on Temperance*, and by Saint Hildephonsus in his *Seventh Sermon on the Assumption of the Blessed Virgin Mary*, where the closed portal is taken as an allusion to Mary's perpetual virginity. By the medieval period it was a familiar and elaborate concept; see, for instance, Albertus Magnus, "De Laudibus Beatae Mariae Virginis," XII: 8–13. For examples of the conflation of the *porta clausa* with the *porta coeli*, also known as the *porta crystallina*, the *porta perpetuae lucis*, the *porta soli deo pervia*, see Salzer, *Die Sinnenbilder und Beiworte Mariens*, 28.

21. Tómas de Villanueva, *Sermones de la Virgen y Obras Castellanas*, introduced, translated, and annotated by Francisco Santos Santamaria, O.S.A. (Madrid: Biblioteca de Autores Cristianos, 1952) 266.

22. Ambrose, *Exhortatio Virginitatis* 34, in Angelo Paredi et al., eds., *Opera Omnia*, 27 vols. (Milan: Biblioteca Ambrosiana, 1977–1989) 14 (2): 226–227.

23. *Exhortatio Virginitatis* 31; in *Opera Omnia*, 14 (2): 222–223.

24. *De Institutione Virginis* 81, in *Opera Omnia*, 14 (2) 168–169.

25. See, for example, Richard of Saint Lawrence, *de Laudibus Virginis* II: 1, elaborated in Luigi Novarini, *Umbra Virginea*, 221: "Virgo enim ut nebula umbram super nos facit, & ab irae divinae ardore, velut a solis radiis, suos suis precibus subducit: expandat super nos Maria suarum orationum, ut ita dicam, velamen, & umbraculum a meridiano divinae aestu erit."

26. Giambattista Marino, *Adone* X, 37; Giuseppe Guido Ferrero, ed. (Turin: Giulio Einaudi Editore, 1976) 180.

27. Tomas de Villanueva, *Sermones*, 241.

28. Johannes Samotheus Lucidus, *Opusculum de emendationibus temporum* (Venice: Luc. Ant. Giunta, 1546) 190 verso.

29. Giovanni Battista Marino, "La Pittura, Diceria Prima," in *Dicerie Sacre* e *La Strage de gl'innocenti*, ed. Giovanni Pozzi (Turin: Giulio Einaudi, 1960) 105.

30. Gerónimo Nadal, S.J., *Adnotationes et meditationes in Evangelia* (Antwerp: Martin Nutius, 1595²) 617–618.

31. Galileo Galilei, *Sidereus Nuncius*, translated and with an introduction, conclusion, and notes by Albert Van Helden (Chicago: University of Chicago Press, 1989) 43.

32. On Galileo's obligation to the Venetian state and the courtly ethos that he violated in turning to Medici patronage, see Mario Biagioli, *Galileo, Courtier* (Chicago: University of Chicago Press, 1993) 11–54.

33. Hugh Tait, *The Golden Age of Venetian Glass* (London: British Museum Publications, 1979) 94. For photographs of ice glass, see 97–98.

34. Hugh Tait, *The Golden Age*, 94; and Alice Wilson Frothingham, *Hispanic Glass: With Examples in the Collection of the Hispanic Society of America* (New York: Trustees of the Hispanic Society of America, 1941) 50–51.

35. Johannes Kepler used it to describe the moon's surface in his *Somnium*, written in the summer of 1609, though not published until 1634.

36. See, for example, Lucretius, *De Rerum Natura*, VI: 701; and Pliny, *Historia Naturalis*, III: 8, 14 (88).

37. Galileo Galilei, *The Assayer*, in *The Controversy on the Comets*, introduced, translated, and annotated by Stillman Drake and C.D. O'Malley (Philadelphia: University of Pennsylvania Press, 1960) 185.

38. For another recent synopsis and analysis of those events, see also James Lattis, *Between Copernicus and Galileo: Christoph Clavius and the Collapse of Ptolemaic Cosmology* (Chicago: University of Chicago Press, 1994) 180–195. On the relationship of Galileo and Bellarmine in general, see Richard J. Blackwell, *Galileo, Bellarmine, and the Bible* (Notre Dame, Ind.: University of Notre Dame Press, 1991).

39. On Father Maelcote's study of the new star of 1604, see Ugo Baldini, "La nova del 1604 e i matematici e filosofi del Collegio Romano: note su un testo inedito," *Annali dell'Istituto e Museo di Storia della Scienza* 6 (1981) 63–98.

40. For these letters, see Galileo Galilei, *Le Opere*, X: 474 and 484–485. On the history of the problem, see Albert Van Helden, "Saturn and His Anses," *Journal for the History of Astronomy* 5:2 (1974) 105–121, and Albert Van Helden, "*Annulo Cingitur*: The Solution of the Problem of Saturn," *Journal for the History of Astronomy* 5:3 (1974) 155–174.

41. For Bellarmine's request for "mathematical" verification of the *Sidereus Nuncius* and the response from the Collegio Romano see Galileo Galilei, *Le Opere*, XI 87–88, 92–93; and Lattis, *Between Copernicus and Galileo*, 190–197.

42. For a reference to Maelcote's address to the Collegio Romano in a letter written by Gregory de Saint Vincent, S.J., to a fellow Jesuit in Flanders,

see Galileo Galilei, *Le Opere*, XI 162–163. For the excerpt of the address prepared by Christoph Grienberger and sent to Galileo, see Galileo Galilei, *Le Opere*, XI: 274.

43. Odo van Maelcote, *Nuntius Sidereus Collegii Romani*, in Galileo Galilei, *Le Opere*, III: 1, 295.

44. Interestingly, by 1614 Jean Tarde, a French visitor to Rome, would note that Father Grienberger and his advanced students at the Collegio Romano "all said that they had seen the planets that are around Jupiter, the moonspots, the sunspots, Venus in her crescent shape, and the other phenomena of which Galileo had spoken [to Tarde] in Florence." As the entry in Tarde's account of his voyage makes clear, the Jesuit astronomers were then preoccupied with the question of the sunspots, currently under debate by Galileo and their colleague Father Christoph Scheiner. See Jean Tarde, *À la rencontre de Galilée: Deux voyages en Italie*, edited and annotated by François Moureau and Marcel Tetel (Geneva: Slatkine, 1984) 79–80.

45. See Niccolò Aggiunti, "Cretum mihi das nectar, christallaque Lyncei," in Nunzio Vaccaluzzo, *Galileo Galilei nella poesia del suo secolo* (Milan: Remo Sandron, 1910) 121–122, where, however, *cyathus*, also written as *ciathus*, is misprinted as *ciathris*.

46. See the letters of the General of the Order, Claudio Acquaviva, in Jesuits, *Epistolae selectae praepositorum generalium ad superiores societatis* (Rome: Vatican Press, 1911) 207–215.

47. James Brodrick, S.J., *The Life and Work of Blessed Robert Francis Cardinal Bellarmine, S.J.*, with an introduction by His Eminence Cardinal Ehrle, S.J., 2 vols. (New York: P. J. Kennedy and Sons, 1928) I: 380–382. The general of the order himself, Claudio Acquaviva, wrote in his *De ratio studiorum vitandisque novis opinionibus* of 1586 "not only can any of [Aquinas'] opinions, *except for that regarding the Conception of the Blessed Virgin*, be defended, but also they should not be abandoned [for other opinions] except after having been gravely considered and for valid reasons." See Camille de Rochemonteix, S.J., *Un collège de Jésuites aux 17e et 18e siècles*, 4 vols. (Le Mans: Leguicheux, 1889) IV: 11. On Jesuit devotion to the Virgin, though not necessarily to the doctrine of the Immaculate Conception itself, see Charles Flachaire, *La Dévotion à la Vierge dans la littérature catholique au commencement du 17e siècle*, with a preface by Jean Guitton (Paris: Apostolat de la Presse, 1957) 30–58.

48. For brief summaries of medieval discussions of the rare and dense moon, see Bruno Nardi, "La dottrina delle macchie lunari nel secondo canto del *Paradiso*," in *Saggi di filosofia dantesca* (Florence: La Nuova Italia, 1967²) 3–39; Roger Ariew, "Galileo's Lunar Observations in the Context of Medieval Lunar Theory," *Studies in the History and Philosophy of Science* 15:3 (1984) 213–226, especially 220–223. For an early seventeenth-century discussion of this traditional view, see *Commentarii Collegii Conimbricensis Societatis Iesu in Libros de Generatione* (Mainz: Ioannes Albini, 1615) 321–322; and *Commentarii Collegii Conimbricensis Societatis Iesu in quatuor libros de Coelo* (Cologne: Sons of Lazarus Zetzner, 1618⁵) cols. 323–328.

49. Plutarch, *De Facie quae in orbe lunae apparet*, translated into English by Harold Cherniss and William C. Helmbold, in *Plutarch's Moralia*, 15 vols. (Cam-

bridge, Mass.: Harvard University Press, 1957) XII: 42–43. For another instance of this comparison, see also XII: 38–39.

50. See pages 64–66 of chapter 2.

51. Giovanni da Fontana [Pompilius Azalus, pseud.], *De omnibus rebus naturalibus quae continentur in mundo videlicet coelestibus et terrestribus necnon mathematicis et de angelis motoribus quae coelorum* (Venice: Ottavio Scoto, 1544) 74 v. On Fontana, see also Marshall Clagett, "The Life and Works of Giovanni Fontana," *Annali dell'Istituto e Museo di Storia della Scienza* 1:1 (1976) 5–28, and Giordana Mariani Canova, "Riflessioni su Jacopo Bellini e sul libro dei disegni del Louvre," *Arte Veneta*, Annata 26 (1972) 9–30, especially 21–23.

52. Lodovico delle Colombe, *Contro il moto della terra*, in Galileo Galilei, *Le Opere*, III (1): 286–287.

53. Lodovico delle Colombe, *Contro il moto della terra*, III (1): 287.

54. Galileo describes such an object in the course of a discussion of the moon's substance and nature in his celebrated *Dialogue* of 1632, and he points out that mother-of-pearl looks more like the moon than does crystal, but that a stone with a rough surface like that of the moon would best imitate the appearance and phases of that body. See *Dialogue Concerning the Two Chief World Systems*, translated and annotated by Stillman Drake, 85–86. Galileo would have been infuriated to know that the anonymous author of the *News for the Curious* understood him to mean that the moon was "like the Mother of Pearl, shewing knobs and redness where there is none," but this error suggests that such spheres were frequently used in discussions of the lunar body. See *News for the Curious* (London: M. Pardo, G. Downes, and B. Aylmer, 1684) 11. Another later seventeenth-century text explicitly compares the moon's spotted appearance to the mottled surface of some precious stones: see the *Cosmografia de un Judío Romano del Siglo XVII*, translated from Hebrew to Spanish by Jose Maria Millas y Vallicrosa and David Romano (Barcelona: S.A. Horta de I. E., 1954) 74. At least three of Galileo's supporters suggested making and exhibiting *rough* spheres, presumably to show to skeptics as evidence of the way light acted on the lunar surface. See Galileo Galilei, *Le Opere*, XI: 602, and XII: 21; and Giuseppe Biancani, S.J., *Sphaera mundi* (Modena: Ex Typographia Iuliani Cassiani, 1635[2]) 73. Finally, it appears that rough lunar spheres, nestled in models of the Copernican world system, were made and exhibited in the 1630s: see references to Dutch and Roman models in Galileo Galilei, *Le Opere*, XVII: 32, 260, and in Nicolas Fabri de Peiresc, *Correspondance*, ed. Tamizey de Larroque, 7 vols. (Paris: Imprimerie Nationale, 1888–1898) VI: 434.

55. On the Scholastics' belief in the crystalline cover of the moon, see Galileo Galilei, *Le messager céleste*, edited, translated, and annotated by Isabelle Pantin (Paris: Les Belles Lettres, 1992) lvi–lvii.

56. Lodovico delle Colombe, *Contro il moto della terra*, III (1): 287.

57. Lodovico delle Colombe, *Contro il moto della terra*, III (1): 287.

58. Galileo Galilei, *Le Opere*, XI: 118.

59. Lodovico delle Colombe, *Contro il moto della terra*, III (1): 290.

60. On Brengger, see Drake, *Galileo at Work*, 163–164, 167–168. For his objection and Galileo's response, see Galileo Galilei, *Le Opere*, X: 460–462, 466–

473. For the "De Lunarium montium altitudine," see Galileo Galilei, *Le Opere*, III (1): 301–307.

61. See Galileo Galilei, *Le Opere*, X: 466–473. The argument for the lunar mountains in this letter, and to a lesser extent that of the letter from Galileo to Father Christoph Grienberger in September 1611 (*Le Opere* XI: 178–202, especially 184–186) seem to be adaptations of Leonardo da Vinci's studies of reflected light and shadow in his *Trattato della pittura*.

62. See a letter from Biancani to Grienberger, and a second one from Grienberger to Galileo in Galileo Galilei, *Le Opere*, XI: 126–127 and 130–131.

63. Galileo Galilei, *Le Opere*, XI: 13–14.

64. Galileo Galilei, *Le Opere*, XI: 38–41.

65. On Lagalla's role at La Sapienza, see the charitable observations of Filippo Maria Renazzi, *Storia dell'Università degli Studi di Roma, detta comunemente "La Sapienza"* (Rome: Stamperia Pagliarini, 1805) III: 34–35.

66. On the Collegio Romano, see Riccardo G. di Villoslada S.J., *Storia del Collegio Romano dal suo inizio (1551) alla soppressione della Compagnia di Gesù (1773)* (Rome: The Gregoriana, 1954). For a somewhat triumphal account of its competition with La Sapienza, see in particular 39–42. For a recent survey of the Jesuit scientific education, see Stephen J. Harris, "Transposing the Merton Thesis: Apostolic Spirituality and the Establishment of the Jesuit Scientific Tradition," *Science in Context* 3:1 (1989) 29–65. For discussions of the cultural importance and scientific authority of the Collegio Romano, often with regard to the influence of Christoph Clavius, S.J., see William Wallace, *Galileo and His Sources: The Heritage of the Collegio Romano in Galileo's Science* (Princeton, N.J.: Princeton University Press, 1984); Richard Blackwell, *Galileo, Bellarmine, and the Bible* (Notre Dame, Ind.: University of Notre Dame, 1991) 135–164; Ugo Baldini, *Legem impone subiactis: Studi su filosofia e scienza dei gesuiti in Italia 1540–1632* (Rome: Bulzoni Editore, 1992) 123–281; Mario Biagioli, *Galileo, Courtier: The Practice of Science in the Age of Absolutism* (Chicago: University of Chicago Press, 1993) 271–273, 276–277; Lattis, *Between Copernicus and Galileo*, 20–24 and *passim*; Feldhay, *Galileo and the Church: Political Inquisition or Critical Dialogue?* 113–115, 222–223.

67. This was in 1613. See William Shea, *Galileo's Intellectual Revolution*, 85–86, and Lagalla's own description of the incident in a letter to Galileo, in Galileo Galilei, *Le Opere*, XII: 499–501.

68. See Galileo Galilei, *Le Opere*, XI: 283.

69. Giulio Cesare Lagalla, *De Phaenomenis in orbe lunae*, in Galileo Galilei, *Le Opere*, III (1): 380, 386–387.

70. Lagalla, *De Phaenomenis*, III (1): 380.

71. Andrea Vittorelli, *Gloriose Memorie della Beatissima Vergine Madre di Dio* (Rome: Guglielmo Facciotto, 1616) 215.

72. Lagalla, *De Phaenomenis*, III (1): 380.

73. Galileo Galilei, *Le Opere*, III (1): 394.

74. See Shea, *Galileo's Intellectual Revolution*, 84, for an example of this kind of inconsistency in Galileo's cometary theory.

75. Lagalla, *De Phaenomenis*, 390.

76. See, for example, the list of lunar features in John Wilkins, *The Discovery of a World in the Moone* (London: Printed by E. G. for M. Sparke and E. Forrest, 1638), also in a facsimile edition introduced by Barbara Shapiro (Delmar, N.Y.: Scholars Facsimiles and Reprints, 1973) 80–81, and the even more elaborate list in Pierre Borel, *Discours nouveau prouvant la pluralité des mondes . . .* (Geneva: N.p., 1657) 41.

77. For the anagram itself, see Johannes Kepler, *Dioptrice*, in *Gesammelte Werke*, 3: 344. For a list of those to whom the anagram was sent, see Galileo Galilei, *Le Opere*, XIX: 611.

78. For a discussion of the peculiar frontispiece of Amico's work, see William B. Ashworth, Jr., "Light of Reason, Light of Nature: Catholic and Protestant Metaphors of Scientific Knowledge," *Science in Context* 3:1 (1989) 89–107, especially 90–92.

79. Bartolomaeo Amico, S.J., *In Aristotelis Libros de Caelo et Mu[n]do* (Naples: Secondinno Roncaliolo, 1626) 366. The story about the Roman was also related by Cesare Cremonini in his account of the semidiaphanous moon; see Cesare Cremonini, *Apologia dictorum Aristotelis de Facie in Orbe Lunae* (Venice: Tomaso Baglioni, 1613) 48.

80. Amico, *In Aristotelis Libros*, 366. Paolo Sarpi refers to the phenomenon (without indicating the gender of the auditor) in his *Pensieri*. See Paolo Sarpi, *Scritti filosofici e teologici*, ed. Romano Amerio (Bari: Giuseppe Laterza & Figli, 1951) p. 30 (*pensiero* 308), where, however, the word *stoici* is a misprint for *storici*.

81. The "Angelus Domini" was accompanied by a tolling bell in various parts of Western Europe from the beginning of the fourteenth century. Though in some dioceses the practice was limited to Fridays alone, by the middle of the fifteenth century the "Angelus Domini" was rung daily. See Pio Paschini, "Angelus Domini," in Giuseppe *Cardinal* Pizzardo et al., eds., *Enciclopedia Cattolica*, 12 vols. (Vatican City: Ente per l'Enciclopedia Cattolica e per il Libro Cattolico, 1948–1954) I, cols. 1260–1261. For an English Protestant's view of this custom, which he says took place "in all cities townes, and parishes whatsoever of all Italy . . . at noone and the setting of the sunne," see Thomas Coryate, *Crudities Hastily Gobled Up in Five Moneths Travells in France, Savoy, Italy . . .* , 2 vols. (Glasgow: James MacLehose and Sons, 1905) I: 394. Similarly, in the second chapter of his *Relation on the State of Religion* of 1605, Edwin Sandys reported that at the sound of this bell—morning, noon, and evening—all Italians, whether at home or in public, knelt and prayed to the Virgin.

82. Lagalla, *De Phaenomenis*, 387, 389.

83. In his *Perspectiva*, Witelo (1220/1230–1300) discussed the obliquity with which the sun's rays struck and penetrated the far side of the moon. Galileo alluded to such a theory in his discussion of the moon's secondary light in the *Sidereus Nuncius*; see p. 54 and n. 53 in Albert Van Helden's translation.

84. Lagalla, *De Phaenomenis*, 388.

85. Lagalla, *De Phaenomenis*, 390.

86. On February 3, 1612, Cigoli wrote to Galileo to say that Lagalla had lectured on the subject at the Sapienza. See Galileo Galilei, *Le Opere*, XI: 268.

87. For a general discussion of the subject, see David Lindberg, "Medieval Latin Theories on the Speed of Light," in his *Studies in the History of Medieval Optics* (London: Variorum Reprints, 1983) chapter 9. See also Galileo's various discussions of the speed of light in the *Assayer* and in the *Two New Sciences* in Galileo Galilei, *Le Opere*, VI: 352, and VIII: 87–89. It is possible that Lagalla's theory is a modification of a hypothesis involving a chasm-riddled moon mentioned in Plutarch's *On the Face Which Appears in the Orb of the Moon*, 922 e.

88. John Wilkins, *The Discovery of a World in the Moone*, 128–129. For a recent discussion of the importance of Wilkins's work, see Jean Dietz Moss, *Novelties in the Heavens: Rhetoric and Science in the Copernican Controversy* (Chicago: University of Chicago Press, 1993) 301–329.

89. See "Boeotia" in *A New Latin Dictionary*, ed. E. A. Andrews, revised and enlarged by Charlton T. Lewis and Charles Short (New York: American Book Company, 1907) 242, citing the opinions expressed by Cicero, Horace, Livy, and Tertullian. To my knowledge, no special stigma is attached to present-day inhabitants of the region.

90. Ovid, *Metamorphoses* V:587–589, translated by Frank Justus Miller (Cambridge, Mass.: Harvard University Press, Loeb Classical Library, 1977³) I: 278–279.

91. Ovid, *Metamorphoses* V: 612–616; I: 280–281 in the Loeb Classical Library edition.

92. For an informative and absorbing study of the development of the iconographical programs of the two most impressive chapels of the church, see Steven F. Ostrow, *Art and Spirituality in Counter-reformation Rome: The Sistine and Pauline Chapels in Santa Maria Maggiore* (Cambridge, U.K., and New York: Cambridge University Press, 1996).

93. For these exchanges between Cigoli and Galileo, see especially Galileo Galilei, *Le Opere*, XI: 168, 176, 209, 229, 240, 268.

94. See Galileo Galilei, *Le Opere*, XI: 212, 229.

95. Luke I: 35.

96. Memo of February 1608, cited in J.A.F. Orbaan, *Documenti sul Barocco in Roma* (Rome: Nella Sede della Società alla Biblioteca Valicelliana, 1920) 96–97; and in Klaus Schwager, "Die architektonische Erneuerung von S. Maria Maggiore unter Paul V," *Romisches Jahrbuch für Kunstgeschichte* 20 (1983) 243–312, 259 n. 87.

97. Martin Kemp, *The Science of Art: Optical Themes in Western Art from Brunelleschi to Seurat* (New Haven: Yale University Press, 1990) 94–96. For a series of solutions to the problems posed by cupolas of various dimensions, see Philippe Morel, "Morfologia delle cupole dipinte da Correggio a Lanfranco," *Bollettino d'arte* 69, ser. 6, no. 23 (Jan.–Feb. 1984) 1–34, especially 21–22.

98. Kemp, *Science of Art*, p. 97 and plate 190.

99. Galileo Galilei, *Le Opere*, XI: 291.

100. Matteoli, *Lodovico Cardi-Cigoli*, 249.

101. This reason was offered by Giovanni Baglione in his *Vita di Lodovico Civoli pittore*; see Matteoli, *Lodovico Cardi-Cigoli*, 42. Cigoli referred often to the dampness of the cupola in his letters to Galileo, though he appears to have mentioned these working conditions not out of concern for his own health, but

rather because they made it difficult for the frescoes to dry. See Galileo Galilei, *Le Opere*, XI: 168, 269, 291, 418. On Cigoli's remarkable diligence as an artist, see Miles Chappell, "Cigoli, Galileo, and *Invidia*," *Art Bulletin* 57 (1975) 91–98, especially 97.

102. Kemp, *Science of Art*, 96; Morel, "Morfologia," 22–23.

103. See Lodovico Cigoli, *Prospettiva pratica*, ed. and trans. Filippo Camerota, Miles Chappell, and Martin Kemp, forthcoming.

104. See John Shearman, *Only Connect . . . Art and the Spectator in the Italian Renaissance*, Bollingen Series 35:37 (Princeton: Princeton University Press, 1992), especially chapters 1, 2, and 4.

105. According to Priscian, those afflicted with *invidia* cannot see; according to Cicero, they see too much.

106. See Miles Chappell, "Cigoli, Galileo, and *Invidia*," *Art Bulletin* 57 (1975) 91–98; and *Disegni di Lodovico Cigoli (1559–1613)*, ed. Miles Chappell (Florence: Leo S. Olschki, 1992) 146–148.

107. Cited in Chappell, "Cigoli, Galileo, and *Invidia*," 96.

108. Chappell, "Cigoli, Galileo, and *Invidia*," 96.

109. Chappell, "Cigoli, Galileo, and *Invidia*," 97. For more details on *Invidia*, see Cesare Ripa, *Iconologia* (Rome: Lepido Facii, 1603[3]) 241–243, now in a facsimile edition introduced by Erna Mandowsky (Hildesheim: Georg Olms Verlag, 1984).

110. Lodovico Ariosto, *Cinque Canti*, I: xl–xliii, lii, ed. Lanfranco Curetti, (Turin: Giulio Einaudi, 1977) 13–14, 16. On Galileo's admiration for Ariosto's "marvellously described" *Invidia*, see the astronomer's *Considerazioni al Tasso*, Canto IV, stanza 9, in Galileo Galilei, *Le Opere*, IX: 95. Cigoli asked Galileo for a copy of his *Considerazioni* in May 1609; see Galileo Galilei, *Le Opere*, X: 244.

111. Ripa, *Iconologia*, 511.

112. Ripa, *Iconologia*, 509, 512.

113. *Disegni di Lodovico Cigoli*, 147.

114. Ripa, *Iconologia*, 508, 510.

115. See Richter-Pedretti, *The Literary Works of Leonardo da Vinci*, I: 385.

116. As Chappell points out in "Cigoli, Galileo, and *Invidia*," 96, and in *Disegni di Lodovico Cigoli*, 147, 148, Cardi may not have known or may have chosen to ignore this version of the allegory.

117. On the question of chronology, see Chappell, "Cigoli, Galileo, and *Invidia*," 95–96, and *Disegni dei toscani a Roma (1580–1620)*, 109–110. As Chappell points out, the date of the unknown Flemish print would have to be 1604–1605. According to Cardi, the charge of plagiarism necessitated a change from one version of the painting to the second in 1606.

118. Cardi, *Vita*, in Matteoli, *Lodovico Cardi-Cigoli*, 31–32.

119. See pp. 36–37 in Albert Van Helden's translation of the *Sidereus Nuncius*, or Galileo Galilei, *Le Opere*, III (1): 60.

120. For other stories of those who used the same bit of information to guess the "secret" of the telescope, see Fulgenzio Micanzio, *Vita del padre Paolo*, in Paolo Sarpi, *Istoria del Concilio Tridentino, seguita dalla Vita del padre Paolo di Fulgenzio Micanzio*, ed. Corrado Vivanti, 2 vols. (Turin: Giulio Einaudi, 1974) II: 1372–1373; Albert Van Helden, "The Invention of the Telescope," *Transac-*

tions of the American Philosophical Society 67:4 (June 1977) 5–64, especially 26; and James Lattis, *Between Copernicus and Galileo*, 185.

121. See Van Helden, "The Invention of the Telescope," 16–18.

122. The term and technique were employed by Galileo, his student Benedetto Castelli, his rival Christoph Scheiner, S.J., Cigoli, and Cigoli's assistant Sigismondo Coccapani—in brief, by many who made solar observations in the early seventeenth century—to describe the method of projecting the sun's dark spots through the Dutch or Galilean telescope and onto a piece of paper, from which these images could then be traced. See Galileo Galilei, *Le Opere*, V: 136–137, and XI: 362. For more on the technique, see Albert Van Helden, "The 'Astronomical Telescope' 1611–1650," *Annali dell'Istituto e Museo di storia della scienza* 1:2 (1976) 11–36, especially 22–24.

123. Galileo wrote in the *Sidereus Nuncius* that it was absolutely necessary that observers use a telescope whose images would be—like the lenses themselves—*perlucida, distincta, et nulla caligine*, or "pellucid, distinct, and unclouded," and that without such an instrument there was no hope of seeing what he had lately discovered in the heavens. See Galileo Galilei, *Le Opere*, III (1): 61. As Van Helden notes in "The 'Astronomical Telescope,'" 18, the chief difficulty in producing a good telescope was in the lens-making.

124. Ripa, *Iconologia*, 509.

125. Galileo Galilei, *Le Opere*, XI: 501.

126. Rudolf and Margot Wittkower, *Born under Saturn* (London: Weidenfeld and Nicolson, 1963) 249–251.

127. Galileo Galilei, *Le Opere*, XI: 476.

128. Lodovico Ariosto, *Cinque Canti*, I: xliii, in Lanfranco Curetti, ed., *Cinque Canti*, 14.

129. See M. Muccillo, "Lodovico delle Colombe," in *Dizionario biografico degli italiani*, 37: 29.

130. Lodovico Ariosto, *Cinque Canti*, I: xlii; Ripa, *Iconologia*, 241.

131. See Guglielmo Righini, "La tradizione astronomica fiorentina e l'osservatorio di Arcetri," *Physis* 4:1 (1962) 132–150, especially 136–138. On Cigoli's decoration of this cupola, part of which concerned the royal ancestry of the Virgin Mary, see Miles Chappell, "The Decoration of the Cupola of the Cathedral of Florence for the Wedding of Ferdinando I de' Medici in 1589," *Paragone* 467 (1989) 57–60.

132. Colombe had the "abitudine di rifugiarsi d'estate al fresco nel duomo di Firenze e di sedere sotto l'arco presso la porticina che porta alla cupola, in un luogo chiamato scherzosamante, dal suo nome, il 'cestino.'" *Dizionario biografico degli italiani*, 37: 29.

133. Galileo Galilei, *Le Opere*, XI: 291.

134. See "Co'l favor di l'invidia son condotti," in Stillman Drake, "Galileo Gleanings XIV: Galileo and Girolamo Magagnati," *Physis* 6 (1964) 269–286, especially 278–279.

135. Galileo Galilei, *Le Opere*, XI: 66. Emphasis mine.

136. Galileo Galilei, *Le Opere*, XI: 80.

137. Galileo Galilei, *Le Opere*, XI: 127.

138. Galileo Galilei, *Le Opere*, XI: 402, 437.

139. On Cesi and the Academy, see the exhaustive study of Giuseppe Gabrieli, *Contribuiti alla storia della Accademia dei Lincei*, 2 vols. (Rome: Accademia Nazionale dei Lincei, 1989). See also Biagioli, *Galileo, Courtier*, 291–297.

140. Galileo Galilei, *Le Opere*, XI: 449.

141. Galileo Galilei, *Le Opere*, XI: 242.

142. See Galileo Galilei, *Le Opere*, XI: 403, 419–420, 422, 428, 438–439, 449, 475, 483.

143. The motif appeared earlier on the work of Galileo's sometime rival Giovanni Antonio Magini. See the title page of Magini's *Novae Coelestium Orbium Theoricae congruentes cum observationibus N. Copernici* (Venice: Damiano Zenario, 1589), where Virtue is at the top, and a dragonlike Envy and the motto *Virtuti si cedit invidia* are below.

144. See Galileo Galilei, *Le Opere*, V: 75–88.

145. Galileo Galilei, *Le Opere*, XI: 461, 468–469, 483–484.

146. Galileo Galilei, *Le Opere*, V: 87.

147. Galileo Galilei, *Le Opere*, V: 87–88.

148. Galileo Galilei, *Le Opere*, XI: 482.

149. Galileo Galilei, *Le Opere*, XI: 483.

150. See Giovanni Targioni Tozzetti, *Notizie degli aggrandimenti delle scienze fisiche accaduti in Toscana nel corso di anni lx. del secolo XVII*, 3 vols. (Florence, 1780) II: 117–121; and Vaccaluzzo, *Galileo Galilei nella poesia del suo secolo*, 31–36.

151. "Alas! we hate unimpaired Virtue, but search it out like envious men once it's lost to sight." Horace, *Odes* III: xxiv, 30–32, in George Long and Reverend A. J. Macleane, eds., *Horatii Opera Omnia*, 2 vols. (London: Whittaker and Co., 1853) II: 199.

152. See Galileo Galilei, *Le Opere*, XVI: 22, 23, 106, 174, 195, 196, 276.

Chapter Five
1614–1621: The *Buen Pintor* of Seville

1. The phrase is from Palomino's biography of Diego de Velázquez. On the Academy itself, see Jonathan Brown, *Images and Ideas in Seventeenth-Century Spanish Painting* (Princeton: Princeton University Press, 1978) 21–83.

2. On Pacheco's library, see the introduction of Bonaventura Bassegoda i Hugas's edition of the *Arte de la Pintura* (Madrid: Ediciones Catédra, 1990) 32–36. On the books owned by Velázquez, see F. J. Sánchez Cantón, "La Librería de Velázquez," in *Homenaje ofrecido a Menéndez Pidal* 3 vols. (Madrid: Hernando, 1925) III: 388–405; and Martin Kemp, *The Science of Art: Optical Themes in Western Art from Brunelleschi to Seurat* (New Haven: Yale University Press, 1990) 104–105.

3. On references to the science of optics within the work of Velázquez, see Kemp, *The Science of Art*, 104–108.

4. On early modern Spanish astronomy and related fields, see Armando Cotarelo y Valledor, "El Padre José de Zaragoza y la Astronomía de su tiempo," in *Estudios sobre la ciencia española del siglo XVII* (Madrid: Grafica Universal, 1935) 65–223; "En torno de las Tablas astronomicas del rey Pedro IV de Aragon," "La

cultura cosmografica en la Corona de Aragon durante el reinado de los Reyes Catolicos," and "Nautíca y Cartografía en la España del siglo XVI," in José Maria Millas y Vallicrosa, *Nuevos estudios sobre historia de la ciencia española* (Barcelona: Casa Provincial de Caridad, 1960) 279–285, 299–316, 317–341; Manuel Fernández Alvarez, *Copernico y su huella en la Salamanca del Barocco* (Salamanca: Universidad de Salamanca, 1974); Victor Navarro Brótons, "Contribución a la historia del copernicanismo en España," *Cuadernos Hispanoamericanos* 283 (1974) 3–23; Juan Vernet Gines, *Historia de la ciencia española* (Madrid: Instituto de España, 1975) 108–126; José Maria López Piñero, *Ciencia y Tecnica en la sociedad española de los siglos XVI y XVII* (Barcelona: Labor Universitaria, 1979) 178–228; Antonio Marquez, "Ciencia e Inquisición en España del XV al XVII," *Arbor* 124 (1986) 65–83; David Goodman, "The Scientific Revolution in Spain and Portugal," in Roy Porter and Mikulas Teich, eds., *The Scientific Revolution in National Context* (Cambridge, U.K.: Cambridge University Press, 1992) 158–177.

5. "In summary, the reasons of all these things are by Copernicus most expertly described and demonstrated in terms of the motions of the earth, while [those of] all the other [planets] fit better. This doctrine of his is not at all contradicted by the saying of Solomon in *Ecclesiastes*, 'But the earth is fixed for eternity.' For this means only that however various may be the succession of epochs and the works of man on earth, still that the earth is one and the same and maintains itself unchanged. . . .

"As for the argument that this chapter of Ecclesiastes and many others in Sacred Scripture mention the motion of the sun, which Copernicus wished to fix in the middle of the universe: this is not at all contrary to his doctrine as the motion of the earth is commonly attributed to the sun in ordinary speech, even by Copernicus himself and those who follow him; they will frequently refer to the earth's course as the sun's course. Indeed there is no passage in the sacrosanct writings which speaks as clearly of the earth's immobility, as his proof that it moves." This English translation and a discussion of Zúñiga's arguments are found in Juan Vernet Gines, "Copernicus in Spain," *Colloquia Copernicana* 1 (1972) 271–291, especially 275–277.

6. Diego de Zúñiga, *Philosophia Prima Pars*, cited and discussed in Brótons, "Contribucion a la historia del Copernicanismo en España," 9–12.

7. Pedro Simón Abril, *Filosofía natural*, cited in Margherita Morreale de Castro, *Pedro Simón Abril* (Madrid: Revista de Filología Española, 1949) 146. This and all subsequent translations are mine, unless otherwise noted.

8. See *Estudios sobre la ciencia española del siglo XVII*, 95–97.

9. Galileo described the rays around certain bodies—the fixed stars and the planets but *not* the moon, which he appeared to believe free of such irradiation—as their "hair" or "hat." See, for example, his description of stars in general in the *Sidereus Nuncius* and of Venus in his third *Letter on the Sunspots* in Galileo Galilei, *Le Opere*, III (1): 75–76, and V: 196–197. For a helpful discussion of the problem and its development, see *Le messager céleste*, translated and annotated by Isabelle Pantin (Paris: Les Belles Lettres, 1992) lix–lxii.

10. Benito Daza de Valdés, *Uso de los Antojos*, with an introduction and commentary by Manuel Marquez (Madrid: Imprenta Cosano, 1974) 255–256. For

an anonymous French translation of this work made in 1627, see Giuseppe Albertotti, ed., "Manoscritto francese del secolo decimosettimo riguardante l'uso degli occhiali," *Memorie della Regia Accademia di scienze, lettere, ed arti in Modena*, 2d ser., 9 (1893) 1–124.

11. Luis Alcázar, *Vestigatio Arcani Sensus in Apocalypsi* (Lugduni: Pillehotte, 1618) 459.

12. Alcázar, *Vestigatio*, 39. Emphasis mine. Interestingly, a comparison not unlike Alcázar's, but one that was published some sixty years later and in a non-Catholic country, appears in an English treatise on language. Henry Rose concludes his *Philosophicall Essay for the Reunion of the Languages* (Oxford by H. Hall for J. Good, 1675) with the following simile: "I propose then to the learned, this new systeme of the languages, not as an incontestable thesis in all its parts but only as an Hypothesis, not altogether irrationall and which besides hath this particular advantage, that although it should be the falsest thing in the world in speculation, it may be at least allowable in the practice. *And I hope to receive the same favour that persons (that were most obstinately resolv'd against his Hypothesis) granted Copernicus by their confession, that let it be never so false it is however the best accommodated to use and Astronomical supputations*" (p. 79). Emphasis mine.

13. Robert Bellarmine, S.J., *Disputations on the Controversies over Christian Faith against the Heretics of the Day*, Controversy 1, Book 3, chapter 3; cited in and translated by Richard J. Blackwell, *Galileo, Bellarmine, and the Bible* (Notre Dame, Ind.: University of Notre Dame Press, 1991) 190–191.

14. For a very helpful survey of this issue, see Alan Scott, *Origen and the Life of the Stars: A History of an Idea* (Oxford: Clarendon Press, 1991).

15. For a recent discussion of the condemnation of Copernicanism, see Blackwell, *Galileo, Bellarmine, and the Bible*, 111–164. For English translations of some of the documents associated with the decision of the Holy Congregation, especially as they pertain to Galileo, see Maurice A. Finocchiaro, *The Galileo Affair* (Berkeley: University of California Press, 1989) 134–153.

16. See Jean Pépin, *Mythe et allégorie: Les origines grecques et les contestations judeo-chrétiennnes* (Aubier: Editions Montaigne, 1958), especially 125–214, 446–466; Henry Chadwick, "Origen, Celsus, and the Stoa," *Journal of Theological Studies* 48 (1947) 34–49; Eleuterio Eloduy, "La generación progresiva en la Estoa y en la Biblia," *Letras de Deusto* 1:1 (1971) 107–136, C. W. Macleod, "Allegory and Mysticism in Origen and Gregory of Nyssa," *Journal of Theological Studies* n.s., 22:2 (1971) 362–379.

17. See Origen, *Homélies sur Jérémie*, translated and annotated by Pierre Husson and Pierre Nautin, 2 vols. (Paris: Les Editions du Cerf, Sources Chrétiennes, 1976–1977) II: 327–329, 337–347; and Scott, *Origen and the Life of the Stars*, 161–162.

18. On this point see pages 76–77.

19. See page 101.

20. On Juan de Pineda's relationship to the Academy of Pacheco, see Brown, *Images and Ideas*, 41–42.

21. Cited by Lodovico delle Colombe in his *Contro il moto della terra* of 1610 and reprinted in Galileo Galilei, *Le Opere*, III: (I) 290. See also Antonio García

Moreno, "Juan de Pineda y el libro de Job," *Estudios Biblicos* 35 (1976) 23–47, 165–185.

22. Juan de Pineda, *Comment. in Eccles.* I: 4. For John Wilkins's reference to Pineda's "bitter and empty reproaches" of Gilbert, see "The Earth May Be a Planet," in *The Mathematical and Philosophical Works of the Right Reverend John Wilkins*, 2 vols. (London: C. Whittingham, 1802) I: 149.

23. On Colombe, see above; for Burton's allusion to Pineda's discussion of Job IV: 9, see "A Digression of Ayre" in *The Anatomy of Melancholy*, ed. Nicholas Kiessling, Thomas C. Faulkner, and Rhonda L. Blair, 3 vols. (Oxford: Clarendon Press, 1990) II: 50.

24. For helpful discussions relating Jesuit scientific culture, especially astronomy, to the contemporary theological debate over free will and the necessity of God's grace for the reconciliation of his enemies to him, see Feldhay, "Knowledge and Salvation in Jesuit Culture," and Blackwell, *Galileo, Bellarmine, and the Bible*, 48–51.

25. Alcázar, *Vestigatio*, i–ii.

26. See Edward Rosen, "The Title of Galileo's *Sidereus Nuncius*," *Isis* 41 (1950) 287–289; Edward Rosen, "Stillman Drake's *Discoveries and Opinions of Galileo*," *Isis* 48 (1957) 440–443; Stillman Drake, "The Starry Messenger," *Isis* 49 (1958) 346–347; Galileo Galilei, *Sidereus Nuncius or the Sidereal Messenger*, translated and with introduction, conclusion, and notes by Albert Van Helden (Chicago: University of Chicago Press, 1989) ix–xi.

27. On the ambivalence among Jesuits about the use of apodictic proof in matters of natural philosophy and the physical sciences, see William A. Wallace, "The Problem of Apodictic Proof in Early 17th Century Mathematics: Galileo, Guevara, and the Jesuits," *Science in Context* 3:1 (1989) 67–87, especially 79–81, and *Galileo and His Sources: The Heritage of the Collegio Romano in Galileo's Science* (Princeton: Princeton University Press, 1984) 126–148; Peter Dear, "Jesuit Mathematical Science and the Reconstitution of Experience in the Early Seventeenth Century," *Studies in History and Philosophy of Science* 18:2 (1987) 133–175; Ugo Baldini, *Legem impone subactis: Studi su filosofia e scienza dei gesuiti in Italia 1540–1632* (Rome: Bulzoni Editore, 1992) 27–56; James Lattis, *Between Copernicus and Galileo: Christoph Clavius and the Collapse of Ptolemaic Cosmology* (Chicago: University of Chicago Press, 1994) 32–37; Rivka Feldhay, "Knowledge and Salvation in Jesuit Culture," *Science in Context* 1:2 (1987) 195–213, and *Galileo and the Church: Political Inquisition or Critical Dialogue?* (Cambridge, U.K.: Cambridge University Press, 1995) 91–92, 162–170, 215–223, 249–255, 278–282.

28. Alcázar, *Vestigatio*, 453.

29. Pacheco, *Arte de la Pintura*, 576–577.

30. Compare the Torre del Oro in the painting with that sketched in the mid-sixteenth century by Anton van den Wyngaerde in *Spanish Cities of the Golden Age: The Views of Anton van den Wyngaerde*, ed. Richard L. Kagan (Berkeley: University of California Press, 1989) 73, 329.

31. On Miguel Cid, see S. B. Vranich, *Ensayos Sevillanos del Siglo de Oro* (Valencia: Ediciones Albatros Hispanofila, 1981) 114–136.

32. For typical discussions, see Jonathan Brown, *Velàzquez: Painter and*

Courtier (New Haven: Yale University Press, 1986) 25; and Nina Mallory, *El Greco to Murillo: Spanish Painting in the Golden Age, 1556–1700* (New York: HarperCollins, 1990) 51–52. For a survey of artistic practices in Seville in this period, see Jonathan Brown, *The Golden Age of Painting in Spain* (New Haven: Yale University Press, 1991) 115–131.

33. See Brown, *Velàzquez*, 7–15, especially 12–13.

34. For a seventeenth-century account of some of the Immaculist events in Seville, see Diego Ortiz de Zúñiga, *Anales eclesiasticos y seculares de la muy noble, y muy leal Ciudad de Sevilla* (Madrid: Imprenta Real, 1677) 613–629. See also Suzanne Stratton, *The Immaculate Conception*, 178–204.

35. *Manuscritos Concepcionistas en la Biblioteca Nacional*, ed. Jose Anguita Valdiva, and introduced by José López de Toro (Madrid: Dirección General de Archivos y Bibliotecas, 1955) 44. Such oaths were common in universities throughout western Europe.

36. Stratton, *The Immaculate Conception*, 203. Graduates of the University of Paris and Cologne had been taking vows to defend the doctrine since the end of the fifteenth century; those graduating in Madrid and Granada took similar vows in 1602 and 1607, as did Carmelite priests in various Spanish and Portuguese cities. See Valerius Hoppenbrouwers, Ord. Carm., *Devotio Mariana* (Rome: Istitutum Carmelitum, 1960) 242–243.

37. Mercedes Cobos, "Dos cartas en torno a la polémica concepcionista. Algunos nuevos datos sobre Francisco de Rioja y Juan de Espinosa," *Archivo Hispalense*, ser. 2, 214 (1987) 114–122.

38. The statement from the *Spiritual Exercises of Saint Ignatius* actually runs thus: "I will believe that the white that I see is black, if the hierarchical Church so defines it." Cited in Blackwell, *Galileo, Bellarmine, and the Bible*, 146.

39. See James Brodrick, S.J., *Life and Work of the Blessed Robert Cardinal Bellarmine*, 2 vols. (New York: J. P. Kennedy and Sons, 1928) I: 134–135, 485–498. For a discussion of "Blind Obedience" in matters of faith and science, see Richard J. Blackwell, *Galileo, Bellarmine, and the Bible* (Notre Dame, Ind.: University of Notre Dame Press, 1991) 143–147.

40. On Aguilon's life and achievements in the Jesuit community, see August Ziggelaar, S.J., *François de Aguilon, S.J. (1567–1617): Scientist and Architect* (Rome: Institutum Historicum Societatis Iesu, 1983), especially 29–52. On the contents of the *Opticorum libri sex* and the influence of this work, see 53–133.

41. On these engravings and the relationship of Rubens's work to Aguilon's theories of optics, see Charles Parkhurst, "Aguilonius' Optics and Rubens' Color," *Nederlands Kunsthistorisch Jaarboek* 12 (1961) 35–49. Michael Jaffe, "Rubens and Optics: Some Fresh Evidence," in *Journal of the Warburg and Courtauld Institutes* 34 (1971) 362–366; Julius S. Held, "Rubens and Aguilonius: New Points of Contact," *Art Bulletin* 61 (1979) 257–264; Ziggelaar, *François de Aguilon*, 72–73, 79, 82–83; Kemp, *The Science of Art*, 99–104. On the symbolism of the frontispiece itself, see William B. Ashworth, Jr., "Divine Reflections and Profane Refractions: Images of a Scientific Impasse in Seventeenth Century Italy," in *Gianlorenzo Bernini: New Aspects of His Art and Thought*, ed. Irving Lavin (University Park: Pennsylvania State University Press, 1985) 179–206.

42. There is other evidence to suggest that the discussion of the moonspots was a late addition: it is not mentioned in the foreword to the reader, which describes the contents of the entire work, book by book; it is not mentioned in the Argument at the beginning of Book V (356–357); it is the only "Disputatio" in the *Opticorum libri sex*, the other sections being entitled "Definitiones," "Lemmata," "Hypotheses," "Propositiones," and "Consecutaria," terms which Aguilon used over and over. The "Disputatio" on the moonspots is in Book V, which concerns luminous and opaque objects; it could have just as well been placed at the end of Book IV, devoted to false appearances in general, and in its last section, to false appearances in transparent and opaque bodies in particular. See François de Aguilon, *Opticorum libri sex* (Antwerp: Plantin, 1613) 352–354.

43. Aguilon, *Opticorum libri sex*, 421.

44. Augustine, *Ennarationes in Psalmos*, col. 132.

45. Aguilon, *Opticorum libri sex*, 421.

46. Aguilon, *Opticorum libri sex*, 422.

47. *Dialogue Concerning the Two Chief World Systems*, 87–88. To my knowledge, this is the only direct allusion to Scripture in the entirety of the *Dialogue*; it is unfortunate that Galileo chose to combine equal measures of piety and stupidity in the assertions of the Aristotelian Simplicio during this discussion of the lunar substance.

48. Aguilon, *Opticorum libri sex*, 421–422. This is only the beginning of Aguilon's discussion of the miraculous column of cloud and fire as it relates to the lunar substance. The comparison of the burning cloud of Exodus XIII with various atmospheric and celestial phenomena was commonplace; in the late sixteenth century, for instance, Friedrich Nausea likened the cloud to a blazing star in his work on meteors. See *A Treatise of Blazing Stars in Generall*, trans. Abraham Fleming (London: Thomas Woodcocke, 1577) chapter 5.

49. Aguilon, *Opticorum libri sex*, 423.

50. Aguilon, *Opticorum libri sex*, 422–423.

51. The anagram ran as follows: "Haec immatura a me iam frustra leguntur o y," and when decoded, "Cynthiae figuras aemulatur mater amorum."

52. Galileo Galilei, "First Letter from Galileo Galilei Concerning the Sunspots," in *Discoveries and Opinions of Galileo*, translated and with an introduction and notes by Stillman Drake (New York: Anchor Books, Doubleday, 1957) 89–97.

53. See *Galileo at Work*, 183–184.

54. Christoph Scheiner, *Accuratior Disquisitio*, in Galileo Galilei, *Le Opere*, V: 67.

55. For Cigoli's references to the Collegio Romano Jesuits and to his progress on the cupola at Santa Maria Maggiore in his letters to Galileo in 1611–1612, see Galileo Galilei, *Le Opere*, XI: 168, 209, 229, 240, 268, 318, 369, 418, 449. Letters from Federico Cesi to Galileo also frequently include references to Cigoli and to his contacts with the Jesuits at the Collegio Romano.

56. See his *Dei Ministeri, et Operationi Angeliche* (1611) 233–234. I owe this reference to Steven F. Ostrow.

57. Vittorelli did not even mention the moon's spots, and merely stated that Cigoli had taken "pictorial license" in depicting a serpent beneath the lunar

globe. See *Gloriose Memorie*, 228. In a letter of 1614 Lorenzo Pignoria, who would have known Vittorelli from the latter's days in Padua, predicted that "the [Pauline] Chapel at Santa Maria Maggiore will surely tire [his] erudite pen." See *Lettere d'uomini illustri*, 125.

58. Andrea Vittorelli, *Gloriose Memorie della Beatissima Vergine Madre di Dio; Gran parte delle quali sono accennate, con Pitture, Statue, & altro nella maravigliosa Capella Borghesia, dalla Santita di N. S. PP. Paolo V. edificata nel Colle Esquilino* (Rome: Guglielmo Facciotto, 1616) 215–216.

59. Scheiner, *Accuratior Disquisitio*, 68.

60. I have used the 1635 edition of Giuseppe Biancani's work; for references to Locher's thesis, see *Sphaera mundi* (Modena: Typographia Giulio Cassiani, 1635) 72; Marin Mersenne, *Harmonie Universelle* (Paris: Sébastien Cramoisy, 1636) 90; Galileo Galilei, *Dialogue Concerning the Two Chief World Systems*, 91–96, and, for a more extended critique of Locher's understanding of dynamics, 219–247; Johannes Hevelius, *Selenographia sive Lunae Descriptio* (Gdansk: Hunefeld, 1647) 121; Giovanni Battista Riccioli, S.J., *Almagestum Novum* (Bologna: Ex Typographia Haeredis V. Benati, 1651) I: 400. For a study of Mersenne's and Riccioli's discussion of Locher's work on motion as reported by Galileo in the *Dialogue*, see Alexander Koyre, "A Documentary History of the Problem of Fall from Kepler to Newton," *Transactions of the American Philosophical Society*, n.s., 45:4 (1955) 329–395, especially 331–345, 349–354.

61. Johannes Georgius Locher, *Disquisitiones mathematicae de controversiis ac novitatibus astronomicis* (Ingolstadt: Elizabeth Angermaria, 1614) 61.

62. See Galileo Galilei, *Le Opere*, XII: 137–138.

63. Galileo Galilei, *Dialogue Concerning the Two Chief World Systems*, 93.

64. In his *Sermon en el dia i fiesta de la Concepcion*, Pineda appears to evoke both Scheiner and Aguilon. He compares the "virginal light" emanating from the woman clothed in the sun of Revelation XII to any number of Marian icons, among them the "miraculous column of fire that once sheltered the early church, and now the new one." See Juan de Pineda, *Sermon en el dia i fiesta de la Concepcion* (Seville: Francisco de Lyra, 1618) 16. In both his *De Rebus Solomonis* (Lyon: Horace Cardon, 1609) and his *Sermon en el primer dia del Octav. votivo a la inmaculada concepcion* (Seville: Alonso Rodriguez Gamarra, 1615), Pineda compared the moon to a moonstone, but only in the former work did he comment on its substance. He believed that the hemisphere that faced the sun was permeable, and that light moved through the globe, probably in the fashion mentioned by Augustine and elaborated by Aguilon. For a list of extant works on the Immaculate Conception by Pineda, see Carlos Sommervogel, ed., *Bibliothèque de la Compagnie de Jésus*, 12 vols. (Brussels: Oscar Schepens, 1960) VI, cols. 799–800. See also the works in Spanish and Latin mentioned in Antonio García Moreno, "Juan de Pineda y el libro de Job," *Estudios Biblicos* 35 (1976) 36–37.

65. See Neil Maclaren, *The Spanish School*, 2d ed., revised by Allen Braham (London: National Gallery, 1970) 129–130.

66. Bruno Bochert, O. Carm., "L'Immaculée dans l'iconographie du Carmel," *Carmelus* 2 (1955) 85–131.

67. See Brown, *Velazquez*, 43–44.

68. Though misidentified by both the original inventorist and Sánchez Cantón as the "*Mathematica*," the work in question was the *Opticorum libri sex*, whose full title was *Opticorum libri sex philosophis juxta ac mathematicis utiles*. Aguilon published no other books, having died before completing a manuscript devoted to catoptrics and dioptrics.

69. Lagalla, *De phaenomenis in orbe Lunae*, 387.

70. On the relationship of Sarpi and Casaubon, see Gaetano Cozzi, "Paolo Sarpi tra il cattolico Philippe Canaye de Fresnes e il calvinista Isaac Casaubon," in *Paolo Sarpi tra Venezia e l'Europa*, 3–133, but especially 110–122. Sarpi's biographer Fulgenzio Micanzio describes their correspondence exclusively in terms of Casaubon's possible conversion: "[Sarpi] wrote to and received letters from [various Gallicans and Protestants], and some as well from Casaubon, when there was a persistent rumor that he was converting to Catholicism." See Paolo Sarpi, *Istoria del Concilio Tridentino seguita dalla Vita del padre Paolo di Fulgenzio Micanzio*, ed. Corrado Vivanti, 2 vols. (Turin: Giulio Einaudi Editore, 1974) II: 1371.

71. Isaac Casaubon, *Ephemerides*, edited, with a preface and notes, by John Russell, S.T.P., 2 vols., (Oxford: Oxford University Press, 1850) II: 725. It is possible that Casaubon was referring not to a Father Varade, as "Varaderius" would suggest, but to a Father Valladier, also an ex-Jesuit, who wrote a work of the sort described in the *Ephemerides*, the *Parallèles et célébrités parthéniennes pour toutes les fêtes de la glorieuse mère de Dieu* (Paris, 1626). For a brief synopsis of this work, see Charles Flachaire, *La Dévotion à la Vierge*, 45–46, n. 64.

72. Casaubon, *Ephemerides*, II: 726.

73. Casaubon, *Ephemerides*, II: 726.

74. Casaubon, *Ephemerides*, II: 727.

75. Casaubon, *Ephemerides*, II: 727–728.

76. See *Ephemerides*, II: 732. Casaubon's distaste for Mariolatry is also evident in his scandalized reaction to Justus Lipsius's deathbed bequest of his fur-trimmed robe to the church of Notre Dame at Halle. For this episode, see Mark Morford, *Stoics and Neostoics: Rubens and the Circle of Lipsius* (Princeton: Princeton University Press, 1991) 3, 132.

77. Paolo Sarpi, *Lettere ai protestanti*, ed. Manlio Busnelli, 2 vols. (Bari: Giuseppe Laterza & Figli, 1931) II: 217, 259–260.

78. See [William Crashaw], *The Bespotted Jesuite: Whose Gospell Is Full of Blasphemy against the Blood of Christ* (London: Bar. Alsop, 1641), devoted in its entirety to exposing the "horrible doctrines and hellish opinions" of the Jesuits in their Mariolatry. For another, only slightly milder discussion of the issue of Marian worship, one less concerned with the Society of Jesus, see [William Fleetwood, Bishop of Ely], *The Life and Death of the B. Virgin: Giving an Account of the Miracles Ascrib'd to Her by Romish Writers, with the Grounds of the Worship Paid to Her* (London: Printed by H. Clark for Thomas Newborough, 1687).

79. Sarpi's sentiments about Mariolatry in Catholic countries, particularly in Italy and especially among "the people," were foreshadowed in the second chapter of Edwin Sandys's *Relation of the State of Religion* of 1605, a work the Venetian theologian annotated around 1607. For the first part of Sandys's work and

the commentary of Sarpi, see Paolo Sarpi, *Opere*, ed. Gaetano and Luisa Cozzi (Milan: Riccardo Ricciardi Editore, 1969) 295–330, especially 296–300.

80. Wootton, *Paolo Sarpi*, 107.

81. Paolo Sarpi, *Istoria del Concilio Tridentino*, ed. Corrado Vivanti (Turin: Giulio Einaudi Editore, 1974) I: 308.

82. Sarpi, *Istoria*, I: 310.

83. Sarpi, *Istoria*, I: 308.

84. Sarpi, *Istoria*, I: 318.

85. Sarpi, *Istoria*, I: 308–309.

86. Galileo Galilei, *Lettera a Gallanzone Gallanzoni*, in *Le Opere*, XI: 142.

87. Galileo Galilei, *Le Opere*, XI: 144–145.

88. Galileo Galilei, *Le Opere*, XI: 149.

89. Galileo Galilei, *Le Opere*, XI: 143. For other references to the issue of "purity" and "divinity," see XI: 145, 146, 148.

90. Galileo Galilei, *Le Opere*, XI: 147–148.

91. Galileo Galilei, *Le Opere*, XI: 146.

92. Galileo Galilei, *Le Opere*, XI: 143.

93. Galileo Galilei, *Le Opere*, XI: 146.

94. In treating the question of Sarpi's sexuality, David Wootton notes the "abstraction of his prose, carefully purged of any hint of sensuality." See Wootton, *Paolo Sarpi*, 139.

95. On the cardinal's defense of the Jesuits after their expulsion from the Veneto in May 1606 and his subsequent negotiations in their favor with Henri IV of France, see Jacques Cretineau-Joly, *Histoire religieuse, politique, et littéraire de la Compagnie de Jésus*, 6 vols. (Paris: Paul Mellier, 1844–1846) III: 138–145. Cardinal Joyeuse was also said by some in November 1611 to have designs on the papacy. See Sir Ralph Winwood, *Memorials of Affairs of State*, 3 vols. (London: T. Ward, 1725) III: 303.

96. Cited in [Bishop Joseph A. Cerutti], *Apologie générale de l'institut et de la doctrine des Jésuites* (Soleure, Switzerland: Jacques-Philippe Schaerer, 1763²) 427 n. 3.

97. Cerutti, *Apologie*, 429 n. 3.

98. Cerutti, *Apologie*, 436 n. 9.

99. Wilkins, *That the World May be a Planet*, 147. Wilkins noted in particular Father Nicolas Serrarius S.J.'s condemnation of Copernicanism as "heretical" in his *Iosue ab utero ad ipsum tumulum . . .* of 1609–1610. For discussion of this passage—crucial in the deposition made by the Dominican Tommaso Caccini against Galileo in 1615—see Blackwell, *Galileo, Bellarmine, and the Bible*, 39, 112–113.

100. See Claudio Acquaviva, S.J., "De soliditate et uniformitate doctrinae," in Society of Jesus, *Epistolae selectae praepositorum generalium ad superiores Societatis* (Rome: Typis Polyglottis Vaticanis, 1911) 207–209. For Acquaviva's subsequent letter on the same subject, the "De observanda *Ratione studiorum* deque doctrina S. Thomae sequenda," of December 1613, see 209–215. For a historical overview of this problem, see Ugo Baldini, *Legem impone subactis: Studi su filosofia e scienza dei gesuiti in Italia 1540–1632* (Rome: Bulzoni Editore, 1992) 75–119; Blackwell, *Galileo, Bellarmine, and the Bible*, 48–51, 135–147; and

Rivka Feldhay, *Galileo and the Church: Political Inquisition or Critical Dialogue?* (Cambridge, U.K.: Cambridge University Press, 1995) 128–145, 223–237.

101. Galileo Galilei, *Le Opere*, XI: 13.

102. Galileo Galilei, *Le Opere*, V: 88.

103. Galileo Galilei, *Le Opere*, XI: 143 n.1.

104. Among the very few religious works owned by Galileo, several were devoted to the Virgin: *Opera di M. Francesco Bocchi sopra l'immagine miracolosa della Santissima Nunziata di Firenze* (Florence: Giorgio Marescotti, 1612); the otherwise unidentified *Officium B. M. Virginis*; and the *Parto della Vergine. Poema eroico in 20 cantici di Giovanni Battista Calamai* (Florence: Pietro Cecconcelli, 1623). See Antonio Favaro, *La libreria di Galileo Galilei descritta ed illustrata* (Rome: Tipografia delle scienze matematiche e fisiche, 1887) 24, 25, 63.

105. For some of these greetings, exchanged through intermediaries, see Galileo Galilei, *Le Opere*, XI: 70, XII: 58, 139, 445, 455. For Caccini's references to their correspondence, see *Le Opere*, XIX: 309–310.

106. Galileo Galilei, *Le Opere*, V: 186–187.

107. On Biancani's arguments for the nature and validity of mathematical proofs, see William A. Wallace, *Galileo and His Sources: The Heritage of the Collegio Romano in Galileo's Science* (Princeton: Princeton University Press, 1984) 141–148; G. Giacobbe, "Epigoni nel seicento della 'Quaestio de certitudine mathematicarum': Giuseppe Biancani," *Physis* 18 (1976) 5–40; Blackwell, *Galileo, Bellarmine, and the Bible*, 148–153; Feldhay, *Galileo and the Church*, 165–169.

108. On this incident, see Feldhay, *Galileo and the Church*, 240–245.

109. For an important reassessment of Giuseppe Biancani's scientific and religious views, see Blackwell, *Galileo, Bellarmine, and the Bible*, 148–153. For a discussion of Biancani's difficulties with Jesuit censors, and a partial presentation of pertinent documents in the Fondo Gesuitico of the Archivum Romanum Societatis Iesu, see Ugo Baldini, "Additamenta Galilaeana: I. Galileo, la nuova astronomia e la critica all'aristotelismo nel dialogo epistolare tra Giuseppe Biancani e i Revisori romani della Compagnia di Gesù," in *Annali dell'Istituto e Museo di storia della scienza di Firenze* 9 (1984) 13–43.

110. I have used the 1635 edition of Biancani's work; see Giuseppe Biancani, *Sphaera Mundi* (Modena: Typographia Giulio Cassiani, 1635) 75–76.

111. Biancani, *Sphaera mundi*, 72.

112. Locher had added that an earthly observer would not even see all parts of this transparent border because the sun's rays did not pass through them to the observer's eyes, but fell outside his line of sight. ". . . in quadam eclypsi Solis, ea Lunae pars, quae Soli supponebatur, perspicué cernebatur, quasi solari luce transluceret; quae vero extra Solem porrigebatur omnino invisa latebat; quoniam radij Solis eam pervadentes alio quam ad nostrum oculum dirigebantur, ut consideranti manifestum est." Biancani, *Sphaera mundi*, 72.

113. Biancani, *Sphaera mundi*, 72.

114. Biancani, *Sphaera mundi*, 71.

115. Luke I: 26.

116. For instances of this pun, see pp. 134–135.

117. In Italian versions of Ptolemy's *Geography*, translators and commentators—among them Francesco Berlinghieri, Girolamo Ruscelli, and Biancani's friend Giovanni Antonio Magini—tended to emphasize the fact that chorographical maps were like pictures, but geographical ones much less so. On this tendency, which amounts to a misreading, or at least a distortion of Ptolemy's text, see my "Reading Maps," *Word & Image* 9:1 (Jan.–March 1993) 51–65, especially 51–52.

118. Biancani, *Sphaera mundi*, 71.

119. In his commentary on *Song of Songs* 5: 13, "Genae ejus sicut areolae aromatum consitae a pigmentariis," Cornelius a Lapide would evoke both aspects of the term by noting that *areolae* were rounded and gardenlike. See Cornelius a Lapide, *Commentaria in Canticum Canticorum*, in *Commentaria in Scripturam Sacram*, IV: 610–611. On medieval uses of the word, see *Mittellateinisches Wörterbuch*, ed. Otto Prinz and Johannes Schneider (Munich: C. H. Beck, 1967) I, cols. 926–927 s.v. *areola*.

120. *Sidereus Nuncius*, 53.

121. Biancani, *Sphaera mundi*, 71.

Acanfora, Elisa. "Sigismondo Coccapani disegnatore e trattatista." *Paragone* 477 (1989) 71–99.

———. "Sigismondo Coccapani, un artista equivocato." *Antichità Viva* 29 (1990) 11–25.

Accolti, Pietro. *Lo Inganno de gl'occhi*. Florence: Pietro Cecconcelli, 1625 (reprinted in Theodore Bestman, ed., *The Printed Sources of Western Art*. Portland, Ore.: United Academic Press, 1972).

———. "Delle lodi di Cosimo II Granduca di Toscana." In *Raccolta di prose fiorentine*, VI: ii, 55–65. 6 vols. Venice: Domenico Occhi, 1730–1734.

Acquapendente, Girolamo Fabricio d'. *De visione*. In *Opera Omnia*. Leipzig: Sumptibus Johannis Friderici Gleditschi, Excudebat Christianus Goezius, 1687.

Acquaviva, Claudio, S.J. "De soliditate et uniformitate doctrinae" and "De observanda *Ratione studiorum* deque doctrina S. Thomae sequenda." In Jesuits, *Epistolae selectae praepositorum generalium ad superiores Societatis*, 207–209, 209–215. Rome: Typis Polyglottis Vaticanis, 1911.

Aggiunti, Niccolò. "Cretum mihi das nectar, christallaque Lyncei." In Nunzio Vaccalluzzo, *Galileo Galilei nella poesia del suo secolo*, 121–122. Milan: Remo Sandron, 1910.

Aguilon, François de, S.J. *Opticorum libri sex*. Antwerp: Plantin, 1613.

Albert of Saxony. *Quaestiones et decisiones physicales*. Paris: J. Badius Ascensius et Conrad Resch, 1518.

Alberti, Leon Battista. *On Painting*. Translated and with an introduction and notes by John R. Spencer. New Haven: Yale University Press, 1966.

Albertotti, Giuseppe, ed. "Manoscritto francese del secolo decimosettimo riguardante l'uso degli occhiali." *Memorie della Regia Accademia di scienze, lettere, ed arti in Modena*, 2d ser., 9 (1893) 1–124.

Alcázar, Luis, S.J. *Vestigatio arcani sensus in Apocalypsi*. Lyon: Pillebotte, 1618.

Alessandrini, Ada. *Documenti lincei e cimeli galileiani*. Rome: Accademia Nazionale dei Lincei, 1965.

Alpers, Svetlana. *The Art of Describing: Dutch Art in the Seventeenth Century*. Chicago: University of Chicago Press, 1983.

Ambrose. *Opere morali*, 14: 1 and 2. Introduced, translated (from Latin to Italian), and annotated by Franco Gori. In Angelo Paredi et al., eds., *Opera Omnia*. 27 vols. Milan: Biblioteca Ambrosiana, 1977–1989.

Amico, Bartolomeo, S.J. *In Aristotelis libros de caelo et mu[n]do*. Naples: Roncaliolo, 1626.

Anguita Valdiva, José, ed. *Manuscritos Concepcionistas en la Biblioteca Nacional*. Madrid: Dirección General de Archivos y Bibliotecas, 1955.

284 BIBLIOGRAPHY

Apuleius. *De Deo Socrati*. In *Apuleii Opera Omnia ex editione oudendorpiana*, II: 955–957. 7 vols. London: A. J. Valpy, 1825.

Ariew, Roger. "Galileo's Lunar Observations in the Context of Medieval Lunar Theory." *Studies in the History and Philosophy of Science* 15:3 (1984) 213–226.

Ariosto, Lodovico. *Orlando Furioso*. Translated and with an introduction by Barbara Reynolds. London: Penguin, 1977.

————. *Cinque Canti*. Edited by Lanfranco Curetti. Turin: Giulio Einaudi, 1977.

Aristotle. *On the Soul*. Translated by Hugh Lawson-Tancred. Harmondsworth, U.K.: Penguin Books, 1986.

————. *Meteorologica*. With an English translation by H.D.P. Lee. Cambridge, Mass., and London: Harvard University Press, 1962.

Arnaldi, Girolamo, et al. *Storia di Vicenza*. 4 vols. Vicenza: Accademia Olimpica, 1989.

Arrighetti, Niccolò. "Orazione delle lodi di Filippo Salviati." In *Raccolta di prose fiorentine*, III: i, 115–133. 6 vols. Venice: Domenico Occhi, 1730–1735.

Arrighi, Gino. "Gli 'Occhiali' di Francesco Fontana in un carteggio inedito di Antonio Santini nella Collezione Galileiana della Biblioteca Nazionale di Firenze." *Physis* 6 (1964) 432–448.

Ashworth, William B., Jr. "Divine Reflections and Profane Refractions: Images of a Scientific Impasse in Seventeenth-Century Italy." In Irving Lavin, ed., *Gianlorenzo Bernini: New Aspects of His Art and Thought*, 179–206. University Park: Pennsylvania State University Press, 1985.

————. "Light of Reason, Light of Nature: Catholic and Protestant Metaphors of Scientific Knowledge." *Science in Context* 3:1 (1989) 89–107.

Augustine. *Ennarationes in Psalmos*. In *Opera Omnia*, IV. 11 vols. Paris: Migne, 1841.

————. *Tractates on the Gospel of John*. Translated by John Rettig. 5 vols. Washington, D.C.: Catholic University of America Press, 1995.

Auwers, Jean-Marie. "La nuit de Nicodème (Jean 3, 2; 19, 39) ou l'ombre du langage." *Revue Biblique* 97:4 (1990) 481–503.

Averroes. *Aristotelis de Coelo cum Averrois Commentariis*. Venice: Giunti, 1562.

Baldini, Ugo. "La nova del 1604 e i matematici e filosofi del Collegio Romano." *Annali dell'Istituto e Museo di Storia della Scienza* 6 (1981) 63–97.

————. "L'astronomia del Cardinale Bellarmino." In Paolo Galluzzi, ed. *Novità celesti e crisi del sapere: Atti del Convegno Internazionale di Studi Galileiani*, 293–305. Florence: Giunti Barbera, 1984.

————. "Additamenta Galilaeana: I. Galileo, la nuova astronomia e la critica all'aristotelismo nel dialogo epistolare tra Giuseppe Biancani e i Revisori romani della Compagnia di Gesù." *Annali dell'Istituto e Museo di storia della scienza di Firenze* 9 (1984) 13–43.

————. *Legem impone subactis: Studi su filosofia e scienza dei gesuiti in Italia, 1540–1632*. Rome: Bulzoni Editore, 1992.

Baldini, Umberto, Anna Maria Giusti, and Annapaula Pamploni Martelli. *La Cappella dei principi e le pietre dure a Firenze*. Milan: Electa Editrice, 1979.

Baldinucci, Filippo. *Vocabolario toscano dell'arte del disegno*. Florence: Per S. Franchi, 1681.

———. *Notizie dei professori del disegno da Cimabue in qua*. Edited and annotated by F. Ranalli. 7 vols. Florence: V. Batelli e Compagni, 1847.

Barker, Peter, and Bernard R. Goldstein. "Is Seventeenth-Century Physics Indebted to the Stoics?" *Centaurus* 27 (1984) 148–164.

———. "Jean Pena (1528–58) and Stoic Physics in the Sixteenth Century." In Ronald H. Epp, ed., *Spindel Conference 1984: Recovering the Stoics. Southern Journal of Philosophy* 23, supp. (1985) 93–107.

———. "Stoic Contributions to Early Modern Science." In Margaret Osler, ed., *Atoms, Pneuma, and Tranquility*, 135–154. Cambridge, U.K.: Cambridge University Press, 1991.

Barlow, Richard G. "Infinite Worlds: Robert Burton's Cosmic Voyage." *Journal of the History of Ideas* 34 (1973) 291–302.

Barsanti, Anna. "Una vita inedita del Furini." *Paragone* 289 and 291 (1974) 67–86, 79–99.

Bartholin, Caspar. *Exercitatio de stellarum natura, affectionibus et effectionibus*. Wittemberg: Gormann, 1609[3].

Bassler, Jouette M. "The Galileans: A Neglected Factor in Johannine Community Research." *Catholic Biblical Quarterly* 43 (1981) 243–257.

———. "Mixed Signals: Nicodemus in the Fourth Gospel." *Journal of Biblical Literature* 108:4 (1989) 635–646.

Bellarmino, Roberto Francesco Romolo. *The Louvain Lectures (Lectiones Lovanienses) of Bellarmine and the Autograph Copy of his 1616 Declaration to Galileo*. Edited and translated by Ugo Baldini and George V. Coyne, S.J. Vatican City: Specola Vaticana, 1984.

Bellinati, Claudio. "Galileo e il sodalizio con ecclesiastici padovani." In Giovanni Santinello, ed., *Galileo e la cultura padovana*, 327–357. Padua: CEDAM, 1992.

Berti, Luciano. *Il Principe dello studiolo*. Florence: Editrice Edam, 1967.

Biagioli, Mario. "Filippo Salviati: A Baroque Virtuoso." *Nuncius* 7 (1992) 81–96.

———. *Galileo, Courtier: The Practice of Science in the Culture of Absolutism*. Chicago: University of Chicago Press, 1993.

Biancani, Giuseppe, S.J. *Sphaera mundi*. Modena: Ex Typographia Iuliani Cassiani, 1635[2].

Biblia Magna Latina Commentarior. Litteralium. 5 vols. Paris: Michel Soly, Matthieu Guillemot, Denis Bechet, et Antoine Bertier, 1643.

Blackwell, Richard J. *Galileo, Bellarmine, and the Bible*. Notre Dame, Ind.: University of Notre Dame Press, 1991.

Bochert, Bruno, O. Carm. "L'Immaculée dans l'iconographie du Carmel." *Carmelus* 2 (1955) 85–131.

Bonaventure. *Commentaria in quatuor libros sentiarum magistri Petri Lombardi*. In *Opera Omnia*, II. 10 vols. Quaracchi, Italy: Ex Typographia Collegii S. Bonaventurae, 1882–1902.

Borel, Pierre. *Discours nouveau prouvant la pluralité des mondes, que les astres sont des terres habitées, & la terre une étoile, qu'elle est hors du centre du monde dans le troisiesme ciel, & se tourne devant le soleil qui est fixe, & autres choses très-curieuses*. Geneva: N.p., 1657.

Boschin, Marco. *Carta del navegar pitoresco*. Edited by Anna Pallucchini. Venice and Rome: Istituto per la Collaborazione Culturale, 1966.

Brahe, Tycho. *Astronomiae Instauratae pars tertia*. In *Scripta Astronomica*, III. Edited by J.L.E. Dreyer. 15 vols. Hveen: Gyldendaliana, 1913–1929.

Brekke, Asgeir, and Alv Egeland. *The Northern Light: From Mythology to Space Research*. New York: Springer-Verlag, 1983.

Brodrick, James, S.J. *The Life and Work of Blessed Robert Francis Cardinal Bellarmine, S.J.* With an introduction by His Eminence Cardinal Ehrle, S.J. 2 vols. New York: P. J. Kennedy and Sons, 1928.

Brown, Jonathan. *Images and Ideas in Seventeenth-Century Spanish Painting*. Princeton: Princeton University Press, 1978.

———. *Velàzquez: Painter and Courtier*. New Haven: Yale University Press, 1986.

———. *The Golden Age of Painting in Spain*. New Haven: Yale University Press, 1991.

Brown, Rawdon, et al., eds. *Calendar of State Papers and Manuscripts, Relating to English Affairs, Existing in the Archives and Collections of Venice, and in Other Libraries of Northern Italy*. 38 vols. London: Longman, 1864–1947.

Buonarroti, Michelangelo, the Younger. "Delle Lodi di Cosimo II." In *Raccolta di prose fiorentine*, VI: ii, 89–113. 6 vols. Venice: Domenico Occhi, 1730–1735.

Burton, Robert. "A Digression of Ayre." In *The Anatomy of Melancholy*, II: 33–67. Edited by Nicolas K. Kiessling, Thomas C. Faulkner, and Rhonda L. Blair. 3 vols. Oxford: Clarendon Press, 1990.

Byard, Margaret M. "A New Heaven: Galileo and the Artists." *History Today* 38 (1988) 30–38.

Cabeo, Nicolas, S.J. *Commentaria in Aristotelis Stagiritae Meteorologicorum*. Rome: Heirs of Francisco Corbelletti, 1646.

Cantelli, Giuseppe. "Per Sigismondo Coccapani 'celebre pittore fiorentino' nominato il maestro del disegno." *Prospettiva* 7 (1976) 26–38.

Cantimori, Delio. *Eretici italiani del cinquecento*. Florence: Sansoni, 1939.

———. "Submission and Conformity: 'Nicodemism' and the Expectations of a Conciliar Solution to the Religious Question." In Eric Cochrane, ed., *The Late Italian Renaissance*, 244–265. New York: Harper and Row, 1970.

Cardi-Cigoli, Giovanni Battista. "Vita di Lodovico Cardi-Cigoli." In Anna Matteoli, *Lodovico Cardi-Cigoli pittore e architetto*. Pisa: Giardini Editori, 1980.

Carthusani, Dionysius. *In Quattuor Evangelistas, Ennarationes*. Lyon: Bartholomeus Honoratus, 1579.

Casaubon, Isaac. *Ephemerides*. Edited, with a preface and notes, by John Russell, S.T.P. 2 vols. Oxford: Oxford University Press, 1850.

Casini, Paolo. "Il *Dialogo* di Galileo e la luna di Plutarco." In Paolo Galluzzi, ed., *Novità celesti e crisi del sapere: Atti del Convegno Internazionale di Studi Galileiani*, 57–62. Florence: Giunti Barbera, 1984.

Castiglione, Baldessare. *Il Cortegiano*. Edited by Giulio Preti. Turin: Giulio Einaudi, 1960.

Cavicchi, Elizabeth. "Painting the Moon." *Sky and Telescope* 82 (1991) 313–315.

[Cerutti, Joseph A., Bishop.] *Apologie générale de l'institut et de la doctrine des Jésuites*. Soleure, Switz.: Jacques-Philippe Schaerer, 1763[2].

Cesi, Bernardo. *Mineralogia*. Lyon: I. & P. Prost, 1636.

Chadwick, Henry. "Origen, Celsus, and the Stoa." *Journal of Theological Studies* 48 (1947) 34–49.

Chappell, Miles L. "Lodovico Cigoli: Essays on His Career and Painting." Ph.D. dissertation, University of North Carolina at Chapel Hill, 1971.

————. "Some Works by Cigoli for the Cappella de' Principi." *Burlington Magazine* 113 (October 1971) 580–583.

————. "Cigoli, Galileo, and *Invidia*." *Art Bulletin* 57 (1975) 91–98.

————. "Portraits and Pedagogy in a Painting by Cristofano Allori." *Antichita' Viva* 16:5 (1977) 20–33.

————. *Disegni dei Toscani a Roma (1580–1620)*. Florence: L. S. Olschki, 1979.

————. "Lodovico Cigoli." In Mina Gregori, ed., *Il Seicento Fiorentino: Pittura, Disegni, Biografie*, I:110–117, II: 117–129, III: 55–58. 3 vols. Florence: Cantini, 1986.

————. "The Decoration of the Cupola of the Cathedral of Florence for the Wedding of Ferdinando I de' Medici in 1589." *Paragone* 467 (1989) 57–60.

————. "Proposals for Coccapani." *Paradigma* 9 (1990) 183–190.

————. *Disegni di Lodovico Cigoli*. Florence: Leo S. Olschki, 1992.

————. "Lodovico Cardi." In *Dizionario biografico degli italiani*, 19: 771–776. 44 vols. to date. Rome: Istituto Della Enciclopedia Italiana, 1960–1994.

Chiarini, Marco, Serena Padovani, Angelo Tartuferi, eds. *Lodovico Cigoli tra Manierismo e Barocco*. Fiesole: Amalthea, 1992.

Cicero. *De Natura Deorum*, Liber II. Translated by M. van den Bruwaene. Brussels: Latomus, 1978.

Cigoli, Lodovico. *Prospettiva pratica*. Edited and translated by Filippo Camerota, Miles Chappell, and Martin Kemp, forthcoming.

Cipolla, Carlo. "The Decline of Italy: The Case of a Fully Matured Economy." *Economic History Review*, 2d ser., V:2 (1952) 178–187.

Clagett, Marshall. "The Life and Works of Giovanni Fontana." *Annali dell'Istituto e Museo di Storia della Scienza* 1:1 (1976) 5–28.

Clark, David H., and F. Richard Stephenson. *The Historical Supernovae*. Oxford: Pergamon Press, 1977.

Cobos, Mercedes. "Dos cartas en torno a la polémica concepcionista. Algunos nuevos datos sobre Francisco de Rioja y Juan de Espinosa." *Archivo Hispalense*, 2d ser., 214 (1987) 114–122.

Colie, Rosalie. "Cornelis Drebbel and Salomon de Caus: Two Jacobean Models for Solomon's House." *Huntington Library Quarterly* 18 (1954–1955) 245–261.

Commentarii Collegii Conimbricensis Societatis Iesu in Libros de Generatione. Mainz: Ioannes Albini, 1615.

Commentarii Collegii Conimbricensis Societatis Iesu in quatuor librs De Caelo, Meteorologicos & Parva Naturalia Aristotelis . . . Cologne: Heirs of Lazarus Zetzner, 1618.

Commentarii Collegii Conimbricensis Societatis Iesu in quatuor libros de Coelo. Cologne: Heirs of Lazarus Zetzner, 1618[5].

Contzen, Adam, S.J. *Commentaria in Quattuor Sancta Iesu Christi Evangelia.* Colonia Agrippina: Ioannis Kinckius, 1626.

Copernicus, Nicolas. *On the Revolutions of the Heavenly Spheres.* Translated, introduced, and annotated by A. M. Duncan. Newton Abbot, U.K.: David and Charles, 1976.

Corsini, Piero. *Important Old Master Paintings.* New York: Piero Corsini, 1990.

Coryate, Thomas. *Crudities Hastily Gobled Up in Five Moneths Travells in France, Savoy, Italy . . .* 2 vols. Glasgow: James MacLehose and Sons, 1905.

Cotarelo y Valledor, Armando. "El Padre José de Zaragoza y la Astronomía de su tiempo." In *Estudios sobre la ciencia espanola del siglo 17*, 65–223. Madrid: Gráfica Universal, 1935.

————. "En torno de las Tablas astrónomicas del rey Pedro IV de Aragon," "La cultura cosmografica en la Corona de Aragon durante el reinado de los Reyes Catolicos," and "Nautica y Cartografía en la España del siglo XVI." In José Maria Millas y Vallicrosa, ed., *Nuevos estudios sobre historia de la ciencia espanola*, 279–285, 299–316, 317–341. Barcelona: Casa Provincial de Caridad, 1960.

Cozzi, Gaetano. "Intorno al cardinale Paravicino, a monsignor Paolo Gualdo e a Michelangelo da Caravaggio." *Rivista storica italiana* 73 (1961) 36–68.

————. *Paolo Sarpi tra Venezia e l' Europa.* Turin: Piccola Biblioteca Einaudi, 1979.

Cozzi, Luisa. "La tradizione settecentesca dei 'Pensieri' sarpiani." *Studi Veneziani* XIII (1974) 393–450.

[Crashaw, William]. *The Bespotted Jesuite: Whose Gospell Is Full of Blasphemy against the Blood of Christ.* London: Bar. Alsop, 1641.

Cremonini, Cesare. *Apologia dictorum Aristotelis de Facie in Orbe Lunae.* Venice: Tomaso Baglioni, 1613.

Cretineau-Joly, Jacques. *Histoire religieuse, politique, et litteraire de la Compagnie de Jesus.* 6 vols. Paris: Paul Mellier, 1844–1846.

Cropper, Elizabeth. *The Ideal of Painting: Pietro Testa's Düsseldorf Notebook.* Princeton: Princeton University Press, 1984.

————. "Artemisia Gentileschi, La 'Pittora.'" In G. Calvi, ed., *Barocco al Femminile*, 191–218. Rome: Laterza, 1992.

————. "New Documents for Artemisia Gentileschi's life in Florence." *Burlington Magazine* CXXXV (Nov. 1993) 760–761.

Dante. *Commedia.* Edited by Emilio Pasquini and Antonio Quaglio. Milan: Grandi Libri Garzanti, 1986.

Da Vinci, Leonardo. *Treatise on Painting* ⟨Codex urbinas latinus 1270⟩. Translated and annotated by A. Philip McMahon, with an introduction by Ludwig H. Heydenreich. 2 vols. Princeton: Princeton University Press, 1956.

————. *The Notebooks of Leonardo da Vinci.* Compiled and edited from the original manuscripts by Jean Paul Richter. 2 vols. New York: Dover Publications, 1970.

————. *The Literary Works of Leonardo da Vinci.* Compiled and edited from the original manuscripts by Jean Paul Richter with a commentary by Carlo Pedretti. 2 vols. Oxford: Phaidon Press Limited, 1977.

Davis, Neil. *The Aurora Watcher's Handbook*. Fairbanks: University of Alaska Press, 1992.

Daza de Valdés, Benito. *Uso de los Antojos*. With an introduction and commentary by Manuel Marquez. Madrid: Imprenta Cosano, 1974.

Dear, Peter. "Jesuit Mathematical Science and the Reconstitution of Experience in the Early Seventeenth Century." *Studies in History and Philosophy of Science* 18:2 (1987) 133–175.

Decrees of Our Holy Father Pope Innocent XI, Containing the Suppression of an Office of the Immaculate Conception of the Most Holy VIRGIN; and of a Multitude of INDULGENCES. Oxford: Printed by Leonard Lichfield, 1678.

Delle Colombe, Lodovico. *Discorso*. Florence: Giunti, 1606.

———. *Contro il moto della terra*. In Galileo Galilei, *Le Opere*, III (1): 253–289.

"De Lunarium montium altitudine." In Galileo Galilei, *Le Opere*, III (1): 301–307.

Dempsey, Charles. "Some Observations on the Education of Artists in Florence and Bologna during the Later Sixteenth Century." *Art Bulletin* 62 (1980) 552–569.

Di Cesare, Mario, ed. *Milton in Italy: Contexts, Images, Contradictions*. Binghamton, N.Y.: Medieval and Renaissance Texts and Studies, 1991.

Diaz, Furio. *Il Granducato di Toscana: I Medici*. Turin: Unione Tipografico-Editrice Torinese, 1976.

Didi-Huberman, Georges. "L'hymen et la couleur, Figures medievales de la Vierge." *La Part de l'Oeil* 4 (1988) 7–21.

Dolce, Lodovico. *Dialogue on Painting*. Translated, introduced, and annotated by Mark W. Roskill in *Dolce's "Aretino" and Venetian Art Theory of the Cinquecento*. New York: College Art Association, New York University Press, 1968.

Donne, John. *The Complete English Poems*. Edited by A. J. Smith. Penguin: New York, 1971.

Drake, Stillman. "The Starry Messenger." *Isis* 49 (1958) 346–347.

———. "Galileo Gleanings XIV: Galileo and Girolamo Magagnati." *Physis* 6 (1964) 269–286.

———. *Galileo against the Philosophers*. Los Angeles: Zeitlin and Ver Brugge, 1976.

———. *Galileo at Work: His Intellectual Biography*. Chicago: University of Chicago Press, 1978.

———. *Galileo: Pioneer Scientist*. Toronto: University of Toronto Press, 1990.

Duplessis-Mornay, Philippe. *Mémoires et correspondance*. 12 vols. Paris: Treuttel et Wurtz, 1824.

Edgerton, Samuel, Jr. "*Mensurare temporalia facit Geometria spiritualis*: Some Fifteenth-Century Italian Notions about When and Where the Annunciation Happened." In Irving Lavin and Georges Plummer, eds., *Studies in Late Medieval and Renaissance Painting in Honor of Millard Meiss*, 115–130. New York: New York University Press, 1977.

———. "Galileo, Florentine *Disegno*, and the 'Strange Spottednesse' of the Moon." *Art Journal* 44 (1984) 225–248.

Eire, Carlos M. N. "Calvin and Nicodemism: A Reappraisal." *Sixteenth Century Journal* 10:1 (1979) 45–69.

———. *War against the Idols: The Reformation of Worship from Erasmus to Calvin.* Cambridge, U.K.: Cambridge University Press, 1986.

Eloduy, Eleuterio. "La generación progresiva en la Estoa y en la Biblia." *Letras de Deusto* 1:1 (1971) 107–136.

Fahie, J. J. *Memorials of Galileo Galilei.* London: Courier Press, 1929.

Falck-Yetter, Harald. *Aurora: The Northern Lights in Mythology, History, and Science.* Spring Valley, N.Y.: Anthroposophic Press, 1983.

Farago, Claire. *Leonardo da Vinci's Paragone: A Critical Interpretation with a New Edition of the Text in the Codex Urbinas.* Leiden: Brill, 1991.

Favaro, Antonio. *Galileo Galilei e Lo Studio di Padova.* 2 vols. Florence: Le Monnier, 1883.

———. *La libreria di Galileo Galilei descritta ed illustrata.* Rome: Tipografia delle Scienze Matematiche e Fisiche, 1887.

———. "Un ridotto scientifico in Venezia al tempo di Galileo Galilei." *Nuovo archivio veneto* 5 (1893) 196–209.

———. *Amici e corrispondenti di Galileo.* 3 vols. Venice: Officine Grafiche di C. Ferrari, 1894–1914. Modern re-edition with a foreword by Paolo Galluzzi. Florence: Libreria Editrice Salimbeni, 1983.

Feingold, Mordechai. "Galileo in England: The First Phase." In Paolo Galluzzi, ed., *Novità celesti e crisi del sapere: Atti del Convegno Internazionale di Studi Galileiani,* 411–420. Florence: Giunti Barbera, 1984.

Feldhay, Rivka. "Knowledge and Salvation in Jesuit Culture." *Science in Context* 1:2 (1987) 195–213.

———. *Galileo and the Church: Political Inquisition or Critical Dialogue?* Cambridge, U.K.: Cambridge University Press, 1995.

Fernández Alvarez, Manuel. *Copernico y su huella en la Salamanca del Barocco.* Salamanca, Spain: Universidad de Salamanca, 1974.

Ferrone, Vincenzo. "Galileo tra Paolo Sarpi e Federico Cesi: Premesse per una ricerca." In Paolo Galluzzi, ed., *Novità celesti e crisi del sapere,* 239–253. Florence: Giunti Barbera, 1984.

Finocchiaro, Maurice A. *The Galileo Affair.* Berkeley: University of California Press, 1989.

Flachaire, Charles. *La Dévotion à la Vierge dans la littérature catholique au commencement du XVIIe siècle.* With a preface by Jean Guitton. Paris: Apostolat de la Presse, 1957.

[Fleetwood, William, Bishop of Ely]. *The Life and Death of the B. Virgin: Giving an Account of the Miracles Ascrib'd to Her by Romish Writers, with the Grounds of the Worship Paid to Her.* London: Printed by H. Clark for Thomas Newborough, 1687.

Fontana, Francesco. *Novae coelestium terrestriumque rerum observationes.* Naples: Apud Gaffarum, 1646.

Fontana, Giovanni da. *De omnibus rebus naturalibus quae continetur in mundo videlicet coelestibus et terrestribus . . .* Venice: Ottavio Scoto, 1544.

Frajese, Vittorio. *Sarpi scettico.* Bologna: Il Mulino, 1994.

Friedlaender, Walter. "Early to Full Baroque: Cigoli and Rubens." In *Studien zur toskanischen Kunst: Festschrift für Ludwig Heinrich Heydenreich*, 65–82. Munich: Prestel-Verlag, 1964.

Frothingham, Alice Wilson. *Hispanic Glass: With Examples in the Collection of the Hispanic Society of America*. New York: Trustees of the Hispanic Society of America, 1941.

Fulke, William. *A Goodly Gallerye: William Fulke's Book of Meteors (1563)*. Edited and with an introduction and notes by Theodore Hornberger. Philadelphia: American Philosophical Society, 1979.

Gabrieli, Giuseppe. *Contribuiti alla storia della Accademia dei Lincei*. 2 vols. Rome: Accademia Nazionale dei Lincei, 1989.

Gage, John. *Color and Culture: Practice and Meaning from Antiquity to Abstraction*. Boston: A Bullfinch Press Book, Little, Brown, and Company, 1993.

Galilei, Galileo. *Discoveries and Opinions of Galileo*. Translated and with an introduction and notes by Stillman Drake. New York: Anchor Books, 1957.

———. *Discourse on the Comets*. In *The Controversy on the Comets of 1618*. Translated by Stillman Drake and C. D. O'Malley. Philadelphia: University of Pennsylvania Press, 1960.

———. *Le Opere*. Edited by Antonio Favaro. 20 vols. Florence: Giunti Barbera, 1965.

———. *Dialogue Concerning the Two Chief World Systems*. Translated by Stillman Drake. Berkeley: University of California Press, 1967^2.

———. *Dialogo sopra i due massimi sistemi del mondo*. Edited by Libero Sosio. Turin: Giulio Einaudi Editore, 1970.

———. *Sidereus Nuncius or the Sidereal Messenger.* Translated and with an introduction, commentary, and notes by Albert Van Helden. Chicago: University of Chicago Press, 1989.

———. *Le messager céleste*. Translated, annotated, and introduced by Isabelle Pantin. Paris: Les Belles Lettres, 1992.

Gambuti, A. "Lodovico Cigoli architetto." *Studi e documenti di architettura* 2 (1973) 37–136.

García Moreno, Antonio. "Juan de Pineda y el libro de Job." *Estudios Biblicos* 35 (1976) 23–47, 165–185.

Garrard, Mary D. *Artemisia Gentileschi: The Image of the Female Hero in Italian Baroque Art*. Princeton: Princeton University Press, 1989.

Gassendi, Pierre. *Opera Omnia*. 6 vols. Lyon: Laurence Anisson & Jean Baptiste Devenet, 1658. (Reprinted in a facsimile edition edited by Tullio Gregory. Stuttgart: Friedrich Frommann Verlag, 1964).

———. *The Mirror of True Nobility and Gentility*. Translated by W. Rand. London: Printed by J. Streater for Humphrey Moseley, 1657.

———. *Vie de Peiresc*. Translated by Roger Lassalle and Agnes Bresson. Paris: Belin, 1992.

Gavel, Jonathan. *Colour: A Study of Its Position in the Art Theory of the Quattro- and Cinquecento*. Stockholm: Almquist and Wiksell International, 1979.

Giacobbe, G. "Epigoni nel seicento della 'Quaestio de certitudine mathematicarum': Giuseppe Biancani." *Physis* 18 (1976) 5–40.

Ginzburg, Carlo. *Il Nicodemismo*. Turin: Giulio Einaudi Editore, 1970.

Ginzburg, Silvia. "The Portrait of Agucchi at York Reconsidered." *Burlington Magazine* 136 (Feb. 1994) 4–14.

Gombrich, E. H. *The Heritage of Apelles: Studies in the Art of the Renaissance*. Ithaca, N.Y.: Cornell University Press, 1976.

———. *New Light on Old Masters*. Chicago: University of Chicago Press, 1986.

Gomez, Susana. "The Bologna Stone and the Nature of Light." *Nuncius* 6 (1991) 3–32.

Goodman, David C. "The Scientific Revolution in Spain and Portugal." In Roy Porter and Mikulas Teich, eds., *The Scientific Revolution in National Context*, 158–177. Cambridge, U.K.: Cambridge University Press, 1992.

Gottlieb, Carla. *The Window in Art*. New York: Abaris Books, 1981.

Grafton, Anthony. "Portrait of Justus Lipsius." *American Scholar* 56:3 (1987) 382–390.

Grassi, Orazio, S.J. *The Astronomical Balance*. In *The Controversy on the Comets of 1618*. Translated by Stillman Drake and C. D. O'Malley. Philadelphia: University of Pennsylvania Press, 1960.

Gregori, Mina. "Rubens e i pittori riformati toscani." In *Rubens e Firenze*, 46–57. Florence: La Nuova Italia, 1983.

———, ed. *Il Seicento fiorentino: Pittura, Disegni, Biografie*. 3 vols. Florence: Cantini, 1986.

Grendler, Marcella. "A Greek Collection in Padua: The Library of Gian Vincenzo Pinelli (1535–1601)." *Renaissance Quarterly* 33 (1980) 386–416.

Griselini, Francesco. *Memorie anedote spettanti alla vita ed agli studi del sommo Filosofo e Giuresconsulto F. Paolo Servita*. Lausanne: M. Michel Bousquet et Compagnie, 1760.

Grudin, Robert. "Rudolf II of Prague and Cornelis Drebbel: Shakespearean Archetypes?" *Huntington Library Quarterly* 54 (1991) 181–205.

Gualdo, Paolo. *Vita Ioannis Vincentii Pinelli*. Augsburg: Christoph Mangus, 1607. Reprinted in Christian Gryphius, ed., *Vitae selectae quorundam eruditissimorum ac illustrium virorum*. Vratislavae: Christiani Bauchii, 1711.

Gualterotti, Francesco Maria. *Vaghezza di Francesco Maria Gualterotti*. In Nunzio Vaccalluzzo, *Galileo Galilei nella poesia del suo secolo*, 40. Milan: Remo Sandron Editore, 1910.

Gualterotti, Raffaello. *Discorso sopra l'apparizione de la nuova stella*. Florence: Cosimo Giunti, 1605.

———. *Scherzi degli spiriti animali*. Florence: Cosimo Giunti, 1605.

Guasti, Cesare, ed. *Il passio o vangelo di Nicodemo*. Bologna: Romagnoli, 1862.

Hahm, David E. *The Origins of Stoic Cosmology*. Columbus: The Ohio State University Press, 1977.

Hale, J. R. *Artists and Warfare in the Renaissance*. New Haven: Yale University Press, 1990.

Hall, Marcia B. *Color and Meaning: Practice and Theory in Renaissance Painting*. Cambridge, U.K.: Cambridge University Press, 1992.

Harris, L. E. *The Two Netherlanders Humphrey Bradley and Cornelis Drebbel*. Cambridge, U.K.: W. Heffer and Sons, 1961.

Harris, Stephen J. "Transposing the Merton Thesis: Apostolic Spirituality and the

Establishment of the Jesuit Scientific Tradition." *Science in Context* 3:1 (1989) 29–65.

Harvey, E. Newton. *A History of Luminescence from the Earliest Times until 1900.* Philadelphia: American Philosophical Society, 1957.

Havenreuter, Ioannes Lodovico. *Commentaria in Aristotelis Meteorologicorum libros quatuor.* Frankfurt: "E Collegio Musarum Paltheniano" [Zacharias Palthenius], 1605.

Held, Julius S. "Rubens and Aguilonius: New Points of Contact." *Art Bulletin* 61 (1979) 257–264.

Hellmann, C. Doris. *The Comet of 1577: Its Place in the History of Astronomy.* New York: AMS Press, 1971.

Hevelius, Johannes. *Selenographia sive Lunae Descriptio.* Gdansk: Hunefeld, 1647.

Hlavackova, Hana, and Hana Seifertova. "La Madone de Most: Imitation et symbole." *Revue de l'Art* 67 (1985) 59–65.

Hooykaas, R. *G. J. Rheticus' Treatise on Holy Scripture and the Motion of the Earth.* Amsterdam: North-Holland Publishing, 1984.

Hoppenbrouwers, Valerius, Ord. Carm. *Devotio Mariana.* Rome: Istitutum Carmelitum, 1960.

Horace. *Horatii Opera Omnia.* Edited by George Long and the Reverend A. J. Macleane. 2 vols. London: Whittaker and Co., 1853.

Hoskin, Michael. *Stellar Astronomy: Historical Studies.* New York: Science History Publications, 1977.

Huemer, Frances. *Portraits.* In Ludwig Burchard, ed., *Corpus Rubenianum*, XIX, I: 163–166. London: H. Miller, 1977.

———. "Rubens and Galileo 1604: Nature, Art, and Poetry." *Wallraf-Richartz-Jahrbuch* 44 (1983) 175–196.

Ioachimicus, Johannes Praetorius. *De cometis, qui antea visi sunt, et de eo, qui novissime mense novembri apparvit, narratio.* Nuremberg: In Officina Typographica Catharin Gerlachin, & Haeredum Iohannis Montani, 1578.

Isnardi Parente, Margherita, ed. *Stoici antichi.* 2 vols. Turin: Unione Tipografico-Editrice Torinese, 1989.

Jacoli, Ferdinando. "Intorno a due scritti di Raffaele Gualterotti fiorentino." *Bullettino di bibliografia e di storia delle scienze matematiche e fisiche* 7 (August 1874) 377–405.

Jaffe, David. "Mellan and Peiresc." *Print Quarterly* 7 (1990) 168–175.

Jaffe, Michael. "Rubens and Optics: Some Fresh Evidence." *Journal of the Warburg and Courtauld Institutes* 34 (1971) 362–366.

———. *Rubens and Italy.* Oxford: Oxford University Press, 1977.

Kemp, Martin. *The Science of Art: Optical Themes in Western Art from Brunelleschi to Seurat.* New Haven: Yale University Press, 1990.

———. "Lodovico Cigoli on the Origins and *Ragione* of Painting." *Mitteilungen des kunsthistorischen Institutes in Florenz* 35:1 (1991) 133–152.

Kepler, Johannes. *Opera Omnia.* Edited by Ch. Frisch. 8 vols. Frankfurt: Heyden & Zimmer, 1858–1870.

———. *Gesammelte Werke.* Edited by Max Caspar and Walther von Dyck. 20 vols. to date. Munich: Beck, 1937–.

Koelbing, Huldrych M. "Anatomia dell'occhio e percezione visivia nell'opera di G. Fabrizi d'Acquapendente." *Acta medicae historiae Patavina* 35–36 (1988–1989) 29–38.

Koyre, Alexander. "A Documentary History of the Problem of Fall from Kepler to Newton." *Transactions of the American Philosophical Society*, n.s., 45:4 (1955) 329–395.

Kristof, Jane. "Michelangelo as Nicodemus: *The Florence Pietà.*" *Sixteenth Century Journal* 20:2 (1989) 163–182.

Lagalla, Giulio Cesare. *De Phaenomenis in orbe lunae.* In Galileo Galilei, *Le Opere*, III (1):309–399.

Langedijk, Karla. "A New Cigoli: The State Portrait of Cosimo de' Medici, and a suggestion Concerning the Cappella de' Principi." *Burlington Magazine* 113 (October 1971) 575–579.

Lapide, Cornelius a, S.J. *Commentaria in Sacram Scripturam.* 26 vols. Paris: Ludovicus Vives, 1866–1868.

Lattis, James M. *Between Copernicus and Galileo: Christoph Clavius and the Collapse of Ptolemaic Cosmology.* Chicago: University of Chicago Press, 1994.

Lebegue, Raymond. *Les correspondants de Peiresc dans les anciens Pays-Bas.* Brussels: Office de Publicité, 1943.

Leclerq, Henri. "Etienne (Martyre et Sépulture de Saint)." In Fernand Cabrol and Henri Leclerq, eds., *Dictionnaire d'Archéologie et de Liturgie*, V (1), cols. 624–671. 15 vols. Paris: Libraire Letouzey et Ané, 1907.

Lettere inedite del secolo xvi–xvii. Ms. Ital. 204. Rare Book Room, University of Pennsylvania.

Lettere d'uomini illustri: Che fiorirono nel principio del secolo decimosettimo: Non piu stampate. Venice: Baglioni, 1744.

Lindberg, David C. *Theories of Vision from Al-Kindi to Kepler.* Chicago: University of Chicago Press, 1976.

———. "Medieval Latin Theories of the Speed of Light." In *Studies in the History of Medieval Optics*, chapter 9. London: Variorum Reprints, 1983.

Link, Frantisek. "Observations et catalogue des aurores boréales apparues en occident de -626 à 1600." *Geofysikalni Sbornik* (Prague) 10 (1962) 297–387.

———. "Observations et catalogue des aurores boréales apparues en occident de 1601 à 1700." *Geofysikalni Sbornik* 12 (1964) 501–547.

———. "On the History of the Aurora Borealis." *Vistas in Astronomy* 9 (1967) 297–306.

Lipsius, Justus. *Physiologia Stoicorum.* Antwerp: Plantin, 1610.

Locher, Johannes Georgius. *Disquisitiones mathematicae de controversiis ac novitatibus astronomicis.* Ingolstadt: Elizabeth Angermaria, 1614.

Lomazzo, Giovanni Paolo. *Trattato dell'arte de la pittura.* Milan: Paolo Gottardo Pontio, 1584.

López Piñero, José Maria. *Ciencia y Tecnica en la sociedad española de los siglos XVI y XVII.* Barcelona: Labor Universitaria, 1979.

Lucidus, Johannes Samotheus. *Opusculum de emendationibus temporum.* Venice: Luc. Ant. Giunta, 1546.

Lucretius. *De Rerum Natura.* Edited by William E. Leonard and Stanley B. Smith. Madison: University of Wisconsin Press, 1942.

Maclaren, Neil. *The Spanish School.* 2d ed. Revised by Allen Braham. London: National Gallery, 1970.

Macleod, C. W. "Allegory and Mysticism in Origen and Gregory of Nyssa." *Journal of Theological Studies,* n.s., 22:2 (1971) 362–379.

Maelcote, Odo van, S.J. *Nuncius Sidereus Collegii Romani.* In Galileo Galilei, *Le Opere,* III (1): 293–298.

Magini, Giovanni Antonio. *Novae Coelestium Orbium Theoricae congruentes cum observationibus N. Copernici.* Venice: Damiano Zenario, 1589.

———. "De astrologica ratione." *Commentarius in Claudii Galeni de Diebus Decretorijs Librum Tertium.* Venice: D. Zenarij, 1607.

Mahon, Dennis. *Studies in Seicento Art and Theory.* London: Warburg Institute, 1947.

Mairan, J.J.D. *Traité physique et historique de l'aurore boréale.* Paris: Imprimerie Royale, 1733.

Maldonado, Juan de, S.J. *Commentaria in quattuor Evangelistas.* Venice: Apud Ioan. Baptistam, & Ioannem Bernardum Sessam, 1597.

Mallory, Nina. *El Greco to Murillo: Spanish Painting in the Golden Age, 1556–1700.* New York: HarperCollins, 1990.

Mann, H. "Die Plastität des Mondes—zu Galileo Galilei und Lodovico Cigoli." *Kunsthistorisches Jahrbuch Graz* 23 (1987) 55–59.

Marani, Ercolano. "Le rappresentazioni cartografiche rinascimentali della città di Mantova." In *Mantova e i Gonzaga nella civiltà del Rinascimento,* 453–470. Mantua: Accademia Virgiliana e Arnaldo Mondadori, 1977.

Mariana, Juan, S.J. *Scholia in vet. et novum Testamentum.* Paris: Ad Agnum Novis, 1620.

Mariani Canova, Giordana. "Riflessioni su Jacopo Bellini e sul libro dei disegni del Louvre." *Arte Veneta* 26 (1972) 9–30.

Marino, Giovanni Battista. "Il Cielo, Diceria Terza." In *Dicerie Sacre* e *La Strage de gl'innocenti.* Edited by Giovanni Pozzi. Turin: Giulio Einaudi, 1960.

———. *Lettere.* Edited by Marziano Guglielminetti. Turin: Giulio Einaudi, 1966.

———. *Adone.* Edited by Giuseppe Guido Ferrero. Turin: Giulio Einaudi, 1976.

Márquez, Antonio. "Ciencia e Inquisición en España del XV al XVII." *Arbor* 124 (1986) 65–83.

Martin, John. *Venice's Hidden Enemies: Italian Heretics in a Renaissance City.* Berkeley: University of California Press, 1993.

Masetti Zannini, G. L. "Libri di fra Paolo Sarpi e notizie di altre biblioteche dei Servi (1599–1600)." *Studi Storici dell'ordine dei Servi di Maria* 20 (1970) 174–202.

Matteoli, Anna. "Macchie di Sole e Pittura, Carteggio, L. Cigoli–G. Galilei (1609–1613)." *Bollettino della Accademia degli Euteleti della Città di San Miniato* 32 (1959) 9–92.

———. "Cinque lettere di Lodovico Cardi Cigoli a Michelangelo Buonarroti il Giovane." *Bollettino della Accademia degli Euteleti della Città di San Miniato* 28 (1964–1965) 31–42.

Matteoli, Anna. *Lodovico Cardi Cigoli pittore e architetto*. Pisa: Giardini, 1980.
————. "Apporti a Jacopo e Domenico Tintoretto." *Antichità Viva* 25:5–6 (1986) 45–50.
Meiss, Millard. "Light as Form and Symbol in Some Fifteenth-Century Paintings." *Art Bulletin* 27 (1945) 175–181.
Mersenne, Marin. *Harmonie Universelle*. Paris: Sébastien Cramoisy, 1636.
Micanzio, Fulgenzio. *Vita del padre Paolo*. In Paolo Sarpi, *Istoria del Concilio Tridentino, seguita dalla Vita del padre Paolo di Fulgenzio Micanzio*, II: 1275–1413. Edited by Corrado Vivanti. 2 vols. Turin: Giulio Einaudi Editore, 1974.
Migne, Jacques Paul, ed. *Patrologiae cursus completus Series Latina*. 221 vols. Paris: Migne, 1844–1864.
Milani, Marisa. "Galileo Galilei e la letteratura pavana." In Giovanni Santinello, ed., *Galileo e la cultura padovana*, 179–202. Padua: CEDAM, 1992.
Millás y Vallicrosa, José Maria, and David Romano, trans. and eds. *Cosmografia de un Judio Romano del siglo XVII*. Barcelona: S. A. Horta de I. E., 1954.
Milton, John. *John Milton*. Edited by Stephen Orgel and Jonathan Goldberg. Oxford and New York: Oxford University Press, 1990.
Mommert, Charles. *Saint Etienne et ses sanctuaires à Jérusalem*. Jerusalem: S.n., 1912.
Montaigne, Michel. *Journal de Voyage en Italie*. Edited and annotated by Maurice Rat. Paris: Editions Garnier Frères, 1955.
Morel, Philippe. "Morfologia delle cupole dipinte da Correggio a Lanfranco." *Bollettino d'arte* 69, ser. 6, no 23 (Jan.–Feb. 1984) 1–34.
Moreni, Domenico. *Delle tre sontuose Cappelle Medicee situate nell'Imp. Basilica di S. Lorenzo*. Florence: Carli e Comp., 1813.
Morford, Mark. *Stoics and Neostoics: Rubens and the Circle of Lipsius*. Princeton: Princeton University Press, 1991.
Moriconi, Annalisa. "Il Covolo di Costozza nella storiografia." In Ermengildo Reato, ed., *Costozza*, 476–490. Vicenza: Cassa Rurale e Artigiana di Costozza e Tramonte-Praglia, 1983.
Morreale de Castro, Margherita. *Pedro Simon Abril*. Madrid: Revista de Filologia Española, 1949.
Moss, Jean Dietz. *Novelties in the Heavens: Rhetoric and Science in the Copernican Controversy*. Chicago: University of Chicago Press, 1993.
Muccillo, M. "Lodovico delle Colombe." In *Dizionario biografico degli italiani*, 38: 29–31. 44 vols. to date. Rome: Istituto della Enciclopedia Italiana, 1960–1994.
————. "Fabrici d'Acquapendente." In *Dizionario biografico degli italiani*, 43: 768–774.
Muller, Jeffrey M. "Rubens's Theory and Practice of the Imitation of Art." *Art Bulletin* 64 (1982) 229–247.
Nadal, Gerónimo, S.J. *Adnotationes et meditationes in Evangelia*. Antwerp: Martin Nutius, 1595².
Nardi, Bruno. "La dottrina delle macchie lunari nel secondo canto del *Paradiso*." In *Saggi di filosofia dantesca*, 3–39. Florence: La Nuova Italia, 1967².
Natali, Antonio. "La 'Deposizione' giovanile del Cigoli." *Paragone* 38, n.s., no. 4: 449 (July 1987) 75–80.

Nausea, Friedrich. *A Treatise of Blazing Stars in Generall.* Translated by Abraham Fleming. London: Thomas Woodcocke, 1577.

Navarro Brótons, Victor. "Contribución a la historia del copernicanismo en España." *Cuadernos Hispanoamericanos* 283 (1974) 3–23.

News for the Curious. London: M. Pardo, G. Downes, and B. Aylmer, 1684.

Nifo, Agostino. *Aristotelis Stagiritae De Caelo et Mundo.* Venice: G. Scoto, 1549.

Novarini, Luigi, C.R. *Umbra Virginea.* Verona: Typis Rubeanis, 1653[5].

O'Connor, Edward Dennis, C.S.C., ed. *The Dogma of the Immaculate Conception.* Notre Dame, Ind.: University of Notre Dame Press, 1958.

Odoardi, G. V. "Ilario Altobelli, *senior.*" In *Dizionario biografico degli italiani,* II: 567–568. 44 vols. to date. Rome: Istituto della Enciclopedia Italiana, 1960–1994.

Oestreich, Gerhard. *Neostoicism and the Early Modern State.* Cambridge, U.K.: Cambridge University Press, 1982.

Orbaan, J.A.F. *Documenti sul Barocco in Roma.* Rome: Nella Sede della Società alla Biblioteca Valicelliana, 1920.

Origen. *Homélies sur Jérémie.* Translated and annotated by Pierre Husson and Pierre Nautin. 2 vols. Paris: Les Editions du Cerf, Sources Chrétiennes, 1976–1977.

Ortiz de Zúñiga, Diego. *Anales eclesiasticos y seculares de la muy noble, y muy leal Ciudad de Sevilla.* Madrid: Imprenta Real, 1677.

Ostrow, Steven F. *Art and Spirituality in Counter-reformation Rome: The Sistine and Pauline Chapels in Santa Maria Maggiore.* Cambridge, U.K., and New York: Cambridge University Press, 1996.

———. "Cigoli's Immaculate Virgin and Galileo's Moon: Astronomy and the Apocalyptic Woman in Early *Seicento* Rome." *Art Bulletin* 78 (June 1996) 218–235.

Ovid. *Metamorphoses.* Translated by Frank Justus Miller. Cambridge, Mass.: Harvard University Press, Loeb Classical Library, 1977[3].

Pacheco, Francisco. *Arte de la Pintura.* Edited by Bonaventura Bassegoda i Hugas. Madrid: Ediciones Catédra, 1990.

Pallucchini, Rodolfo. *La pittura veneziana del Seicento.* 2 vols. Venice: Alfieri, 1981.

Panofsky, Erwin. *Galileo as a Critic of the Arts.* The Hague: Martinus Nijhoff, 1954.

———. "Galileo as a Critic of the Arts: Aesthetic Attitude and Scientific Thought." *Isis* 147:1 (March 1956) 3–15.

Parkhurst, Charles. "Aguilonius' Optics and Rubens' Color." *Nederlands Kunsthistorisch Jaarboek* 12 (1961) 35–49.

Paschini, Pio. "Angelus Domini." In *Enciclopedia Cattolica* I, cols. 1260–1261.

Patrizi, Francesco. *Nova de universis philosophia.* Ferrara: Benedetto Mamarello, 1591.

Pecham, John. *Perspectiva communis.* Edited and with an introduction, English translation, and critical notes by David C. Lindberg. Madison: University of Wisconsin Press, 1970.

Peiresc, Nicolas Fabri de. *Correspondance.* Edited by Tamizey de Larroque. 7 vols. Paris: Imprimerie Nationale, 1888–1898.

Pépin, Jean. *Mythe et allégorie: Les origines grecques et les contestations judeo-chrétiennnes.* Aubier: Editions Montaigne, 1958.

Petrarch, Francesco. *Canzoniere.* Introduced and annotated by Piero Cudini. Milan: Grandi Libri Garzanti, 1974.

Peurbach, Georg. *Theoricae Novae Planetarum.* Edited by Erasmus Reinhold. Wittemberg: I. Lufft, 1553.

Pigafetta, Filippo. *La descrizione del territorio e del contado di Vicenza (1602–1603).* Edited by Alvise da Schio and Franco Barbieri. Vicenza: Neri Pozza, 1974.

Piles, Roger de. *Cours de peinture par principes.* Paris: Jacques Estienne, 1708.

Pineda, Juan de, S.J. *De rebus Solomonis.* Lyon: Horace Cardon, 1609.

———. *Sermon en el primer dia del Octav. votivo al la inmaculada concepción.* Seville: Alonso Rodriguez Gamarra, 1615.

———. *Sermon en el dia i fiesta de la Concepción.* Seville: Francisco de Lyra, 1618.

Pizzardo, Giuseppe Cardinal et al., eds. *Enciclopedia Cattolica.* 12 vols. Vatican City: Ente per l'Enciclopedia Cattolica e per il libro Cattolico, 1948–1954.

Pizzorusso, Claudio. *Ricerche su Cristofano Allori.* Florence: Leo S. Olschki Editore, 1982.

Plutarch. *Concerning the Face Which Appears in the Orb of the Moon.* Translated by Harold Cherniss and William C. Helmbold. In *Moralia*, XII. 15 vols. Cambridge, Mass.: Harvard University Press, 1957.

Pobladura, Melchiore a, O.F.M. Cap., ed. *Regina Immaculata.* Rome: Institutum Historicum O.F.M. Cap., 1955.

Poppi, Antonio. *Cremonini e Galilei Inquisiti a Padova nel 1604.* Padua: Antenore, 1992.

Pseudo-Dionysius, the Aeropagite. *The Complete Works.* Translated by Colm Lubheid. Foreword, notes, and translation collaboration by Paul Rorem. Preface by René Roques. New York: Paulist Press, 1987.

Purnell, Frederick, Jr. "Jacopo Mazzoni and Galileo." *Physis* 14 (1972) 273–294.

Réau, Louis. *Iconographie de l'Art Chrétien.* 3 vols. Paris: Presses Universitaires de France, 1957.

Redondi, Pietro. "Galilée aux prises avec les théories aristoteliciennes de la lumière (1610–1640)." *Dix-Septième Siècle* 136 (1982) 267–283.

Reeves, Eileen. "Reading Maps." *Word & Image* 9:1 (Jan.–March 1993) 51–65.

Renazzi, Filippo Maria. *Storia dell'Università degli Studi di Roma, detta comunemente "La Sapienza."* Rome: Stamperia Pagliarini, 1805.

Revised English Bible with the Apocrypha. Oxford: Oxford University Press, 1989.

Rhodiginus, L. Coelius. *Lectionum Antiquarum.* Basel: Per Hier. Frobenium et Nicol. Episcopium, 1542.

Ribera, Francisco de. *In Sacram beati Joannis apostoli et evangelistae Apocalypsim commentarii.* Lyon: Ex Officina Iuntarum, 1593.

Ricci, Saverio. "Federico Cesi e la *nova* del 1604." *Rendiconti, Accademia nazionale dei Lincei, Classe di scienze morali storiche e filologiche,* 8th ser., 43 (1988) 111–133.

Riccioli, Giovanni Battista, S.J. *Almagestum Novum.* Bologna: Ex Typographia Haeredis V. Benati, 1651.

Richter, George M. *Giorgio da Castelfranco called 'Giorgione.'* Chicago: University of Chicago Press, 1937.

Righini, Guglielmo. "La tradizione astronomica fiorentina e l'osservatorio di Arcetri." *Physis* 4: 1 (1962) 132–150.

Ripa, Cesare. *Iconologia.* Rome: Lepido Facii, 1603³. (Facsimile edition introduced by Erna Mandowsky. Hildesheim: Georg Olms Verlag, 1984.)

Rizza, Cecilia. "Galileo nella corrispondenza di Peiresc." *Studi francesi* 5 (1961) 433–451.

———. *Peiresc e l'Italia.* Turin: Giappichelli Editore, 1965.

Rochemonteix, Camille, S.J. *Un collège de Jésuites aux XVII et XVIII siècles.* 4 vols. Le Mans: Leguicheux, 1889.

Romano, Ruggiero. "Tra XVI e XVII secolo. Una crisi economica: 1619–1622." *Rivista storica italiana* 74: 3 (1962) 480–531.

Ronconi, Giorgio. "Paolo Gualdo e Galileo." In Giovanni Santinello, ed., *Galileo e la cultura padovana,* 359–371. Padua: CEDAM, 1992.

Rooses, Max, and Charles Ruelens, eds. *Correspondance de Rubens et documents épistolaires concernant sa vie et ses oeuvres.* 6 vols. Antwerp: J. E. Buschmann, 1887–1909.

Roschini, Gabriele, Giuseppe Low, and Emilio Lavagnino. "Immacolata Concezione." In *Enciclopedia Cattolica,* vol. 6, cols 1651–1663.

Rose, Henry. *A Philosophicall Essay for the Reunion of the Languages.* Oxford by H. Hall for J. Good, 1675.

Rosen, Edward. "The Title of Galileo's *Sidereus Nuncius.*" *Isis* 41 (1950) 287–289.

———. "Stillman Drake's *Discoveries and Opinions of Galileo.*" *Isis* 48 (1957) 440–443.

Rossi, Paola. "Alcuni Ritratti di Domenico Tintoretto." *Arte Veneta* 22 (1968) 60–71.

———. "I ritratti femminili di Domenico Tintoretto." *Arte Illustrata* 3 (June–September 1970) 93–99.

Rotondò, Antonio. "Atteggiamenti della vita morale italiana del Cinquecento: La pratica nicodemitica." *Rivista storica italiana* 79 (1967) 991–1030.

Ruspoli, Francesco. *Sonetti di Francesco Ruspoli.* With the commentary of Andrea Cavalcanti(?). In *Scelta di curiosità letterarie.* Bologna: Commissione per i Testi di Lingua, 1968.

Salzer, Anselm. *Die Sinnbilder und Beiworte Mariens in der deutschen Literatur und die lateinischen Hymnpoesie des Mittelalters.* Darmstadt: Wissenschaftliche Buchgesellschaft, 1967.

Sambursky, Samuel. *Physics of the Stoics.* London: Routledge and Kegan Paul, 1959.

Sánchez Cantón, Francisco Javier. "La Librería de Velázquez." In *Homenaje ofrecido a Menéndez Pidal,* III: 388–405. 3 vols. Madrid: Hernando, 1925.

Santillana, Giorgio de. *The Crime of Galileo.* New York: Time, 1962.

Sarpi, Paolo. *Le Opere di Fra Paolo Sarpi.* 8 vols. Helmstadt [Venice]: Per Jacopo Mulleri, 1761–1768.

———. *Lettere di Fra Paolo Sarpi.* Edited and annotated by F. L. Polidori. 2 vols. Florence: Giunti Barbera, 1863.

Sarpi, Paolo. *Lettere ai protestanti*. Edited by Manlio Busnelli. 2 vols. Bari: Giuseppe Laterza & Figli, 1931.

―――. *Scritti filosofici e teologici editi e inediti*. Edited by Romano Amerio. Bari: Giuseppe Laterza & Figli, 1951.

―――. *Opere*. Edited by Gaetano and Luisa Cozzi. Milan: Riccardo Ricciardi Editore, 1969.

Saunders, Jason Lewis. *Justus Lipsius: The Philosophy of Renaissance Stoicism*. New York: The Liberal Arts Press, 1955.

Savio, Pietro. "Per l'epistolario di Paolo Sarpi." *Aevum* 14 (1936) 3–105; 15 (1937) 13–75, 275–322; 17 (1939) 2–60; 18 (1940) 3–84; 20 (1942) 3–43.

Scheiner, Christoph, S.J. *Rosa Ursina*. Bracciani: Apud Andream Phoeum Typographum Ducalem, 1630.

―――. *Pantographice, seu Ars Delineandi Res Quaslibet per Parallelogrammum*. Rome: Luigi Grignani, 1631.

―――. *Accuratior Disquisitio*. In Galileo Galilei, *Le Opere*, V: 39–70.

Schiller, Gertrud. *Iconography of Christian Art*. Translated by Janet Seligman. 2 vols. Greenwich, Conn.: New York Graphic Society, 1971.

Schlief, Corine. "Nicodemus and Sculptors: Self-Reflexivity in Works by Adam Kraft and Tilman Riemenschneider." *Art Bulletin* 75:4 (1993) 599–626.

Schofield, Christine Jones. *Tychonic and Semi-Tychonic World Systems*. New York: Arno Press, 1981.

Schove, D. Justin. "Sunspots, Aurorae and Blood Rain: The Spectrum of Time." *Isis* 42 (1951) 133–138.

Schwager, Klaus. "Die architektonische Erneuerung von S. Maria Maggiore unter Paul V." *Römisches Jahrbuch für Kunstgeschichte* 20 (1983) 243–312.

Scott, Alan. *Origen and the Life of the Stars: A History of an Idea*. Oxford: Clarendon Press, 1991.

Segre, Michael. *In the Wake of Galileo*. New Brunswick, N.J.: Rutgers University Press, 1991.

Seneca. *The Workes of Seneca*. Newly inlarged and corrected by Thomas Lodge. London: W. Stansby, 1620.

―――. *Quaestiones Naturales*. In N. M. Bouillet, ed., *Opera philosophica*, V. Paris: Bibliotheca Classica Latina, 1830.

Settle, Thomas. "Ostilio Ricci, a Bridge between Alberti and Galileo." *12ᵉ congrès international d'histoire des sciences* (Paris, 1971) 3 B: 121–126.

Shea, William. *Galileo's Intellectual Revolution*. New York: Science History Publications, 1977.

Shearman, John. *Only Connect . . . Art and the Spectator in the Italian Renaissance*. Bollingen Series 35:37. Princeton: Princeton University Press, 1992.

Shrimplin-Evangelidis, Valerie. "Michelangelo and Nicodemism: The Florentine Pietà." *Art Bulletin* 71:1 (1989) 58–66.

Siscoe, George L. "An Historical Footnote on the Origin of 'Aurora Borealis.'" *Eos* 59 (1987) 994–997.

Snellius, Willebrord. *Descriptio Cometae Anni 1618*. Louvain: Elzevir, 1619.

Soldani, Jacopo. *Capitolo contro i Peripatetici*. In Nunzio Vaccalluzzo, *Galileo nella poesia del suo secolo*, 19–30. Milan: Remo Sandron, 1911.

Sommervogel, Carlos, ed. *Bibliothèque de la Compagnie de Jésus*. 12 vols. Brussels: Oscar Schepens, 1960.

Sosio, Liberio. "I 'Pensieri' di Paolo Sarpi sul moto." *Studi veneziani* 13 (1974) 315–392.

Spalding, Jack J. "Santi di Tito and the Reform of Florentine Mannerism." *Storia dell'arte* 47 (1983) 41–52.

Spedalieri, Francesco, S.J. *Maria nella Scrittura e nella tradizione della Chiesa primitiva*. Rome: Herder Editrice, 1968.

Staigmueller, Hermann. "Württembergische Mathematiker." *Württembergische Vierteljahrshefte für Landesgeschichte* 12 (1903) 227–256.

Stano, Gaetano, and Francesco Balsimelli. "Un illustre scienziato francescano amico di Galileo." *Miscellanea Francescana* 43 (1943) 81–129.

Stechow, Wolfgang. "Joseph of Arimathea or Nicodemus?" In Wolfgang Lotz and Lise Lotte Moller, eds., *Studien zur toskanischen Kunst*, 289–302. Munich: Prestel-Verlag, 1964.

Stella, Aldo. "Galileo, il circolo culturale di Gian Vincenzo Pinelli e la 'Patavina Libertas.'" In Giovanni Santinello, ed., *Galileo e la cultura padovana*, 307–325. Padua: CEDAM, 1992.

Stratton, Suzanne. "The Immaculate Conception in Spanish Renaissance and Baroque Art." Ph.D. dissertation, New York University, 1983.

Strothers, Richard. "Ancient Aurorae." *Isis* 70 (1979) 85–95.

Sylveira, João da. O. Carm. *Commentarii in Apocalypsim*. Lyon: Anisson et Posuel, 1687–1701.

Tait, Hugh. *The Golden Age of Venetian Glass*. London: British Museum Publications, 1979.

Tarde, Jean. *À la rencontre de Galilée: Deux voyages en Italie*. Edited and annotated by François Moureau and Marcel Tetel. Geneva: Slatkine, 1984.

Targioni Tozzetti, Giovanni. *Notizie degli aggrandimenti delle scienze fisiche accaduti in Toscana nel corso di anni lx. del secolo XVII*. 3 vols. Florence: Giuseppe Bouchard, 1780.

Tasso, Torquato. *Le Rime di Torquato Tasso*. Edited by Angelo Solerti. 4 vols. Bologna: Romagnoli-dall'acqua, 1898–1902.

Tirinus, Jacques, S.J. *Commentaria*. 3 vols. Antwerp: Apud Martinum Nutium,1632.

Toesca, I., and R. Zapperi. "Giovanni Battista Agucchi." In *Dizionario Biografico degli Italiani*, I: 504. 44 vols. to date. Rome: Istituto della Enciclopedia Italiana, 1960–1994.

Tomasini, Jacopo Filippo. *V. C. Larentii Pignorii Pat. Bibliotheca et museum*. Venice: Giovanni Pietro Pinelli, 1632.

Vaccalluzzo, Nunzio. *Galileo Galilei nella poesia del suo secolo*. Milan: Remo Sandron, 1910.

Vagnetti, Luigi. "Prospettiva." *Studi e Documenti di Architettura* 9–10 (March 1979).

Valcanover, Francesco. "Gli affreschi di Tiziano al Fondaco dei Tedeschi." *Arte veneta* 21 (1967) 266–268.

Van den Wyngaerde, Anton. *Spanish Cities of the Golden Age: The Views of Anton van den Wyngaerde.* Edited by Richard L. Kagan. Berkeley: University of California Press, 1989.

Van Engen, John H. *Rupert of Deutz.* Berkeley: University of California Press, 1983.

Van Helden, Albert. "Saturn and His Anses." *Journal for the History of Astronomy* 5:2 (1974) 105–121.

———. *"Annulo Cingitur:* The Solution of the Problem of Saturn." *Journal for the History of Astronomy* 5:3 (1974) 155–174.

———. "The 'Astronomical Telescope' 1611–1650." *Annali dell'Istituto e Museo di storia della scienza* 1:2 (1976) 11–36.

———. "The Invention of the Telescope." *Transactions of the American Philosophical Society* 67:4 (1977) 5–64.

Vasari, Giorgio. *Le Opere di Giorgio Vasari.* With new annotations and comments by Gaetano Milanesi. 9 vols. Florence: G. C. Sansoni, 1906.

———. *Le Vite.* Edited and annotated by Rosanna Bettarini and Paola Barocchi. 7 vols. Florence: Sansoni, 1966–1976.

Vernet Gines, Juan. "Copernicus in Spain." *Colloquia Copernicana* 1 (1972) 271–291.

———. *Historia de la ciencia espanola,*108–126. Madrid: Instituto de Espana, 1975.

Vicomercati, Francisco. *In quatuor libros Aristotelis Meteorologicorum commentarii.* Paris: Vascosanus, 1556.

Viegas, Blasius. *Commentarii exegetici in Apocalypsin.* Venice: Apud Societatem Venetam, 1608.

Vignola, Jacopo Barozzi da. *Regole della prospettiva Prattica.* With a preface by Ciro Luigi Anzivino. Sala Bolognese: Arnaldo Forni, 1985.

Villanueva, Tómas de. *Sermones de la Virgen y Obras Castellanas.* Introduced, translated, and annotated by Francisco Santos Santamaria, O.S.A. Madrid: Biblioteca de Autores Cristianos, 1952.

Villoslada, Riccardo G. di, S.J. *Storia del Collegio Romano dal suo inizio (1551) alla soppressione della Compagnia di Gesù (1773).* Rome: The Gregoriana, 1954.

Vitello. *Perspectiva.* In Friedrich Risner, *Opticae Thesaurus.* Basel: Per Episcopios, 1572.

Vittorelli, Andrea. *Gloriose Memorie della Beatissima Vergine Madre di Dio; Gran parte delle quali sono accennate, con Pitture, Statue, & altro nella maravigliosa Capella Borghesia, dalla Santità di N. S. PP. Paolo V. edificata nel Colle Esquilino.* Rome: Guglielmo Facciotto, 1616.

Vitruvius. *De Architectura.* Pisa: Giardini Editore, 1975.

Viviani, Vincenzo. *Racconto istorico.* In Galileo Galilei, *Le Opere,* XIX: 597–632.

Vliegenthart, Adriaan. *La galleria Buonarroti: Michelangelo e Michelangelo il Giovane.* Florence: Istituto Universitario Olandese di Storia dell'Arte, 1976.

Vranich, S. B. *Ensayos Sevillanos del Siglo de Oro.* Valencia: Ediciones Albatros Hispanofila, 1981.

Wallace, William. "An Account of the Inventor of the Pantograph." *Transactions of the Royal Society of Edinburgh* 13 (1836) 418–439.

Wallace, William A. *Galileo and His Sources: The Heritage of the Collegio Romano in Galileo's Science*. Princeton: Princeton University Press, 1984.

———. "The Problem of Apodictic Proof in Early 17th Century Mathematics: Galileo, Guevara, and the Jesuits." *Science in Context* 3:1 (1989) 67–87.

Weber, F. W. *Artists' Pigments*. New York: D. Van Nostrand Company, 1923.

Westman, Robert S. "Proof, Poetics, and Patronage: Copernicus's Preface to *De revolutionibus*." In David C. Lindberg and Robert S. Westman, eds., *Reappraisals of the Scientific Revolution*, 166–205. Cambridge, U.K.: Cambridge University Press, 1990.

Wilkins, John. *The Discovery of a World in a Moone*. Introduced by Barbara Shapiro. Delmar, N.Y.: Scholars' Facsimiles and Reprints, 1973.

———. "The Earth May Be a Planet." In *The Mathematical and Philosophical Works of the Right Reverend John Wilkins*, I. 2 vols. London: C. Whittingham, 1802.

Winkler, Mary G., and Albert Van Helden. "Representing the Heavens: Galileo and Visual Astronomy." *Isis* 83 (1992) 195–217.

Winwood, Sir Ralph. *Memorials of Affairs of State*. 3 vols. London: T. Ward, 1725.

Wittkower, Rudolf and Margot. *Born under Saturn*. London: Weidenfeld and Nicolson, 1963.

Wootton, David. *Paolo Sarpi between Renaissance and Enlightenment*. Cambridge, U.K.: Cambridge University Press, 1983.

Wotton, Henry. *Elements of Architecture*. London: Printed for John Bill, 1624.

———. *The Life and Letters of Sir Henry Wotton*. Edited by Logan Pearsall Smith. 2 vols. Oxford: Clarendon Press, 1907.

Zen Benetti, Francesca. "La libreria d Girolamo Fabrici d'Acquapendente." *Quaderni per la storia dell'Università di Padova*, 9–10 (1976) 161–183.

———. "Per la biografia di Lorenzo Pignoria, erudito padovano." In Maria Chiara Billanovich, Giorgio Cracco, and Antonio Rigon, eds., *Viridarium floridum: Studi di storia veneta offerti dagli allievi a Paolo Sambin*, 315–336. Padua: Editrice Antenore, 1984.

Ziggelaar, August, S.J. *François de Aguilon, S.J. (1567–1617): Scientist and Architect*. Rome: Institutum Historicum Societatis Iesu, 1983.

Zurawski, Simone. "Reflections on the Pitti Friendship Portrait of Rubens: In Praise of Lipsius and in Remembrance of Erasmus." *Sixteenth Century Journal* 23:4 (1992) 727–753.

abbagliamento, 94–96, 100, 112

Academy of Design, 6, 228*n*15

Accademia della Crusca, 51

Accolti, Pietro, 118–119, 255–256*n*97

Acquapendente, Girolamo Fabrici d', 86–89, 247*n*102

Acquaviva, Claudio, 219, 264*n*47

Aggiunti, Niccolò, 153

Agucchi, Giovanni Battista, 5, 227*n*8

Aguilon, François de, 197–201, 203, 204, 205, 210–211, 221, 222, 225, 275*n*41

Albert of Saxony, 47–48

Alberti, Leon Battista, 29, 110, 112

Alberti-style modeling. *See* down-modeling

Albertus Magnus, 154

Alcázar, Luis, 184–185, 187–194, 202

alchemy, 42, 52

Allori, Cristofano, 6, 102, 117, 255*n*97

Altobelli, Ilario, 68, 76–77, 81, 99, 244*n*69

Ambrose, Saint, 141, 146–147

Amico, Bartolomeo, 48, 162–163

Amicta sole, 140, 143–144, 201, 202–205, 222

anagrams, 151, 162, 201

Annunciation, 143–144, 145–146, 162–163, 169, 213, 217, 223–225, 262*n*17

Apelles, 5–6, 197, 201–202, 203, 207

Apuleius, 47

Aquinas, Thomas, 141, 153, 219, 264*n*47

Arcimboldisti, 7, 18

Arethusa, 164–167

Aretino, 101–102, 251*n*35

Argonauts, 213

Ariosto, Lodovico, 19–21, 102, 124, 174, 179

Aristotelians, 39–40, 59, 61, 62, 63, 77–78, 79, 87, 90, 108, 109, 134, 155, 251*n*30

Aristotle, 9, 39–40, 64–65, 81

ashen light. *See* secondary light

Assumption, 143, 261*n*12

astrology, 52, 73, 74

Augustine, Saint, 47–49, 131, 141, 198, 236*n*72

aurora borealis, 15, 57, 64–68, 79–80, 155, 240*n*27

Averroes, 39–40, 154

Bacon, Francis, 229*n*30

Badouvert, Jacques, 176, 177

Baldinucci, Filippo, 12, 44, 49–50, 103, 117, 120

Bandinelli, Baccio, 20

Barberini, Maffeo. *See* Urban VIII, Pope

Bartholin, Caspar, 48, 49

Bellarmine, Robert, Cardinal, 62, 76–77, 151, 167, 189, 190, 191, 197, 243*n*62

Bellini, Giovanni, 20

Bellini, Jacopo, 155

Bernard, Saint, 141, 215

Berosus, 46–47, 198, 200

Biancani, Giuseppe, 18, 158–159, 197, 205, 213, 221–225

Bianco, Baccio del, 12

Bible, citations of:

 Acts of the Apostles **1:11**, 135

 Acts of the Apostles **8:2**, 131

 Baruch **3:17**, 188

 I Corinthians, 48

 Ecclesiastes **1:4**, 191, 272*n*5

 Ecclesiastes **7:26**, 143

 Ecclesiasticus **24:6–7**, 147

 Ecclesiasticus **24:13**, 143

 Exodus **13**, 199–200, 276*nn*47, 48, 277*n*64

 Ezekiel **44**, 146, 262*n*20

 Genesis **3:15**, 142

 Genesis **28:12**, 143

 Isaiah **19:1**, 146–147

 Jeremiah **27–28**, 188–191

 Job **9:6**, 56, 158, 185–186, 191

 John **3:1–21**, 132

 John **3:12**, 134

 John **3:20**, 139, 183

 John **3:21**, 134

 John **7:50–52**, 132, 134–135

 John **19:38–40**, 132–133

Bible, citations of *(cont.)*
 3 Kings 6, 143, 144, 208, 225
 3 Kings 18:44, 208
 Luke 1:26, 223
 Luke 1:28, 142
 Luke 1:35, 145, 169
 Luke 2:15, 38, 40, 46, 55, 135
 Luke 23:44, 128, 257–258n127
 2 Maccabees 5:1–4, 65
 Mark 15:33, 128, 257–258n127
 Matthew 27:45, 128, 257–258nn126, 127
 Revelation 12, 16–17, 139–140, 142, 143, 153, 168, 187–194, 201, 202–203, 208, 222, 223–225, 277n64
 Song of Songs 2:1, 143
 Song of Songs 3:10, 214
 Song of Songs 4:4, 143, 225
 Song of Songs 4:7, 203, 224
 Song of Songs 4:10, 143
 Song of Songs 4:12, 143, 144, 224
 Song of Songs 4:15, 143
 Song of Songs 5:13, 224
 Song of Songs 6:9, 143, 224
 Song of Songs 6:10, 140, 144
 Zechariah 6:12, 145
Bilivert, Giovanni, 255n97
Bonaventure, Saint, 244n69
Borgo, Cherubino dal, 175–178
Boschini, Marco, 100
Brahe, Tycho, 48, 58, 62, 74–75, 77–78, 99
Brengger, Johann, 158
Bruno, Giordano, 78
Buonarroti, Michelangelo, the Younger, 181, 234n49, 260n149
Buontalenti, Bernardo, 6
Burton, Robert, 8–9, 191, 228n23
Busch, Georg, 74–75

Caccini, Tomaso, 135, 220
Calcagnino, Celio, 191
Cappella dei Principi, 7, 41–46, 51, 234–235n49, 235n52, 236n60, 237n82
Capra, Baldessare, 67, 73–74
Cardi, Giovanni Battista, 41–42, 45, 55, 103, 120–121, 123–124, 136–137, 175–178
Cardi, Lodovico. *See* Cigoli, Lodovico
Casaubon, Isaac, 213–215, 217
Castelli, Benedetto, 229n36
Castiglione, Baldessare, 100

Cavalieri, Bonaventura, 76, 229n36
Celio, Gaspare, 175–178
Cesi, Bernardo, 232–233n22
Cesi, Federico, 179, 181–183, 238n6
Chaldeans, 46–51, 53, 89, 135
Chimenti, Jacopo, 6, 117, 255n97
Cicero, 62, 76, 78–79
Cigoli, Lodovico, 4, 5, 6–7, 41–42, 51–54, 82, 96, 103–104, 112, 117, 118, 120–121, 160, 167–168, 181–183, 191, 222, 255n97, 270n122
 Adoration of the Shepherds of 1599, 15, 24–25, 38–41, 46, 55–56, 132
 Adoration of the Shepherds of 1602, 15, 24–25, 42, 46–51, 54–56, 132, 135, 168
 Allegory of Virtue and Envy, 172–180
 Deposition of 1578, 126, 130
 Deposition of 1607, 16, 24–25, 125–137, 168, 170, 178
 Immacolata, 16–17, 25–26, 103, 135, 138–139, 167–176, 203, 220
 Martyrdom of Saint Stephen, 131
 Portrait of Galileo, 121
 Prospettiva pratica, 41–42, 118, 120–125, 171
 Saint Peter Healing the Cripple, 175–178
Clavius, Christoph, 77, 99, 101, 151, 152, 154, 157, 167, 190, 197, 218
Coccapani, Giovanni, 103
Coccapani, Sigismondo, 5, 103, 270n122
Collegio Romano, 77, 149, 151–152, 160, 162, 167, 181, 191, 203, 234n37, 238n6, 264n44, 266n66, 276n55
Colombe, Lodovico delle, 10, 51–54, 89–90, 94, 96–98, 118, 123–124, 155–158, 160, 179–180, 191, 199, 204, 212, 218, 225, 255n95
Colombi, 17, 97, 124, 135, 157
comets, 59, 60, 160
comet of 1577, 74
comets of 1618, 48, 75–76, 116, 151, 246–247n94
condensation and rarefaction, 61–63, 79, 82, 83, 87–89, 104, 248–249n121
conjunction, planetary, 66, 79–80
contubernium, 60, 69–70, 74, 87, 239n9, 248n115
Copernicus, 36, 40, 63, 73, 99–101, 184, 185, 188–191, 273n12
Costozza, 88

Cremonini, Cesare, 267*n*79
Cresti, Domenico, 5, 6, 117, 179, 255*n*97, 256*n*103
cyathus, 150–153, 220
Cybele, 214

Dante, 28, 82, 178, 264*n*48
Danti, Egnazio, 31–32
Daphne, 174
Daza de Valdés, Benito, 11, 14, 186–187, 209–210
Diana, 165
Diodati, Elia, 13
Dolce, Lodovico, 101–102, 112
Donne, John, 4, 214
down-modeling, 95–96
Drebbel, Cornelis, 14, 230*nn*44, 45
Duns Scotus, John, 141–142

earthshine. *See* secondary light
eclipse, lunar, 48, 52, 53, 97–98
eclipse, solar, 126, 128–129, 187–188, 200, 201, 202–204, 210, 222, 280*n*112
Egidi, Clemente, 120
Elsheimer, Adam, 19
Empoli, Jacopo Chimenti dall'. *See* Chimenti, Jacopo
Envy. *See Invidia*
exhalations. *See* vaporous masses

Feather art, 7, 18
Ferreri, Martin, 43
Filiis, Angelo de, 181–182, 219
Fontana, Francesco, 12–14, 229*n*35, 230*n*37
Fontana, Giovanni da, 155, 161
Fugger, Georg, 231*n*1
Furini, Francesco, 228*n*16

Galen, 78
Galilee, 134–135, 223–224
Galilei, Galileo, works:
 Assayer, 7, 75–76, 82–83
 Considerations of Alimberto Mauri, 37, 57, 69, 94, 96–104, 112, 123, 124, 125, 129
 Considerazioni al Tasso, 19–21
 De sistemate mundi, 25, 36, 108, 109, 115
 De visu et coloribus, 25, 114–118
 Dialogue Concerning the Two Chief World Systems, 7, 13, 34, 43–44, 45,

102, 105, 107–109, 113–116, 182–183, 186, 199, 205, 206
 Dialogue of Cecco di Ronchitti, 57
 Discourse on the Comets, 66, 76, 240*n*27
 Exordium on the New Star of 1604, 58–60, 84
 Fragments Concerning the New Star of 1604, 61, 63, 67, 81–82, 92–93
 Letter to Gallanzone Gallanzoni, 17–18, 216–220
 Letter to Jacopo Mazzoni, 36, 37
 Letters on the Sunspots, 5, 7, 42–43, 120, 181–183, 201–202, 221
 Operations of the Geometric and Military Compass, 94
 Sidereus Nuncius, 3, 8, 11, 16–17, 19, 23, 25, 26–27, 34, 37, 52, 54, 98, 101, 105–106, 110, 112, 118, 129, 138, 149–152, 156, 157, 167–170, 176, 177, 180, 185–186, 192–193, 196, 203, 209, 213, 221, 223, 225
 Trattato della sfera, 24, 36, 39–40, 46
Galilei, Michelangelo, 3–4, 227*n*1
Gamaliel, 131
Gassendi, Pierre, 12, 13–14, 48, 85, 87
Gentileschi, Artemisia, 7, 228*n*17
Gilbert, William, 44, 191
Giorgione, 111, 254*n*71
Gonzaga, Vincenzo (duke of Mantua), 70, 73, 95
Grassi, Orazio, 75, 116, 151, 254–255*n*86
Gregory the Great, 139–140
Grienberger, Christoph, 151, 152, 167, 203
Griselini, Francesco, 109
Gualdo, Paolo, 20–21, 37, 85, 135, 231*nn*51, 52, 234*n*38
Gualterotti, Francesco Maria, 51, 245*n*86, 246*n*95
Gualterotti, Raffaelo, 51–55, 76, 78–83, 89, 94, 96, 105, 119, 129, 178, 237*n*82, 246*n*95

Henry IV (king of France), 41
Hercules, 60, 239*n*12
Hevelius, Johannes, 205
Horace, 100, 102, 183

Immaculate Conception, 16, 17–18, 141–144, 147–148, 153, 196, 202, 207, 208, 215–220, 264*n*47, 277*n*64

Incarnation, 145–147, 148–149, 162–163, 169, 200, 202, 218, 223
inlaid wood, 18, 21
Innocent XI, Pope, 142
intarsia. See inlaid wood
Invidia, 172–183
Ioachimicus, Johannes Praetorius, 63

Jerome, Saint, 131, 188–191
Jesuits, 6, 17, 18, 111, 149, 151–153, 158, 167, 183, 187, 191, 193, 197, 201, 203, 205, 213, 215, 218–220, 222, 234n37, 264n47, 274nn24, 27, 276n55, 278n78, 279n95
Jonson, Ben, 230n45
Joseph of Arimathaea, 128, 133
Joyeuse, François, Cardinal, 216, 218, 279n95
Jupiter, satellites of, 172, 174

Kepler, Johannes, 9, 10, 23, 28, 36, 62, 123, 135, 151, 192, 229n30, 231n1

Lagalla, Giulio Cesare, 10, 159–167, 168, 199, 204, 211–212, 225
Lembo, Giovanni Paolo, 151
Leonardo da Vinci, 28, 29–34, 96, 107, 114–118, 124, 171, 175, 178, 255n92, 266n61
Leschassier, Jacques, 105–112, 116
Ligozzi, Iacopo, 5, 227n7
Lipsius, Justus, 60, 69–70, 72–73, 278n76
Locher, Johann Georg, 197, 205–206, 207, 222, 225, 277n60
lodestone, 44–45
Lodge, Thomas, 90
Lomazzo, Giovanni Paolo, 32, 38–39, 95, 175
Lorenzini, Antonio, 98–99, 250n25
Lucian of Caphargamala, 131–132
Lucidus, Johannes, 148
Lucretius, 46, 49
luminescence, 85–89

Maelcote, Odo van, 151–153, 193, 197, 212, 220, 222
Maestlin, Michael, 23, 28, 34–35, 112
Magagnati, Girolamo, 180–181
Magini, Giovanni Antonio, 53, 99, 101, 246n99, 271n143

Mancini, Giulio, 170
Mantegna, Andrea, 70
Mantua, 70–72, 242nn51, 52
Marino, Giambattista, 83, 147, 148
Mary, Blessed Virgin, 138, 139–149, 153–154, 213–218, 264n47, 270n131, 278nn76, 78, 79, 280n104
Medici, Cosimo II de' (grand duke of Tuscany), 43, 91–92, 93–94, 119, 126, 150, 234n49
Medici, Ferdinando I de' (grand duke of Tuscany), 41–42, 79–80, 235n51, 236n60
Medici, Ferdinando II de' (grand duke of Tuscany), 12, 44, 45
Medici, Francesco Maria, Cardinal, 120
Medici, Giovanni de', 6, 118, 255n95
Medici, Giuliano de', 151
Medici, Maria de' (queen of France), 41
Medici, Maria Maddalena de' (archduchess of Tuscany), 43
Medusa, 42–44
Mellan, Claude, 12, 13, 229nn34, 36
Melzi, Francesco, 31
Mercuriale, Girolamo, 61, 64, 67, 69, 75, 81, 242n44
Mersenne, Marin, 205
Micanzio, Fulgenzio, 88, 89, 220, 228n36, 248nn115, 116
Michelangelo, 7, 11, 102, 127, 133, 228n21, 259–260n149
Milton, John, 4, 9, 13, 230n40
Montaigne, Michel de, 235n51
moon:
 as allegory of temporal goods, 139–140, 149
 as allegory of the Church, 47, 198–199, 200, 221
 as allegory of Christ's humanity, 187–188
 color of, 46–51, 51–53, 89–90, 157, 179, 202, 204–205
 crystalline or transparent, 53–54, 138, 144, 156, 159–160, 182, 194–196, 197, 202–207, 210, 211, 216–220, 222
 as emblem of the Virgin Mary, 140, 143–148, 152–154, 162–163, 164–167, 202–205, 207–208, 212, 216–220
 inhabited, 9, 13, 14, 29, 162, 228–229n23

as mirror, 108–109, 113, 198
mountains and craters of, 98, 110–112,
 129–130, 138, 144, 149–167, 187,
 198, 202, 209–210, 222, 224
nature and substance, 16–18, 33, 39–40,
 46–55, 97–98, 108, 109–112, 119,
 138, 144–145, 151–152, 154–167,
 182, 187, 198–201, 202–212, 216–
 220, 222–224
opacity of, 168–169, 171–172, 175,
 193, 199, 203, 217
semidiaphanous, 138, 144, 149, 151,
 154–167, 168, 182, 187, 198–199,
 202, 205–205, 222, 223, 264n48,
 267n79
two-toned, 46–51, 89, 123, 135, 198,
 200, 277n64
vaporous mantle of, 52, 129–130, 168
moonspots, 5, 10–11, 12, 17–18, 27,
 29, 33, 98, 109–112, 114–115, 144,
 149–150, 161, 198, 203, 223,
 276n42

Nadal, Geronimo, 148–149, 203
Neostoicism, 15, 36–37, 57–64, 69–70,
 72–73, 75–84, 87–89, 189, 238n3,
 248n116
New Star of 1572, 58–59, 67, 74
New Star of 1604, 15, 25, 36–37, 52, 96–
 99, 123, 178, 238n6, 241n39
Nicodemism, 133, 259n147
Nicodemus, 128, 130–136, 139, 183
Nifo, Agostino, 40
Nova of 1604. See New Star of 1604
Novarini, Luigi, 145
novelties, 153, 206, 216, 217, 218–219

Opificio delle pietre dure, 42, 44
Origen, 188–191
Orosius, 131
Ovid, 164–167

Pacheco, Francisco, 4, 11, 17, 139, 184–
 185, 191, 193–196, 208, 209–210, 211,
 212, 222
Paci, Giulio, 87
Pagani, Gregorio, 117
Parmigianino, Francesco Mazzola il, 20, 21
Passignano, il. See Cresti, Domenico
Patrizi, Francesco, 27
Paul V, Pope, 26, 142, 146, 170, 175, 192,
 215

Pecham, John, 28, 29
Peiresc, Nicolas Fabri de, 12, 13, 14, 67,
 68, 85, 86–89, 246n97
Pena, Jean, 62, 63, 77–78
Pereira, Benedict, 76–77, 190
Perez de Baron, Juan Batiste, 69–70
Peripatetics. See Aristotelians
Petrarch, Francesco, 146
Peurbach, Georg, 53
Philip IV (king of Spain), 209
Philolaus, 163
phosphorescence. See luminescence
Pietre dure, 7, 18, 41–46, 103, 234–
 235n49
Pigeons. See Colombi
Pignoria, Lorenzo, 20–21, 37, 67, 85,
 135, 181, 230nn51, 52, 247n102,
 277n57
Pineda, Juan de, 158, 191, 207, 277n64
Pinelli, Giovanni Vincenzio, 33, 37, 85, 87,
 118, 234n38, 248n115, 252n43,
 255n92
Pippione, 124, 179
planetary movement, 62–63, 76–79, 83,
 189, 243n63, 244nn68, 69
Platter, Felix, 123
Pliny, 6
Plutarch, 9–10, 16, 78, 79, 111, 154, 160
Pseudo-Dionysius, 128–129
Ptolemy, 36, 99–100, 119, 180, 186,
 281n117
Pythagoras and Pythagoreans, 63, 73, 163,
 186, 189, 240n23

Raphael, 11, 102, 126
Reinhold, Erasmus, 53, 97, 145
Rheticus, Georg Joachim, 56
Rhodiginus, Coelius, 48, 49, 232n22
Ricci, Ostilio, 6, 25, 35
Riccioli, Giovanni Battista, 205
Richardot, Willem, 69–70, 85
Ripa, Cesare, 174, 178–179, 181
rosary, 142–143, 152–153, 197, 222
Rosso, Fiorentino, 11
Rothmann, Christoph, 77–78
Rubens, Peter Paul, 4, 14, 15, 37, 68–
 76, 102, 103, 125, 197, 230n44,
 275n41
Rubens, Philip, 68, 69
Rudolph II (Holy Roman Emperor), 10,
 23, 230n45
Rupert of Deutz, 144

Sagredo, Giovan Francesco, 108–109,
 113–115, 220
Salusbury, Thomas, 102
Salvatus, Claude 12, 229n34
Salviati, Filippo, 108–109, 113–115, 181
Salviati, Francesco, 11
Sandelli, Martino, 181
Santa Maria del Fiore, 179–180,
 270n131
Santi di Tito, 49–50, 102
Sarpi, Paolo, 28, 31, 32–34, 85, 87–89, 92,
 104–112, 116, 213–216, 217, 218
Saturn, tribodied, 151, 162
Scheiner, Christoph, 5–6, 197, 198, 200–
 206, 210, 219, 221, 222, 225, 227n6,
 264n44, 270n122
Scholastics, 33, 87, 141, 254n74,
 265n55
Scripture. See Bible
secondary light, 8–9, 15–16, 23–35, 81,
 85–90, 91–94, 104, 106–112, 114,
 118–120, 122–123, 126 130, 134–
 136, 138, 157, 163–164, 204–205,
 224–225, 232–233n22
Seggett, Thomas, 135
Seneca, 59, 60, 62, 63, 70, 75–76, 78, 79,
 88, 89–90, 248n116
Simón Abril, Pedro, 186, 191
Sixtus IV, Pope, 142
Snel, Willebrord, 48
Society of Jesus. See Jesuits
Soldani, Jacopo, 251n30
Stelluti, Francesco, 182
Stoicism. See Neostoicism
sunspots, 5, 6, 42, 80, 103, 174, 179, 182–
 183, 197, 198, 201–202, 205, 221,
 264n44, 270n122
supernova. See New Star of 1604

Tarde, Jean, 227n6, 264n44
Tasso, Torquato, 19–21, 85–86, 231n51

telescope, invention of, 105–106, 113,
 176–177, 182, 269–270n120
Thomism. See Aquinas, Thomas
Tinghi, Cesare, 43
Tintoretto, Domenico, 70, 102, 252n39
Titian, 102, 111, 254n71
Toscanelli, Pietro Paolo, 180
tota pulchra, 143–144, 224–225
trompe l'oeil, 7, 18

Urban VIII, Pope, 109, 116, 181

vaporous masses, 61–66, 80, 81–82, 161–
 162, 178
Varaderius, 213–215, 217, 218, 278n71
Varchi, Benedetto, 100
Vasari, Giorgio, 38, 95–96, 100, 112
Velázquez, Diego, 4, 11, 17, 139, 184,
 185, 194–196, 207–212
Venus, phases of, 201
Vicomercati, Francesco, 65–66
Vignola, Giacomo Barozzi da, 31–32
Villanueva, Tomas de, 146, 148
Vinci, Leonardo da. See Leonardo da Vinci
Virtú, 172–183
Virtue. See Virtú
Vittorelli, Andrea, 160, 203
Vitruvius, 46–47, 49
Viviani, Vincenzo, 6, 117, 120

Welser, Mark, 158–159, 181, 201, 218,
 219, 221, 225
Wilkins, John, 90, 165, 191, 219, 231–
 232n3
Witelo, 28, 29, 53, 97
Wotton, Henry, 27–28, 229n30
wunderkammer, 18, 19–21

Zúñiga, Diego de, 55–56, 158, 185–186,
 191
Zurbarán, Francisco de, 207, 211